Robert Rauschenberg

The Columbia Oral History Series

The Columbia Oral History Series

Edited by

Mary Marshall Clark

Amy Starecheski

Kimberly Springer

Peter Bearman

Robert Rauschenberg

An Oral History

Edited by

Sara Sinclair with Mary Marshall Clark and Peter Bearman

Columbia University Press
New York

Columbia University Press
Publishers Since 1893
New York Chichester, West Sussex
cup.columbia.edu
Copyright © 2019 Columbia University Press

Library of Congress Cataloging-in-Publication Data
Names: Sinclair, Sara, editor. | Clark, Mary Marshall, editor. |
 Bearman, Peter S., 1956– editor.
Title: Robert Rauschenberg : an oral history / edited by Sara Sinclair with
 Mary Marshall Clark and Peter Bearman.
Other titles: Robert Rauschenberg (Columbia University)
Description: New York : Columbia University Press, 2019. |
 Includes bibliographical references and index.
Identifiers: LCCN 2018060641 (print) | LCCN 2019000796 (e-book) |
 ISBN 9780231549950 | ISBN 9780231192767 (cloth : alk. paper)
Subjects: LCSH: Rauschenberg, Robert, 1925–2008. |
 Artists—United States—Biography.
Classification: LCC N6537.R27 (e-book) | LCC N6537.R27 R64 2019 (print) |
 DDC 709.2 [B] —dc23
LC record available at https://lccn.loc.gov/2018060641

Printed in the United States of America

Unless otherwise noted, all artworks copyright
Robert Rauschenberg Foundation

Cover design: Julia Kushnirsky

Cover image: © Robert Rauschenberg Foundation/
Licensed by VAGA, New York

Book design: Lisa Hamm

"I refuse to be in this world by myself." *

ROBERT RAUSCHENBERG, 1997

* *Robert Rauschenberg: A Retrospective* (New York: Guggenheim Museum Publications, 1997), 227.

Contents

Preface

A PAINTER, sculptor, photographer, printmaker, sometime performance choreographer, and maker of hybrid forms thereof, Robert Rauschenberg is widely considered to be one of the most influential American artists of the twentieth century. In June 2013, the Columbia Center for Oral History Research was awarded a grant from the Robert Rauschenberg Foundation to conduct a project on the life and influence of the artist, and we realized that creative challenges lay before us. The first set of challenges were methodological; we learned a great deal about how to link our practices in the oral history world with similarly rigorous practices in the art world, resulting in creative exchanges and new standards.

METHODOLOGICAL CHALLENGES

During the project's pilot phase, the Rauschenberg and Columbia teams came to understand a difference in their respective fields. Oral historians and art historians think about subjectivity in different ways. In oral history, we are aware that we are studying memory itself, and we allow for its rearrangements, which reveal different meanings. Art historians understandably place great value on exact record keeping, preserving each image and its source with care to allow direct access to others. This difference led to the creation of a new step in processing the transcript. The normal work flow at the Columbia Center for Oral History Research is as follows: conduct an interview, have it transcribed, audit-edit the transcript (making sure the transcript is an accurate record of

the audio file), and return it to the narrator for his or her edits. On the Raus-chenberg project, we added a new step—fact-checking the transcripts. In addi-tion to confirming proper names, we checked for accuracy and full expression of titles of Rauschenberg's work, including the date of all creative works, and checked for accuracy of descriptions of pieces, exhibitions, and locations when a narrator mentioned Rauschenberg was present. The foundation staff pro-vided further research into Rauschenberg's artistic processes as well as details pertaining to all other artists' work.

Fourteen video sessions were conducted for the project, including a num-ber of what we called *technical oral histories*, a hybrid interview form that was conducted with Rauschenberg's former studio assistants and fabricators. These interviews were captured on film and were shot in the presence of artworks to best facilitate in-depth discussions about the materials and methods used in their creation. These interviews were held at the Rauschenberg warehouse in Westchester, New York, which houses the foundation's art collection and some archival material. Each narrator identified the series to which he would like to speak, Rauschenberg Foundation collections manager Gina Guy found the best examples of that series still in the collection, and Rauschenberg's then senior registrar, Thomas Buehler, installed them in the warehouse space so that narrators could literally speak to, and about, the work. Columbia interviewers collaborated with conservator Christine Frohnert to collect the story and the process behind each work of art displayed.

Overall, the interviewing team completed ninety-eight oral history sessions with fifty-nine narrators, totaling 179 recorded hours. These reminiscences are archived at the Columbia University Center for Oral History Archives at the Rare Book & Manuscript Library in Butler Library and at the Rauschenberg Foundation.

A very dynamic challenge in the Robert Rauschenberg project was that we needed to depend on those who were close to the artist—his friends and family, curators, critics, and others—to paint a picture of his world after his death. Due to the careful work of the Rauschenberg Foundation, who con-nected us to his network, and of the extraordinary work of the interviewers who stimulated narrators to reconstruct memories of Rauschenberg's world, the art world, and their own memories, the project came to life. This says something very positive about the tangible legacy Robert Rauschenberg left

and the creative ability of oral history to resurrect the past for the sake of transmitting memory.

Our objective was to establish an oral biography of the artist by recording firsthand accounts of his life, work, and legacy as told by his family, friends, former lovers, professional associates, studio assistants, and collaborators. We also strove to capture the spirit of the larger art world that Rauschenberg inhabited throughout his life. Drawing from a consideration of Rauschenberg's life and work situated within the larger scope of art and social history, we identified four periods of inquiry: the 1950s and 1960s, the 1970s, the 1980s, and the 1990s until Rauschenberg's death in 2008. We attempted to capture three vital strands in each period: Rauschenberg's life and legacy as told through the interviews we conducted; the contributions of the individuals we interviewed to the art world of their times; and how, through innovation and experimentation, Rauschenberg and his collaborators influenced each other to create something new.

The materials held at the Robert Rauschenberg Foundation were invaluable to our preparation. The large collection of letters to Rauschenberg from his colleagues in the art world, writings by the artist, the collection of documentary photographs relating to Rauschenberg's art and life, sketches, exhibition photos, newspaper clippings of interviews with Rauschenberg, reviews of his exhibitions, an extensive collection of exhibition catalogs organized by year, posters, and other assorted archival documents and books were all made available to our interviewers.

The second set of challenges we faced was theoretical. Although oral history has recorded the art world at Columbia and beyond, it is only recently that we have considered the still photograph, the moving image, and dance and performance as primary sources. To help you understand how we approached the visual and embodied world of Robert Rauschenberg, we next provide a brief review of the nature of oral history's contribution to an understanding of visual history and memory.

ORAL HISTORY: THE VISUAL ARTS AND MEMORY

In the introduction to *The Art of Memory*, Frances Yates writes that "in the ages before printing a trained memory was vitally important and the

manipulations of images in memory must always to some extent involve the psyche as a whole."[1] Yates's phrase, "psyche as a whole," is analogous to what oral historians would call "subjectivity," the intimate yet enormous world we carry inside of us that defines who we were, who we are, and who we aspire to become in relation to many external worlds. Oral history is the intersubjective and dialogical activity of exploring the past in relation to the present and the future; it is itself an art form that also involves capturing the psyche as a whole as well as the particular social and historical contexts that define subjectivity. In that sense, the work of the oral historian and the work of the artist and of art historians are deeply interconnected, even though it is only recently that oral historians have come to embrace memory in its visual, embodied, and tangible forms. We are fortunate that work on the Robert Rauschenberg Oral History Project coincided with a time that began to embrace the visual world within oral history, providing a context through which we could explore the synergies between our disciplines and artistic forms. To better understand the exciting symmetries between oral history and the arts that exist now, it is important to understand that until recently the modern oral history profession favored suppressing the visual image, and the body as well, in highlighting the importance of the written word. In many ways, understanding the arts has contributed to the growth of a new and visual form of oral history.

Oral history, classically defined as being as old as the act of speech and as constant as the activity of passing down stories to preserve the intimate and tangible memory of cultures, flourished long before there was a name to describe the activity.[2] As Frances Yates so beautifully records in her history of how visual memory preserved history through art and architecture in *The Art of Memory*, the act of transmitting memory was connected to the art of telling, mnemonically and historically. In the transmission of memory, the orality of the word and the subjectivity of the image belong to one another organically in the transmission of memory through art and architecture. Mnemosyne, the mother of all muses, enables the fullness of memory to flow through time, integrating the image with the spoken word in the performance of stories. In Yates's world, the word and the image belong together to such a degree that memory cannot perform its function without one or the other. The visual imaginary is part of subjectivity and the art of transmitting memory in its fullest, most embodied sense.

In a sensory inclusive definition of oral history, the visual artist and the oral memoirist play a similar role. Through the integration of the word and the image, a "picture" of the still living past is created so that the renewal of memory can occur. It is through this reinvigoration of memory that the images and words of one generation are passed to another even when, important to oral history, the language of memory has been lost, erased, or not recorded at all. Jan Assmann has written about how, in this sense, oral memory is deeply connected to archeology, a process of restoring the past through examining the traces of visual memory in palimpsests for what remains in an effort to restore memory.[3] Andreas Huyssen, in *Present Pasts: Urban Palimpsests and the Politics of Memory*, argues that a palimpsest is an evocative symbol of the violence of erasure in the twentieth century, an erasure that in the end stimulated cultural memory studies, memorials, and films obsessed with what has been lost.[4]

Oral history, in its modern form dating to the 1930s and 1940s, had little interest in the visual and aural dimensions of the story and almost no interest in subjectivity or memory. In the United States, oral history was defined as a source of historical evidence that, like letters, diaries, and other documents, were most valuable in their written form. Allan Nevins, founder of the Center for Oral History Research at Columbia in 1948, instructed his staff to reuse the reel-to-reel tapes to save money. In fact, some oral historians in the United States have argued that oral history does not meet the standard of evidence *as* oral history until it is deposited into an archive and made accessible. Aside from a few pictures of notable narrators and staff, no visual evidence of oral history activity existed until the late 1990s, when the Center for Oral History was given a grant from the Carnegie Corporation to shoot video and use photographs to create a more public and visible legacy of its work and to create a field of visual oral history. Our mutual goal was to create a field of visual oral history that retained the scholarly values of oral history but would expand its public use by making it accessible through visual media on the internet.

One early manifestation of the positive results of telling a scholarly and public story through visual media was our Carnegie Corporation Oral History Project, Phase II, oral history. Specifically, we produced a website and video, "Voices from South Africa,"[5] that traced Carnegie supported research on white poverty in the 1930s, which was used to create a blueprint for apartheid, and later black poverty in the 1970s and 1980s, which was used for the cause of

liberation. These two oppositional and entangled histories came to life through images of black and white poverty, visual digital transcripts, and the video-taped narratives that expressed the strong emotional content of South Africa's contested past as well as its conflicted history.

A REVALUING OF ORAL SOURCES

Luisa Passerini, an Italian intellectual historian with a strong interest in the impact of fascism on the working classes, was one of the first historians to use oral history for the purposes of analyzing oral sources for evidence of the legacy of fascism in ordinary lives. In her landmark article, "Work Ideology and Consensus Under Italian Fascism," she described the value of oral sources in interpreting the subjective violence of fascism. Passerini connected the analytical use of oral sources as a primary methodology for recording the complex impact of political history and violence in ways that historians using only written sources could not. In fact, she argued that Italian historiography at the time had no methodology for interpreting the silences and distortions of memory that she found regularly in her interviews. Passerini's thesis had a tremendous impact on the growing field of culturally sensitive oral historians and others, separating empirical oral historians from those who acknowledged the ambiguities and contradictions in oral history as a source of valuable knowledge.[6]

Alessandro Portelli, an Italian oral historian writing and researching on the complex legacy of fascism in the same time frame, used his training as a literary scholar to expand on the ways in which oral sources are bound in time in folk traditions and are expressions of history, memory, and ideology in the form of their telling.[7]

As the field of oral history grew through the remarkable efforts of Luisa Passerini, Alessandro Portelli, and others, who turned to the *voice* itself and the languages of memory within the voice, scholars and practitioners around the world began to see the value of oral history in interpreting political and culture violence, displacement, and loss. Even without a focus on the visual imaginary in the 1970s and 1980s, oral history stretched to include the "wholeness" of memory and experience, retold in order to be interpreted not only for the past

but for the living present. Portelli made specific contributions to expanding the field of oral history by demonstrating how oral memory can reverse popular collective memory in his magnum opus, *The Order Has Been Carried Out: History, Memory and Meaning of a Nazi Massacre in Rome.* The award-winning book excavates a memory of a Nazi massacre of over three hundred people, blamed on a small group of partisans who attacked a group of Nazis near the end of World War II. The Nazis reported after the massacre that the partisan attackers were ordered to turn themselves in or ten times the number of partisans would be shot. In fact, Portelli discovered, through an extensive number of interviews with surviving family members and others, that the order was never posted. The architecture of the book itself, framed by first person testimony of surviving family members and others, serves to literally deconstruct an official memory and replace it with an authentic one constructed from five decades of living memory.[8]

Most important for the teaching of oral history theories that underlie the intersubjective structure of the oral history interview, Passerini's book, *Memory and Utopia: The Primacy of Intersubjectivity*, clearly defined the multiple ways in which subjectivity defines the content and shape of oral history.[9] This is true, she argued in the International Oral History Association's meeting in Rome in 2004, even when a breakdown of communication occurs, mirroring social differences that cannot be bridged but must be understood. She was already beginning to apply that rigor to her own work, understanding the cultural limits of Europe through the stories of those who crossed its borders to seek refuge.

Passerini, Portelli, and others, including Raphael Samuels in Britain (*Theaters of Memory*), succeeded in introducing the idea of cultural memory and subjectivity to the oral history world through their examination of "orality" and, in Samuel's case, visual images as primary sources, ideas that spread throughout the oral history world in the 1980s and 1990s. With their contributions, the field of oral history—as it expanded to include a worldwide community of scholars—began to shape its own expectations as a multidisciplinary field of study and practice that went far beyond the goal of populating the archive with transcripts. The small but intensive gatherings of global oral historians expanded into international meetings through which broader conversations were held about the relationship between history and memory, including how

oral history might address and redress historical violence. It became clear that oral history could be a platform for deep exchanges on politics, culture, and memory in multidisciplinary and cross-cultural contexts. As the field grew through these international meetings, leaders began to ask probing questions about the future of oral history.

A VISUAL TURNING POINT

It was during the 1993 meeting of an international group of oral historians, gathered in Siena, Italy, that Passerini issued an urgent call for the use of visual sources that was as powerful as her passionate call for the use of oral sources had been in 1979. During an already enlivened debate about whether the nascent international oral history group would expand outside of Europe's borders, she stood up in a general meeting and declared, "Unless and until oral history moves into the visual realm of memory, it will inevitably die."[10] Those of us who witnessed this call also heard the collective silence of the group that was gathered, astonished at the strength of her Cassandra-like prophecy that, instinctively, many of us knew to be true if the field was truly turning toward representing the voices of those who were rarely represented in the Western canon and its written histories.

In retrospect, it is easy to see how the themes of the 1993 Sienna conference stimulated Passerini's call for visual oral history as the ideal form through which to capture turbulent historical times. The key themes of the Sienna conference—migration, generation, gender, and the processes of identity and cultural construction—carry within them the imagination of the body itself as a locus of identity and mobility. Passerini has devoted the last five years of her work to these themes, exploring these ideas in depth through the lens of visual representations of living memory and the experience of recent migrants traveling to Europe.

This shift to the incorporation of visual materials in oral history has been carried forward by others. Ann Cvetkovich, a noted literary critic and author of *An Archive of Feelings: Trauma, Sexuality and Lesbian Public Cultures*, analyzed ACT-UP New York's collection of images and videos in relation to her own oral interviews, making the argument that public activism can be a form

of resistance against historical trauma. In so doing, she made a parallel claim to that of Passerini—to ignore the life of the body is to ignore history itself. Beyond that, and in a framework similar to that of Passerini's, Cvetkovich put forth the idea that embodiment is central to oral history work and analysis, and that without it, it is impossible to understand the transformative potential of cultural and political movements.[11] Kathy Davis examined how feminist theory and the body intersect in her landmark book, *The Making of Our Bodies, Ourselves: How Feminism Travels Across Borders.* In the same general time period, dance and oral history scholar Jeffrey Friedman, who did extensive interviews with artists with AIDS in San Francisco, made the argument that oral history was directly linked to the worlds of performance and dance with the body as the focus of the process of meaning-making. Della Pollack, in *Remembering: Oral History Performance,* instantiated performance studies as a part of oral history. Although Alex Freund and Alistair Thomson's 2011 edited collection, *Oral History and Photography,* is limited to an examination of the value of the still image, it makes a valuable point that the oral and the visual are deeply linked, especially in memory work.

RESONANCES

The synchronicities between the fields of art history, the study of memory, and the growth of oral history have been striking to us in the time frame during which the Robert Rauschenberg Project was completed. As we were learning about the importance of bringing the world into the interview room, we were listening to narrators in the Rauschenberg project discussing ways Rauschenberg insisted on the same. As we were realizing that there is no way to capture the wholeness of the psyche without the literal memory of embodiment, we were analyzing the stories of how Rauschenberg came to life when he began to collaborate with dancers. As we have been wondering how to think about objects of memory in oral history interviews, we were learning about how Rauschenberg, led the art world in recognizing their literal and symbolic value inside the museum. As we were loosening the grip of the archive on our thinking processes about how oral history is defined and what interviews we conduct, we were inspired by Rauschenberg's insistence that museums open

their doors to incorporate the art and artifacts of real life—to let the world in. Robert Rauschenberg's life and work, including his philanthropy, aspired to create new forms and utopian possibilities. This oral biography of Robert Rauschenberg, told in multiverse, is our attempt to strengthen our collective understanding of his impact, not only on the art world but on all the audiences he reached.

Reader's Guide

FORTY-FIVE voices come together in the following pages to narrate the story of Robert Rauschenberg's life and the larger story of the ever-changing art world that he occupied. This book was assembled through an editing process that sought to put our project narrators in conversation with one another. Given the editing process undertaken for this book, punctuation and the exact order of text may not precisely match the narrators' transcripts. In the appendix, we provide a series of network graphics representing the people mentioned and how the edges connecting them reflect their connection in some aspects of the narrators' stories. You will watch the world around Rauschenberg expand and contract from the 1950s through to the turn of the century. Also in the appendix is a graphic showing the cumulative network of all the people mentioned and their ties to one another. From these images and the narratives, the rich collaborative world that Rauschenberg built comes alive through the personal influences that shaped his work and the people whose lives were, in turn, shaped by his creative engagements. Of course, thousands of others surely were influenced as well; here we capture just a small component of that larger network, which includes well-known others, family, friends, artists, collaborators, agents, and critics.

Following the prologue, narrated by Rauschenberg's sister Janet Begneaud, our story begins with chapter 1, "Small World," in which narrators invoke New York's tiny art world of the 1950s and 1960s. It was a scene so small that, as Calvin Tomkins recalled, "You could, on a Saturday morning, see all of the new shows that had opened during that week of contemporary work. You could easily do it."

Today we are accustomed to the presence of everyday objects in art, but when Rauschenberg first began to bring "life" into art, it was an innovative move. In his most oft repeated words, Rauschenberg's desire was to work in that gap between art and life. "I don't want a picture to look like something it isn't. I want it to look like something it is. And I think that a picture looks more like the real world when it's made out of the real world."[1] The narrators in chapter 2, "Collaborations," reveal how this way of thinking was shaping Rauschenberg's creative alliances in New York City during the 1960s and how these relationships resulted in the dissolution of the once rigid boundary between the fields of visual and performance art.

We follow these voices into the 1970s in chapter 3, as new characters join the party at Rauschenberg's 381 Lafayette Street address, in what Laurie Anderson remembers as "dark downtown SoHo." The scene is still a small one, but it expanded to include new friends that join the narration here. Equally important, Rauschenberg's influence was expanding outside of the city, and narrators recall the changing life of the now wealthy and celebrated artist.

In 1970, Rauschenberg made his home on Florida's Captiva Island, his principal residence. In chapter 4, "Captiva," some of the people introduced in New York accompany Rauschenberg as he moves to this island getaway that will be his home and the center of his creative work until his death. These old friends and colleagues offer different perspectives on why he made the move, thoughts on the consequences that this relocation subsequently had on his art, and together with new voices on the island they bear witness to the work and life that unfolded there.

Despite having a long-standing permanent address, Rauschenberg traveled frequently from Captiva. Chapter 5, "Travelogue," follows Rauschenberg on some of the working trips he took across the globe in search of new materials.

In chapter 6, "Rauschenberg Overseas Culture Interchange" (ROCI), the friends, family, and workmates who accompanied Rauschenberg throughout that endeavor describe how the idea for the long traveling exhibition emerged, how it was organized and assembled, and the political and cultural contexts in which it took place.

In 1991, while ROCI's final presentation was on display at the National Gallery, Washington's Corcoran Gallery of Art was presenting *Robert Rauschenberg: The Early 1950s*. This exhibition featured about one hundred lesser-known

works made by Rauschenberg when he was twenty-four to twenty-nine years old, during his first five years in New York. Chapter 7, "Curating and Installations," begins with a critical review of the artist's work at these two stages of life, and it brings together the voices of the preeminent gallerists and curators Rauschenberg worked with over the course of his career. These narrators share their memories and appraisals of some of his most important shows, shedding light on how Rauschenberg's exhibitions were researched and fulfilled.

In chapter 8, "An Expanding American Art Market," many of the same narrators assess how the emergence and growth of the art market affected Rauschenberg independently and the art scene more generally. As Arne Glimcher said in his oral history, "I think [the market] might change the energy in New York City, and, more dangerously, it changes the energy in the artist."

The book closes with "No One Wanted It to End," memories from Rauschenberg's companions at the end of his life as he faces challenges to his health and ultimately passes away in his Captiva studio. Finally, the friends and family that accompanied Rauschenberg to this end are rejoined by voices from earlier stages of his life who share their personal reflections on his legacy.

In the words of Dorothy Lichtenstein: "It's going to sound corny, but I just thought of the word love. That he really loved that interchange. I remember when Sid [Felsen] and Joni [Moisant Weyl] got married. I don't know, somehow, we were all at Bob's at the end of the evening, and I remember him saying, 'Oh, don't go home. Come and stay here with me tonight,' and it was—I just think that he had a kind of love for being with people that was so nourishing, so freely given. This is what he wanted—that spirit he had, he would want to put out to the world."

In this book, source citations appear in the backnotes. Editorial clarifications appear in the text, in square brackets. Longer interventions are in footnotes. The footnotes are of two types: "narrator notes," notes that narrators added to their own transcripts during their opportunity to review them, and "editor notes," which provide context or clarification longer than convenient for a simple square bracket in the text.

Acknowledgments

IN JUNE 2013, the Columbia Center for Oral History Research (CCOHR) was awarded a grant from the Robert Rauschenberg Foundation to conduct a project on the life and influence of the artist. Over the course of a productive and fruitful four-year collaboration, we were honored to work closely with the Rauschenberg Foundation, and we are greatly indebted to its staff for their great energy and enthusiasm for the work as well as the countless meaningful contributions they made to the collection, analysis, and editing of the transcripts from which this book has been created.

The Columbia Center for Oral History Research, one of the world's leading centers for the practice and teaching of oral history, has been producing biographical interviews and projects since 1948. CCOHR is housed at the Interdisciplinary Center for Innovative Theory and Empirics (INCITE), where it administers an ambitious research agenda with the goals of recording unique life histories, documenting the central historical events and memories of our times, providing public programming, and teaching and doing research across the disciplines.

The Robert Rauschenberg Oral History Project at CCOHR was codirected by Mary Marshall Clark and Peter Bearman and managed by Sara Sinclair, with assistance from Sarah Dziedzic and Adam Storer. Other INCITE staff who supported the project in a variety of capacities are Michael Falco (associate director), Audrey Augenbraum (research assistant), Nicki Pombier-Berger (Robert Rauschenberg Oral History Project research fellow), Erica Fugger (project coordinator), Jamie Beckenstein (administrative coordinator), and nearly a dozen students from the Oral History Master of Arts program housed

at INCITE/CCOHR. We are especially grateful to Michael Falco for keeping a complex project on track and on budget. Audrey Augenbraum generated the network graphs that have provided such a rich visual enhancement for this narrative. Nicki Pombier-Berger provided help across the board, from getting project materials ready for the archive to research on the book. Her steady presence on our team gave us great peace of mind.

The project's interviewing team included Mary Marshall Clark, director of the Columbia University Center for Oral History Research, Columbia professor Brent Edwards, art scholar James L. McElhinney, dance writer Alessandra Nicifero, Columbia University Oral History master of arts graduates Sara Sinclair and Cameron Vanderscoff, and Donald Saff. The Columbia team worked closely with the art historians and archivists on the Rauschenberg Foundation staff in all phases of the project, from preliminary research to the completed transcripts.

The main editing of the oral history material was undertaken by Sinclair, who arranged the material so that our narrators could speak to one another as they described the various settings in which Rauschenberg worked (and played). Bearman envisioned the project and guided the work. Clark's insights are scattered throughout, and her initial engagement with the Rauschenberg Foundation (as co–principal investigator of the project, along with Bearman) was absolutely essential. We are deeply grateful to the Columbia Center for Oral History Archives, where the Robert Rauschenberg collection will be deposited and carefully curated and archived. The material is also available at the Robert Rauschenberg Foundation Archives.

Our colleagues at the Rauschenberg Foundation provided immeasurable help throughout. Julia Blaut, director of curatorial affairs, led the Rauschenberg team on this project. It was a great pleasure to work with Blaut, and we thank her for her friendship and partnership. Collections manager Gina Guy and senior curator David White offered invaluable institutional memory to our interviewers. We thank Guy and White for sitting down with us and for sharing stories and unearthing information that led to so many valuable lines of questioning. We couldn't have found these cues without them. Assistant curator Helen Hsu demanded an attention to detail that elevated our work throughout.

Thomas Buehler, then senior registrar at the Foundation, provided invaluable assistance with the interviews at the Rauschenberg warehouse. The emotion,

thought, and recognition his installations evoked in our narrators was striking. Christine Frohnert, conservator, shared her expertise during these sessions and collaborated with us to capture the process behind the making of Rauschenberg's art. Sharon Ullman, deputy director, and Christy MacLear, then chief executive officer, were enthusiastic supporters throughout. Ann Brady, director, Rauschenberg Residency, and Matt Hall, facilities manager, assisted with coordinating interviews at the Captiva residency. We also thank Francine Snyder, director of archives, Jenny Sarathy, and Kayla Jenkins for their support.

Finally, our deepest thanks go to our narrators who generously, patiently, and spiritedly shared their time and experiences with us. Editing this book has felt akin to making a painting with your words.

Robert Rauschenberg

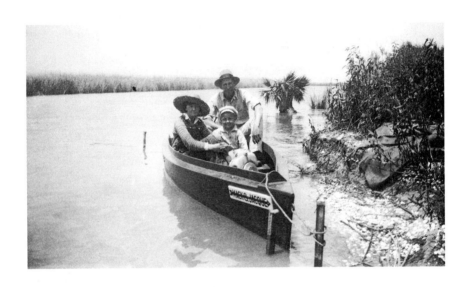

Rauschenberg boating with his parents, Ernest and Dora Rauschenberg, on the bayou near Port Arthur, Texas, ca. 1927. Photograph: Unattributed.
Photograph Collection: Robert Rauschenberg Foundation Archives, New York.

Prologue

JANET BEGNEAUD: Bob and I were very fortunate—I feel it even more the older I get—that we had the simple, loving family that we did. We were fairly poor. Neither one of us really knew that.

My dad was born in Gatesville, Texas—actually, he was born in Rosebud, Texas, and I think Rosebud has disappeared. It was near Gatesville. And he didn't finish high school. There were five boys and a girl in the family, and farming. And, if you have ever been to Gatesville, Texas, to see the soil there, you know farming was a pretty poor business to be in. It was just like hard sand.

Anyway, Daddy left when he was fourteen and went to get a job. He ended up going to work for the Gulf States Utilities Company, [which] transferred [him] to Port Arthur.

Mother was born in Galveston, Texas, and she had a bad childhood. Her father was an alcoholic, and my mother, I think because of that, was always, till the day she died, a total teetotaler. And [her father] finally died of tuberculosis or something like that, and it just was amazing to me, with the lack of sanitation, how none of the kids got sick. He slept on the screened-in porch. In Galveston, Texas, the screened-in porch would be like being in an oven [because] it was so hot there.

Then it was my grandmother and five children. She went to Port Arthur because one of her uncles had a dairy there, and Mother kind of helped. So that's how Mother got to Port Arthur.

And she got a job at the telephone company. This was back in the days when they did the plug-in devices. The operator would answer the phone [with]

"Who do you want to speak to?" All that. Mother was working at the telephone company, and this friend of Daddy's, Ed Ward, was dating this lady that was also a friend of my mother's. So it was kind of a blind-ish date.

Port Arthur is surrounded by oil refineries. Magnolia was on one side, the Gulf Refinery was on one side, and Texaco was on one side, and then the marsh was on the other side, so it always smelled great in Port Arthur. But if you lived there, you didn't notice so much. It was when you left and came back that you went, "Gahhh."

My mother [was] very religious. My daddy hunted and fished a lot. In fact, during the Depression, Daddy got a part-time job at the Gulf refinery. [He] was actually meat hunting for extra money, and he got a shift job so that he wouldn't have to go to work early in the morning. And he'd go duck hunting and kill the ducks. And they would clean them and get them nice, and then he would sell them to the doctors and the people that were wealthier.

Our friends and people we socialized with were mostly Mother's sisters (she had four sisters) and her brother and their families. We vacationed together, and our entertainment and socializing was like making homemade ice cream in the yard with one of those crank ice cream makers. The kids would all take turns getting to sit on the ice cream maker because, see, when it starts getting hard, it's hard to stay balanced. So they'd put some towels on it, and we'd take turns sitting on that. Life was simple then. Very simple.

In fact, one of the memories that I have [of] being in Port Arthur was that Mother and her sisters on Saturday night—this was like a big event—we would go downtown. Now we had like a Chevrolet car, without air conditioning, of course, and at least two of Mother's sisters would go. So there were three adults, and they would sit in the front, and all of the kids would be in the backseat of an un–air conditioned Chevrolet. And they would ride downtown on the main street and park in front of the movie theater to watch the people go by. How simple is that? Isn't that funny? We never did go in[to] the movie, and it wasn't a big deal. It's like we didn't expect to go. This was the entertainment. We'd each get a nickel, and we could go in there and buy popcorn or candy or whatever [we] wanted for our nickel, and then come back outside. And then sometimes Mother and her sisters and the kids would walk up the street—this was at night, so all the stores were closed—to window shop.

We had two bedrooms. Maybe a 1,000 to 1,100 square feet. Two bedrooms and a bath and a living room, dining room, and kitchen. We had a separate garage and [a] nice, neat garden.

[Bob] painted—I'll never forget this—with, like, red paint; he painted designs all over the wooden bed. I saw him doing it, and I didn't pay too much attention to it. But I remember I was out playing or something, and when I came back in, he really had painted a lot of the furniture in there with fleur-de-lis. So I ran in and told dad about it, and Bob didn't really appreciate that very much. Of course he got into trouble. And this was kind of like, na-na-na-na-nah! I was tacky. I really was tacky, but he forgave me.

All of his textbooks and things like that were all just full of designs, but it was not really looked upon very kindly. Teachers didn't like that because he was messing up the school books.

When he was in high school, he was running for treasurer—or, I don't know, could have been president—and he had a wonderful, wonderful campaign.

He went to the butcher shop where Mother traded and got the guy to give him a whole bunch of butcher paper. He'd do a picture of Betty Grable, and [it] would say, "Betty Grable says, 'Vote for Rauschenberg!' " and then he would do, "Hedy Lamarr says, 'Vote for Bob Rauschenberg!' " Mother said that the posters would go all around the whole lobby, naming all the movie stars of the day, saying "Vote for Rauschenberg."

[Bob] left when he graduated from high school. He left to go study at [the University of] Texas in Austin. Then I got the whole room by myself.

When he went away to school, he didn't come home that often, and he was busy over there flunking out. Eeny, meany, miny, mo kind of thing of what he was going to be. He barely got out of high school. See, he was dyslexic, very dyslexic. Back in that day dyslexia was not recognized as being a real problem that was okay and that you could do something about it. So Bob just always thought he was not as smart as he was supposed to be.

Bob has always been, not just—it's not like happy go lucky. That's not it—he's just always been a happy person, and even when things weren't going exactly the way he wanted them, he would fix it so that it would be okay. In fact, when he first decided that he was going to pursue art, he thought, "Well, all real artists went to Paris." That's where you had to be if you were going

to be a real artist. He, of course, didn't have the money to get to Paris, so he taught dancing on a cruise ship to little gray-headed ladies so that he could get [there].

Anyway, he got over there and that's where he met [Susan] Sue [Weil], and I think he then began to realize that that was not exactly where he should be. He broke all the rules. And not like, "I'm not going to do what they're doing." It wasn't any kind of thing about being a rebel. It was just, that's not the way he saw it.

There was a lot of argumentation when Bob first started doing stuff. Sometimes critics would tell him, "That's not art. That's garbage." I remember one time I was standing next to Bob when this university doctorate, probably in New York, was just really reaming Bob out. He said it was just disgusting, what he was doing. "This is not art, it's just really"—and he'd shake his head and say—"this is really garbage. This really is just garbage." And just, "You can't call that art." I've often wondered what he thinks now.

Mother and I took [a trip to New York City] when [Bob] was living in an abandoned building, he and Jasper ["Jap"] Johns. Jap lived on the floor above Bob, and they had to act like they weren't sleeping there. So they had built some sort of makeshift wooden platform thing to put over the mattress in the daytime. And they had to make it look real artsy; they even had an easel that they put on top of it. I don't think either one of them painted on an easel. But that's what they did to make it look like it was okay, because building inspectors would come around occasionally, and they could have gotten in trouble. And there was a hero sandwich shop underneath them, and Bob used to laugh that he and Jap couldn't both leave in the evening at the same time because the hero sandwich shop caught fire occasionally with the grease trap or something or other. So someone had to be around that [so], when the smoke would come in, they could call the fire department.

Anyway, Mother and I used to go visit, and one of the neat times . . . I'm not sure if this was over the hero sandwich shop; it might have been one of those other abandoned buildings he lived in. Anyway, it was fun because you went up in the elevator, and then when the elevator opened, you were in the house. You were there. It was really kind of strange that there was not anyone knocking on the door and saying, "May I come in?" or anything. Just the elevator door would open and ta-dah!

ILEANA SONNABEND, that was where we met her. Of course, we Port Arthu-
rans did not have much exposure to Europeans. I remember she just impressed
me so much. The elevator opened, the door opened, and she walked out—and
it was the wintertime, so, of course, she had all of y'all's big New York coats
on. We don't even have coats like that down here. So she had on this big heavy
coat and boots, and she had an armload of irises. I thought that was so cool.
Of course, that's so European. After I grew up, I learned that. She opened a big
shawl over her shoulders, showed her huge presence. And so many irises.

My little mom was so adoring. Momma would say, "Oh now, Milton, this
one's pretty. I like this one with the roses on it," and stuff. So, I told her, I said,
"Mom, Bob's art is not pretty. She said, "I never know what to say," and I said,
"Let me tell you what. You don't really have to say anything. Just kind of change
the inflection in your voice. Just kind of go, 'uh-huh, uh-huh,' because Bob's not
really waiting for you and I to comment, but just to seem interested. Like you
do get it." And so, I said, "Just kind of change the inflection in your voice. This
is nice." That kind of thing, but not that it's pretty or cute, because he doesn't
really like cute art.

So the next time we were walking through [a show] and we'd walk up to
one of the pieces, Mother would go, "Uh-huh!" And we'd walk up to the next
one and she'd go, "Ohh!" About three pieces later, Bob said, "Mom, it's okay. It
doesn't matter. I know you like what I'm doing, but you don't have to . . ." And
she kind of got almost like little tears in her eyes. She said, "Well, I never know
what to say." She said, "I really like what you do, but I don't know what to say."
Bob hugged her and said, "Mom, you don't have to say anything. You just don't
have to say anything."

He just wanted you to see it. Just to take it in. And you didn't have to like it.
That was not a piece of it. You didn't have to like what he was doing, but he just
wanted you to just really look at it and to see it.

One time, this lady . . . I believe this show was in Houston [Texas]; Bob had
a chicken that was part of it. It was a stuffed chicken, of course. This woman
was standing there and she said, "Oh, look at that stuffed chicken. Eww, that's
gross." This was a long time ago when people wore hats and gloves. So this
woman had a hat with feathers on it, and he said, "As a matter of fact, I was
just noticing your hat with those feathers on it." He said, "That's so gross."
She looked at him kind of like she was mortified. She just looked at him kind

of funny. And he said—his eyes were just kind of open—and he said, "That was a bird that those feathers came from, wasn't it?" And, of course, then she got it. So she kind of started laughing. She said, "You're right. I guess it's not much different."

Bob taught me to see things differently. We'd go photographing a lot of times when he'd come home, we'd take a ride and go photographing. And he wasn't interested in the oak trees with the dripping moss. He would rather see the broken light post with the old bicycle leaning against it or something. When you start looking at things like that, then you see things differently.

I see things like that now. I'll notice them. He told somebody one time . . . This person was again ridiculing and sort of shaming him for painting things that were like the streets of New York. This guy was saying, "We have so many beautiful things here. You just put all the dirty things, the broken things, into your art. We have beautiful things. Why don't you put that in there?" He just kept going on and on about it. And so Bob told him, he said, "When you walk down the street, what you see are the things that you have in my art. If you feel like they're dirty and not worth seeing," he said, "how miserable are you when you walk down the street?" He said, "It's not like you're walking in Central Park. You're walking down the street." He said, "You have to learn to appreciate what you see."

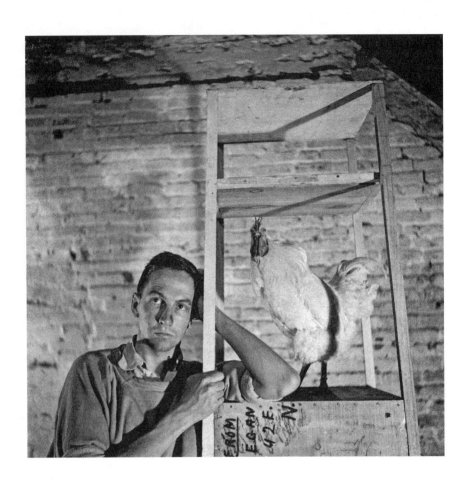

Robert Rauschenberg, *Untitled* [portrait with *Odalisk*, early state, Fulton Street studio], ca. 1954
Contact print, 2 1/4 × 2 1/4 inches (5.7 × 5.7 cm). ©Robert Rauschenberg Foundation

CHAPTER 1

Small World

CALVIN TOMKINS: I was writing for *Newsweek* magazine in the mid-1950s. *Newsweek*, in those days, had no art department, had no art column, and no art writer. And neither did *Time*. There was no publicity about what was happening in American art aside from the very small group of dealers, collectors. There was almost nobody interested. And when I began, you could, on a Saturday morning, see all of the new shows that had opened during that week of contemporary work. You could easily do it.

Once in a while, somebody in the top editorial staff would decide that there was a story on art that they should cover, so they would pull somebody from another section of the magazine. I was called up and told, "Go and interview Marcel Duchamp." This was in 1959, the year of the first monograph on Duchamp's work. It was published simultaneously in Paris and New York, [and it] was news. And so I went to the St. Regis Hotel, to the King Cole bar. I had, I guess, a two-hour interview with him. And I was so fascinated and surprised and interested in him and the things he said that it really started me thinking about contemporary art.

And so as soon as I left *Newsweek* for the *New Yorker*, which was a year later, in 1960, I began writing about art. The first piece I did was a profile on Jean Tinguely. I didn't know anything, and so I was asking advice from a lot of people: "Who should I talk to about him?" And several people said, "Well, you must talk to Bob Rauschenberg."

When Tinguely came here to do his great *Homage to New York* [1960], the machine that destroyed itself in the garden of the Museum of Modern Art [MoMA, New York], he met several artists, one of whom was Bob

Rauschenberg. And they got along extremely well. Although Tinguely then spoke no English, and Rauschenberg no French, they got along.

So, of course, I interviewed Bob. This was the first time I'd met him. And once again, as with Duchamp, I was completely fascinated. All my vague ideas about what art was were overthrown when I interviewed Bob, and I immediately thought, "Well, he's a great subject. I'd like to do a profile on him." Which I did.

DOROTHY LICHTENSTEIN: Jean Tinguely came to New York. He made a machine that would self-destruct, and they had it in the Museum of Modern Art, in the garden. And turned it on, and it did. It self-destructed, burst into flames, actually! Everyone loved the sense that, yes, we're breaking down these old, stuffy values.

This was really the place to be. This is where everything important happened. A lot of artists who had been in Paris came to New York, either during the war, or right after the war. And they had an influence on the Abstract Expressionists. All the contemporary artists from France, from Italy, from England, they wanted to come to New York. Prior to that, anyone interested in art had grown up thinking you had to go to Paris.

America seemed really promising at that time. I mean, the sixties, you just thought everything's changed, everyone's changed. There was this feeling— rich, poor—class didn't matter, race didn't matter. It was a hippie idea, really, that underneath everybody was the same. There was this idea about equality. There was great optimism.

ARNE GLIMCHER: The narrative was based on our naiveté, our wonderful naiveté and innocence that we had in the 1960s. We had the world going for us. We had the first president of the United States whom we, as younger people, could identify with; a first lady who brought contemporary arts into the White House. We had a group of artists who had made history already, the Abstract Expressionists. From Cubism, [we had] waited forty years for [that] next thing. People don't realize that today, but there was this kind of innocence and optimism and the urge to build a new world.

The Abstract Expressionists had reached for the sublime. People think that that's something like religion and looking at the sky; it wasn't. They were

reaching for the sublime inside of the human being, and they achieved that. It was an extraordinary achievement. What did the next younger artists, like Rauschenberg and Johns, have to deal with? They wanted to bring in a new kind of realism, not necessarily figuration, but recognizable signs. In order to introduce a new kind of realism, a new kind of sublime, they [would] find it in the street. So that was exciting: the rediscovery of the image of America.

JOHN GIORNO: It was just completely generational, and generational in terms of like tectonic plates making an important move. The Abstract [Expressionist] painters were so self-centered and drunk; it was just a different mind. They were all brilliant, and they were alcoholic, and that's that. Whereas the pop artists were on speed, happily, and smoked. And Bob, he was in our generation. [And there] was openness. That's what attracted me to Bob more than any of them, [it] was [this] openness of concept. Anything that came to mind was workable. You just do anything that comes to mind, and if it works, you follow it into development.

That was the most important lesson that I learned in my life.

YVONNE RAINER: I fell in love with New York and its possibilities. I was here with a painter, Al Held, whom I eventually married and then separated from. Everything was new. I went everywhere, to music, to plays, to dance concerts. I took three classes a day, two at the [Martha] Graham School [of Contemporary Dance], a ballet class in between, and went to all the films at the Museum of Modern Art.

I knew very little about postwar American art. Al introduced me to the Cedar bar [Cedar Tavern, New York] and his friends, and I went to openings. I went to what must have been [Bob's] first show at the [Leo] Castelli Gallery on East Seventy-Seventh Street. I saw the goat [*Monogram*, 1955–1959] and the chicken on the shelf [*Satellite*, 1955]. I nearly rolled on the ground with laughter. It was so refreshing after Abstract Expressionism. He was still an Expressionist using paint in that way, but so irreverent. I think my own sense of humor and irreverence began when I saw that show, and it opened up a whole new set of possibilities.

LAWRENCE WEINER: The first time I thought that Rauschenberg might be somebody I would like to hang out with, because that's the way one thought,

I was living on Duane Street, and it was at a Martha Jackson show. It was just the chair on the canvas [*Pilgrim*, 1960]. It was that simple. And I looked at it, and there was something so eloquent about the fact that he had remained and retained a simplicity. I thought, oh, I'd like to [meet him]. Then somehow or other, the way New York works, you found yourself within that sphere.

CALVIN TOMKINS: It was really in Bob's studio that I began to get an idea of what art could be, or how many different things it could be. I suppose, like most people, I'd always thought of art as a form of self-expression. And Bob had no interest in expressing himself in art. In fact, he said, "I think art should be a lot more interesting than that, than my personality."

DOROTHY LICHTENSTEIN: There were really a handful of galleries. The Kornblee Gallery, a gallery called Sidney Janis Gallery, the Green Gallery, run by a man named Dick [Richard] Bellamy. I knew Bob's work because I had started working in an art gallery in 1963, the Bianchini Gallery. And while we didn't show Bob's work, the gallery was right around the corner from the Castelli Gallery. And the Castelli Gallery was *the* place. They had so many—well, "success" is a funny word to use, but—well-known artists in the contemporary scene.

ARNE GLIMCHER: Even the dealers were collegial in those days. We were all so interested in succeeding in some way with the art that we thought was important. It was very hard; there were [only] a handful of collectors. I met Jasper [Johns] and Bob and [Cy] Twombly. They were a group unto themselves. I knew the Abstract Expressionists. I was a very good friend of Mark Rothko's and Louise Nevelson, and actually, I think Nevelson introduced me to Bob and Jasper. They were all friends, and very often they went to her house to parties. There was a loft party, or a house party, every Saturday night, and everyone just went. You weren't invited. You just went. That was how small the community was. You would go to a loft party at Oldenburg's, and while the party was beginning, Patty [Mucha] Oldenburg would be sewing up one of the soft sculptures at a sewing machine, and then finish what she was doing and join the party. It was very relaxed—a different lifestyle. None of us ever thought that art would become a business.

CALVIN TOMKINS: [Bob] was in the Broadway studio then, on Twelfth Street and Broadway [809 Broadway] above a billiard table factory. It was a big studio, a big, long, former industrial space, and there were always a lot of people in it. He was living with Steve Paxton. This was after Jasper [Johns]. And he was doing a lot of different things. He was working on a piece for the New York World's Fair for Philip Johnson [*Skyway*, 1964], and he was working for the Merce Cunningham Dance Company, doing the costumes and sets.

ALEX HAY: Deborah [Hay], my former wife, was a dancer, and she took classes with Merce Cunningham. Merce used to have people come in and observe the classes, so I would often go. He had a row of benches down one side of the studio, and it was just so great to watch. It was basically rehearsals and developments of his pieces; the classes were based on that. Then at one point, I think 1961 and then 1962, Judith Dunn, one of his female dancers, and Bob Dunn, who was a composer but also played piano for Merce, did a workshop based on John Cage's theories of chance composition. I attended those, and Rauschenberg came because Steve Paxton, Rauschenberg's partner, was in Cunningham's company. That's where I first came into contact with Rauschenberg. Those workshops were such an amazing turn-on. It was just beautiful to see what happened, what they came up with. And at the end of it, they decided they would go down to Judson [Memorial] Church [New York] and continue the group. It was no longer workshops, it was just a group of people in his [Cunningham's] company [who] went down there. Reverend [Howard R.] Moody, the pastor of the church, encouraged it. They had a music theater and a dance theater, and they did literary performances and readings there. He was very active in that community of artists, so it was a natural place for us to go. So, we all went down there, and that's where I got really involved with Rauschenberg. We would meet once a week at Judson and bring in pieces.

PATTY MUCHA: Oldenburg would often say, "Oh, Poopy, we're going out. It's seven." You know, I wouldn't know where we were going. And then we'd go and see Yvonne Rainer or someone throwing mattresses against something. The way they danced was questionable in my world, but I enjoyed it because they were so mad. They all became friends. The dancers were very much a part of Bob's world.

ALEX HAY: Rauschenberg had a huge loft. It was like 50 feet wide by 150 feet long. It was a gigantic loft. Deborah [Hay] and I were living in a little apartment—[a] basement apartment down near Tompkins Square on East Seventh Street, which was the middle of the ghetto at that time. We spent many, many hours at Rauschenberg's loft because we were all involved in the performance stuff. And that was a time of loft parties. Every weekend there would be a loft party somewhere; we would all go, and there would be great dancing.

LAWRENCE WEINER: It was about rumors. You heard where somebody went, and then you went there. If you were interesting enough, pretty enough, or something, you got into a conversation, and if the conversation grew into something, you ended up in that scene. If not, it petered out, and you were out. That's the way it was.

That's one of the very funny things that I used to talk about sometimes with Bob. There were rumors of an artist who was doing this, or an artist that was doing that. Somehow or other you tracked it down. Bob knew everything that was going on. He was a yenta. Total yenta. He and Billy Klüver could tell you who was sleeping with who[m] everywhere in New York City. Everyone.

JOHN GIORNO: It was a tiny scene. I had a friend, Wynn Chamberlain, and he gave me a party in 1963. I'd been on the scene for two years then, so I knew everybody, and he gave me a birthday party and there were eighty people there. And those eighty people didn't come for my birthday party, they just came because they wanted to be together. This was typical of the very early 1960s.

So there were all the pop artists. I mean, Andy had shot *Sleep* in the summer of 1963, and this is December, and I'm a poet, so I was already published in *C* magazine, *St. Mark's Place* [Poetry Project], *World*. But who was there? Like, the seven pop artists and their wives and girlfriends, and John Cage and Merce Cunningham, and Frank O'Hara and John Ashbery, and then the second generation of New York School of poets, and all the other artists, Yvonne Rainer, and Jonas Mekas, and that other world. George Sugarman—just endless artists—and Bob. Bob came at one point with Steve [Paxton], because he had broken up the year before with Jasper, and he stayed for a half hour and left. And then Jasper came—Jasper! And Barbara Rose, because Barbara Rose liked talking to Andy Warhol, and Frank [O'Hara] sort of liked Andy. And it was

before the politics solidified and nobody went anywhere. But it was my birthday party, and nobody cared or knew who John Giorno was. It didn't matter, but it was the spirit of it. So that was 1963.

DOROTHY LICHTENSTEIN: Yes. Well, the energy was really all over at that time, 1964. They always say that was the year the music changed. It was just [that] so many things were going on at the same time that we felt freer than anyone had before. I mean, I was out of college by 1960, and things were so stiff then, you know? Women were still wearing corsets and gloves sometimes. And it was really people like Bob Rauschenberg, who was one of the first to stand for [a] kind of freedom.

LAWRENCE WEINER: What Rauschenberg had was a scene [of] people who were able to collate some people of privilege, some money, some here, some there, to build this structure. It was open; it was obviously open enough for me to get into it. And it had to do with the fact [that] it was necessary. If I couldn't take a shower at Lee Lozano's, I didn't get a shower. I didn't have any hot water. If you couldn't hang out at the Café Figaro [Le Figaro Café, New York] and get warm, or in Mickey Ruskin's old place, the artist's café, you didn't get any warmth that day, because you didn't have anything to eat. Some people had something [that] other people didn't.

ROBERT WHITMAN: [And Bob was] astoundingly generous. He sponsored all this stuff; I mean he just jumped in. God bless him. Luckily, he was also the kind of guy who managed his life in such a way that he had the resources to be able to do [it]. Another kind of generosity, which [was] his ferocious ability to do an awful lot of work, that, I think, is the biggest generosity. It's very hard.

LAWRENCE WEINER: Filmmakers [writers, dancers]. Bob was part of all of that. Totally involved. These were all people who had taken a step outside. We were all outside, it was almost like Sumo wrestling; we were all outside the center, trying to decide if we really wanted to be in the center. We wanted the rewards, but nobody was quite sure how much they wanted to be in that center. They would constantly keep shooting [themselves] in the foot on purpose.

[But Bob] saw art as art. For some reason, in the back of his head, he knew his place in it from the beginning. That's probably what makes him such an important artist. He woke up one morning and realized he had a place in history.

DOROTHY LICHTENSTEIN: One time somebody was doing a short film on Roy [Lichtenstein], and they came to Captiva to interview me, but they really wanted to interview Bob.

They asked him what the scene was. And he was sort of thinking and thinking, and he just couldn't [answer]. Maybe it was too early for him.

I said, "I think you were the scene."

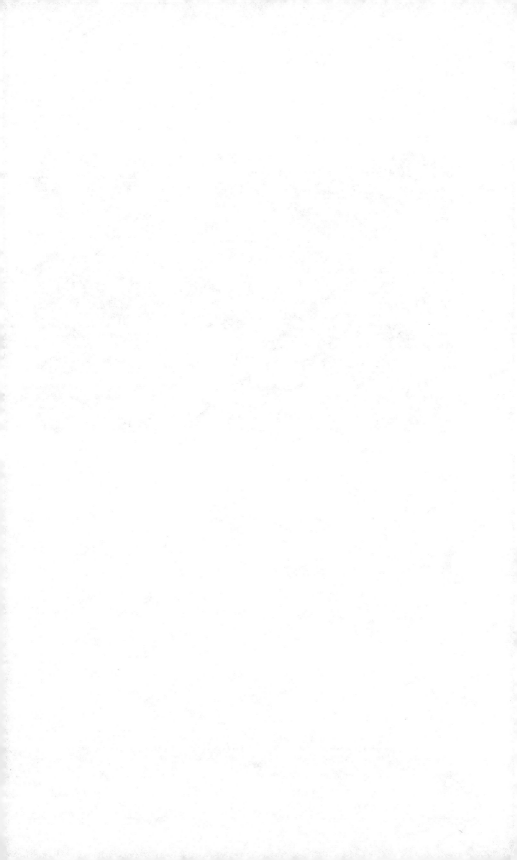

Artists in Loft. © Jerry Schatzberg. Collection: Robert Rauschenberg Foundation Archives, New York.
Rauschenberg with Jasper Johns, John Cage, Bob Cato, and others, in Rauschenberg's and Johns's Pearl Street studio, New York, 1955.

CHAPTER 2

Collaborations

TWO HUNDRED FIFTY patrons and reporters gathered at the Museum of Modern Art's Abby Aldrich Rockefeller Sculpture Garden on March 17, 1960. They were there to witness the self-destruction of Swiss artist Jean Tinguely's *Homage to New York*, a sculptural contraption made of found trash, broken-down bicycles, musical instrument parts, bottles, motors, and a meteorological balloon. The machine did self-destruct, just not in the way the artist had envisioned. Glass shattered, wheels whirled, smoke filled the air, and the sculpture's metal parts imploded. When sparks became flames, a firefighter drenched the machine, putting an end to the show.[1]

New Yorker art critic Calvin Tomkins was among those in attendance that evening. He was writing a profile on Tinguely, the first of what would become many for the magazine. Tinguely had asked Bob to contribute something to the piece, and Bob's contribution was a money thrower (*The Money Thrower for Tinguely's H.T.N.Y.*, 1960). "He made a thing consisting of two heavy springs, and between them was a bunch of coins. I think they were silver dollars. At a certain point, a fuse was activated and the springs flew apart and the coins were scattered over Tinguely's machine."[2]

Tinguely told Tomkins, "*Homage to New York* was for me an attempt to liberate myself from the material. The best way to do this was to make it self-destroying, like Chinese fireworks, so that during the event—and naturally it became an event, a spectacle—all these materials, even the smoke, became part of the sculpture . . . it was the form of art that seemed the most perfect I have yet found. It could be stripped of all significance, or it could be interpreted in a symbolic sense; it could be taken as a spectacle, a rape, a joke,

a gadget—anything you wish."[3] This was a tribute to New York City's regenerative energy, one of the earliest collaborations between artists and engineers and a piece of art that was also cause for a gathering, a happening, a performance; the evening encapsulated much of what was shaping the artistic and cultural life of the city at the time.

Tinguely had grown up in Basel, Switzerland, and moved to France in 1952 to pursue art. In the period following World War II, a move to New York City was a more common one. Artists began to flee Europe during the Nazi rise, and in the rebuilding years following the war, New York City became the international center of finance, media, and culture too.

One significant beneficiary of this exodus from Europe was North Carolina's Black Mountain College. Founded in 1933 by the classicist John Andrew Rice and a group of disillusioned faculty from Florida's Rollins College who refused to sign the loyalty pledge, the school centered its curriculum on the arts. Josef Albers, a founder of the Bauhaus, became one of the school's leading professors, arriving with his wife, Anni, a textile designer, the year of the college's opening, direct from the Bauhaus, which had just been permanently closed by the new Nazi government.[4] Other exiles followed.

The Alberses wrote, taught, and made art themselves; and all of this output informed a new kind of art curriculum, best characterized by educational reformer John Dewey's mantra to "learn by doing." On Fridays, Josef Albers's legendary sessions on drawing, material, and color were the only classes held at the school. An exercise in group problem solving, the classes were attended by most students and many faculty members.[5] This collaborative, hands-on method characterized the college's approach to education. The school's financial destitution also played a definitive role. Chronically underfunded, students and faculty scavenged Black Mountain's farms and junk piles for materials with which to make their work.[6]

Rauschenberg and his future wife Susan Weil arrived at Black Mountain in 1948 after a brief summer stint studying at Académie Julian in Paris. In addition to studying under the legendary Albers, Rauschenberg met faculty members—and future collaborators—composer John Cage and dancer-choreographer Merce Cunningham.

This was a formative time for Rauschenberg. He worked with a diversity of methods and materials, including mono prints, painting, photography,

drawing, and sculpture, often in combination with each other. His early col-
laborations with Cage and Cunningham inspired his work in conceptual
performance.[7] Cage's 1952 performance *Theater Piece No. 1*, involving several
members of the Black Mountain community, is also considered an important
influence on the experimentation that led to Allan Kaprow's Happenings of
the late fifties and early sixties. In the piece, Robert Rauschenberg purportedly
hung his *White Paintings* from the rafters and projected slides onto them while
choreographer Merce Cunningham danced throughout the room with a dog
and David Tudor played the piano.[8]

Although he continued to spend time at Black Mountain for the next several
years, Rauschenberg moved to New York in 1949, where he was introduced to
the work of the Dutch artist Willem de Kooning and other painters working in
the style that would later come to be called Abstract Expressionism. The move-
ment developed in New York in the 1940s and was the first American style of
international influence, "putting New York City at the center of the western art
world, a role formerly filled by Paris."[9]

In his work made at Black Mountain and in New York City during this time,
Rauschenberg integrated the Abstract Expressionists "free brushwork" into his
paintings and later built upon this by incorporating "recognizable images and
materials taken from his immediate environment. . . . He impressed pebbles
into the dark pigment of his *Night Blooming* paintings (1951); the uninflected
White Paintings (1951) became screens for light and shadow, responding to the
conditions around them; and newspaper collage formed the ground of the
series of black paintings."[10] What he took most of all from Black Mountain
College was the ethos of collaboration; he, Cunningham, and Cage brought the
spirit of collaboration back to New York City.

The collages and sculptures Rauschenberg made while traveling with artist
Cy Twombly in Europe and North Africa (1952–1953) contain motifs that con-
tinued for decades: "body parts, modes of transportation, fine art reproduc-
tions, lettering, and diagrams." The found materials used in Rauschenberg's
assemblages made in Italy, and the *Elemental Sculptures* and *Red Paintings*
made after returning to New York in 1953, were test sites for the later Combines,
in which he united kitsch and fine art in wall paintings, freestanding sculpture
and hybrids of sculpture, by combining traditional media and found objects,
including photographs ripped from the pages of popular magazines and urban

debris.[11] To give his viewers the opportunity to make their own interpretations, Rauschenberg let chance play a role in the position and combination of the disparate found images and objects in his work.

Found images and the principles of chance were informing the work being made in many artistic fields in New York City in the 1960s. The poet and performance artist John Giorno was inspired by his relationships with Andy Warhol, Robert Rauschenberg, and Jasper Johns. In Frank O'Hara's words, Giorno was a "poet among painters." Using the pop art techniques of found imagery and montage in his writing, Giorno helped to bring poetry into the multimedia age.[12] As Giorno narrates in his interview, his *Electronic Sensory Poetry Environments*, psychedelic poetry installations/happenings produced with synthesizer creator Robert Moog, were inspired by Rauschenberg's Experiments in Art and Technology (E.A.T.) events of 1966.

The world of dance was being shaped by similar influences. Just as Giorno summoned chance into his writing and challenged the New York School of poets' practices, experimentation happening in the dance world encouraged improvisation and rejected the constraints of the form's established styles. In 1960, dancer-choreographer and social activist Anna Halprin taught a groundbreaking workshop on her famed outdoor dance deck north of San Francisco. It was a fundamental moment in the history of postmodern dance; among the dancers attending the now famed workshop were Simone Forti, then married to sculptor and conceptual artist Robert Morris, and Yvonne Rainer.[13]

Forti spent four years training with dancer-choreographer Halprin, exploring improvisation. She also organized open work sessions with Morris, gathering artists together for "multidisciplinary explorations of movement, objects, sound and light."[14] In late 1960, Forti moved to New York and began developing the pieces eventually titled *Dance Constructions*: dances built around everyday movement, chance, and unassuming objects such as rope and plywood boards. The pieces premiered at Soho's Reuben Gallery and were performed in Yoko Ono's loft the following year. The work represents "a watershed moment when the relationship between bodies and objects, movement and sculpture, was being fundamentally rethought. Dancers balanced on seesaws, embraced in a huddle of bodies, and stood still in hanging loops of rope."[15] By developing work out of movements not normally associated with dance, Forti demystified the form within the framework of conceptual art.[16]

Experimental dancer, choreographer, and filmmaker Yvonne Rainer was born in San Francisco but moved to share a loft with Forti and Morris when they moved to New York. Rainer had been "affected . . . deeply" by a Forti improvisation of sitting in various spots amid a roomful of rags. She began to play with repetition, first of complete sequences, and later of combinations of simple movements, building from or chipping away at the foundations laid out by Cunningham's and Halprin's work.[17] Rainer cofounded the Judson Dance Theater in 1962, whose performing collective (1962–1964) of dancers, composers, writers, and visual artists had materialized from a composition class taught by musician Robert Dunn, himself a student of John Cage. A place for multidisciplinary collaboration, the group held weekly meetings to perform and critique each other's work.

Like Forti, the Judson artists rejected the restrictions laid out by the fields of classical and modern dance. Many of the Judson artists used untrained performers and dancers to communicate a fresh and uncontrived approach to movement. The rejection of "virtuosity, glamour, and style" in Yvonne Rainer's "No Manifesto" was a way to impart what the Judson Dance Theater wanted: to showcase the beauty of everyday movement.[18] Like Rauschenberg's focus on the materialism of the object, they were showcasing the ordinary movements of the body in space.

In 1966, Judson dancers Alex and Deborah Hay, Steve Paxton, and Yvonne Rainer were among the artists who collaborated with engineers Billy Klüver and Fred Waldhauer, and artists Rauschenberg and Robert Whitman, on 9 Evenings: Theatre and Engineering, a series of ten performance pieces that united artists with engineers from world-renowned Bell Laboratories. Held at New York City's Sixty-Ninth Regiment Armory, 9 Evenings was the culmination of ten months of work between artists and engineers to generate new technical equipment and engineering systems integral to the artists' performances.[19]

Their combined efforts delivered many firsts in the use of new technology for the theater and in the innovative use of existing technologies of everyday life. Closed-circuit television and television projection were used on stage for the first time; an infrared television camera shot action in the dark; a Doppler sonar device converted movement into noise; and wearable wireless FM transmitters and amps broadcast performers' vocalizations and body sounds through loudspeakers in the armory.[20]

A few years earlier, Robert Whitman had collaborated with Cage student Allan Kaprow and artists Jim Dine, Red Grooms, and Claes Oldenburg to create Happenings on Manhattan's Lower East Side. "A man dressed all in red feverishly [painted] the words 'I LOVE WHAT I'M DOING, HELP' on a large canvas, [poured] two jars of paint over his head, then [proceeded] to dive headfirst through his finished work. A woman, cradled in the arms of her dance partner, [took] a bite from a loaf of challah while reading the Sunday comics. A man wearing a nine-foot-tall costume of a foot [performed] a routine on the floor of a school gym with another man dressed as a human torso." These performances had mixed elements of dance, theater, poetry, music, and visual art, melding boundaries between art and life and creating a new way of making and sharing these innovative artistic practices.[21]

Kaprow's 18 Happenings in 6 Parts at New York City's Rueben Gallery, in 1959, is considered the first event to formally use the term Happenings. In the following four years, Happenings were created by a range of artists working within their own styles, although all the events shared a crude aesthetic. As Robert Whitman later said, "Everything about the production was as crude and as primitive as it could be, because nobody really had any money to spend on any of this stuff." Although the events usually had some structure, they lacked character development and plot. "It was generally more visual than traditional theater: the accent was on the plastic composition more than storytelling."[22]

Although stimulated by a variety of sources—including European visual artists' experimentations with performance and Cage's aforementioned performance at Black Mountain College—Kaprow credits Jackson Pollock's drip paintings as his premier inspiration. In a 1958 essay for ARTnews, he wrote, "Pollock, as I see him, left us at the point where we must become preoccupied with and even dazzled by the space and objects of our everyday life."[23]

Rauschenberg was working from a point of similar inspiration. It has become conventional that the stuff of everyday life be used to make art, but Rauschenberg was an innovator when he began to do it.

The narrators featured in this chapter offer a glimpse into how this philosophy shaped Rauschenberg's creative collaborations in New York City during the 1960s. They reveal how small the art world was at the time, and how easy it was, consequently, to cross the formerly hard boundaries between performance and visual art. They also reveal the nature of the art scene and suggest

why, in that moment, it was so innovative. Rauschenberg emerges as central to that innovation, as seen here from multiple viewpoints in the dense and crowded art world that characterized the city.

BOB WAS ALWAYS A VERY GOOD TALKER

CALVIN TOMKINS: [Bob] was always a very good talker. He was always highly verbal and intelligent. And I think when he would come up to the Cedar Bar, he must have been interesting, certainly to [Franz] Kline. I think also to [Willem] de Kooning. Of course, the thing that interested de Kooning was the idea of Bob's wanting to erase one of his drawings [*Erased de Kooning Drawing*, 1953].

People have said it was an act of aggression: "You have to kill the father before you can supplant him." That he was somehow trying to erase de Kooning who was, at that time, the number one American artist in the minds of all the others. But [Bob's] explanation for doing it was that he had tried erasing some of his own work. He was trying to make a work of art by the technique of erasing. It's how his mind worked. "Can you make a work of art by erasing?" And he tried it with his own work. And that didn't work because it was only half of the process. He couldn't be sure that his own work was art. It had to really be art, and de Kooning was unquestionably the most important artist of the whole period.

So he got up his nerve and went to see de Kooning and explained what he wanted to do. And he said de Kooning didn't like it much at first. He didn't like the idea. But gradually he understood it. And he went and got three portfolios of drawings. He looked through one and he didn't see anything. He looked through another and pulled out one. He said, "No, that would be too easy." And then he got a third portfolio and leafed through it and found a drawing and he said, "This is going to be really hard." It had several different kinds of drawing, in grease pencil and crayon and ink. And it was going to be very hard to erase. And he said, "Okay. You can have this one."

So de Kooning participated willingly, completely, in this project. I think Bob saw it as a joint project. He said he spent three weeks on it. He wore out about forty erasers. And he said it really worked. It was a work of art that was created by the technique of erasing. And so he said, "That's why I didn't have to do it anymore. That was it."

BLACK MOUNTAIN WAS FULL OF PEOPLE, EYES WIDE

SUSAN WEIL: Mother and Father decided since I was bound and determined to be an artist [that] I should go to Paris. Because of their generation, they thought artists had to go to Paris. I was enrolled in the Académie Julian to study painting. And I moved into this pension. And Bob was there on the GI Bill [Servicemen's Readjustment Act of 1944] studying art. I couldn't have missed him if I tried. He had this great big laugh. You could hear him all over the pension because he laughed so fully, like a musical instrument—a really amazing sound.

We became great friends. We were both zany painters. We both just needed to paint every minute. At the pension, there was a kind of a visiting area, and on the floor of it was an old oriental rug. And Bob and I would paint there. We would set up easels and we would paint things. And if you spilled a little paint on the floor, a drop of paint, we would say, "Uh-oh, we will get in trouble." And we would do the same color on the other three quadrants of the rug.

The Académie Julian wasn't really the right place for me. They would have a model in the middle of the room, and the model would stand for a month in the same position. Well, I'd move around and draw and paint the model from here and there just to make it different. But I mean, it just seemed to me so boring. I told Bob that I was going to go to Black Mountain College. And he looked into it and ended up there.

[Black Mountain] was full of people, eyes wide, trying to understand everything about possibilities. I always thought that the most important thing [there] was not the classes you went to but in the evening, when you'd sit in the dining hall and you'd talk to poets and you'd talk to scientists and you'd talk to music students. It was the bigger picture. We had the wide experience of the creative life.

[Bob] loved it. He loved it. He just was so joyful there. He got so involved with Cage and Cunningham. And also in the dance world. I mean, he just couldn't believe it. [He] came from the South from a very rigid, religious upbringing. His mother was from the Church of Christ, and you weren't supposed to dance and you weren't supposed to play cards and you weren't supposed to do anything. And here he was in this wonderful environment.

We had our studies and we did our work for our classes. But we had a working farm, and students were all part of making the school run. Bob and I were on a trash group. Everybody got so jealous of us because we had such a good time. We'd go around to all the buildings and pick up what they were throwing out to take to the dump. We were having such a good time, and we'd come back with wonderful things that we found. Everybody wanted to go with us to the trash because it was so delightful.

I took French. And I took some writing classes. But my focus was mainly [Josef] Albers's classes. He was intense. He had all these rules, and you had to do everything his way. I was still a teenager, so I was not good at accepting being told what to do all the time, nor was Bob very good at it.

There were these rules about drawing. You had to draw with a stuttering line. You had to have the least line possible to express the most space. And erasers were completely out of the question. You could not use an eraser. It's the greatest thing now when I use an eraser; I always think of Albers.

SIMONE FORTI: I think we all felt—maybe without even knowing—we felt Black Mountain College. The communications that had happened between Merce Cunningham, John Cage, [and] Charles Olson. They were all learning from each other's thinking and thinking together, and that continued to us. It came to us through John Cage, who was teaching at the New School [New York]. We certainly were interested in each other's work and what we were doing, and we were not so much looking at the artists in our individual fields who had come before us. We were looking into each other's fields.

YVONNE RAINER: Merce used to say, at some point, he said, "we," meaning all the Judson people, we were John's children, not his. He was right in a way. I think we were Cage's and Rauschenberg's children. The two of them had a permanent influence on a number of us.

LAWRENCE WEINER: [Bob] was a catalyst for people who were not making art. He had a way or a demeanor or a charm that could bring them into the world. The strange thing is that if he thought they were worth bringing into the world, they also had another value. They did something. Whatever they did, they did [it] reasonably well. Once you bring anybody into

your world who does something reasonably well, your world gets stronger and stronger.

He built networks because he needed people. He needed people around him. He also needed a kind of a muse. Merce, Cage—they functioned as a muse. They made it possible—when you woke up in the middle of the night and thought that you were mad because you were thinking this strange thing, that a stroke is this and a gesture means that—to be around other people who could understand what you were saying. They may not agree, but [they] could understand what you were saying to the point of even disagreeing, instead of just rejecting. That's a muse. He understood the building of that. He tried to build a world.

I can't speak for anybody else, but what I genuinely believed in at the moment was that there was a change in the venue of what constituted the object and what constituted art. Perhaps crudely expressed, perhaps eloquently, I don't know. I honestly don't. But it was all out on the street, and Bob Rauschenberg was one of the people who intellectually and educationally was capable of understanding what was going down.

A FREE, OPEN, CASUAL WAY OF WORKING

CALVIN TOMKINS: [Bob's studio] was a big, long room. Maybe a hundred feet long by thirty feet wide. And windows in front on Broadway and no windows elsewhere. But he would work in about the middle half of it. He had his living accommodations over to one side, against the wall. Somebody had partitioned off one section with a stove and some shelves. And a mattress on the floor was the bed. And aside from that it was all workspace.

So a large part of the floor would be covered with these canvases, stretched canvases, laid flat on the floor. [And] he worked in a kind of effortless way. There was no stress. It seemed like he didn't do much stopping and thinking and stepping back to look. He would just put down a screen and squeegee the color over it. Then pick it up and look at it for a minute or so. Then he'd take another screen, not waiting for the first one to dry.

It seemed like such a free, open, almost casual way of working. But there was something going on there that I didn't understand until much later. There

was this uncanny precision of his own design sense, how one thing would go here and how one image would work, not necessarily with another but against another. How the image of a big clock face would work in conjunction with a geometrical drawing or a very simple image like a plain glass of water or a pile of blankets. I mean, a lot of these images that he had made into silkscreens were for ads in magazines. But he also used very different images, not connected to that in any way.

All these different relationships. Shape, contour, color, reference. And this was all going on continuously without much, or any, forethought. He said once, "I don't want to work schemingly." He was only comfortable when he was, as he said, "When I'm unfamiliar with what I'm doing. As soon as I get too familiar with what I'm doing, then I stop and do something else."

But there was this amazing continuing process at work. It certainly had nothing to do with self-expression. It had a lot to do with the contemporary world, with images that were drawn directly from the contemporary world. He said that discovering the silkscreen process was like Christmas to him. That for years he would go out on the street and find stuff and bring it back and use it in paintings, and this was like being able to do that, but without having to go out and forage. You find an image that had already appeared in the world.

JOHN GIORNO: In my work there are just endless threads that began, some with Bob. [Some] went on, some dwindled and vanished and were absorbed. I had stopped writing poetry for a year and a half—after Columbia [University, New York], come to think of it. It was 1959 into early 1960. Then, from early 1960, 1961, I started going to all these shows and seeing people use the found image. So, by 1961 I understood it in a way. I had gone to Columbia and I had studied art, and I knew [Marcel] Duchamp and Dada and the Italians and the Russians, but somehow that was not an influence in my life. It was like dead, learned history that I knew about. But it was seeing [James] Jim Rosenquist or George Segal or anyone, just seeing what they did repetitively, [at] shows that opened. Frank Stella with those early lines. Just seeing it on a daily basis, at some point I said to myself, about the found image—with Bob later—if they can do this for art, why can't I do it for poetry? And that was the impetus for the rest of my life. I mean, if they can do it, just hold your nose and jump.

[The first time I worked with found images] I thought about it for months, and then I actually picked something—I'm not sure [of] the exact words—but it was in the *New York Times*, and it had something to do with almost a *National Geographic* kind of subject matter, and what the found images then became for me, was each of these stupid words, the three of them together, is like a metaphor for something else that's inexplicable. It's not traditional [metaphor], saying this is something else. It was just [that] they [were] so pure, these images, that somehow they work[ed]. Then something curious happened. Fred Herko, of the Judson Dance Theater and Andy Warhol's *Sleep*—Freddie Herko died. And I made my second found poem from the obituary in *The Village Voice*.

Everyone loved it because they were all kids on the Lower East Side. So the poets, artists who were older than me, whoever, read it. The[re] were *Mimeograph* magazine, *World*, and *C* magazine, and others, and editors were very good at giving them out free. This tiny art world that included everybody—everybody was given one. So I was this sort of a minor little star, and they loved my found poetry because they related to it. They didn't have an axe to grind. Frank O'Hara—it was not poetry for Frank O'Hara. He had a thing about, you can't do that. You can't take found images. It's not poetry. And Allen Ginsberg, the same thing. I mean, with Allen or the Beat poets, somebody can give you an idea like Jack [Kerouac] can give William [Burroughs] *Naked Lunch* [1959] as a title, but somehow that's not a found title. William always said he used lots of things in his work, in cut-ups, but the Beats didn't approve of it. So the Beats didn't like me, [nor did] the New York School of poets, but there [was] another world of young poets who just adore[d] me. And, of course, the big support would have been anybody in the art world because it was just cool. I was trying. The art world was supportive. Somebody liked it.

[In] 1962, -3, -4, -5, -6 I was working with endless kinds of use of found image[s]. At some point before that, early 1965, I started making collages. Collages were a real problem for me. It's too easy. Like today, it's too easy to make visual, pasty collage. So I chose images and very carefully I made line breaks, and then put them in a lineal order, weaving a tapestry of images, so each related to each other. This is what I was doing when I met Bob in 1966. In those months, I just saw what [Bob] used in paintings, the kind of image he used and why.

All that we did in those years was listen to phonograph records. We just bought them and played them, bought them and played them. You sat there

and you were listening to sound, so why can't these be poetry records? I mean, I didn't quite get the idea of what I was doing because this was so early, but this was a venue for poetry, the LP record, because you sat in a chair, more than one person, listening.

The fall of 1965, like October or November, I wrote this pornographic poem. Like porn on the [inter]net, but I just happened to have printed words. So I just took one really stupid pornographic paragraph that I broke into a page, and it was a gay and excessive pornography, and then it was published in, I guess, Ted Berrigan's *C* magazine. Nobody used pornography in such a blatant way. I mean, it was just porn and taking it abstractly the way that Andy would have taken any of those images. And then Random House did the anthology of [the] New York School of poets in 1968, and Ron Padgett included it as something that was important.

Skip three years, by 1969 or 1970, all those pornographic newspapers like *Screw* were on the newsstand with covers that everybody could look at, and pornography had changed. The world had changed radically, and I stopped doing it shortly after. Those were Bob's years. *Chromosome* [1967] and *Raspberry* [1967].

[We recorded *Raspberry*] here [at my loft]. I think I got an idea of having different people record it because I realized that the personal quality of the person, the way that they pronounced words was so personal, with feeling, that [the poems] became something else. Two people reading the same thing became two plays. So I got the idea that I should just ask people to do it, and I asked—I don't remember now—eight or nine or eleven people to do it. Like Yvonne Rainer. She came here. This is where she did it. Gave a perfect, cool reading. Brilliant. And then Patty [Mucha] Oldenburg, who was the wife of Claes Oldenburg, who was very over-the-top, you would think she would give a great performance, she gave a very nervous performance. "I thought this was great!" And then Brice Marden, who is quite straight, was really cool with it, and Brice's wife Helen [Marden] read it also, was really cool. Then Timothy Leary's wife, Nena von Schlebrügge. Nena, a great Danish woman, read it with the great aplomb of a Danish aristocrat. So everybody brought this thing.

Then, at some point, Yvonne Rainer was doing a piece at BAM [Brooklyn Academy of Music], and I had done four or five of the [recordings] already, and she said, "John, I'd like to use three of them," and I hadn't done Bob yet.

I kept nagging—not nagging, like we were all busy. Then on a funny day, it was sort of a cloudy day like now and it rained, and we all had enormous hangovers from like three days drinking. Maybe it was Sunday or something, and we sort of saved the day, and it was recovery, and it [was], "Bob, you haven't done that poem. Today you have to." And it was no problem. He went over to the other room, and he read it. But we had been fucking all day, and being stoned and with this hangover, so his voice was incredibly sensuous. Just every phrase was honey. And so I was very happy with that. And it became a piece and it went on one side of the record, and the others went on the other side. That was my first LP record, and I went on to do fifty more albums.

YOU SAW ALL THE SAME PEOPLE

YVONNE RAINER: I really first met [Bob] in 1959 when I went to the Connecticut College dance festival. That was the first time I saw [Merce] Cunningham, and Rauschenberg was there. I guess already he was collaborating, doing costumes.

By that time, 1959, 1960, I was studying with Merce. I mostly remember [Bob's] boozy, very friendly presence, sitting around at intermission during that dance performance.

In the spring or summer of 1960, I met Simone [Forti]. She was taking a beginner's class at the [Martha] Graham School. I was introduced to her by a mutual friend, Nancy Meehan, who was also born and raised in San Francisco, ten blocks from where I grew up. The three of us had some improvisation sessions during the early summer, and Simone persuaded me to go back to San Francisco and take Anna Halprin's workshop with her. At the end of the summer, we both ended up back in New York taking Robert [Bob] Dunn's composition class, which took place in the Merce Cunningham studio.

Those first sessions of the workshop with Dunn, there were only five of us. We were all dancers of one kind or another. There was Simone and me and Steve Paxton and former Graham dancer Paulus Berensohn, and Marni Mahaffey, who was trained in ballet. Very odd bedfellows, you might say. Bob Dunn mainly was explicating John Cage's score for *Fontana Mix* [1958] and suggesting ways we might adapt it to our own interest in movement. I immediately

began to use chance procedures. I threw dice to deal with movement that I was already making in my studio.

Very odd things kept happening in that workshop. I remember Steve eating a sandwich, and Simone describing the movement of an onion that, as it sprouted, eventually toppled over. Everything was dance. Anything you could think of that involved some kind of movement was dance and, of course, that was all very revelatory to all of us. Bob Dunn was totally appreciative and encouraging of anything that happened in the class.

At that time the art world was much smaller, more condensed. You went to music concerts and dance concerts and Happenings. You saw all the same people. We all followed each other's work. That year, Yoko Ono rented a huge loft on Chambers Street and opened it up for music concerts and dance and performance events. La Monte Young was involved there, as were other avant-garde composers.

In 1962, those of us who had taken Bob Dunn's workshop realized we had a body of work that we wanted to show to a larger audience. Some of us had already auditioned for young choreographers up at the annual Ninety-Second Street Y Dance Recital, and we'd all been rejected. It was Ruth Emerson, [Lucinda] Cindy Childs, Trisha [Brown], me, [and] Steve Paxton; we were all turned down. So we went to the church, and [Reverend Alvin Allison] Al Carmines [Jr.] saw a few of us, and he invited us in. Steve was there, I remember. I showed my [*Three*] *Satie Spoons* [1961], as I called it. Al Carmines, the cultural minister of the church, said years later "I didn't quite know what I was looking at, but I sensed that it was important." So we got his backing. July of 1962 was the first Judson concert.

Rauschenberg was involved in that. He was in Steve's early dance. It opened with Jennifer Tipton, who became a famous lighting designer, carrying an aluminum pan, a bucket or a dishpan, out into the space. She got into it, and Steve came out and promenaded her. He taped a square downstage right, and I came out, stood in it, and ate a pear. That's all I did. I didn't speak. I ate it as you would eat it at home. Then there was a trio with Rauschenberg and Lucinda Childs and Trisha.

After that first concert, we decided to have weekly workshops in the gym of the church. Whoever came to the workshop and presented work could be in the next concert. There was a committee of three people each time to organize it.

A sculptor came to us with an idea. Charles Ross would make these big sculptural environments, and we could do whatever we wanted with them. One was a trapezoidal aluminum pipe frame, something like a children's swing set, but much bigger and without the swings. Another was a wooden platform supported by aluminum pipes. There was a whole evening involving these big structures [Judson Dance Theater, Concert of Dance #13, Judson Memorial Church, 1963]. One was especially vivid in my memory because it was all women [*Carla Blank's Turnover*, 1963]. Six or eight women collaborated in turning this big trapezoid over and rolling it around. You'd pick up a bottom bar, it would be received by people on the other side, and you'd be suspended in the air while the other group would roll it over, and you would descend to the ground. It felt wonderful because it was women doing real labor, and it was slightly dangerous.

This close association and interaction of visual artists and dancers was very unusual and unique, and I don't know that it's happened in a comparable way since then.

[I think Bob took from the activities of the dancers] the materiality. The substance of the body. You see it in his collages, even in the later work, what he chose to photograph, the everyday. Of course, that comes from Cage, who I believe was a big influence on him, and on all of us, of course. It was that realness of the body—bringing a real stuffed chicken to sit on a shelf [*Satellite*, 1955], and a quilt to paint over [*Bed*, 1955]. From the very beginning, this materiality of possibility was what he dealt with. His relation to dancers was a continuation of that interest.

The theatricality was something that he and Cage and Merce, in his own way, and all of us post-Cunningham people were challenged to expand. From Cage's piping in sounds from the street, to Rauschenberg's use of objects as decor, or use of everyday. Something else was happening in the art world also. [Bob's] contemporaries, [Claes] Oldenburg and [Andy] Warhol, of course, were dealing with some of the same ideas.

HAPPENINGS. THEY WEREN'T HAPPENINGS.

PATTY MUCHA [OLDENBURG]: We did our first Happening at the Judson. If you call that a collaboration; I don't know. It was just the two of us grunting

and whipping around. I don't know if it was a collaboration. I mean, Claes made the costume, and he just told me to jump around and say, "Yip, yip. Yip, yip. Yip, yip." Which I did. He was making horrible sounds. That was a short performance.

But the ones in *The Store* [1961] were really wonderful. They were really wonderful because there were ten of them. Every week, we'd have new performers with us. Claes and I and Lucas [Samaras] and, at the beginning, Gloria Graves, this artist. We [were] the four. We were the repertory cast. But [Claes] fired [Gloria] after two sessions because she shouted at him. She called him a sadistic bastard, actually. That's a direct quote. And threw a bedspring at him. See, you can't do that to the director. Actors have to know their place.

So we had those ten performances. On Monday Claes would take a look at everybody and see who came—because people volunteered—and he'd look at their body types and what they could do. Then he'd figure out props. By Friday, after a few rehearsals, we'd perform. Two on Friday and two on Saturday. Then we did a little bit on Sunday for the movies.

ROBERT WHITMAN: When I saw what was going on with dance at the time, excepting of course Simone [Forti] and Trisha [Brown], I found it horrifically precious. I just thought, oh my God, they're forgetting stuff. They're forgetting a certain kind of physicality and energy. They're too busy being pretty. So it was anti my own personal aesthetic, which wants a lot of dirt and mess.

Excepting Claes's piece called *Snapshots from the City* [1960; referring to a film by Stan VanDerBeek] at the Judson, he made the set. Some of the set was deliberately made with little city images out of cardboard with black spray paint. And then the stuff on the floor, he picked up on the street. You didn't know what was in those bags all the time, so it was garbage. And the costumes were garbagey, raggedy muffin costumes.

What happened was you heard this noise, and the only people who could see it w[ere] however many people could stick their heads in the doorway. So it was limited to ten people looking around. And Lucas was just inside the doorway with a light switch, and when he turned the light on, [the performers] would freeze and then he'd turn the light off. So that was the snapshot, and then you'd hear the bump, bump—the noise of them moving around—and then another snapshot. And, of course, the movements were all exaggerated—they were all

very expressed, jumping around kind of expressionist moves. And, of course, during the course of the performance, which couldn't have been more than a few minutes, the dust would begin to rise from the floor from all this stuff.

JULIE MARTIN: I met Robert Whitman as early as 1960. Hugh Mitchell was studying writing at NYU [New York University] and was part of the crew helping Whitman put on the theater piece, *The American Moon* [1960]. [He] invited Robert and me to the performance and we went.

I had no idea what was going on, but I vividly remember some of the images and the experience of sitting in one of the tunnels facing the main space and seeing Bob and Simone rolling over each other and then hopping, lying down around the space, the sounds from above, the clear plastic shape that filled the center space. That was the first theater piece or performance I'd ever seen; the first artist's performance, which everyone calls Happenings.

Happenings. They weren't happenings. It started with a group of young artists being interested in doing performance. Whitman actually had gone to Columbia to be a playwright. His interest was really in a kind of theater. Then he got, through the people he knew at Rutgers [The State University of New Jersey], like Lucas, a fellow student, and [Allan] Kaprow, who was his professor for some courses, he started making art or became as interested in making art.

Kaprow, of course, had published his now famous article, "The Legacy of Jackson Pollock" [1958], and how from Pollock's overall paintings, art was moving off the canvas into what were called "environments" in those days, probably called installations today, and he talked about performances.

Kaprow did a performance called *18 Happenings in 6 Parts* [1959]. [It] was the first performance at the Reuben Gallery in the fall of 1959. People began calling Anita Reuben, who owned the gallery, and her husband at the time Max Baker, who was handling publicity, and asking, "When's the next happening?" Max Baker liked the word, and they began to use the word for all of the performances the artists were doing from then on. Red Grooms did, I believe, plays; Whitman always talked about theater performances or theater pieces; [Claes] Oldenburg called his performance series Ray Gun Theater; and Jim Dine also talked about painter's theater.

Their works always had a script or score, and [there] was always a distinction between the audience and the performers, even if the action sometimes

surrounded the audience, as in Whitman's *Flower* (1963), when some actions took place behind the rows of audience seats, or in *Night Time Sky* (1965), where the audience sat in a large white cloth dome, and events took place in alcoves above their heads and films were projected on the dome walls. Or in Oldenburg's Ray Gun Theater, the audience was lined up along the walls in a very long narrow space.

Kaprow went on to do pieces where he involved the audience. For instance, he carried people into the large waiting room at Grand Central Station [New York; *Calling*, 1965]. If you want to use the word Happenings, there is a tradition and a trajectory that Kaprow started and pursued very different from the others. These other artists really were talking about theater and a new form of theater.

Bob Rauschenberg got involved in doing performances. He had, of course, been working with Merce Cunningham since 1954 doing lights and costumes, and from 1962 with the dancers at the Judson Church also doing lights. The story is that when Alice Denney, encouraged by Billy [Klüver], organized a pop art show, *The Popular Image*, in spring 1963 for the Washington Gallery of Modern Art in Washington, D.C., she included a concert of dances by members of the Judson Dance Theater, and in the announcement for the series, The Pop [Art] Festival, she had listed Bob as choreographer. So he rose to the challenge and made *Pelican*, performed with Per Olof Ultvedt and himself on roller skates wearing those very large parachute "wings" on their backs, and Cunningham dancer Carolyn Brown in pointe shoes at a roller rink in Washington, D.C.

Bob R.'s interest in performances developed differently from Whitman and the others. It came out of dance. The first one, *Pelican*, was billed as a dance, and first done as part of a Judson Theater concert out of town, in Washington, D.C. He did some other works as part of the Judson concerts later in 1963, and then during his travels with Merce Cunningham. But as he worked more with performance, his later ones increasingly were progressions of overlapping, changing, distinct images or actions.

For Rauschenberg, it was very much the milieu, and him being part of it, working with people he knew—primarily, Steve, Alex [Hay], and Deborah [Hay]. He did some of those early pieces several times, especially *Pelican*. But in the 1990s when interest revived in performances of the 1960s, and people

asked to redo works, for example his 9 *Evenings* [*: Theatre and Engineering*] piece, *Open Score* [1966], he said he didn't want to do the pieces again. He said, "They're of the time." It's sort of like a painting. You can't make a painting again thirty years later.

PATTY MUCHA: I was a slave. No. I was not. I'm always happy. All these young art historians tell me I'm a collaborator. Crazy. I was a fucking slave. I'm physical. I'm a doer. We had to strip the place between every week. I'd help make the props. I'd paint on the walls. I'd do everything. I'd stuff. And [Claes Oldenburg would] keep saying, "Poopy, stop reading stuff," because we'd stuff with newspapers and I'd be reading.

Maybe now it's called a collaboration, but then I didn't feel like it was a collaboration. Maybe it would've been better if I'd thought it was at that point in my life. I don't know. I loved [Claes] so much so it didn't matter. We were having a good time.

WE WENT OUR SEPARATE WAYS

ALEX HAY: Rauschenberg, Deborah, Steve, and I were very closely collaborating, and going places and doing performances. Deborah and Steve and I were always in his performances, and vice versa. And so, on the [Merce] Cunningham [Dance Company's world] tour [1964], it was determined that I would go along as Rauschenberg's assistant: to help him do the lighting and the stage.

Deborah was going to go because someone was leaving the tour in London and they needed a replacement.

Merce was the dance director of the company and Cage the music director and Rauschenberg the artistic director. But as it turned out, Cage and Cunningham had free rein to do anything they wanted, but Bob was almost required to light the dances and do the stage sets so they didn't interfere. And Rauschenberg wanted to get himself more integrated as an independent member of the company. So we did a performance in London where Rauschenberg started doing this.

We had a clothesline strung way up high over the stage and a huge ladder, a free-standing ladder that went up to it, and Rauschenberg would put stuff in

water, and I would take it up on the ladder and hang it on the clothesline. And we strapped a stuffed eagle with outspread wings on my back. [Cunningham's] *Story* [1963] was the piece that that occurred in, and at the end of that performance, Merce wouldn't even take curtain calls, he was so furious.

In Germany we did another thing, [in Cunningham's] *Winterbranch* [1964]. That was a place where Bob was asserting what he wanted to do. All the costumes were gray, and he never lit any of the dancers. Sometimes the light would appear on the stage, sometimes it would be in the audience, some of it would be up into the flies or across the stage horizontally. It was just amazing because I think, at that point, the [dancers] realized what Bob was doing, so they would adapt to this and they would change their patterns and run and jump into the light and the light would go away.

If [Cage and Cunningham] had accepted that and let Bob in and adjusted to Bob, that would have been a whole new dimension to the company, but they didn't, so at the end of the tour, [in] Japan, half of the company left. We went our separate ways.

CALVIN TOMKINS: The problems began with the [Merce] Cunningham [Dance] Company's world tour in 1964. It was the first time the company had had a really important series of engagements outside of this country. And it was a very touch-and-go thing to see if they could raise the money. The State Department had absolutely refused to give them funds for international appearance.

They had scraped together enough money to start on the trip, but they had to raise money for other things that came up. The problems really reached a head at the Venice Biennale in 1964 because this was the year that Bob Raus- chenberg won. And Bob won it. There was an enormous amount of publicity and pro and con. There were a lot of people who were very opposed to Bob's winning it. This was really the watershed of his reputation. Before then, he'd been sort of the bad boy. He'd been struggling. And now, all of a sudden, he was recognized as a really important artist. In England, a review called him, "The most important American artist since Jackson Pollock."

So it was no longer possible to dismiss him. His whole life sort of changed after that. But it was also a big problem for Cunningham and John Cage because, until then, Bob had been a loyal collaborator and had been in service

to promote Merce's genius. Everybody believed Merce was the greatest choreographer of the century. And a lot of people were willing to give up everything of their own to help Merce.

Bob himself had done this. He had subordinated his own interests time and time again. But in Venice, all of a sudden, he was a major celebrity. Reporters were all interested in him and what he had to say about the company. And he said a couple of things that made John Cage feel he was talking as though it was his company, not Merce's company.

But, then, he and Alex Hay and Steve Paxton were also—Bob couldn't resist any sort of artistic activity. He wanted to be a dancer too, and a choreographer. And he and Alex Hay and a couple of others had done some performances, including one with Merce's great dancer, Carolyn Brown.

He and Alex Hay had done a dance with Carolyn Brown in which they were on roller skates wearing costumes made out of parachutes, these enormous winglike costumes. And Carolyn was en pointe in a tutu—no, not tutu but in a ballet leotard. And they would swoop around, on roller skates and, at times, pick her up and carry her [*Pelican*, 1963]. And I think Merce was terrified that she was going to get injured.

But this was a huge hit. And this led them to want to do more, so they did some performances of their own in Europe. They did a performance in Stockholm, and there was a lot of publicity about that. [Five New York Evenings, Moderna Museet, 1964; program included Rauschenberg's *Elgin Tie* and *Shot Put*, both 1964.] And I think John Cage, in particular, felt that Bob was being disloyal. So there was quite a bit of tension. And then at another point during the tour, when they went to Asia, they ran out of money. And Bob said, "Well, I guess old Bob will have to get out the crayons," which he did. And [he] sold a couple of things and got them enough money to continue.

But then the whole thing came apart in Japan. A lot of bad feeling had built up. I think John and Merce felt that Bob had allied himself with several of the dancers in the company and that they had become fascinated with him. But they had always been fascinated with him.

And at the end of the tour, Bob and Steve, who'd been a featured dancer, announced that they were leaving the company. I think Deborah Hay, who was Alex Hay's wife, also left the company. It looked as though the company was disintegrating. It wasn't. Merce reconstituted it later.

But it was a very bad moment. And so that was really the end of Bob's relationship, which had been a very important relationship. I mean, his relationship with John Cage and Merce Cunningham had been absolutely central to his whole development, much more than his relationship with any other artist. I think it was probably inevitable because, as he became increasingly sure of himself and famous, there was bound to be conflict. He wasn't going to go on being the loyal supporter of the greater talent, Merce. It was probably inevitable, but it was very, very painful for John and for Merce and for Bob. I think it was a great loss to all three of them.

And Cage, talking about the days before the split said, "I always had the feeling I didn't need to have any other friends." It was a complete creative unit.

ANNE LIVET: I'm sure he was a handful in many ways when he was working with Merce and on the road with him, because he would be mischievous. They had that breakup when it was announced that Bob was the nominated American artist in 1964 at the Venice Biennale. There was a rupture, which really hurt him in a big way, because he couldn't understand it, he couldn't understand how Merce could have let him go.

And I've never really understood all the trappings of that either. But I do know that many years later when Merce was performing for the first time on Broadway, I was staying at Bob's, and we were going, and he brought up the tutus and stuff that he had made as costumes and he had put Merce in: bright pink and tied tin cans to him.

And I thought, was this a little bit payback time? And Merce [was] like, "Pink? Pink?" And Bob said, "Yes, but I've got you this tail of tin cans."

But the piece was fantastic [Merce Cunningham, Travelogue, 1977].

LIVING TOOK LESS MONEY. THERE WAS MORE FREE TIME.

JULIE MARTIN: I was at 9 *Evenings* [: *Theatre and Engineering*, 1966]. But for how I got there I need to go back in time. Bob Whitman did *Prune Flat* in December of 1965 at a benefit. It was on Forty-First Street in some basement theater. Whitman says that John Brockman was trying to do fund-raising for Jonas Mekas and the fledgling Filmmakers' Cinematheque. He went to

Whitman and said, "Claes and Bob Rauschenberg are doing it. Will you join?" Then he went to Rauschenberg and said, "Whitman and Oldenburg are doing something." He got them all to say yes.

As part of the benefit, there was a party for the artists, performers, and audience. It was in a room next to the theater. I remember Claes and Patty [Mucha] doing a series of improvised tableaux on the stage, opening and closing the curtain, each time revealing a different pose. Then at one point Bob R. had Simone [Forti] in a cloth bag and he was carrying her on his shoulder walking around the party and she was singing inside the sack. And it was this exact thing that he added to the second performance of his 9 Evenings piece, *Open Score*. He picked her up and carried her to different parts of the [Sixty-Ninth Regiment] Armory floor and put her down for a time before picking her up and moving her to another part of the space, and all the time she was singing a Tuscan love song. It was gorgeous.

Whitman did *Prune Flat* [1965] at *9 Evenings*. One of his classic pieces. It was a film piece. A film of images filled the back wall of the stage, and two performers [Simone Forti and Lucinda Childs] came on stage moving and interacting with the images on the wall. Then the third performer [Mimi Stark] came out, and a second film was projected on her. She followed the actions in the film as she walked across the stage, smoked a cigarette, undressed. At the end of the piece, action on stage followed a film of it—a bright light bulb went on high above the two performers' heads. It was pulled down by Lucinda, and Simone threw water from a glass at it and it broke. Simone was amazing—if the water didn't break the bulb, she would just reach out and hit it with the glass to break it.

YVONNE RAINER: As far as I remember, the predecessor to *9 Evenings* [: *Theatre and Engineering*, 1966] was Steve Paxton's Stage 73 series, a series of dance and dancelike events. I had a solo called *At My Body's House*, and Billy Klüver was on the scene. I had known him for a couple of years through Rauschenberg, met him at parties and here and there. I talked to him about how I wanted a contact microphone somehow attached [to me] so that it would amplify my heartbeat and my breathing. The mic was taped to my throat, and my breathing was amplified. This was 1964. For the next couple of years, ideas were batted about, about how Bell Laboratories scientists could collaborate with dancers and artists. I got involved.

ROBERT WHITMAN: I don't know how [it] happened. The one astounding thing [was] I don't know how many people participated, but if you count only artists and their friends and friends of friends, I'm guessing there were maybe one hundred people who jumped in and nobody got paid anything. I mean, there were a few people, like a bookkeeper maybe, that was it. And, I asked Julie [Martin] how John [R.] Pierce—who was Billy [Klüver]'s immediate superior at the labs [Bell Laboratories]—allowed all these guys to participate. How did that happen? Because the deal was they were only supposed to do this on their own time, not on company time. Well, you knew damn well that these guys were doing stuff at the labs that related to this. So Billy asked John Pierce how he let it happen, and according to Billy, he said that there was so much positive energy that he couldn't stop it.

YVONNE RAINER: My proposed piece was very elaborate, where there would be minimalist actions on the ground, and in the air would be remotely programmed events, like big plastic balls traveling across the space.

Rauschenberg's event [*Open Score*, 1966] was a tennis match between two people. Every time the ball was hit, a light would go off until it was dark.

ROBERT WHITMAN: It [was] a tennis game. First, people come out, and I think they set up the net and [stood] there because they had to hold the net taut. You couldn't just mount the net on the floor of the armory where it took place. Each time the ball was hit, the sound of the ball was amplified through the space and the speakers. So you heard the cosmic pock of the sound of the ball hitting the racket. And each time the sound came, a light went off, until the space was in complete darkness.

YVONNE RAINER: I forget the name of my scientist [Per Bjorn], but he had me running down to Lafayette Street and getting all kinds of apparatus, technical things that he needed to program my events.

There were a lot of mishaps in these collaborations. Cage had all this equipment, and we were all splicing wires for him for a week. This big platform ran over and cut some of these wires, and it all had to happen again. The first night of my performance, I shared the evening with Cage, none of my events happened. They had been programmed backward or something. Nothing was

working, and I remember I was up on a balcony and Bob crawled [up] on all fours and said, "Nothing is happening. What shall we do?" I was supposed to be giving directions to my performers. I said, "Well, let them do whatever they want," moving all these objects around, from a piece of paper to a mattress to free weights. It was a landscape of objects.

ROBERT WHITMAN: I would have to say that [9 *Evenings: Theatre and Engineering*] was completely insane. No rational person would have thought of doing this, but Billy [Klüver] just proceeded as though there were no obstacles. It was mad. Everybody was under amazing stress.

The stress. That was something else. The stress was huge. And nobody killed anybody, and nobody even had a fight.

YVONNE RAINER: The events had been advertised as the eighth wonder of the world, and what did the audience see? A tennis match where the lights kept going out? Or my event, where performers were standing around waiting for instructions, which didn't happen. [The audience] started to applaud with displeasure. It was a disaster.

ROBERT WHITMAN: The reviews at the time were not good. A lot of the audience came with no experience of this kind of work, and they didn't get it. Including critics. But they hadn't been paying attention. They hadn't been paying attention to the different performance stuff that had been going on. I bet a lot of them, if they went back and looked at the material today, they'd be completely surprised.

They would say, "Holy shit, this is pretty good."

JULIE MARTIN: During 9 *Evenings*, there wasn't time for thinking, there was the need to get things done. For me, the intellectual excitement came later.

[Billy Klüver's] collaboration with Tinguely, working with Jean on the machine that destroyed itself [*Homage to New York*, 1960], after that experience Billy wanted to keep working with artists. Very much. So he would say to artists whom he was getting to know, "Do you have an idea that needs an engineer?"

Jasper [Johns], for example, came up with the idea of using a neon letter in a painting and not have the painting attached to the wall by wires, he asked

for portable neon. Andy Warhol asked for a floating light bulb. When battery technology made it that the bulb would have to be as big as a house to float, Andy looked at the heat-sealable material Billy had found for him and asked for clouds. While Billy and his colleagues at Bell Labs were trying to figure out how to heat seal rounded shapes and not have them fall over, Andy simply folded the material over and made his rectangular *Silver Clouds* [1966].

I remember talking with Billy. Specifically, the idea that the collaboration between artists and engineers not only benefits the artists but also could benefit the engineers and the development of technology. And wow. I remember thinking that was amazing. The aims were about bringing different communities— the art community, the technical community, and the industrial community—in society to work together, and also about empowering the individual. The idea that they agreed on was that the development of technology could empower the individual and improve each individual's life.

When I started working with Billy and with E.A.T. [Experiments in Art and Technology], all of a sudden they talked about "collaboration." I found that word very strange because the only way I had heard it used was in reference to World War II. And collaboration in that context was a negative word. It took a while for me to get used to that word in that new context. It was Billy and Bob R. who used and developed the idea of one-to-one collaboration between artists and engineers. Bob R., in particular, Billy says. Billy's first idea about engineers working with artists was that the engineer would furnish the artist with a new palette. He used that metaphor: a palette for the artist. He saw the engineer as offering the artist new possibilities.

Another element in Billy's thinking from the beginning was the idea that the individual could influence the larger systems he was contributing to, the idea of the individual taking responsibility for his work. He wrote about this in 1960 in a piece he published in Alfred Leslie's *Hasty Papers* [1960], a "Fragment on Man and the System." In his early "collaborations" with [Jean] Tinguely and Bob R., he saw in particular that the artist takes full responsibility for his work, and by working with engineers, it would encourage the engineer to take responsibility for the systems he was working on. Billy soon came to feel that it was the engineer who needed to work with the artist. That the engineer could benefit in his professional capacity through working with the artist. Not in the way of discovering new equipment or technical ideas but in using his

knowledge in a new situation and enriching his own way of working. The engineer could offer the artist a new palette, but the artists could offer the engineer a new sense of possibilities in his work as well. To understand the way the artist works could prompt the engineer to question or expand his own system. Ask different questions of it. See different possibilities in it.

I don't think Billy ever thought that the artist and the engineer working together were going to make any kind of scientific discovery. He always said, "You are kind of working on a lower level." You may be at the forefront of engineering technology and ingenuity, but you're not at the forefront of knowledge.

But the possibility of asking different questions of what you're doing was the idea of the value of the collaboration the engineer could have with an artist. The engineer could use his skills in ways he hadn't considered before.

More and more I see EAT as so much a part of the whole utopian fervor of the sixties—of political, social, civil rights, and later women's rights. It was the manifestation in the art world—or at least in this part of the art world—of those idealistic utopian ideals. I didn't think about it that way then. This kind of idealism is probably needed more than ever. The problems facing us—the environment, global warming—seem more intractable. There's less technological optimism.

Some of the things that made EAT possible have changed, like a kind of generosity. It was easier to live. Living took less money. There was more free time. There was more sense for the engineer that he could come work with an artist and get some sort of satisfaction but not necessarily be paid. Not everything had to be on a paying basis. Now life is really hard, right? It's very hard. I do think young artists volunteer with their friends. But I think [a] time has passed in the sense that a kind of openness and freedom within society for people to volunteer, a kind of generosity, may have passed. But the need for this kind of collaboration is still valid.

9 EVENINGS CHANGED HIS LIFE

JOHN GIORNO: Somehow the turmoil of 9 Evenings changed [Bob's] life. It was sort of a transition period from having a stable relationship with Jasper [Johns] and having a stable relationship with Steve Paxton—I don't think

anything bad was happening with Steve—and somehow that was ended, and I was there. There was no reason why he did this thing, fall in love with me. Then it only got worse. *9 Evenings*, it was a big project. And then Bob drank a lot in those years and that takes its toll.

[Bob's] life was changing. Maybe when he and Jasper were together in the late fifties, they had a quiet life together in another kind of way, and Bob maybe went on to have a quiet life later on in Captiva. But not those years because, like, Billy Klüver stopped by every day, and Olga Klüver, and whoever else, and Julie Martin, and [there was] this constant flow. [There's] something about being very social, but that's not social. It [was] a part of all these projects. So that all the people and then the friends who were friends, like Deborah Hay and Alex [Hay], they came by to visit, and they were sort of just comforting to Bob, I think, yes.

For me, he was this great artist and this enormous influence. I was sort of the struggling poet who was trying to reinvent what poetry [was], so I wasn't thinking myself very important.

I think [the awareness of one's influence] probably has to occur to every artist whether verbal or not. In relation to Bob, I mean, he had his limitations. Nobody [was] allowed to talk about being gay. I mean, Andy [Warhol was] so gay, but it's not allowed to enter [the work]—it's sublime. It doesn't enter the painting in any way other than camp, which is invisible.

So there's that world. But then one knows that because of the homophobia, those abstract painters, they were homophobic. Their wives were fag hags. I knew them, but they themselves were homophobic. And for anybody who had any aspiration like Bob and Jasper and Andy, it was a big curse, the homophobia, and that's why they weren't understood. That's why they didn't want to allow it into their work or their lives, even to talk about it. But I didn't let that be an issue. It's not my problem. I was so admirational. But it was quite retrograde.

We [were] lovers so you're naked with somebody, [but] the most important thing I got from Bob Rauschenberg was just being with his mind. I've had that experience with others, like William Burroughs—when you spend a lot of time with a great person's mind, somehow it has a profound influence on yours. One sort of obvious cliché is that it has a radiation. Somehow this mind that produces great works has a blessing effect. It's a cliché word, but it has this blessing effect on you.

And then the other influence was just seeing what he did. Like, why he would pick this glass rather than that, or the other way around—they're the same things, but somehow you understood why he made that decision. That's some kind of a nonverbal teaching. On a daily basis dealing with objects or thoughts or ideas or words—and I think that's teaching, even though it's non-verbal and you can't explain it. It has to do with being able to use deep intuition. It comes from another part of the mind maybe.

I'm a Buddhist, Tibetan Buddhist for countless years. Tibetans often relax their mind, and then to see an idea with that state of mind rather than continuing a discursive thought, they let the mind rest for two seconds or ten seconds. Maybe what [artists] do. They don't know they're meditating, Andy or Bob, everyone, and what comes up is sort of wisdom, and that's what becomes an image or a choice or work.

It's some subtle thing that's general to great people, I think. It's probably common to everybody, in their special state of mind in how they affect their partner or the person who relates to them. Because it's not only these three guys in the world, these six, eight, ten guys in the world. It's not about being special. But maybe their genius has a certain quality. Like, in great lamas, great Tibetan lamas that have the ability to give blessings, or the power of their mind is slightly transformative or helps in some way, some subtle fashion. More like a little bit like that.

[Bob's mind] was very active and very rich and very expressive. What he did in his art he did in daily life. He drank a lot and smoked a lot of cigarettes and grass, and so he [was] always expressing these strong feelings in the work and every day.

Relationships sort of end. I think he was just going through problems with what he was doing with his life, and emotionally and otherwise. Then he started making these various guys. "I'm going to see my lover tonight." He was doing that, and I have a life, and so I just at some point had enough, and it just sort of ended. I didn't call back.

Then my life went on. William Burroughs came to New York. It changed. William comes—it's 1968. How many things happened in 1968? Columbia College, getting batted on the head by police and getting carted off to jail, and William Burroughs arriving from the Chicago convention, and I spent a month with him and all of that radical politics, and [Jack] Kerouac, [William F.] Buckley. There were endless things happening.

Bob was just like us. He was this guy who was successful, but he flies out to Los Angeles. I think it was the spring, or maybe it was late spring [of 1968], whatever. Gemini [G.E.L.], again. He had been many times to Gemini. But that was the time he met Warren Beatty, and I think that when he came back he was different in some way. He saw that world of Hollywood on its highest level. I guess maybe all of those movie stars treated him as an equal, as he was. You know, in our world, to me Janis Joplin is somewhere in the Fifth Heaven or something [laughs], and then he got to know Janis Joplin well. And that set him in another world of playing. It's another world. And that other world he went to after 1968. I mean, 1968 until the rest of his life.

Rauschenberg in the kitchen of his Lafayette Street home and studio, New York, 1968. Photograph: Shunk-Kender © J. Paul Getty Trust.
Getty Research Institute, Los Angeles (2014.R.20). Photograph Collection: Robert Rauschenberg Foundation Archives, New York.

CHAPTER 3

381 Lafayette Street

ROBERT RAUSCHENBERG and Sue Weil rented an apartment on West Ninety-Fifth Street in the fall of 1950.[1] Their son Christopher was born in July of 1951, and in August the family returned to Black Mountain College. The couple separated, and Weil departed with Chris later that year. In late fall, Rauschenberg returned to New York, and in August of 1952, he sailed to Palermo, Italy, with Cy Twombly. In early 1953, after travels in Europe and North Africa, Rauschenberg returned and moved into a loft at 61 Fulton Street in lower Manhattan, the first in a series of raw downtown spaces he would occupy for the next decade.

Rauschenberg was one of the first New York artists to establish a studio in a once industrial space. During this time, he lived on fifteen cents a day ($1.36 today), and the Fulton Street loft's proximity to the fish market provided him with easy access to the boxes on which he slept.[2] John Cage, Merce Cunningham, Morton Feldman, and Philip Guston lived in a nearby building.[3]

Rauschenberg's move to 278 Pearl Street in 1955 brought him into contact with Jasper Johns, who occupied a studio in the building. Both men stayed there for the next three years and saw each other daily, "exchanging ideas and discussing their work."[4] When that building was condemned, Rauschenberg and Johns moved into the second and third floors of 128 Front Street, respectively. In July of 1961, Rauschenberg moved to 809 Broadway, a commercial space in which residential dwellings were illegal.[5] As Carolyn Brown remembers it, "Bob's apartment [on] Broadway exacted an irresistible, magnetic pull on the downtown art and dance community. Pied Piper Bob's 'Let's make stuff! It's fun!' ideology revved up the creative engines of everyone beating a path to his door."[6]

But it was his next, and final, New York address that has come to be synonymous with Rauschenberg: 381 Lafayette Street. The building had formerly been an orphanage's administrative offices and a chapel of Saint Joseph's Union Mission of the Immaculate Virgin.[7] Rauschenberg purchased the space in 1965, when "Soho was the Wild West plopped into Downtown Manhattan. Building codes were lenient, police lackadaisical, and *space* there was just so much space."[8]

Real estate agent Jack Klein, one of the first working on downtown loft conversions, helped Bob find the place.[9] As Dorothy Lichtenstein recalls, "the same person that found the bank on the Bowery for Jay Maisel found this for Bob. He used to joke and call himself [the] 'Slumlord to the Artists,' and his business was to help artists find places. They were usually living in lofts, and there would just be cold water and no shower, or no bath. He would fix them up a little, actually have a shower, hot and cold running water, make them a little homier than they were. And he would usually trade, take some artists' work—not with everyone, but with some people, if he wanted the work. So I think he found that building for Bob. And for nothing."[10]

As Hisachika Takahashi remembers it, "artists chose to live around there because of bigger apartments, bigger kinds of studios, and very low prices. But at the same time, there were factories, like for sewing blue jeans, [and] storage for food, like eggs, meat, the fish market. It was not high quality of living for people, but . . . it was easier to have a connection with the artists there and it was easier to buy big buildings or to buy bigger spaces. So the galleries started moving downtown. But a lot of crime was going on downtown. At the same time, there were free spaces. It was to me like spaces in the country—they were open for everybody."[11]

The same year that Bob bought 381, Johns and Rauschenberg had been declared the "The New Old Masters."[12] In April of 1965, *Harper's Magazine* published a long piece on Rauschenberg's victory at the 1964 Venice Biennale. And in June, *Arts*, the Paris weekly newspaper, named Rauschenberg the "most important artist to have emerged since World War II." Much had changed for Rauschenberg since his early years in the city, and 381 Lafayette gave him the space to host the work, and the party, of which he always seemed to be at the center.

In addition to his continuing involvement with Billy Klüver and Experiments in Art and Technology (EAT), and his ongoing collaborations with New York City's performing artists, Rauschenberg was increasingly involved

in printmaking. This interest had begun in 1962, when after two years of invitations from Tatyana Grosman, founder of Universal Limited Art Editions (ULAE), Rauschenberg accepted the offer to make prints at her press.[13]

By 1970, some of the prints he was producing were "conceived to remind us of the love, terror and violence of the last ten years. Danger lies in forgetting."[14] The collage he employed in his print *Signs* (1970), comprising images of "Janis Joplin, John F. Kennedy, Robert F. Kennedy, American soldiers in Vietnam, an astronaut in space, demonstration scenes, and Martin Luther King Jr. lying in his casket,"[15] illustrated just how much Rauschenberg had been affected by the previous decade's social and political reverberations.

New forms in the art world were being shaped by these reverberations too; the creation of land and feminist art were rooted in the hippie movement and student protests of the late 1960s, and in New York City, SoHo's streets were increasingly populated with artists, contributing to a communal feel in the neighborhood best exemplified by the social experiments enacted by Gordon Matta-Clark. His artist-run restaurant FOOD, which opened in 1972 at the corner of Prince and Wooster streets, was a place friends could meet and eat together, "engendering a new way to integrate life and art in the form of living sculpture."[16] Celebrated artists and performers, including Rauschenberg and John Cage, created meals at the restaurant.[17] Matta-Clark created a meal called Matta-Bones, in which the bones from the meal were used to make necklaces for patrons to wear. On one occasion, Matta-Bones served more than one hundred people. After they ate, Richard Peck cleaned the bones, and Rauschenberg's assistant, Takahashi, drilled holes in the bones to string them into necklaces.[18]

The kitchen at 381 Lafayette was an infamous gathering place too. With Leo Castelli, Marian Goodman, Sid Felsen and Joni Moisant Weyl, Alana Heiss, Roy and Dorothy Lichtenstein, Billy Klüver, Julie Martin, Brice and Helen Marden, and Ileana Sonnabend among Rauschenberg's regular guests.

As was the case with Rauschenberg's collaborations the preceding decade, there were many interconnections among his 1970s community. When the musician Richard Landry moved to the city from Louisiana, he met Rauschenberg through his girlfriend, dancer and artist Tina Girouard, who worked with Deborah Hay. Landry went on to work with composer Philip Glass, who frequently collaborated with Laurie Anderson, a writer, director, visual artist, and

vocalist and an acquaintance of Rauschenberg's. Anderson also knew Girouard as one of the cofounders of FOOD. And Mayo Thompson met Bob while walking by Ileana Sonnabend's gallery in Paris with his wife, the conceptual artist Christine Kozlov.

Rauschenberg's world was still a small one. As Anderson remembers it, "dark downtown SoHo in those days . . . and the art world in general, has had a huge overhaul, and it's gotten to be, I bet it's a hundred times as big. When you think of how many artists there really were, there were like sixty artists in SoHo. One gallery, one restaurant. There weren't thousands. We were living in isolated lots, turning our lights out at night so we wouldn't be discovered. It was a very, very small scene."[19] In the following pages, you will see that the scene was also expanding. Takahashi had arrived in NYC from Japan by way of Italy, Mayo Thompson from California, and Tina Girouard and Richard Landry from Louisiana; and each artist brought new flavors and culture to the city.

Rauschenberg's reach was extending *beyond* the city too. His work was celebrated, his success firmly established, his wealth was accumulating, and his acclaim was cemented. He was "Rauschenberg" now.

MOSTLY THEY WERE PARTIES, WILD PARTIES

LAURIE ANDERSON: When your story gets told, I'm just thinking of Paul [Benjamin] Auster and Sophie Calle. Paul had somebody called Sophie in one of his early books, I forget what it was [*Leviathan*, 1992]. It was a story of a woman who followed a man to Venice and wrote about him. It was Sophie Calle's early work, and he credited her in the foreword of the first edition but didn't ask her if he could use her story. They knew each other. In the second edition, he didn't credit her. Her life was in there as fiction, and she said, "Paul, I need you to say that that's me in your book," that that's her real life you're talking about. "Here's why. Because when I'm telling somebody about what happened to me and they go, 'Gee, that's just like that character in that Paul Auster book,'" she said, "that's why I'm telling you that you need to do this." He did not do it, however.

So all of these things get mixed in our minds, of fiction and reality, and I'm surprised that we're able to tell the difference at all. I mean, I think that

authorship is a very sticky thing. I'm thinking of somebody who was just telling me this dream. "Oh, I was in the mountain pass, it was so beautiful with thick clouds. It was nighttime, it was really dangerous, and I was so afraid. I was this little person walking through the pass," and I have to think, "Wait a second. Who do you think invented that beautiful mountainscape? Who made those giant clouds? Who wrote that? And who wrote this, how come you said you were going to be this little helpless person? Why did you cast yourself in that role? Did you forget that you're the author of all of this? You're telling it like a movie you saw last night. Accept the authorship of the way you see the world and through what filters you're seeing it."

So when I talk about or think about being an artist in the 1970s, there were a number of stories that I would haul out. Obviously you can only talk about them in the sketchiest of ways unless you've really gone into it. And so in a way I almost find it ridiculous to try to say something about it. But if I were going to say something, it would be that it was a moment when we helped each other a lot in making work. Sculptors helped painters helped dancers helped musicians, and everybody was interested in changing the world. Nobody thought they would ever be paid for this—ever. So it had that kind of innocence and lack of competition because no one would ever make a dime doing this. If there was competition, it was who could go the furthest in terms of ideas. But generally I have memories of that time as largely that—of generosity.

I remember being over at [Rauschenberg's] place more than seeing his work. And mostly they were parties, wild parties, and I remember them being full of this Southern joy. A lot of people had come from a lot of different places, and New York was where we all experienced our freedom. Jene Highstein, Phil Glass, Trisha Brown, Gordon Matta-Clark, Bob, Richard Nonas, [Susan] Susie Harris, Tina Girouard, [Richard] Dickie Landry. These [people] are all from radically different parts of the country. Radically. And everyone brought this almost international feeling to New York.

Also in the 1970s, the thing that is easy to forget is that it wasn't that far from the 1960s. There had been created a communal culture called the counterculture, which we all were part of. That was why we wore those clothes; that was why we ate that food, which was largely kind of a weird health food. That culture had its own clothes, fashion, music, philosophy, political stance, and spirituality. It came filtering into the 1970s in ways that were really

interesting, especially into the art world, and that's also how different strands of Buddhism got there as well. Not only through [John] Cage and [Shunryu] Suzuki, but also through people who approached their art as a meditation. It was about extended time. It was about a very long form [such as] Trisha Brown crawling up the buildings. It required focus, and it required the same kind of duration that you would use in a Phil Glass rehearsal, which you'd be there for eight hours. So it was a radically different sense of time. You'd go over to somebody's party, and you wouldn't be there party hopping for twenty minutes—you'd be there for five hours. Everyone had more time; that is one of the biggest differences. Everyone had more time to hang out. It wasn't cut up by gadgets.

People helped each other a lot. If I had to have my floors sanded—I was here in 1975 and you wouldn't think that much of it if somebody goes, "Hey could you help me sand my floor this weekend?" Can you imagine asking your friend these days, "Could you sand my floor this weekend?" He'd go, "Are you kidding me? Here are some recommendations for sanding companies." You would not ask them to do that. Would twenty-year-old kids ask each other to [do that]? Yes, probably, but not as much as we did, I don't think.

Predominantly my memory is that we helped each other a lot in making work.

BRICE MARDEN: Bob had been traveling with Merce [Cunningham], and while he was traveling his stuff was moved into this new house on Lafayette Street. And when I was going around looking for [a] job, I ran into Dorothea [Rockburne]. I knew Dorothea, saw her at an opening. She said, "There might be something where I live."

And I went, and it was Bob, and he had just moved in. [Steve] Paxton had done a piece for 9 *Evenings* [: *Theatre and Engineering*, 1966]. My first job was to fold up this pile of taped-together plastic sheets, and that's what I did. And I did pretty good. And then Bob said, "Well, I'm going to be doing some work in a little while. Maybe you can keep busy around here, and then when I get started with the work you can help me with that." So that's what I did. We moved various things around the house, and I washed all the windows.

I thought he was a really nice guy. He was just very generous, and it was very comfortable working there. And then eventually it evolved into a thing like I would go to work at eleven or something, and he would come upstairs and

I'd have the coffee ready. And then the phone would start ringing, and I would answer the phone. And I was pretty good at being able to identify people on the phone, and I could say, "Oh, yes, Ileana [Sonnabend]," and he could go, "Yes" or "No," whether he wanted to talk to them. The job, in essence, was to make everything easier for him just to do his work.

LARRY WRIGHT: It was all centered out of 381 Lafayette Street. The phone number, incidentally, is BATLATH, which is the anagram. I couldn't remember numbers, and I told Bob, and he loved that name, so that was what we used to call it: BATLATH. There was [Hisachika] Sachika [Takahashi], who lived on the top and took care of the house. He was sort of the majordomo. David [Newkirk] White—the ubiquitous David White, incredible person. He was always on the scene. Then there was a revolving group of people who were around Bob and did various things. At one time or another, everyone seemed to live there. We called it Milton's Hilton. I lived there for a while. After coming back from Captiva, I didn't have a place to live, so I crashed up on the third floor. There were some French girls who had something to do with Sachika and his wife, Agathe [Gonnet], who were around, and with the French girls came [an]other kind of Euro trash that was always seemingly there in the morning. There was a constant ebb and flow of social interaction.

BRICE MARDEN: The house had been an orphanage, and it had this big stove, which he had all cleaned up and made operable. He loved cooking. He loved stuff really hot. Really, really hot. Spicy. And it was always like there'd be somebody else there, and the spice would be kind of a contest who could eat the [hottest]. Helen, my wife, she likes really hot stuff. So they'd get in these face à face eating contests. At a certain point, there'd be all these people sitting around, and Hisachika would just come in and start cooking. Everybody would eat.

SIMONE FORTI: Sachika as working for [Bob] and was constantly cooking soups and little Japanese delicious things. There was an enormous table with vodka and orange juice, and people were just dropping in. Rauschenberg would come and sit with us and enjoy the fun, and then he'd go back to his studio.

RICHARD LANDRY: Straight to the kitchen, every time. The kitchen was the main place. The steady stream of people in and out, Hisachika cooking, fussing, Bob constantly watching TV. The kitchen was the center of activity; the giants of the art and music world at one time or another sat at [that] table. I would arrive sober and would leave drunk. Parties after parties after parties, hundreds of people in all various states of mind.

BRICE MARDEN: A lot of interesting people were hanging around Bob. This whole thing with the kitchen. You weren't just making him a pot of coffee. By four in the afternoon, there're all these people sitting around drinking Jack Daniel's, and, well, sometimes Bob would come over and make some horrendous kind of hangover concoction. I mean, drinking was a big deal there.

PATTY MUCHA: If Bob was having a party, [Claes would] say, "Patty"—Poopy, he called me—"Poopy, be careful. You know what a troublemaker Bob is."

381 WAS KIND OF A PASS BY

HISACHIKA TAKAHASHI: My friend came [to Italy] from New York, to show an Andy Warhol movie, a very nice, strange movie—one actor, and I think with Ultra Violet, talking at a bus stop, both naked.

I met John de Menil, the art collector and founder of Rothko Chapel [Houston] at the screening. And he asked me, "Could I come to your studio to look at your painting?" So I said, "Of course." He came over and said, "I want to buy this panting, how much does it cost?" I had no idea, but somehow I made up a story. I think I asked for five hundred dollars. He said, "Okay, you bring it to New York and I'll pay for it, and you can stay for three weeks' vacation in New York. You can stay at my house."

I had ten pairs of shoes, five suitcases, and eight or nine paintings with me. When I arrived at the airport, a black, huge Cadillac was waiting, a limousine, and inside it, a secretary, I think it was Simone Swan's secretary. She handed me a big envelope full of money, and I said, "What's this for?" She said, "Oh, this is for your expenses, for spending three weeks." All five-dollar bills, like this, and she said, "Don't spend too much money." I was very shocked to have a

black limousine and we got to the bridge and saw Manhattan, and I said, "That is New York!"

New York was a very open and international community. There were different languages going on, and people looked, to me, very free and very easy to communicate with. In Italy, the people walking the street were sort of camouflaging themselves so that nobody could see them.

I stayed at de Menil's house. The house was completely full of artwork. Rauschenberg and Jasper Johns, and [Willem] de Kooning and [René] Magritte and Andy Warhol. And I sat with this big painting called *Evening Falls* [1964], the Magritte painting with the broken glass, with the sun. I was almost touching the painting; it was that close.

This was 1969. And de Menil made a big party, about a hundred people sitting at tables, with lobster and champagne, the best champagne. My table had Jasper Johns, Rauschenberg, a girl who is a photographer, quite famous, and the writer Norman Mailer. We had some conversation, and I didn't speak very much English but Rauschenberg tried to communicate with me. So I said, "You know, I'm kind of bored here, almost three weeks have passed, and I'd like to be of help to an artist. I left my telephone number with Rauschenberg, and he called me a couple of days after and said, "Would you come in to help me paint?" I went right away.

He had a house on 381 Lafayette Street, at Fourth Street, a five-story house with a church adjoined to it, and two basements. I lived in a small room in the house, to take care of it. He asked me to come in at eleven o'clock, so I said, "Eleven o'clock in the morning?" He said, "Yes," and so I went there at eleven o'clock in the morning, and he wasn't there. And the maid has come over and started to cook lunch, and he's not there. I was getting tired of waiting. At five o'clock, he gets up, and then fixes for our morning, a first morning drink, a vodka and grapefruit or something, and next, he changes to Jack Daniel's. Well, this is all day, and people are coming and going, visiting, a lot of people, phone calls, and I'm falling asleep. I said to him, "I'm going to fall asleep," and he said, "Well, we must eat dinner." Okay, so we eat dinner, and I'm getting more sleepy. And I said, "Well, I'm falling asleep, I'm going home," and he said, "Oh, no, no, we must work." He was making artwork with mirrors, with lighting behind them, and plastic glass silkscreens, with a very strong sexual image. They were called *Carnal Clocks* [1969]. It was five o'clock in the morning when we started

working, and it was so exhausting. He said, "Why don't you sleep here?" And it ended up that I was given a small room.

[381] was kind of a pass by instead of using a hotel. People just came in without invitation and would sit in the room. Sometimes people didn't even say hello to you and would go to the icebox and get a drink. I didn't like it, but I got used to it. They fixed a drink and came to the table and said, "Oh, hi." You should be invited first. Anyway, I figured out the New York people.

Oh, my God, so many parties. We like to do a party; I mean especially Rauschenberg. Most times he opened a party, so many people would come in and usually they'd never leave. And in the morning there were people sleeping all over. Sometimes it would be my job to kick people out.

One party had all the artists there. A lot of big strong men, and they're pushing each other for much of this. Brice Marden was there and his wife Helen Marden, and she was very charming. And my ex-wife was there, and John Chamberlain came over to the party. He was a complete drunk, but he was very charming, and somehow he grabbed Helen Marden's pants, pulled down the pants, so she was naked. Meanwhile, everybody's around, and John Chamberlain is laughing, and Helen gets very upset. So she pulled her pants back up. She turned around, went into the greenhouse, picked up a big plant with dirt. She ran behind Chamberlain and hit the back of Chamberlain, and Chamberlain was so big and strong, he was laughing. Every artist, macho guy, wanted to do something, but nobody did anything. Somebody told Rauschenberg, "I think John Chamberlain must get out of the house, be kicked out." So Rauschenberg—I'm sure it was the only time that he did this—Rauschenberg followed [him] to the staircase, and John Chamberlain said, "Bob, you are going to kick me out of the party?" Bob said, "I think you'd better go home." He'd had trouble with his wife before; they had a fight when they came in to the party [and] he got drunk.

John Chamberlain said, "Listen, why don't you look in my eye?" He was two steps down the staircase. He said, "Look me in the eye to tell me about it." So Rauschenberg said, "I'm looking at your necktie. I cannot see your eye."

At the same time, my wife came over with a big cast iron frying pan. She wanted to come over to hit John Chamberlain in the head. I was lucky, I was next—so I grabbed the frying pan and said, "Are you kidding me, you're going to kill somebody." John Chamberlain left. That's a party.

DOWNTOWN TO THE ART WORLD

RICHARD LANDRY: In 1969, I moved to New York City with my now ex-wife, Tina Girouard. When I arrived in the city, I knew two people: Keith Sonnier from Mamou, Louisiana, and William "Bill" Fisher, an African American, who was a high school band director in Opelousas, Louisiana. I met Keith in 1962 at the university art department in Lafayette. Keith had recently graduated from Rutgers [University] and was now living in New York City. I met Bill when I went to the school where he was teaching to give a bid on the instruments to repair. I walked in, and I took one look at him and the first thing that comes out of my mouth [is], "You smoke marijuana, don't you?" He looked at me, shocked, and said, "How did you know?" I said, "I just have the feeling." We became friends. When I arrived, I began working with Keith, who was with the Leo Castelli Gallery. The artists in that gallery were Robert Rauschenberg, Roy Lichtenstein, Jasper Johns, Andy Warhol, and James Rosenquist.

I went downtown to the art world. It was through Keith, Richard [Serra], and Philip that within a few months I met all these artists. [Gordon Matta-Clark, Robert Smithson, Michael Heizer, Walter de Maria, Steve Reich, Philip Glass, Jon Gibson, Laurie Anderson, Ulrick Rückrem, Susan Rothenberg, Mary Heilman, Nancy Graves, Spalding Grey, Richard Nonas, Jene Highstein, Joan Jonas, Jasper Johns, Jim Rosenquist, William Burroughs, Mabou Mines, Chuck Close, Robert Wilson, Lawrence Weiner, Bill Wegman, Joseph Kosuth, Bruce Nauman, Lucinda Childs, Trisha Brown, Deborah Hay, and so many others.]

I am melting lead and splashing it against walls with Richard Serra. With Keith Sonnier, I am helping him build his large glass and neon pieces that are also dangerous. I am a videographer for both Lawrence Weiner and Keith. With Gordon Matta-Clark, I am helping him cut up buildings. In the meantime I am taking photographs of all these happenings. I enjoyed this work better than interpreting someone else's music in the recording studio.

[Tina and I] rented an apartment at 98 Horatio Street in the West Village. At the time she was working with a dancer, Deborah Hay. Deborah wanted to watch a 16mm film of hers; I had the 16mm projector. She asked me if she could invite a few friends. I said, "Sure, invite whoever you want." The first person to show up at the door at this very tiny apartment was Bob Rauschenberg and a

Swiss art dealer. I recognized him, and I said, "Before you come in, I want to tell you how I know who you are." I recounted the story of seeing his work in high school. He walks in saying, "Thank you," and "What do you have to drink?" "I have Jack Daniel's." He said, "Perfect, my drink!" This was nine o'clock at night. We viewed the film and we drank. I was smoking a lot of weed in those days, and I offered him some; he said he had never done it. I was surprised. "You, never?" He responded, "Never!" He smoked a little. They left at four or five in the morning, completely drunk and high. I had to put them in a cab and give the cabbie the address: 381 Lafayette.

A couple of weeks later, while working with Keith Sonnier, he mentioned he was looking for a 16mm film camera. I said, "Rauschenberg has one, you should call him." His response: "Oh, I cannot call him." I said, "You guys are in the same gallery, so I assume you know him?" "Oh, no, I cannot call him." I eventually called Bob, and he remembered who I was and invited me to a party. I arrived there at 7:00 p.m.; the party was in full swing. I left the next morning at six or seven, completely inebriated. I was stumbling out the door with his 16mm Arriflex movie camera. He said, "Wait a minute, wait a minute, I really do not know who you are, and you are leaving with my twelve-thousand-dollar camera—oh, but you are from Lafayette. You are okay!" I started going to a lot of his parties, openings, and soon after I began to perform at his openings.

It was through Keith Sonnier that I got to meet Philip Glass. Visiting Keith, he mentioned that he saw an interesting concert by a composer, Philip Glass. Keith thought that it was visually interesting and aurally interesting." I said, "What do you mean by visual?" He said, "Philip had a maze constructed, and he had one continuous sheet of music pinned to the wall. A violin player then walked through the maze performing the music.

I called Philip and visited him at his home on Eighth Avenue and Thirteenth Street. At the time he was married to JoAnne Akalaitis and had two kids. He had just come back from Paris where he had been studying with the classical composer Nadia Boulanger. I know what a score looks like, and I could see the scores all stacked up. Philip was fumbling through them but was not showing me anything. In hindsight, I believe he did not want to show me his scores because he had put that music in the past. He was coming up with his own style, which later was coined minimal music.

The next day I went [back]. As I was leaving, Philip mentioned that he was having a dinner at Steve Reich's loft the following week. He said, "Bring your horn." There were several composers there, and we each performed one of our compositions. Then Philip said, "I am going to play a short piece." He played for forty-five minutes! I am sitting in a chair, and I went through every emotion in the book.

When he finished, I said, "Philip, this is the best new music I have heard in a long time." While I was in university in Louisiana I was very interested in the new avant-garde music coming out of Europe—Karlheinz Stockhausen, Pierre Boulez, Luigi Nono, and others. Every two months I would organize concerts at the university and get the best players to interpret this very complex music. Hearing Philip's music, on the contrary, was sweet, beautiful, and mesmerizing, while the other, I thought, was cacophony.

This was the fall of 1968. Philip mentioned to me that he was starting an ensemble in January and asked, "Do you want to be in it?" I said, "Sure!" So I came back to Louisiana thinking I have a job in New York City, I will be playing music. I arrive in the city and realize that Philip had only one concert in 1969.

NEW DOGS WERE JOINING THE KENNEL

MAYO THOMPSON: When I got to know him, Rauschenberg represented, to me, a man who belonged to a logical progression that I was learning about in school.

I was always on the lookout. I found Rauschenberg because I was on the lookout, looking for something else, something that had not been done, something that hadn't been chewed to pieces. Though it had its roots in the past and you could see where it had come from, the tradition had its own identity, it had its own character.

In Paris, walking by Ileana [Sonnabend]'s place—there sat Bob. Christine [Kozlov], my wife—said, "Oh, there's Bob Rauschenberg." They knew each other from New York. It was Bob: "Christine!" Christine was an artist, a conceptual artist, one of the first people to make it, in fact. He trusted her; trusted her eye, her taste, and somehow her approval was important to him. She was an extraordinary woman; wild is the traditional description of women who do the kinds of things that she would do, which was anything she fucking felt like, whenever.

Bob had a huge show in Paris where he was making the *Early Egyptian* series [1973]. That's where I got my start with him. They were trying to write a press release, and [he said]: "He can write." I wrote the press release, and they liked it. "Hey, I can do something, wow. I like your shoes too. Cool, plain brown. Like that."

There was an economy there, which had to do with who one was, who one belonged to, what was going on, what was important, the trend of ideas. And always with this progressive involvement, like where art and the art world are part of the good. That belonged to this positivism, and Bob's a positivist, extremely, a force for positive, a force for good.

With Bob, one met Abba Eban and Mrs. [Suzy] Eban, and [Theodor] Teddy Kollek, the mayor of Jerusalem, and Shimon Peres, and that order of people. [Jacob K.] Jake Javits, Marian Javits. It was that level of activity and that kind of people. Plus Bob likes to be around people who will find something that they can do, who can do something, and who are prepared to do whatever. And me, I'm not proud, I'll sweep, pick up the dogs, take the dry cleaning, go shopping, whatever you like. Want something written? Fine.

So there was a certain can-do environment. "Ah, some kids, a new generation," that kind of thing. Some fresh blood, and Bob sustaining. He represented a kind of security, and also, for me, it was just fascinating to think, this is more fun than you're going to have anywhere else. Why not? Let's see what goes on. So we did. After working with him in Paris, somehow we let him know that we needed to do something. And Hisachika Takahashi was also there, and he made a place for us, and we went to work for him.

This was a crash course in "like, you know, like yeah, it happens, wow, look." And that's the way things were in the 1960s and 1970s. So I was used to things unfolding quickly, not having to sit on your hands and wait to see if somebody makes up their mind, do you or don't you, or will you or won't you. I like that fluidity that Bob had, and Bob liked that I can talk on the telephone and I'm not intimidated by that kind of situation. So I could represent him and stand in for him in certain circumstances, and they could trust me also. I'm not going to mess him around.

We moved into [381] Lafayette Street and just started doing what needed to be done. Hisachika accepted that new dogs were joining the kennel. Bob went to Florida eventually, went to work down there. When Bob would come

to town—get ready for boogie. Here comes the butcher with a box of steaks, a hundred steaks, and the turtle needs to be washed; this needs to be taken over to Leo's house.

In the first instance, it was really like doing things and going places and being part of it and showing up and being there at dinnertime and going to the restaurants and support, support, support, support. "Goodnight, Bob, blah-blah-blah," "Good morning, Bob, la-la-la," that kind of stuff. Like family life. High tolerance, and then some kind of understanding for the real schedule, because it's productive, it's an environment, it's a factory. An industry. Bob Rauschenberg, Incorporated. And he cranks it out, and the guy's a rigorous worker, a hard worker, in his studio every day, all day, until the end of the day. A typical workday, you get up in the morning, have something to drink, a little something to eat, and then one o'clock, into the studio, come back for a light little lunch, and then back in the evening until ten-thirty, eleven o'clock. Then come back, sit down, watch TV until bedtime, twelve o'clock bed, one o'clock bed. And the morning, same thing again. Every day, every day, cranking it, and on his own, encouraging.

In New York the evenings were always heavy duty because around the table would sit Brice Marden, Helen Marden, Alanna Heiss before PS 1 [New York], Marian Goodman before Marian Goodman [Gallery, New York], Billy Klüver, Julie Martin, on and on and on and on. A lot of drinking, a lot of eating, sometimes. One night there was a party, and by this time I was getting a little tired at some level and thought to myself [that] I could change the art world with a hand grenade. Cynical thought, an evil thought. Not my thing, to change the art world like that. But it was that thing, because everybody who was there was there.

New York was tense for Bob because he's on stage all the time, heavy performance relation, and you've got to keep it together and stretch it out over hours and have energy for six-hour stretches and ten-hour—I mean, it's really hard, hard, hard work. Fortunately, he had the stamina of a mule. Drink was a problem, but he was never dysfunctional. There would be no day that he didn't show up. There'd never be a night when he went so far that he couldn't function the next day. He always managed. The bell rang, he was there.

I had more fun than a barrel of monkeys. I adored it. Because, even though I was not a player, I was in the middle and observing all the things that I was

interested in. I rubbed elbows with Amiri Baraka and his crowd, Congress of Afrikan People before they became the revolutionary whatever they were. That was fascinating. I had a good time doing that too. The Anti-Imperialist Cultural Union, Artists Meeting for Cultural Change, all those things were fun, fun, fun. Because that was genuine class struggle at the point of production and, therefore, in my view, mitigated by that fact, because it is a productive environment, a productive atmosphere. You're standing in New York, and what we're talking about is producing culture here, not just culture in the sense as whatever human beings do, that's culture of course, but then there's high culture, and some of it counts, and some of it gets paid for, and people live and die for it.

New York seems to me to be stupid in some sort of way, like believing in itself so hard that you even begin to think that there's an "it" that believes in itself, that there is this dynamic and everybody's part of it somehow. I never felt part of it. I felt at home at Bob's place, and around Bob. That was good enough for me, because otherwise I feel homeless most of the time.

[The essence of that time was] activity, production, people knowing each other, and then the downside would be the content. The structure, the form, the mechanisms, and the devices, those kinds of things were all wonderful. New York is an engine for grinding out fascinating things, but you [have] got to be on the make, and you'd better not have any feelings.

Rauschenberg is a true artist. You ask him, "What are you?" [and he says,] "I'm an artist." Ask me what I am, [and] I'm going to hem and haw and hedge. I'm not anything. I'm a human being. During the time that I met Rauschenberg, I had an extremely limited disposition as to what was feasible to be doing, what was worth anybody's time. Sitting at that table in New York, I was looking for [how] art was relevant in some sort of sense. Because it was a question of rising, as it became powerful in the 1970s. Does art have a social purpose? What is it? People began talking about audience, and Rauschenberg had made the audiences that were talking to each other about being audiences, and who should be an audience. That's when all that socialist discourse entered into the whole picture, because the war was over as well, and people in SoHo were casting about for something meaningful to be doing with their careers. I feel for all of the people who do this kind of stuff, because I would suggest that one of the realizations that goes with doing this kind of stuff is how relatively unimportant

it is on the relative scale of things that are truly important. It's important to me, and it makes me a better self-managing unit, able more to contribute to society in a meaningful sort of way, helps me keep my balance and all that, and a tiny bit of entertainment for somebody else. But outside of that—the generation I belong to believed that they were purveying knowledge. I learned this is not so.

[Bob] believed. I think the difference—I would put it this way: he belonged to a philosophical world in which it was possible still to work—that worked from totality, from a notion of totality, or holism, where everything fits together; there are no contradictory bits.

I think he found it deeply meaningful. [And] he really believed in magic. Powerfully. I sat next to him when Muhammad Ali knocked George [Edward] Foreman out in the eighth [October 30, 1974, The Rumble in the Jungle], and he showed me he had a silver spike in his hand that he always held when he was wishing for something. He said, "I knew it!"

I would accept that there's virtue, but goodness, I don't want to hear about it. I don't know how. I've read [George Edward] G. E. Moore. Bertrand Russell [argued] about this question and [wrestled] with it, and I read a lot about moral philosophy. That's one of the reasons why I liked conceptual art, because it was back to the basics about what dialectic is and what cognition is and what mental representation is, and what language comes to and where it comes from and what it represents. When people start telling me they can do this and that in art and nobody else can do that, I laugh. Because they're cutting off their nose to spite their face. The whole game in art is to find out who can share what with whom.

I learned that from Bob.

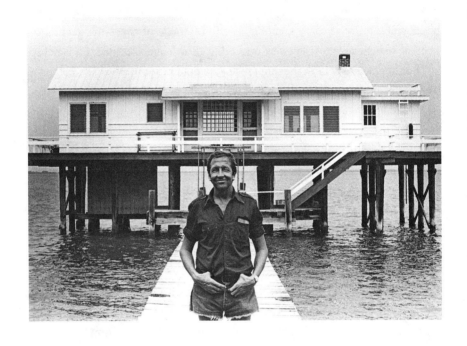

Rauschenberg in front of the Fish House, Captiva, Florida, 1979. Photograph: Terry Van Brunt.
Photograph Collection: Robert Rauschenberg Foundation Archives, New York.

CHAPTER 4

Captiva

RAUSCHENBERG purchased his first Captiva home in 1968. A flat, sandy island twenty miles south of Fort Myers on Florida's western coast, Captiva measures just four miles long and a mile and a half wide. There has been much speculation about why Rauschenberg left New York City for this small, remote destination. Some point to how many of Rauschenberg's peers and friends were departing the city. "They were ready to escape from loft studios in crumbling ex-industrial buildings, from trash on the streets and a city on the verge of financial collapse, from openings, dinner parties, and late-night bars, from the pressures of production and the politics of a nation at war abroad and with itself."[1] Agnes Martin had set off to New Mexico, Jasper Johns to the Caribbean, Donald Judd to Marfa, Texas, Steve Paxton to Vermont, and Alex Hay to Bisbee, Arizona.

Others in Rauschenberg's inner circle speculate that his move was due to his feelings that the art world was moving on, leaving him behind. "Like, what's happening to me? I'm still Rauschenberg. Everybody loves me—but I'm not the be-all and end-all."[2]

Or perhaps New York City had simply fulfilled its purpose. Pace Gallery owner Arne Glimcher characterized the city's 1960s art world as a pressure cooker. Artists came to have dialogues with each other and to learn what they needed to know. "After that burst of energy, people create[d] their own lives less dependent on the exchange of the ideas of other people."[3]

As his son Christopher tells it, Rauschenberg was responding to changes in his immediate community. "He called in an astrologer and said, 'What's going on? My friends are getting divorced. Am I doing something wrong?' This sense

of it's all family. And he got back this sort of Delphic message. 'You need to live near water.' "[4]

Despite all others' speculations on the subject, Rauschenberg's love for Captiva was clearly stated: "Captiva is the foundation of my life and my work," he wrote. "It is my source and reserve of my energies."[5]

A two-level building on the Gulf of Mexico's shore, Rauschenberg's Beach House was his first property on the island. Dolphins swam just off the shoreline, grapefruit and lime trees were heavy with fruit, and the white sands were peppered with seashells.[6] In 1970, Rauschenberg made the Beach House his principal residence, building a studio on its ground floor.

This haven likely felt especially invigorating to Rauschenberg. At the time of his move, he said he was exhausted by the total focus "on world problems [and] local atrocities."[7] "Something in the 1960s was coming to an end. Race riots, the death of Bobby Kennedy, the death of Martin Luther King, the death of Janis Joplin. . . . It was the end of an era of postwar Utopian optimism. . . . Captiva allowed him to start again."[8]

Before departing New York, much of Rauschenberg's time was spent on Experiments in Art and Technology [E.A.T.], promoting collaboration between artists and engineers. In Captiva, he wanted something different; he wanted to work "in a material of waste and softness."[9] As had been the case in New York, in his European and North African travels, and before that at Black Mountain College near Asheville, North Carolina, Rauschenberg's surroundings became the "source of material for his work."[10]

At Black Mountain, Albers had taught the relativity of visual experience—for example, how our experience of a color is totally determined by its surroundings. This relational approach to materials remained a constant throughout Rauschenberg's career. "In his art, one thing always leads to another in an endless chain of relations and reactions."[11]

In this way, his early work in Captiva was a "direct [departure] from the technically complex art he'd been making in New York with E.A.T." The *Cardboard* series (1971–1972), "wall sculptures made from found cardboard boxes," started off with what Rauschenberg found there. "There was sand and there [was] always something being shipped to him in a cardboard box."[12]

In addition to engaging with these new "softer" materials, Rauschenberg's printmaking practice thrived in Captiva. In 1970, Rauschenberg invited

respected printer Robert Petersen to live and work with him on the island. Petersen had been employed as an assistant printer at Gemini G.E.L. in Los Angeles and had worked on Rauschenberg's editions, including his *Stoned Moon* series (1969–1970), during which time the men became close friends. In 1971, Rauschenberg bought the Print House, renamed it the Print Shop, and with Petersen founded Untitled Press, Inc. They named one of the presses Little Janis after fellow Port Arthur resident Janis Joplin, and they printed their own work and the work of visiting artists, including Hisachika Takahashi, Cy Twombly, Brice Marden, David Bradshaw, Robert Whitman, and Susan Weil.[13]

In 1972, Rauschenberg met another significant collaborator, Donald Saff, founder and director of Graphicstudio at the University of South Florida [USF]. Saff founded Graphicstudio in 1968, and the organization came to be celebrated for its collaborations with many of the late-twentieth-century's leading artists, including Rauschenberg, Jim Dine, Nancy Graves, Roy Lichtenstein, Philip Pearlstein, James Rosenquist, and James Turrell. Following his retirement from USF, Saff went on to found Saff Tech Arts in Oxford, Maryland, where he continued his collaborations with many of these artists.

As the narrators in this chapter reveal, Rauschenberg's move to Florida brought together a new group of collaborators, including printmaker Larry Wright and studio assistant Hisachika Takahashi, who visited Rauschenberg from New York, and craftspeople he hired locally, including carpenter Tim Pharr and his then wife, seamstress Sheryl Long. In the decade following his move, Rauschenberg bought six additional properties covering twenty acres. He was Captiva's single largest landowner, and many of his staff lived on the premises.

As curator Jack Cowart remembers it, Captiva facilitated a spontaneity that led to creative production, and Rauschenberg's place became a destination for other artists too. "Everybody wanted to go drop in on Bob in Captiva. The enterprise of art being made on the premises, and probably conceived on the premises—it wasn't like when you go into these big commercial print shops where you have already made the collage, you've already made the instructions. I got the feeling that a lot of stuff was really happening down there. If David Bradshaw or Bob Whitman wanted to do something, he had thought of it five minutes before, and then, okay, let's see if we can do that."[14]

As Sheryl Long recalls, Rauschenberg thrived on these challenges. "In certain years he'd collaborate with scientists and engineers to do art together. He was like that even at my level. Some of the pieces I worked on later were huge challenges, and he would just kind of go, 'Well, figure out a way and tell me what it is.' Bob collaborated with everybody. Even though I was not an artist, I had no art training or anything like that, and there [were] people coming through who were serious artists.' "[15]

Some of Rauschenberg's observers believed that the move from New York came at a cost to the quality of his work. As Calvin Tomkins said, "He thought of himself as a collaborator with materials and with other artists. And after he left New York, he didn't have that."[16] Despite raising this question, Tomkins concedes that the move did result in an uptick in Rauschenberg's productivity. When he settled into his Beach House and started drawing, "For the first time since 1964," Tomkins wrote, "Rauschenberg was turning out a great deal of new work."[17]

As always, the communal life lived on Captiva was itself a kind of art too: "It became a performance piece. I think the life at Captiva was really ongoing performance of many kinds."[18] It was also a site of intense creation; Rauschenberg was immensely productive on Captiva. From 1970 until his death in 2008, visiting artists, printmakers, fabricators, and local craftspeople generated a hive of activity with him on the Captiva compound. In this chapter, though, his narrators focus on the early years on Captiva and Rauschenberg's transition from collaborating with artists to collaborating with technicians.

"It [was]—the word is really 'funky,' at that time. It was unvarnished, it was, we're all here together, let's do stuff, let's have fun, let's work, let's make it. We've got something to do."[19]

THE ART WORLD IS MOVING ON

BOB MONK: [In New York Rauschenberg is] having exhibitions, they continue to happen. But they're not selling the way they were in the beginning. He's having exhibitions regularly, [but] I think he sees that the art world is moving on. And he's so social and so much involved in the Rauschenberg community that I don't think he wants to fight those fights by being in New York all the time.

I think he felt that he could continue to do his work and he could be the master of his own island by moving down to Captiva and having people around him who were there to support him. Where in New York, all of a sudden, there was [Bruce] Nauman, there was Lawrence Weiner at Castelli. This whole new group came up starting in the 1960s. By 1974, there was [Richard] Artschwager, Ed Ruscha, Nauman. All these people were making a big splash all of a sudden at Castelli. So Castelli maintains this place within the art world. Still the crème de la crème of galleries, of course, starting off with Rauschenberg and Johns and Warhol and Lichtenstein and Kelly, but now there's a whole new group of people whom even students and writers are paying attention to. So, yes, you know that work, you know the Lichtensteins, you know the Rauschenbergs. But you're suddenly starting to pay attention to other artists. It must have been really strange for Bob, in a way, that his studio assistant [Brice Marden] all of a sudden becomes this big deal.

And I think he just felt very comfortable down there. They built a studio, he had people there day and night—this group of people who worked for him. If he wanted to stay up all night with the TV on making art, they would stay up all night. All of a sudden, the mean streets of New York were not his playpen anymore. It was not like he was still going out looking on the streets for old pieces of tin and tire and cardboard. He was Rauschenberg now.

DOROTHY LICHTENSTEIN: I think Johns moved—yes. I think maybe the 1960s really got to people. And a lot of the artists really did move away during the 1970s. Andy bought a house in Montauk [New York], but he didn't really like it. He bought it with Paul Morrissey, his friend who was a film person. I guess Paul's family used to come out all the time, and that's why Andy didn't want to go there. But people had this interest in leaving and moving away from the city, maybe just to catch their breath.

We moved, actually we came out to Southampton in the summer, after we bought this house, in 1970, and we just stayed out here. We didn't make a decision. We let our place in the city go after about two years, and we lived here year-round.

ROBERT PETERSEN: An astrologer in Manhattan, Zoltan Mason, who Bob went to see to read his chart, advised him at that time that he needed to be

near water; he'd be happy near water. He was happy on Manhattan because it's surrounded by water, but he took a drive from Manhattan, and took every exit to the left, toward the water, and it went all down the south, eventually found Captiva Island and purchased that property, which was right on the beach.

BRICE MARDEN: He, very early on when he was showing in New York, had sold something. He bought a Jaguar. And he drove the entire East Coast, just scouting for places where he might want to be. And that's when I think he saw Captiva right across the Gulf [of Mexico] from Port Arthur [Texas, Bob's hometown]. So it was very nice. And I assume Port Arthur really isn't very nice. And I think that was it. I mean, he wanted it warm. He wanted to swim. And it was really great.

So he contacted realtors. I remember him getting the call. And they said, "Something's come up down here." I think he went down there the next day, or two days later. And I think he bought it right away. And at a certain point he called us all together. All the people who were working for him. Me, Dorothea, and Sachika, a lot of us, and he said, "You really don't have to be working for me anymore." And he was right. I was teaching. And he said basically he was just going to move the operation down there. And that was it. Then he gave us what I thought were very, very generous severance situations. And that was it. And he moved down there. And he just . . . it seemed to be no problem at all.

CHRISTOPHER RAUSCHENBERG: There was a resonance in being in that climate for him, and being in New York; everybody wanted to party all the time and come to his house, and it's like, you can skip the party, but it's hard to if it's at your house, and your house is also your studio. So I think it partly had to do with feeling like he wanted more studio time.

Florida made sense in terms of give me more head space to do my work, and to be less involved in New York's social scene. I mean, it wasn't [Andy] Warhol's Factory over here [at 381], but it wasn't nothing either.

It had to do with wanting to get in the studio more and be more focused on making art, because that was his favorite thing to do. It [was], like, why am I doing anything other than my favorite thing to do?

SUSAN DAVIDSON: By the 1970s there were more people and more activities. I think Bob left New York because he was sort of exhausted by it. He always said, oh, people were breaking up and this, that, and the next thing, and I think he just needed more space, and a different [kind of space]—he needed what I often say, to clear his palate. In fact, the work does do that. It goes less image-based and is very kind of minimal. Of course, that's also what was going on in the art world at the time.

But I do think that, yes, he needed to take inspirations from other parts of the world, and that's why he started traveling again. It's also why I think he started photographing again, because that coincides [with] around that time. In 1979 is when he picks up a camera again, and 1976, 1979, is when he starts really going out [into the world] from what his base is. It's interesting. He's a little bit like a forager. He goes out, and then he brings [stuff] back, and squirrels it away and interprets it and reuses it and reinvents it, and then goes out again. In a lot of ways, that's what the ROCI [Rauschenberg Overseas Cultural Interchange] project was. But before he got to that, he had been working in France. He'd been working in India. He needed more material, I would say.

JACK COWART: I don't know why Bob left New York and went to Captiva, myself. I never gave it a second thought. This was the ignorance and the blissfulness of youth. I never thought about "What's this guy doing here?" It was a very creative atmosphere.

I have had so many retrospective thoughts about why Bob was there: it was the Gulf Coast; it wasn't Texas, but it was across the coast from Texas; it would be there, and not there. The climate's the same; a little bit different, more tropical. But then I saw certain equivalencies to why Roy and Dorothy left New York to go to Southampton—old Southampton, before it got fancy. It was old money Southampton, but it was outside the scene, which can be enervating if you're in the middle of it, where it makes it seem like it's more work and production and being on call for everyone else's agenda rather than your own. I missed all the previous iterations of Bob in New York, but this paradise that was opened on the west coast of Florida seemed just natural, and free. So that was persuasive.

To come from an insurance city like Hartford, leaving Connecticut and arriving in Fort Myers was persuasive. Knowing people like Cleve Gray and Josef Albers, who had a studio near Yale [University], an orderly set, more or less. Bob was truly independent of all that; he didn't have a teaching job, he didn't have those kinds of daily operations. You could say it was overachievement, it was a bit far away; you didn't have to go that far away to get out of the city metaphors. You can go to Bucks County [Pennsylvania], you can go into the mountains, at that time you could have gone out to eastern Long Island [New York], go to wherever. But it was kind of rugged, and it was a barrier to accessibility, which I think is another good thing.

DONALD SAFF: At the point that I started being involved with him, he was first really establishing himself in Captiva and setting up the ground rules for himself. Rather than walking around the city and finding material there, he decided to work with what he could find on the island. And, of course, it started off with what's there. There was sand, and there's always something being shipped to him in a cardboard box.

So the first works were, "Okay, this is what's available to me. This is what I'll make in terms of art." I guess the *Early Egyptian* series [1973–1974] and other works that were cardboard boxes, or cardboard boxes with sand applied to it, were the products. The art was a product of "I live in Captiva and this is the material that I have to work with."

Whatever was bountiful and available to him and probably least likely to be used in the context of a work of art was what he used. All of that neglected material—and there sure is a lot of neglected sand on beaches throughout the world—and Bob was there to save it.

LARRY WRIGHT: He'd stay in the Beach House that he eventually lived in on the Gulf of Mexico side of the island. He constructed a painting wall outside, which was simply a freestanding wall that Bob could work against. Because the house was on stilts, there was no basement. That was the way he started. But, of course, it was outside, and down there being outside, everything tends to get overgrown and covered—things grow on everything. So it was necessary to make a studio that was more climate controlled. So he started buying all the neighboring houses up the block.

HISACHIKA TAKAHASHI: And then Rauschenberg had a print shop called Untitled Press. In the print shop, Rauschenberg invited artists to come in to make new prints on the Untitled Press. He invited artists there; they'd have good times and make a print. The machine had belonged to an artist neighbor, she had it in her home. Once Rauschenberg inherited it, he needed to have the machine cleaned and then reset. Rauschenberg's friend Bob Petersen, he [was] a Gemini printer, we worked together to set it up. The Untitled Press catalog had artists Cy Twombly, David Bradshaw, me, Shusaku Arakawa, [and] Sue Weil.

BRICE MARDEN: I did a group of lithographs [completed a series of lithographs with Untitled Press in 1972]. And I think at that point I made a couple of drawings, or one drawing. He had just cut a path through the jungle, so you could walk from his house to the print workshop. And I was taking this acid. And I had these little tabs; I would just kind of walk through the jungle, nibble on the thing, and go work on the prints. And it was never anything where you're really tripping or anything. It was just a great kind of acid high. That's my real memory of the pieces. And basically we were just hanging out. I think Helen [Marden; Brice's wife] was there. She was hanging out at the house. It was nice. He seemed really happy there. It was also this kind of thing where you would go there, and then you were kind of stuck there.

JACK COWART: That kind of immediacy was tonic to a structured curatorial mind that has to then do something else with it. I think you just understood, or got a sense for the indeterminacy, the spontaneity of it. He became a destination down there. Everybody wanted to go drop in on Bob in Captiva. It was very exciting, completely overwhelming in its own right. But at that time, I wasn't put off by these kinds of complexities.

It's off the mainland, and it's not central Florida. It's beautiful, and it's a compound. I think that this community of like-minded individuals—albeit you have to be on [the] Bob clock; but if you're down there, you're already inclined to having it be that way—it became an art performance, never losing sight of the art part. Dealers would drop in on occasion, I assume, and we'd go down there to try to do a deal. But it wasn't set up as some kind of show-and-tell factory. Because there were various houses where you had to walk—and they're far

more gussied up now than they ever were then—even going out from Bob's house to the road, you were thinking, I'm going to be attacked by wild animals, or something scary or spooky at night, and I don't want to go there. I want to stay on the main road and come in the other entrance. It seemed slightly off the grid, and it was.

It's hard to maintain that in the twenty-first century, especially with all the rest of the studio development in the building, and the price of real estate and the fancy people, and the big villas, and all these things that are going on, and the occasional hurricane that comes in and tops everything, and you start all over. Then, it seemed a world near, but very far away, that was creative.

DONALD SAFF: I'd go down to Captiva. And you never knew how to bring up a project with [Bob]. You always had an idea for a new project, but he had this way of putting you off. You didn't sit down and have a conversation, so you didn't know how to bring up: "Would you like to do a new project? I have this idea." Somehow, he deflected frontal approaches. And so we would sit till about, at that time, maybe two in the morning, and he'd then say, "Let's go over to the studio," at two in the morning to start work and work for a few hours. You'd keep him company. Then he'd come back and he'd sleep, and he'd sleep till midday. Of course, I'm up at six in the morning, no matter what time I went to bed. And you're waiting for him to wake up. Finally, you ask him whether he would like to do a project, and you wouldn't always get a direct response. Everything was sort of choreographed by him. It's like from the days of Merce [Cunningham] and traveling around Europe. Everything was choreography. He danced around everything.

As I thought back over the years, that was really consistent with the way in which he approached his art. You couldn't get him to say that he favored one painting or another or that that was a tour de force as opposed to a lesser work. There was no hierarchy of material. Dirt was as important as gold, and so it was hard to get responses from him. Anyhow, that was the beginning of working with him.

Anybody who would come and visit, they would be there for the work as well. They'd have dinner. He'd make this wonderful dinner, and then he'd go over to the shop, and oftentimes they would come and watch him work. He certainly had an open situation in the studio. He was the consummate collaborator.

He said, "With two people, you always have at least three ideas." What I took that to mean is that you have an idea, I have an idea, and the combination is more than the two. He had no problem with people being around when he worked. It was hard for me to conceive of initially. It was a completely open situation. He wasn't hiding anything technically. Obviously, he didn't want banter necessarily going on when he was thinking about something, but you got the message about when to be quiet and do something else or just watch. But it was a totally open and fluid situation. In that sense, it was very hospitable. You went there, and you left there—if you weren't engaged, as I was, having to get something done and get a project—you left there always better than when you arrived. You knew more. You experienced more. It was always positive artistically.

The studio was huge, big, white, giant, sterile inside. He produced the "decorations." Studio architecture or interior wasn't going to produce any decorations for him. I remember him coming to my house in Maryland, and I had a chandelier—an art nouveau chandelier—that I purchased in Paris. He was staying at [my house]—my house is white, too, inside—and he was standing there saying, "God, what's that ugly thing doing there?" He's in my house. "What's that ugly" I said, "What are you talking about?" "That chandelier." I said, "What's the problem with the chandelier?" He says, "It's terrible." Okay. "Why is it terrible, Bob?" And he said, "It interferes with conversation. It takes away from conversation. It distracts." Apparently distracted from him. And he had a problem—he had an ego problem with the chandelier. Rather than him illuminating all things.

Really. The guy was so remarkable. And while these things might be painful for the moment, they were all revelatory in terms of what he was about, what triggered him positively, negatively, whatever. And if you could ride over these things, it could be a positive learning experience. Sometimes it hurt though.

LARRY WRIGHT: It was an all-embracing, very supportive, very egalitarian experience. In other words, we all cooked and we all cleaned—it's your night to cook Larry, and it's your night to cook, Bob. Then we'd have to get into one of the cars to go into Fort Meyers to buy groceries.

He had two cars. He had the Volkswagen Beetle convertible, and he had the International Harvester, which is like a Suburban. But they were called

This and That, and it was always a great routine to go out in the driveway, "What are we going to take, Larry? This or That?" We'd say, "Well, I think we should take This." So, it was sort of like a sitcom. A lot of comedy routines were going on.

The whole place was very sparsely furnished. Bob didn't have furniture really; he didn't have any chairs. In the main house, everything was white—the walls, the floors, the ceiling. There were a couple of pillows, but really you stood around. There was a Formica island peninsula from the kitchen that we all used to stand around, and that's where the days got planned. We usually didn't start working until the heat of the day had passed. Maybe ten at night or later, we'd all get in This or That and drive up the Jungle Road to the print house. Each of the houses seemed to have little functions of their own; there was studio house, and there was curating. The print house was an old ranch house that had the presses in it. All of the other rooms were filled with fabric samples and bits of broken metal and wood and stuff.

BOB WAS AS GOOD AT CHOOSING PEOPLE AS HE WAS AT CHOOSING MATERIAL

LARRY WRIGHT: The atmosphere was very upbeat. Faith Popcorn [née Plotkin] just wrote an article in the *Huffington Post*, prompted by the demise of the *Mad Men* TV show [2007–2015], she was talking about being in that industry as a young woman and how alcohol really kind of greased the whole creative process. And it's one of the things that's missing in modern political correctness, the fact that they'd go out and they have these multimartini lunches, or they'd go out after work and they'd be drinking beer. That's sort of what it was like in Captiva. The worktable—the taboret that we had for working in the studio, on wheels, a little tray—it had the brushes and acrylic paints and some adhesives and tape and rulers and all that one might expect, but it also had a big bucket of ice and Bob's bottle of Jack Daniel's and my bottle of vodka. We would drink, but nobody ever seemed to be really drunk. But now that I think about it, it was definitely part of the way that Bob felt like he could become uninhibited. And you know, without that, sometimes he'd get very stiff, maybe very fearful on certain occasions. It was a very social scene, and we really enjoyed being at

this kind of party with one another. All the best parties have kids and dogs, and that's what it was like. The neighbors would come.

Everybody got along very well. We really were a close family, and you kind of had to like one another. If you didn't like somebody, it would have been detrimental to the process. And Bob was as good at choosing the people as he was at choosing the material, and I think he understood the chemistry that has to exist.

It was like a motorcycle gang. Everything came from one thing: your social life, your work life, your transportation, your love life. Everything was all the group, and occasionally you would have to bring somebody in. It was all part of that group, but it was a very closed, insulated group. It was a family, and it had the dynamics that a family would have. It was a very loving and supportive family. It could be a little neurotic at times. I think the takeaway from it is that everybody really loved one another, and it was this unconditional love that I think made everything possible. There was never a point at which you held back. Everybody was willing to go over a 100 percent toward the group effort.

BOB MONK: [The first time I went to Captiva,] well, I thought it was delightful. I remember that he started buying up his neighbors' houses. But he was so kind, the whole idea was—say two ladies or a lady and a gentleman were eighty and they were going to live to be a hundred. His whole thing was, "Oh, no, no, no! You're my neighbor. You stay there as long as you want." When they would pass on, he would take over that land and use those houses. But it was so much like the house in New York—like horizontal living versus the house in New York, which was six stories of vertical living. I always thought it was enchanting.

ONLY HE KNEW WHEN THEY WERE DONE

TIM PHARR: I think I probably first met Bob during the first year that I was here. The company where I was working was a maintenance company, property maintenance, and we did all sorts of plumbing and electrical repair work, painting repair work, carpentry, all kinds of stuff. Yard maintenance. We had a maid service. It was a complete property maintenance business, and I have an

idea that I probably met him initially making some sort of a service call to his house, the house on the Gulf [of Mexico]. Ultimately, [when] I was working on my own, he called me, or [Robert] "Bob" Petersen, who lived there at that time, called me. They wanted to put new windows in the house. I was working there putting [the] windows in, and he got a call from the Fort Worth Art Museum [now the Modern Art Museum of Fort Worth, Texas]. They were having a show of Texas artists, so they ask[ed] if he would do a piece for the show.

If I remember correctly, he woke up either the next morning or very shortly after that, and he had the name of a painting in his head. It was *Rodeo Palace* [(Spread), 1976]. What he envisioned with this painting, as he described it to me, was a series of panels that were fairly tall, three or four feet wide, and that they would come apart, but you could assemble them together and make a painting, a big painting. I think the initial one was probably something like twelve or sixteen feet long, and maybe ten feet tall. Also, there would be these doors that you could open and close—he described to me what he had in mind, and he asked if I could build the structural frames for these paintings. You wouldn't see them. They'd be behind the paintings so that they could be taken apart and transported and then bolted together. So he sketched me the layout that he wanted for this: how many panels he wanted, and where he wanted doors in them. He had some old doors either under the house or under the studio or someplace, and he showed me which of the doors he wanted to use. Then he asked me if I'd build the framework, put all this stuff on.

That was the beginning of my four- or five-year involvement with what he was doing. He began a series with that painting. The series [was] called *Spreads* [1975–1983] *and Scales* [1977–1981]. Apparently, in the process of building this painting, he had determined that he wanted to continue in that line. I guess we came to some sort of agreement as to what our relationship would be, and, essentially, I was always self-employed when I worked for him. I wasn't on the payroll. I wasn't on staff. I billed him regularly for my work. It was just an hourly rate. There were no estimates, nothing of that sort, just working whenever I needed to, in order to get the projects done that had to get done.

SHERYL LONG: Bob Petersen knew that my husband was a carpenter, and he actually engaged him to do some work, some kind of repairs at their house. I guess in talking to Tim Pharr, my husband, he found out that I could sew.

And so one day I'm at home and I answer a knock on the door, and it's Bob Petersen, who I knew, but only vaguely. He came over and just chatted, and I actually was working on a quilt. I had a quilt frame set up and he goes, "Oh, that's right, you sew." The *Hoarfrost* [1974–1976] series was in process by the time this happened. The way it seemed it was just, whoever was currently visiting on Captiva and could sew was making the eyelet buttonholes, which were handmade silk buttonholes that the pieces hung from.

And the last person who did it was leaving, or had left, or something like that. So I got recruited to make these buttonholes.

TIM PHARR: His printer at that time was Peter Wirth. Periodically Peter would come over to the studio, and he would roll out paper on the floor or something. He'd lay a whole bunch of these door skins out, and he'd get a roller, and he would put gesso on them. He'd put a coat on the back, and flip them all over, and then two or three coats on the front, to prep them for the image transfer, which he was doing at that time over in the print shop set up in the garage of the old house.

They did image transfer at that time primarily from magazine photographs. Frequently in the afternoons—Bob's mornings but other people's afternoons—I would see him standing at the counter in his kitchen. He would be ripping pages out of magazines. He'd just be flipping through them and ripping pages out, and Bob Petersen would collect them, and put them in folders, and they would end up over in the print shop. As he was working, he'd be looking through images to find what he wanted to put on his canvas, so to speak. Those gessoed panels were the canvas that he worked on.

LARRY WRIGHT: Bob got all kinds of catalogs and printed material from everywhere: seed catalogs, Sears Roebuck, magazines. When I was first there, Bob was doing solvent transfer prints, and this was something that I had always admired and loved about him. Early on in his career, Bob had illustrated Dante's [degli Alighieri's] *Inferno* [1314] using Ronsonol lighter fluid as a solvent [*Thirty-Four Illustrations for Dante's Inferno*, 1958–1960]. So Bob got this reputation of being a very current and political artist, but he was actually driven by the time constraints of what his materials were. So he was not in his own right necessarily political, but the time when he was illustrating Dante's *Inferno* was

during the race riots and all of the troubles that we had in that long, hot summer of American history. Bob was using images of black demonstrators being attacked by police dogs and of all of these police beatings, just horrible stuff, to illustrate Dante's *Inferno*. [The later drawings for Dante's 700th birthday, 1965, commissioned by *Life* magazine, were made with silk screens and contain the imagery described here.] And it really set people off. I mean, it was stunning, startling, and amazing and beautiful. Bob was really thinking of them as, like, color, or gray, but it was actually something else. The biggest photographs in the newspapers were always on the front page, and it was always the worst shit that was on the front page that was news.

TIM PHARR: He did the image transfer. Using matte medium, he glued down a lot of fabrics for color. If I remember the process correctly, he would most often put the fabrics on first, with matte medium, to get the colors, and then do the image transfer on top of that after it dried. He and Peter worked nights, primarily. Depending on a lot of different things, they would start to work about dark or anytime between there and midnight, and then work until three, four, five, six o'clock in the morning. They did that image transfer, and then at the same time as they were doing that part of it, and prepping those panels, doing all the artwork on the panels, I was building the frames that they were going to be mounted on.

My shop was underneath the old studio. That's where I built everything. Then I took the frames upstairs, and when they were complete with them, they would bring them over, and I would glue them down to the frames, and then they'd be assembled and put on the wall. Sometimes they would hang on the wall for quite a while because Bob would come and look at them in the afternoons. He would come over and look at them hanging on the walls because they weren't really done. As far as I was concerned, only he knew when they were done and when they weren't done. Sometimes one would go from there over to the house, where it [hung] on the wall at the end of the living room, and he spent a lot of time looking at them. Eventually he would do something—or not—and say, "It's done."

LARRY WRIGHT: Bob used to like to just take a pile of stuff, and he'd put it out on the table and he'd start pawing through it, and he'd look at the fabric colors

and he'd sort of make decisions very spontaneously. It was very like painting in that sense. There wasn't a lot of time spent planning. There was a sort of an inertia that he got going and everything would just flow from that.

Half A Grandstand [Spread, 1978] is aptly named because it is very big. It's six door skins, horizontally arranged—three on the top, three along the bottom on their sides—so it's about twenty-one feet long, by about six or seven feet high. *Half A Grandstand* was the product of quite a night. There was a lot of drinking going on as we were working, but it was just part of the background, part of the wallpaper. There were occasionally nights that stood out, in which case we'd meet up at the Beach House in the morning and Bob would say something like, "It was very drunk out last night." This was one of those nights. *Half A Grandstand* was truly a party. We were printing and we were painting and we were gluing and we were making stuff, and Bob was just—he took everything off of my worktable. He put my ruler in it, he took my towel, my rag. I would work with something, and he'd just take it, and boom, it was in the artwork. It was kind of a snapshot of the free-for-all that the work environment was, or at best, could be.

TO WATCH HIM WORK WAS TRULY ELECTRIFYING

LARRY WRIGHT: He was just brilliant, and when the spirit was upon him, as they say, there was just no stopping him. It was contagious, and everybody—myself and anybody else in the room—would get caught up in it. The *Half A Grandstand* piece, it does have lots of stuff in it that wasn't intended. There was very little planning. We knew we were going to make something real big and real horizontal. But it really sort of just birthed in front of us.

Bob was really fast. It was amazing to watch him work. He had this intrinsic talent that was so much a part of him. You'd be speaking with him and he'd be telling you something, and he'd put three or four things on the table and you'd look at him and just say, "Shit, that's beautiful. The arrangement of what you just did with the saltshaker and that cup. And look at the napkin." I mean, he just would do things—he would elevate any three-dimensional situation into art. To watch him work was truly electrifying because he made connections between things, among things, that all just seemed perfect. You put two things

next to one another that are unrelated, but Bob would see the connectivity. It's like some savant pool player who, you see the pool table and the cues, he sees the dotted lines that go to the corner pockets. Bob was like that. He would see something the rest of us didn't see.

You'd be walking down the street with him and you're all looking at the same stuff, but Bob would see something. He'd just sort of go over and take a picture of some little detail—a standpipe in front of a building—and it was beautiful, or suddenly it became like an animal or suddenly it became a person's figure of some kind. The thing about photography with him was that you were a little bit able to know what it was like to be inside of his head. You know, you'd see the results of it, but especially with the photographs, the things that interested him—the sort of imperfection and stuff that he was attracted to, which really make things interesting—would call to him in a way that other people couldn't hear.

So [for] the *Half A Grandstand*, we've got our dishtowel; we've got my two napkins because we ate something. He's got an image—an anatomical image—in our beer flats, we had anatomical images of body parts and stuff. So he has a kind of medical drawing of a leg, and then he has all of these—from the plants and fruits box he has grapes. Actually, the leg is supposed to be Italy, and they're stomping on grapes, which is wine. So that all relates. That's a whole little highlighted panel that sits very bright in the middle of a yellow rectangle on the far left side of *Half A Grandstand*, and it's a little ode to the muse, to the grape. This is a little parable. A little story.

TIM PHARR: Most of my waking hours ended up being spent here, either because there were things going on or because I was working. A lot of people visited. Occasionally people came in from the East Coast, and some of the staff from New York would come down here, and we always enjoyed each other's company, spent a lot of time together. The constant ebb and flow of people in and out, from people who were staff from other locations, to people who were associated with the galleries or the museums who would come and stay for a while, or visit for a while. All of that was always very intriguing and, in a way, very energizing. There was, at some level, an expectation that the people who worked here were sociable. We enjoyed it. We met a lot of people, people we never would have met before. There was always a curiosity about people who

were coming, and you wanted to be here to meet and see these people. I remember the first time Sid Felsen ever came here. To me it was almost like a movie star showed up. He got out of the cab. He was wearing all white and had on a hat, and he just looked like California. [Peter and Bob] always talked about Sid like he was a mythical figure because of his print shop [Gemini G.E.L.] and all that he had been involved in. So, you know, when you hear Sid Felsen's coming, you want to be there. You want to see him, you want to see what Sid has to say.

I remember when Cy Twombly came here one time. We loved Cy Twombly. He was just this great guy. He had such an incredible ability to make an understatement. He was just phenomenal. His swimming was a good example, the best example of his understatement. His swimming was to wade out in the water about waist deep and then pitch water up on himself. That was going swimming. He was that way about everything. He just had a way to condense an event or a happening or something into a sentence that just absolutely nailed it, in such few words. He was just tremendous. But his work—you look at the things he has done, and it's like a little scribble here and a little scribble here and a little blotch of something here. And it's the kind of stuff that everybody looks at and goes, well, my kid could do that. Even the titles of his paintings—they had such incredible literary references, many times. It certainly gave me a different way of looking at that sort of stuff and seeing some value and some meaning in it, other than scribbles on paper.

Watching Bob Petersen paint—he was famous for taking a straightedge and drawing a line down the edge of a canvas and looking at it and saying, "I'll have to get back to that tomorrow." Or those sorts of things. It's such an expression of people, and it's such an expression of their creativity, and it's so individual, that I think it's easy for most of us to really overlook the value of that kind of work.

BOB NEVER WANTED PEOPLE TO LEAVE

TIM PHARR: There was a very social aspect of things, as well, that extended beyond the work, frequently having meals here. The most difficult thing in the course of most days, if it was more of a social situation, was leaving. Even when you wanted to leave, Bob didn't want you to leave. It was always difficult

because you'd want to sneak out. You'd see people sneaking out the back door to avoid the scene that would happen, because he just didn't want people to leave. He wanted you to stay and have a good time and enjoy it. That became sort of a contrivance. You had to contrive ways to get out of the house at times.

SHERYL LONG: Particularly if I was working the next day, I wouldn't stay as late. But Bob never wanted people to leave. If he knew you wanted to leave, he would get you in a conversation and just not stop, because he did not want you to leave. He loved having people around him. I don't know, somehow that fueled him. So he would—if he could sense you were ready to go—I don't know if he was afraid of going to sleep, or who knows what it was. But he did not like being alone. He'd bring up something that was about something you were working on, where you couldn't leave.

TIM PHARR: I didn't get away from here that often, a couple times a year maybe, to install shows in Los Angeles or New York. But having the people coming here gave you a much better idea of what the big picture was like, what the whole scene was like. Because these people, they're coming in and talking about all the stuff that is going on here, and what's going on there, and all of that was very energizing to be involved in.

SHERYL LONG: At that time, I don't think anybody was on staff. At that time, Bob would pay by the project. Bob's day wouldn't start until noon or one or two, or whatever. So that would maybe push back a start time. It was never definite. Sometimes you'd go there and everybody would help cook dinner. Or sometimes you'd go there, and you'd go to the studio maybe at nine o'clock and work until two, and then dinner would get cooked. Because Bob never started to work then; I mean, if you were there most times by, I would say, midnight, maybe not quite that late. But I can't remember. There may have been times that somebody would call and say, "Where are you?" It was just like you were expected to be there, and you knew that.

Usually, when a project was finished, there'd be a party, and he would give everybody their check. And you would always think, "Oh, wow, this is so much money," it's like, "I'm so lucky to have this job." But the truth of the matter was, there weren't any benefits. And if you really calculated your hours, like you

were there, say, sometimes six or eight hours before any work began. Granted, you weren't working, but it was part of your life that was tied up. So your hourly figure wasn't very big if you really calculated it. Over time, some of the people realized that they really needed—if they were going to commit to their job with Bob, that he really needed to have, like, salaried people. I don't know if they were hourly or salary or not. But I never questioned what I got from him; it always seemed very generous. But in hindsight, when you'd sit down and kind of think about that, it wasn't quite as generous. But again, it was such a wonderful experience, and I certainly had other jobs. This wasn't a full-time thing for me.

Somewhere between when my daughter was born [in] 1980 and 1986, we sort of parted ways. His life controlled the life of everybody who worked for him. You almost had a sense of you don't have your own life. It's, like, you couldn't go on vacation unless he was gone somewhere, or, you were expected to be there from this point, not knowing if you were even going to work that night.

I know, for a lot of people, if you sort of split from Bob, that was usually a rift that wasn't breachable, or it couldn't be healed. I think Bob felt betrayed when somebody left—and I don't think he thought of it as he was controlling their lives. I think he felt like it was always like a give-and-take scenario, and it was. But the bottom line was, if you wanted to work with him, his life was so—like any great person—it was so complicated, and schedules and personality and ego and everything were all tied up in that.

DONALD SAFF: He was incredibly cruel to the people who worked for him, and incredibly generous. And they all stayed there and hung in with him. It was really quite schizophrenic to be around him. I remember somebody saying to him—he was about to have a performance. This person said, "Break a leg." He went nuts. "Break a leg? I don't ever want to hear that. I don't ever want to hear that. How dare you say that stupid thing to me?" Okay, it's out of a context. People say it. If you don't like it, then there's another way of letting somebody know that. You feel, like, this big because all you're doing is saying something that is traditionally said that he has—and maybe rightly so—he has a different insight into that. He has a different take. He doesn't follow those traditions. He made his own tradition. And you don't say to this guy who's in a different context,

"Go break a leg." But instead of conveying that to you, he'll mop the floor with you first. And so the person feels humbled, to say the least.

There were many such instances as that, many such instances. Then, within an hour, he's giving you a kiss and has his arm around you. And you say, "This guy's really not so bad." And everybody stayed with him. Nobody left, basically, because he was Bob Rauschenberg, and so you went for the ride. A lot of the people that worked for him really had no career other than Bob Rauschenberg. His friends were the people who worked for him. They were the people he wanted to be around. The people he could control were the people he wanted to be around. He wasn't, other than these parties, a big socializer in that sense.

He was just very vulnerable. And for the most part, I think, he was up. For the most part, he didn't have angst. There wasn't a lot [of] down about him. For the most part, he might be mean, but he was up and had a positive spin on things. But he suffered through situations—like Cy [Twombly] was supposed to show up for Thanksgiving and Bob cooked the meal and Cy never showed up. And it just killed him. It just killed him. Occasionally he'd talk to me about it. "I cooked this meal and he didn't show up. He never had the courtesy to call." He just didn't understand why these guys couldn't deal with him anymore. They just couldn't deal with him. It was just overbearing. It's overbearing.

Enough is enough. Same with Jasper—enough is enough. And Jasper is a mean son of a bitch. And I saw Bob go over to Jasper at the Meyerhoffs [Robert E. and Jane B. Meyerhoff]. I was with Bob, and we walked over to Jasper together. Bob tried to be as nice and as gracious as you could be, and Jasper just summarily dismissed him with really rude words and turning away and just walking away from him. There's certain things he could never mend. He'd try to. It's not that he didn't try to. He kept inviting Cy back. He kept trying to engage Jasper. But these guys had just had it. They weren't playing anymore.

He'd wear you down. He'd just wear you down. Enough was enough. If you didn't need him, then you'd probably want to insulate yourself and walk away because he was an umbrella that shaded everybody else from their entitled sunshine. The spotlight couldn't get through to you while Bob Rauschenberg was around, that's for sure. So at some point, you'd just walk away from it. I guess that's what these people did. And there are other professionals and people who didn't necessarily want to be with him. They didn't get the laughter that you were obliged to go along with. He had this manner of hysterical

laughter that seemed somewhat phony, and when you were there you laughed along with him. You were sort of obliged to. That didn't go too well with Roy [Lichtenstein]. He didn't want to be in that situation. So if Roy had to go over there for dinner because they were in Captiva—Dorothy [Lichtenstein] loved him—Roy, he didn't want to go there and talk about Bob.

There were some people around, some younger people—Al Taylor, and some young budding artists. They were people who were not a threat. They were artists who were coming up, but were not a threat. I don't know of his liaison with other artists. Other than talking positively about Merce, John, and Trisha, because he spent time with them and produced great collaborative works. But it wasn't an ongoing relationship. He just didn't have that. There wasn't any room for that.

[CAPTIVA] IT WASN'T A COLLABORATION

CALVIN TOMKINS: He had his boyfriends who would come with him, and they were artists. But it wasn't a collaboration in that sense anymore. I don't think he ever had another. The whole idea of collaboration is so important to Bob, and what he had with Merce and John was so fulfilling that you can wonder a little bit if something went out of his own work when that kind of shared energy was no longer available to him.

SHERYL LONG: Bob collaborated with everybody. He would want you to do something, and if it couldn't happen, you would explain why to him. If he could see a compromise way to do it, maybe you'd end up doing that, or he'd go, "Okay, we're going to do this." And he would just kind of go, "Well, figure out a way and tell me what it is."

TIM PHARR: I remember that [Robert S. F.] Bob Hughes wrote an article, I think, for *Time* magazine or *Newsweek* magazine, and he referred to those of us who were around Bob in some sort of disparaging way. I can't remember exactly the word he used, and maybe I misunderstood the word, [and] there were those people who just wanted to be there because they liked being involved, close to someone like him. But I think most of the people I knew who

were working around Bob were artists in their own rights, and most of them were making a contribution of some significant sort. Most of them were not there simply as suck-ups. I think that's what I thought the word he used meant. I don't know if I have that article still, but at any rate, I didn't get the impression that most of the people were that way. There were some people who would try to drop in at his house when he was up there in New York, probably more so than there were down here. I remember him avoiding some people who would want to come see him because he knew that's all they were there for. But most of the people who were down here were not here for that reason. This was where the work happened.

CALVIN TOMKINS: [Moving to Captiva] really changed him. There is a major change in the work he did after moving there. He used to complain about it. He used to say, "Not much washes up on the beach here."

In New York you could always walk around the block and find something discarded— an automobile tire or something—[that] you could lug back and put in a painting. For Bob, the whole idea of collaboration was just central. He spoke of himself as collaborating with materials. He didn't want to use materials to—how did he put it? He didn't want to make materials—the materials he was working with—do something that he wanted. He wanted to collaborate with the materials so they could realize their own qualities.

WE WERE ALL THERE BECAUSE OF BOB RAUSCHENBERG

TIM PHARR: Knowing [Bob], once he completed [a] body of work, I'm sure that he was always anxious about how it was going to be received. I don't think that he could possibly have avoided that. I don't think he had that kind of arrogance, that—"I don't care what people think. This is my work. They can like it or not. Who cares?" I think he cared a lot about how his work was received. I never really talked to him about that. The only conversation I ever had with him that gave me any insight into that sort of thing was when I told him I was leaving. We had a conversation then that gave me as much insight into him as anything I'd ever experienced prior to that. Especially after that conversation, I feel certain that he always had a certain amount of anxiety—I may be wrong.

He never told me that he did, but from what I know of him and what little bit of insight I really had into him, I feel fairly certain that everything he did had great import, as far as he was concerned. If you think about people who are in the position that he was in, he didn't get there by not taking chances, and he didn't get there by happenstance. He got there by working hard and, I think, by putting himself in situations where he could fail, and fail big time. I think that every time he produced a body of work like that, he was in that position. This might be the ones that nobody likes, or these might be the ones that they go, "What in the world was he thinking?" I'm sure he had a certain amount of anxiety. He drank a lot, and especially on those opening nights at the galleries, he drank a lot. I think a lot of that had to do with that anxiety. I don't know. I suppose he was an alcoholic. Maybe he would drink a lot anyway. I don't know. But I don't think that he took any of his work lightly. I don't think he was frivolous about any of it. He had fun doing it, but he wasn't frivolous. Very serious.

Even at the pinnacle of his success. Even at that time, he still, I think, had a level of insecurity about what he was doing, and a level of uncertainty about his success. He needed to be reassured.

He was such a figure. To me, with the status that he had, he could have taped shells to a canvas and called it art, and people would go, "Whoa, that's great. That's incredible." He wasn't 100 percent secure in what he was doing, [or] that his work was beyond reproof. He couldn't produce something bad because he was Rauschenberg. That's the way people were. When I went to the openings, I didn't hear anybody going, "Well, that's an ugly piece of junk. What in the world was he thinking when he did that?" They didn't say that. Everybody was just, "Oh, it's awesome, it's just incredible." And it was. It was like, in Hollywood, when they have the premiere nights for movies. That's sort of the way these openings were. He was the star of the show, and people couldn't get close enough to him. People couldn't spend enough time with him. You'd see people dragging somebody over to meet him because he was the man. He was the one.

[There were] a lot of people from a lot of different backgrounds who happened to be in a place at a time, by no design of any one of them. It may have been a design by virtue of some unspecified cosmic intent. That sort of thing is left to more intellectual people than me. I guess there was a compatibility, which I think had to do with the fact that all of us knew that we were there by our own rights, or by virtue of our own—I want to say importance, but

importance is such a relative term. We were all there because of Bob Rauschenberg. We weren't there because we were all art students. We weren't there because we were all art dealers or art collectors or anything of that sort. We were all there because of Rauschenberg. We weren't there because we were all carpenters. The reason we were all there was because of Rauschenberg and because of where we fit into that whole conglomeration of people and things and events that made that time.

Obviously, we were all special in our own way, but there was nothing about any of us that made one of us more important than the other in that circumstance, and I think we all recognized that. There may have been the occasional person who had some delusions of grandeur or illusion about how important they were versus someone else, but for the most part, I didn't hear anything about it. Didn't see anything about it. Didn't see people role-playing in any way that indicated that. I think that was almost because of our recognition that none of us would have any importance in that situation if Rauschenberg weren't at the center of it. If you took him away from it, then what would be left?

Now I look at this situation, here now, where he is not, but he has left a legacy, and his legacy is at the center. So it's still at the core of it. It's still at the core of a lot of things that are happening in a lot of people's lives [here]. All of that is still centered, in many ways, around him and his work. I don't think it was a whole lot different then.

Coming to know the art world, or at least some aspects of the art world, to the extent that I was exposed to it, I saw it differently because of that. I saw it differently because of getting to know him and his personality, and you can see that in his work. He was a very big personality. He could be just the most fun person in the world. He could be a pain too, but he could be a lot of fun. He liked to have fun. He liked to laugh. He loved people. Loved to interact with people a lot. You can see that in his work.

Rauschenberg and Asha Sarabhai working on *Unions* series (1975), Sarabhai Retreat, Ahmedabad, India, 1975. Photograph © 1975 Sidney B. Felsen

Photograph Collection: Robert Rauschenberg Foundation Archives, New York.

CHAPTER 5

Travelogue

J UST AS Rauschenberg's move to Captiva had provided him with new materials with which to make art, his travels continued to provide the supplies and the inspiration for more work. Rauschenberg had long embraced the wider world in his work—"its objects and subjects, its motion and flux, other actors and disciplines—to connect the experience of art to the experience of life."[1] Beginning in the 1970s, his work increasingly referenced the place where it was made or was inspired by his travels.[2]

Rauschenberg visited Venice in May of 1972, traveling without any scheduled meetings, press interviews, or preparations required for an upcoming show, which was unusual for him. He explored the city in a purely sensual pursuit, and when he arrived home in Captiva, he worked with "slumping umbrellas, twisted tires, tattered lace curtains, stagnant water, old bathtubs, and cast off architectural fragments, and with upright logs and cords recalling mooring posts" to translate this still vivid impression "of elegance, of grandeur, of fragility and decay, this feeling of the city digging itself slowly into the waters, without us being able to do anything to help it."[3]

Texas gallery owner Fredericka Hunter recalled seeing Rauschenberg's *Venetians* at the Art Museum of South Texas, Corpus Christi. She described the time as "a strange moment in the early '70s in Texas, where culture started to take these bigger leaps,"[4] making more room for contemporary art to be seen in the city. Curator Anne Livet and Rauschenberg's assistant Mayo Thompson also shared their recollections of Texas's burgeoning art world, a world to which Rauschenberg returned to show and to make new work. Collectively their memories illustrate the ties that Rauschenberg

maintained to his home state, a connection he was given artistic license to communicate through work Livet commissioned while a curator at Fort Worth Art Museum.

Livet recalled how Rauschenberg conveyed a deep sense of place in his pieces *Rodeo Palace* (Spread, 1976), and *Whistle Stop* (Spread, 1977). *Rodeo Palace* was commissioned by the Fort Worth Art Museum for an exhibition titled *The Great American Rodeo*, held in celebration of the American bicentennial. The piece was meant to portray "the glamour and grit of a rodeo performer's life" and was viewed as a celebration of Rauschenberg's roots, with direct references to his own experiences of Texas.[5]

In *Whistle Stop*, Rauschenberg worked with five panels, totaling fifteen feet wide, and hung a pair of screen doors at the piece's center, which opened to imagery of marshlands, wild birds, and the everyday lives of people living in the Southwest.[6]

Together with his increasing tendency to establish sense of place in his work, the 1970s also saw Rauschenberg begin his international art-making travels, in which he sought out collaborations with local artisans and materials to work away from home. In 1973, he traveled to Ambert, France, for a project with Gemini G.E.L. at Moulin à Papier Richard de Bas, a manufacturer of high-quality handmade paper.[7]

An introduction by U.S. Senator Jacob Javits to Israeli Foreign Minister Abba Eban the previous year led to Rauschenberg's next foreign work trip in 1974.[8] The Israel Museum invited Rauschenberg to be a guest artist, and he spent three weeks in Jerusalem. The museum's curator, Yona Fischer, guided him around the Old City, the shores of the Dead Sea, and the city of Jericho. Complaining to the city's mayor that its streets were so clean he could find no supplies, the desert itself provided Rauschenberg's inspiration for his *Made in Israel* series.[9] Rauschenberg gathered sand from each of the region's deserts and found materials including cardboard, wheelbarrows, poles, and buckets. He incorporated local newspapers into his works using a solvent transfer technique,[10] and then he set to work with assistants Robert Petersen, Hisachika Takahashi, Christine Kozlov, and Mayo Thompson to make six scriptural constructions that he called the *Made in Israel* series and five drawings (mixed media on paper) that he called *Scriptures* in tribute to the Dead Sea Scrolls and the nation's religious heritage.[11]

The audience at the exhibition's opening was not lacking critics. Many people had come expecting a show of pop art or neo-Dada and were instead confronted with an installation of work made from "what they felt were ugly cast-offs from their own landscape."[12] In response to this view, Rauschenberg stated, "One of the reasons I use such general materials is that there's no speciality there. Anyone has seen a cardboard box; anyone has seen sand. . . . I see more humanity in that water tank than I did in the silver in the next room, and I don't see less beauty. . . . My whole direction has been to confront people with something that might remind them of their own lives, in some way that they might look at it differently."[13]

The same philosophy guided Rauschenberg's work in India the following year, when he was invited to work at a paper mill in Ahmedabad, Gujarat. The city had once been a center for handloom weaving, and Mahatma Gandhi had founded the mill to provide the city's untouchable caste with focused training in papermaking and other crafts.[14] The invitation to Rauschenberg was extended by the Sarabhai family, the mill's current owners, who were friends of John Cage, and whom Rauschenberg had met on the Merce Cunningham Dance Company's 1964 world tour. As had been the case in France, the plan was to make art in a traditional way.[15]

Rauschenberg set to work on two series. The first, called *Bones*, he devised while observing the mill workers making white paper pulp combined with Egyptian cotton rags.[16] The second project, *Unions*, was a series of sculptural objects made out of the mud that was used to build simple houses in the region. The material was in itself interesting to Rauschenberg, and he felt that "using it this way would pay homage to the ordinary people of India."[17] These series represented the mill's first collaborative pursuit, but once again Rauschenberg was at the forefront of a new kind of artistic partnership; invitations were later extended to more American artists, including James Rosenquist, Keith Sonnier, and Frank Stella.[18]

The trip to India made a big impact on Rauschenberg. He said, "For the first time, I wasn't embarrassed by the look of beauty, or elegance. Because when you see someone who has only one rag as their property but it happens to be beautiful and pink and silk, beauty doesn't have to be separated."[19] The experience also freed him from his self-imposed restraint in the use of fabric. In the fall of the following year, back in Captiva, Rauschenberg set to work on *Jammers*, a series of primarily fabric wall hangings.

The working projects described in this chapter represent Rauschenberg's ravenous appetite for more material, an appetite that fed his desire to make art throughout the world. But as Asha Sarabhai recalls, no matter where in the world Rauschenberg went, "it felt as though he carried his way of doing things. . . . It was allowing things in."[20]

A TEXAS SENSIBILITY

FREDERICKA HUNTER: All in a matter of a couple years, the Museum of Fine Arts added a new wing [1974], the Contemporary Arts Museum [Houston] built a new building [1972], and in Corpus Christi Philip [C.] Johnson built the Art Museum of South Texas. The opening shows at the Art Museum of South Texas were curated by David Whitney. The opening show was in 1972 and the second one in 1974. [Rauschenberg's work was included in *Eight Artists*, 1974.]

Bob was in that phase where he was wearing buckskin and he sort of looked like Buffalo Bob; kind of a chamois suit is what it was, a western-looking, Native American, kind of cliché chamois suit. We got to hang out with him. I was not close to him then. It was just adoration.

There was quite a little clutch of [galleries] at the time. [The Houston landscape] was not well-defined at all. There had been galleries in the 1960s: Louise Ferrari, the New Gallery, and the Louisiana Gallery, [which] had shown artists who were living and working there. And also, Louise Ferrari had been influential in bringing very wonderful paintings to the de Menils, to the Sarofims— Franz [J.] Kline, important Mark Rothkos—important works she brokered. So there was always an incredible exchange between New York and Houston. There was always a kind of natural connection. A lot of artists went back and forth. Brice Marden, when he got a summer job, came to Houston; at some point, he lived on Polk Street.

MAYO THOMPSON: My mother had taken me to the Museum of Fine Arts [in] Houston as a child. This was back when they had a basement; you would go downstairs and there would be all the art and so on. I went to the gallery there, and Louise Ferrari was sitting there, and Dr. [Jermayne Virginia] MacAgy ran

the joint. I said, "So, this gallery," I thought, it's the university, and I said, "Do students show here?" And she went, "Oh, no, no, no." She explained to me that the de Menils [John and Dominique] were behind the gallery in some sort of sense, and Dr. Macagy; and it was tied to the art history department, and it actually belonged to the real art world. That was the first I ever heard that there was such a thing. When I say real art world, I'm talking about the extended connection of institutions and all of those things. James Johnson Sweeney was at the Museum of Fine Arts [Houston], and it was quite a place. Donald Barthelme ran the Contemporary Arts Museum Houston for a while.

Houston was a sleepy city, but extremely rich, and there were some highly cultivated people there who knew what was what and who was who and who had power and where they were.

FREDERICKA HUNTER: I think it was partly the burgeoning wildcatters. You could say that, socially, they wanted to be part of a larger cultural scene; they were aspirational, and they had money to burn. But Houston has a unique quality from Dallas in that it is less defined, more open, less tied to the Bible Belt, less judgmental as a whole. And, as certain families got very, very rich, they were very, very generous to all the institutions, and the institutions in New York as well. There was a switch early in the 1970s as these big institutions became more solidified and more professional and not so homegrown, partly led by Mr. and Mrs. de Menil providing a more international or cosmopolitan viewpoint. But James Johnson Sweeney [came] into the Museum of Fine Arts, Henry [T.] Hopkins with the Fort Worth Art Museum, Harry [S.] Parker [III] in Dallas, and Richard Brown also in Fort Worth. It wasn't focused just on that [one] place. The earlier galleries—the ones that had been around in the 1960s [and] where we went to the openings as students—they had started to change, and then certain galleries started to morph or started to come up. Betty Moody had worked for another gallery and then started her own.

There were still people in Houston who thought that having clean white spaces was very New York or very snobby. But then a lot of people thought it was perfectly normal. Dave Hickey had a gallery in Austin in 1971, 1972, or something like that, and we would go see him, and we traded things back and forth. He, of course, called it A Clean, Well-Lighted Place [1967–1970].

MAYO THOMPSON: The de Menils were always quite nice. You could always pick up a dollar painting the place when they were getting ready for an exhibition. It was quite a lot of fun to be involved in making something happen. It had this international aspect. They had Henry Geldzahler flying in, bringing in slides of the latest Larry Poons paintings to look at. It was on the grounds. [Marcel] Duchamp came to the school, Texas Southern University, like, "Who? Marcel Duchamp? He's coming here?" Mr. and Mrs. de Menil were power players, and they had the wherewithal to play.

I think that they thought that they were using their money to good purpose, and that they were using wealth in the classical Renaissance tradition— what wealthy people ought to do with their money is to sustain institutions. They knew what the ins and outs were; they'd been around power their whole lives. She had, anyway. You could just tell that they knew what was going on.

I mean, they were a connection to the Warhol world. They were a connection to all of it. It was like everybody: René Magritte sculptures, the whole dealio. You could see how connected up it was. It was full-scale.

ANNE LIVET: In 1971, I enrolled at Texas Christian University [TCU, Fort Worth], went back to school. Many of the professors in the English department disappointed me. They seemed isolated and hermetic and even a little crazy. Their attitude to life convinced me I didn't want to be a professor. I just couldn't deal with the insularity and longed to be in something mainstream.

I told Dr. Rothrock that I wanted a job, a real job in the real world. And he said, "Well, there's a new director of the Fort Worth Art Museum," which is what it was called then, it's now called the Modern Museum of Fort Worth. "He's supposed to be really dynamic. His name is Richard Koshalek, and they are looking for someone to do part time PR [public relations]. So you could do that and continue your doctorate studies and see what happens." Never mind that I had never worked before, knew nothing about art, and even less about public relations. I felt my stomach clench, and I thought how great this would be. I wanted the job so much. I sent Mr. Koshalek an application letter and my resume, such as it was. Then I called all [of] my mother's society friends and got them to write letters of recommendation for me, recommendations for somebody who had zero qualifications.

Dave Hickey, who had been an editor at *Art in America*, the letter he whacked out in minutes was beyond anything I could have imagined. He had this great way of describing me: "She's got a[n] unusual and valuable quality—'social fluidity.' She can literally go anywhere and meet anyone without ever being condescending or overly ingratiating." Basically, that letter got me the job.

This was such an exciting time in my life. Richard Koshalek would let his staff do anything they wanted to do if he liked the idea. So while still doing PR, I developed a large and exciting performing arts program, bringing Merce Cunningham, Twyla Tharp, Trisha Brown, and others to Fort Worth while trying to come up with more ideas and find the money to fund them.

There are some fine regional museums in the country, and we were a regional museum. Despite that, Richard taught me to have the same standards that one would have at a major museum in a big city. He thought it wrong to dumb things down because your audience isn't as sophisticated as audiences in bigger cities. He didn't believe in condescending to people. We both felt it was very important to educate people. I felt it was important to educate the community about what they were getting, to realize how lucky they were to have these great museums, the Kimbell Art Museum being one, the Amon Carter Museum of American Art [Fort Worth, Texas] being another and then—what was then the Fort Worth Art Museum. And Richard felt that way too. He was so ambitious that he wanted to do so much so fast, and he wanted to change the way things were done.

I wasn't a curator then. I was in charge of public relations, and I'd just barely started. [*Rodeo Palace (Spread)*, 1976] was [commissioned for] one of the first shows that we did.

The museums in Fort Worth are located on a big lawn. It's right in front of something called the Will Rogers Memorial Auditorium, with a statue of Will Rogers on a horse in front. It's an Art Deco coliseum—and it was billed as the largest indoor rodeo in the country when it was built. They still hold an annual rodeo there. But there were also three major museums on this lawn— the Amon Carter Museum of Western Art [now American Art], the recently opened Kimbell Art Museum of ancient European Art, and the Fort Worth Art Museum—now the Modern—which was about contemporary art. So the idea was to take something that was right in the backyard of the museum—an idea of Richard Koshalek's—and do a show based on the great American rodeo.

Of course, they thought about Bob immediately because he was a great artist but also from Texas. They also had a huge Red Grooms piece. He basically redid the rodeo, and he did real faces of real people in the rodeo. They had a Terry Allen piece. Terry Allen is another Texan from Lubbock, another good friend of mine, and the great photographer, Garry Winogrand, who did a series of photographs of all the people at the rodeo.

At any rate, Bob made a big piece that had his notions of what rodeo would be like, and I would imagine that he just did pretty much what he wanted to [do]. There's a horse and three doors, and this pillow. I remember that too. I remember the pillow. My guess on this would be that Bob just followed his instincts and tried to recall certain things. I mean, the way he would usually work would be to rifle through drawers of clippings that the studio assistants had clipped, and he would shuffle through them until he found something that rang a bell with him. I love the fact that he made what he would call a palace, and he created a kind of house with doors. It's just full of Texas iconography, this piece is. The doors are not from Texas probably, but they look like they could be. Something that he might have seen growing up. And the horse and the bucket, like a horse might eat oats out of the bucket. This is all like—could be right out of one of those early Larry McMurtry movies. Larry McMurtry, you know, taught in Fort Worth at TCU, so it could have been from *Hud* [1963] or any of those early movies, or just Bob's childhood.

It looks like they're also screwdrivers or something [in it]. Not screwdrivers, wrenches, or something similar, and mushrooms. Oh, my. But it's a great piece. There's another horse. No, that's a shoe. A tennis shoe. A bug? That is sort of perfect for Bob to put that in there because he was obsessed with bugs and things growing up, and it's almost like he just juggled these things from his memory and put them all together to make something.

But this was not the only commission for the museum. Later we commissioned him to do *Whistle Stop*, and he had the commission to do the Viola Faber piece, which he named *Brazos River*, a famous river in Texas that has had a series of dams along it. Possum Kingdom Lake is the result of a dam, as is Granbury, and this damming has caused a lot of problems for water shortages and things like that. So John Graves—another Fort Worth writer—wrote a book called *Goodbye to a River* [1960], where he traveled the length of the Brazos, before Bob's piece, camping out. And it's rich with

folklore of the Comanches and everybody that lived along it. All these artists share a similar awareness of Texas culture and the disappearance of Texas culture that is included in the disappearance of a river, but I don't think Bob was particularly sentimental in that way. I mean, he definitely could be sentimental, but I don't think he was like somebody that would want to go back to the Texas of that time, but I think there had to be a certain nostalgia for it because he grew up at a time when Texas was not a huge sprawling chain of cities with surrounding suburbs encroaching and encompassing ranch lands. I bet Port Arthur was small when he grew up. And it was before all those freeways and all of that development. So he must have been speaking to houses that were out in the country that had faded wallpaper and rickety doors that would swing back and forth and screen doors that banged in the wind. It's a beautiful piece.

[With] *Whistle Stop* [*(Spread)*, 1977], I remember saying to Jay [Belloli], we really should commission a piece and get a Rauschenberg into this collection. There's not one in any museum in Texas, and let's do it before Dallas does it.

I said, we've really been working with him, and we've all grown so close to him. I think I probably called him and just said, "We'd really like to get a work of yours for the museum. We'd like to commission a really beautiful work here." I said that I really wanted something that was Texas-oriented, and no museum in Texas owned his work, and we had a small number of dollars we could commit. Bob said it was fine, "Don't worry about it," and he did a piece called *Whistle Stop* which is at the museum and often on view now, with a little train light "RR"—either railroad or Robert Rauschenberg—that goes on and off. It's a gorgeous piece—more like a Combine.

The Combines seemed to me the most "Texas" of his pieces, and they're also the most "New York." Isn't that weird? It's like—well, there's so much Texas iconography in so many of the Combines. Not all of them, but some of them. And they're also so full of New York iconography; faded billboards and things that are blowing in the streets and all of that. The signs and newspapers and all of that are pervasive. And they don't feel like California, or even Florida much. I feel like there's a sensibility that is a Texas sensibility, but there were a lot of available things in New York City that gave it some meat, made it less nostalgic. *Whistle Stop*, however, does seem slightly nostalgic as a piece, like it could be a memory.

McMurtry tells about witnessing one of the last cattle drives when he was growing up in Carson City in north central Texas, a long, legendary event [that] lasted only twenty years. And it came through Fort Worth along the Chisholm Trail. McMurtry remembers seeing the cattle drive going, and then afterward hearing a train coming along the tracks, and just wondering if the train was going where the cattle were going, and this whole idea of travel. So in *Whistle Stop* he puts that little light—there's a light that goes on and off, and although there's not really a whistle—but the light blinks on and off like a train light. It evokes that kind of nostalgia, and I think in those days, young men in their bedrooms in those faraway towns would hear a train going by and think, I want to be on that train one day. I want to get out of here, I want to be on that train.

I saw *Whistle Stop* not too long ago. It really is beautiful. I am so happy they have it on view. Bob did a good job, and I think he wanted to do a good job for us because he liked us, and I think that can make a difference, you know. He liked us, we trusted him, and I think he wanted it to be good, and it was.

THEY ARRESTED HIM

ROBERT PETERSEN: I recall the trip—oh, gosh, very clearly—to Texas. We flew in. Anne Livet picked us up. Then—let's see. We went out to lunch. Nice little restaurant in Fort Worth. Then there was a party given at a ranch house, in a big Texas ranch. The land. Not so big of a house, but a nice ranch with a lot of cattle.

ANNE LIVET: I invited Bob to come so we could have a party in his honor with the work up. Carol McKay offered to have a party at her ranch. Also the mayor, who was a dynamic Democrat and a good friend of Carol's, came to the museum and made Bob an honorary citizen, and we drank champagne. On the bus I served snacks and drinks. The sky was overcast, and when I mentioned that to Bob apologetically, he said that was the way he remembered Texas. At the ranch in Lipan, we had *cabritas* [goat] roasted on the open spit and mariachis played and all of us danced.

ROBERT PETERSEN: It was a wonderful party. They had made a tent out in the back, just overhead with lights, and a dance floor. They were dancing, like square dancing. Bob loved to dance, and he's an incredible dancer. The way he moved. That rhythm.

JANET BEGNEAUD: It was out on a hill, and they had a big dance floor out there, and they had two bands. One was a regular like band, band. Kind of maybe a little bit rock, and the other one was a cowboy band. Bob and I—he loved to dance—so Bob and I learned to do the dance [in which] the girl would hook her thumb in the back of the boy's belt. That's that Texas thing. And you can't stand still. You've got to go. It's like you're on a skating rink or something. You just have to move. We had so much fun dancing that night. In fact, this was in the days when we all had platform shoes, and then your pants drug the floor around them, just about. I had gotten so tired that I had taken my shoes off, and I literally ruined my pantsuit.

ROBERT PETERSEN: We're out there, and it was getting dark, and the lights were on, and we were having dinner and dancing, and having corn on the cob. I remember the corn on the cob was so good. They're grilling steaks. Nice. Bob and his mother and his sister [and] Ricky Begneaud were there.

We were having the party, the dinner, and the dancing, and it was getting dark. Suddenly there were some lights in the distance. It was a helicopter, getting closer and closer. So then the hostess went out with some of the hired hands, or friends, and they all had lights. They went out in the back, close to the dance floor, out on the lawn, and they made a circle with lights. Then the helicopter came down and landed in that circle. The sound of a helicopter—just the sound and the visual.

So the helicopter landed and the host said, "Oh, Bob, the mayor has arrived." The mayor, with his suit, like the president, came down. He came out on the lawn, and he came over to the dance area, and they had a ceremony, and the mayor presented Bob with the key to the city. It was a ribbon with a gold key. People are celebrating. The mayor stays around celebrating too. It's getting late, so he shakes hands with Bob. "Congratulations."

ANNE LIVET: The mayor flew in on a helicopter and gave Bob the key to city. I did everything I could to make the night special because I was so grateful to him for giving the museum such an amazing piece at such a great price. I think we paid one hundred fifty thousand dollars, something like that. The piece has got to be worth a lot of money today.

Then it is time to get back on the buses. There are three buses, and there are no cell phones. And I have a date with some guy that's a lawyer or something, and we stop in Granbury, Texas. We stop in Granbury, which in those days was dry and very, very redneck with very conservative values.

ROBERT PETERSEN: We get about an hour and a half away, and the bus driver stops at a little side road country store. You know, the old kind of Texas, little wood grocery store.

JANET BEGNEAUD: Sort of a stop-and-shop kind of store. It was a huge parking lot, and so they stopped that bus out there and everybody walked into the store. And we laughed because these two state troopers were coming out through the cars, and like Bob says, drinking their RC Colas and eating their Moon Pies.

ROBERT PETERSEN: He stops to give everyone a stretch. People get off. They go in and buy a bag of potato chips or whatever. Bob gets off the bus. I think I stayed on the bus, or maybe went out and had a cigarette. I used to smoke. I'm walking around, then standing there, and suddenly I see a police car pull in. No big deal. Police car. Doesn't have the lights on or anything.

ANNE LIVET: A lot of people got off the bus to go to the bathroom, and Bob went as well. But there was a line at the bathroom, so Bob went around behind the bus and ended up just peeing on the tire behind the bus. But when he did that, he was immediately surrounded by Texas Rangers with drawn guns.

ROBERT PETERSEN: The bus is parked by the side of the road. The police car comes in, and it goes around to the back of the bus. He's back there, visiting and having fun with people. Suddenly the police car comes out from around the bus, and Bob's in the police car.

He comes by, and he's by the window, and I go, "Bob, where are you going?" He was, well, urinating, on the back tire of the bus. So they arrested him for public [urination].

And it's dark. There are no lights. It's not a town. It's just a little country store. The local police.

I'd had a few drinks; well, I was pretty—in one of those moods—you know. Like, "What's going on?" Just this adrenaline, and I run over to the police car, start banging on the hood with my fist. I say, "Stop! Stop! Don't take Bob away."

ANNE LIVET: And I am like, what in the name of God is going on? I go to get off the bus, and there are Texas Rangers with their guns drawn. They take him to the jail in Granbury. To the Granbury jail. And I refuse to let the bus go back to Fort Worth. The other two buses go. And there are people on the bus that really did not want to sit there, but I didn't give a shit.

His mother was furious with him, and I heard his sister Janet [Begneaud] and his mother asking, "What if this gets in the newspaper that he was going to the bathroom? They're going to talk about his exposing himself and maybe being homosexual," or something like that. It went on and on. Finally, I got this boyfriend/lawyer/date of mine to persuade the police to let him get off the bus so he could go call Bill McKay, who'd given the party. And he was successful, and that's how Bill McKay pulled up laughing his head off thinking the whole thing hilarious. He knew all the Texas Rangers and made sure they thought it as funny as he did.

Apparently, in the jail they asked Bob to empty his pockets. Bob always stashed his lucky pieces in his pockets—seashells, bones, feathers, keys, and so on. As he took them out, emptying these [laughs] weird things on the table, they reached to take the key to the city off him. "What's that?" they said. "It's the key to the city of Fort Worth." And they said, "Well, take it off," and Bob said, "Why? Does it open the jail?"

So when Bill McKay arrives and they release him, the jail people say, "He's been perfectly nice, but those people on the bus are whom we really should have arrested." We get him and we get back to Fort Worth, and he's staying at a hotel in the country a bit. The next day I'm in a state of panic because I hadn't had much sleep. A friend of mine, Mary T. Ard, was giving a luncheon, a brunch, and I didn't want Bob to oversleep. And Bob was notoriously late

everywhere. So I went to the motel, and Bob Petersen, Rauschenberg's lover, opened the door and said, "Oh, Anne, you'd better come in and give Bob a big hug." Apparently his mother had gone in there that morning and woke him up. And [she] sat on the edge of the bed and said, "Milton, you listen to me. If one word of this arrest gets to"—where were they going? Lafayette [Louisiana]—"to Lafayette or Port Arthur, I'm never traveling with you again." So I went in and sat down, and looked at him with the covers drawn over his head. And he was scrunched down in the bed, and I said, "Bob, what's the matter?" and he said, "Don't let my mother in here again." So we pulled ourselves together and got dressed, and I drove us over to Mary T. Ard's house.

I knew the house very well because I had known the daughter of the owner, Gwen. Her father, Ted Weiner, was very ahead of his time, and he had a beautiful sculpture garden out there. But Mary T. had the house, and she had Warhol's *Elvis Presley* installed just inside the door. Once she opened the door with Bob [he was] a bit nervous because he's been a bad boy who got arrested and whose mother was truly mad, and he's just like nervous about getting in. But Mary T. was just fabulous. She put her arms around him and she said, "Oh my god, I heard what happened to you last night. It's happened to four men that are here today." She said, "You can't pee anywhere anymore, can you?" [Laughs] So he was just totally relaxed, and we had a great brunch, which was lots and lots of fun.

"I'LL BUY YOU TICKETS TO ANYPLACE IN THE WORLD, AS LONG AS IT'S NOT PORT ARTHUR, TEXAS"

ANNE LIVET: I had this yellow station wagon, and I'm driving all of them—Bob, Bob Petersen, Bob's mother Dora [Rauschenberg], and his sister Janet, trying to get him to the airport. Another thing Bob had done was to invite all of the workers at the museum who were not invited to the party out on the McKay ranch to come to the airport to say goodbye to him. That was very typical of Bob, to spot the really interesting and promising people and somehow find a way to include them. He did this all the time, insisting that his staff—most of whom were artists—be invited to whatever party he was invited to. And a lot of those artists/staff people grew into full-blown careers later on. So I was driving them to the airport when my car broke down.

JANET BEGNEAUD: But anyway, so here we are standing on the side of the road with our luggage, and there's no traffic. Finally this guy comes by in a truck, and it had an open bed on the back of it. It was like a, not a dump truck, but it was like a farm truck. He stopped to help us. He was so funny. He was an old black guy. So he said, "Where you ladies going?" Anne said, "We've got to get to the airport." He was going to call someone to see about a car. She said, "No, we'll have to tend to that later." She said, "We've got to get to the airport." So we all three got in the front with him, and it wasn't a two-seater. It was all just one seat. We all three got in the front, put the luggage in the back, and struck out to the airport. Anne's giving him directions of how to get to the air-port. She lived, I think, in either Fort Worth or Dallas at that time, and so she knew the area and got us there. It was so funny. I think that's why we ended up in a private plane, because we missed our other one, I think. Anne just left her car out there smoking. I never did know for sure if it burned down.

ANNE LIVET: Ultimately, as we stood on the side of the highway without the benefit of cell phones, I flagged down a pick-up truck and watched them drive away, his mother sitting in the back with his sister and Bob and Petersen stuffed into the cab. I didn't make it to the airport to see them off, but accord-ing to some of the people that were there, when Bob arrived and saw these young people that he liked so much, he said, waving his AmEx [American Express] card, "I'll buy you tickets to anyplace in the world, as long as it's not Port Arthur, Texas."

BOB WAS ALWAYS PICKING STUFF UP THAT HE NEEDED

MAYO THOMPSON: We were in Naples. Bob had a show at Lucio Amelio [*Robert Rauschenberg*, Modern Art Agency, Naples, 1974], and Ileana had hooked us up. There was a collector in New York, I don't recall his name, he lived up Lafayette Street by the post office up there. He and his wife [Sam-uel and Adeline Dorsky] had some connections in Jerusalem, and they put up money for Bob to go over there and make something on-site, and for the thing to be bought and contributed to the museum. So Bob Petersen, Hisachika, Christine, and I went with him.

HISACHIKA TAKAHASHI: We were going to Israel, the Jerusalem museum [Israel Museum, Jerusalem], to have Rauschenberg's show [*Robert Rauschenberg in Israel*, 1974]. Rauschenberg took the crew, me, his assistant, and somebody who was taking pictures and that person's girlfriend. Petersen was another sort of assistant. Basically Petersen was doing his own artwork more than assisting. The idea was [that] Rauschenberg would go to Israel, pick up garbage from the street and deconstruct it, making artwork. We looked all over the city. We didn't find any cardboard boxes or anything. The museum had a section to work in, and somehow, we went to the basement to look, and there was an incredible amount of cardboard. So we chose many of the best ones, and brought them into the studio to work on the next day. The day after, we got to the studio, in the museum, and everything was gone—taken back to the basement. It was quite shocking, but it was very reasonable because the museum people needed these boxes to pack.

So now we had a real problem, so one more time we were forced to go to the city, looking for anything we could find. In the evening, we found a broken wheelbarrow. We pushed it, and we reconstructed it, and brought it back to the museum. On top of this, we went to pick up sand from the desert, any desert, we would go there and collect sand, and so there are many different colors of different sections of sand. And we started gluing together and putting things together, and gluing the sand. In some places we painted color, but where exactly, I don't remember. We used paint, the glue was [the] medium, and the glue was constantly strong, water-based, and still holds everything together right now. We had sort of an incredible time.

MAYO THOMPSON: Bob was going to make the work in situ. We had worked with him on the *Early Egyptian* series, so we knew something about how these procedures work, some of the moves and things that could be done. So we were prepared. They organized a vehicle for us, which was an irony, a Volkswagen microbus with a bit of a pickup truck bed in the back. Green. I drove a lot, and we drove around the Holy Land, as they call it, and Israel, and went to Jericho, where Sachika was a big hit because they all loved Bruce Lee, and they loved kung fu movies. The Arab kids would throng around him, and he would entertain them. Every place you went into, there'd be a little glass showcase kind of thing where images of the heroes had been pinned up. There was always

[Gamal Abdel] Nasser [Hussein], of course, and [Joseph] Stalin, who was popular still with that crowd out there, and this one and that one. It was calm.

We went to Jericho, we went to Bethlehem. We drove through the Shatila camp one time, when we had some official with us, somebody from the museum, maybe Yona Fischer or somebody like that. We were driving one time and we drove in through there, and you could see people peering out. This was before the Intifada.

Bethlehem was a strange thing. One is watching all of this stuff, and there was a French film crew, and we crossed paths with them. Bob traded shoes with them at one point. There's a photograph, you see Bob putting on these white patent-leather shoes; he traded them with one of these French film crew people. We dined in the same restaurant one afternoon. So we had a leisurely bit, and we drove around and collected junk, you know, like scraps from the Seven-Day War and some sand and a long length of hose and an old wheelbarrow and a big stick, a bunch of junk.

We were there for a week to two weeks, something like that. It was organized that Bob Petersen should have an exhibition too, and there was a contemporary gallery in Jerusalem where he hung some stuff up and had a show [*Robert Petersen*, Sara Gilat Gallery, Jerusalem, 1974]. Shimon Peres showed up with a bodyguard, the hardest-looking dude I ever saw. Snake eyes. Very impressive, very impressive. We met Teddy Kollek, we were invited around to Abba Eban's house and sat there. And Abba was busy that day, so we sat with Madame Eban and had tea in the library.

Bob remembered the night that the Ebans had been over to the house, to the studio on Lafayette Street up on the top floor, on the kitchen floor, having dinner. Abba had been obliged to excuse himself and get back to the UN, and he said, "I think peace is breaking out."

Another time we were invited out to Beersheba, to meet a Bedouin, a sheik, and we sat in his tent. I have a recording of him playing this one-stringed instrument, fantastic, and then he and his mates sitting there and laughing. They gave us this very nice mint tea. We all sat around insulting them—showing the bottoms of our feet—not knowing anything.

Bob was always looking and collecting things and picking stuff up that he needed. Then we get back to the museum, and we install ourselves in there and start making stuff. I had shipped a crate of art supplies from New York

and had to go get that in Tel Aviv, and customs was giving them a hard time about letting it in. They were obviously working it for political reasons—one department against another department and on and on. Bob was hostage to these relations, even though he was a feted cultural guest. He still had trouble with bureaucratic red tape. Finally, we get the crate, put it in the truck, take it back over to the museum, and start making the stuff.

BOB PETERSEN: [The *Scriptures* were a tribute by the artist to the Dead Sea Scrolls, and Israel's religious heritage] and installed in the Israel Museum in Jerusalem in 1974 [Robert Rauschenberg in Israel].

Bob [had] this paper, he bought reams of it for his series *Currents* in 1970. But it's mounted on the back, it has, I believe a linen or a muslin. We called it linen-back paper. But someone years ago a friend looked at it, and he said that that was muslin. Bob had purchased, for the *Currents* series, big reams of it. And the muslin was adhered to the paper in Germany; it was the only mounting machine existing at the time that would handle a large roll of paper, and actually archivally mount the cloth to the back of the paper. Because in the *Currents* series Bob did a silkscreen, it's about sixty feet long, the whole series of the *Currents* editions from the original drawings that were shot and made into silkscreens. Then he worked with them, overlaying different screens with other screens. But that's where this paper is from, and Bob used it for years.

We rolled off quite a bit of it onto a core and had it sent to the museum in Israel so Bob would have it available. I imagine some of the cheesecloth from Untitled Press was sent to Israel, to Jerusalem, and then we had some matte medium sent to Israel, but all the other materials we got in Israel.

In Jerusalem at the museum, we spread out large sheets, rolls of plastic to protect the rug in the museum because of the matte medium on the cardboard boxes and the sand Bob collected. We'd go out and collect sand and dirt from different parts around the city of Jerusalem. And the landscape changed, you'd find a finer sand, maybe a red, more reddish sand. If you went toward Tel Aviv, the soils changed a little bit, and Bob liked that, different colored soils for the boxes. And then the paper bags are adhered with the matte medium, the paper bags he found in Jerusalem. And the newspaper is from Jerusalem, you see the different writing, Arabic, and the transfer. This transfer was not done with

roller blanket wash because we didn't take that to Israel, it's too dangerous to put in your baggage, or even to have shipped, because it's flammable.

Bob was invited to the print shop at the Jerusalem University, into their print department. We went in, and Bob actually worked on the press there. I didn't run the press; the students did.

He loved printmaking, he said, "Oh, it's already right reading for me," because of the dyslexia. Beautiful.

MAYO THOMPSON: Maybe I was a fan of Rauschenberg's work, and then as I got to know him I really appreciated him. But I did not feel inferior to him in any sense, right? He did not seek to make me that, or to put me in that kind of position. So it was all quite normal. It was distribution of labor, and also distribution of functions, so the various kinds of working things. . . . Bob is slowly looking around, and he's got criteria: he's got the space, he sees the space, he knows how many pieces he wants to put in it, he knows what his responsibilities are to make something, and he makes something for the art school, and he makes something for this, and he makes something for that, and he satisfies everybody, because it's all part of the game. And Ileana is the puppet mistress of all of these relations, and she's hooking everybody up and dealing with all the other kinds of stuff.

The adequacy of [the work] was the thing that always astounded me. He always managed it. There was never a bad piece. There was never something you'd think, "Oh, minus that, cool." All of it somehow fit. So he had a sense of space, and how to use space, like what it was to walk into it, and the series of effects and what happens when you turn around and all of that stuff. He'd absorbed all of the lessons, and he'd been to a million shows and seen how other people had done it. He deeply absorbed. He was an expert in his domain.

[In a] conversation I had with Mike [Kelley], he said, "It's weird. In art, I'm the master of my domain and my materials." He said, "But of course I'm an idiot who never knows a thing about what I do." And he didn't mean it in a pejorative sense; he just means someone comes in and goes "Huh?" and does something I never thought of. I said, "Yeah, but it's still your work." And that's the thing that Bob knew. And then Warhol. Whoever claims to have made those paintings, they're Warhols. There was a Warhol recipe, Warhol formula. The thing is, I couldn't make a fake Rauschenberg. I don't think there's any way [to do that].

GOING TO INDIA

HISACHIKA TAKAHASHI: We were going to India for the Gemini project, a printing project. So we got to our home, and this time I think it was Petersen and myself and Rauschenberg. We went to India, and Rauschenberg had a wonderful friend called Sarabhai, and Sarabhai opened the house for Rauschenberg. [Charles-Édouard Jeanneret] Le Corbusier made the house in cement, and with very small windows, and the house was quite hot because Corbusier didn't want to use air conditioning. So there were little fans going on the ceiling, that's it. But when we arrived in the airport, because we were first class, there was air conditioning and champagne and everything. When we arrived, they opened the door to go downstairs in the airport. It was 108 degrees, something we had never felt before. Everybody started to complain, "It's too hot, too hot." Usually, when it's so hot, you don't sweat, you only see crystal salt on the skin. So I thought that ice is sort of a good idea. So we started there, and we started complaining, we're hot, which wasn't going to change anything, so I said, "Let's not say hot anymore. Nobody say hot anymore." That was a wonderful trick.

ASHA SARABHAI: As I remember, what happened was that Anand [Sarabhai], Suhrid's brother, got a phone call late one night from Bob saying, "We were supposed to be going to China but I don't want to go to China," because he was coming with Gemini [G.E.L.], with Sidney Felsen, and people. He said, "I don't want to go to China. So is it all right if we come to Ahmedabad?" Anand said, "Yes, sure, but it's—you know, it's May. It's very hot." So he said, "The heat doesn't bother me. So can we come?" I think the next morning Anand must have mentioned it to all of us. We had our own separate home, but we used to have lunch or dinner, many meals in common. So I think Anand said to us that this rather large group of people was planning to come. Everyone said, "Yes, fine." It was only when they suddenly arrived that you realized that your life was going to be turned upside down for a bit. But it was great. It was really great.

John Cage and David [E.] Tudor and Merce Cunningham had all been [here in 1964] and were good friends of Mani's. [Bob] must have [met the family

in 1964]. And it was also an incredible opportunity that [I] had not in any way thought about preemptively. But suddenly to have Bob there, Bob Petersen, Christopher [Rauschenberg], and then Gianfranco Gorgoni, Hisachika [Takahashi]—it was just like a wonderful breath of fresh air, to be honest, to be able to have these long conversations that meant a lot, which were about life rather than anything specific or art. Also, during the day to be involved quite intensively with helping make some of the things, or to be there and doing stuff was wonderful. It was a great experience. I'm very grateful to Anand that he brought that into [my] life. I had no pre-understanding or concept that Bob was this major art [figure]—it was just a name, really, at that point, which I'm very grateful for too.

HISACHIKA TAKAHASHI: I was on the plane [and] quite interested in the rice fields and stuff I could see, and we took pictures from the airplane. And somebody came over [and said], "You cannot take pictures." I said, "Why not? I'm taking a nice view picture, I am not doing anything wrong." And when I arrived at the airport, some kind of security guard came over and said, "We want to have your camera." And I said, "What do you mean?" He said, "We want to check out your film." So I left the camera in the airport. They were going to take the film out, develop what kind of picture? They were scared that I was a spy or some kind of nuclear assistant. And there probably [were people like that] around there, I have no idea. I got back my film and my camera. That was the beginning of India, shocking.

The place we were working was the paper mill, handmade paper. Usually making paper is any shred of fabric [that] is melted up, chopped up and melted, and put in to make paper pulp, with water. And then it goes through the screen to take the water out. And only cotton fiber was on the screen, and Rauschen-berg wanted to make artwork from that. It was quite a good technique. Layer over layer, it's wet, it shrinks, and somehow [we] used cow pee to make a sort of seal for the paper. He ended up using big pressure to take all the extra water out, and it was one by one, put in the sun, to make it completely dry.

ASHA SARABHAI: The paper [that] was used in the work was rag paper made at the Gandhi Ashram [at Sabarmati, Ahmedabad] in a very beautiful space. It's a very rhythmic, peaceful space in which they actually make the rag

paper and then hang it out to dry. I don't think they do it consciously—it's an old way of making paper—but I think when Gemini had it tested, because they were worried about its longevity, I think they found that actually it had a perfect pH, whatever all the contents, the necessities are. They found that actually this paper had it.

The paper seems to stand up to years and years with very little problem, which is great. It's one of the activities of the Gandhi Ashram in Ahmedabad. That's where all the paper basically came from and where Bob did some of the work as well.

And the first thing he said, which again has become apocryphal for everyone, was that "we're here, and if anyone mentions the heat once, I'm putting them on the next plane back." So everyone worked through really swelteringly hot days. And it's very dry heat, so maybe that's easier to do, but really, really bone-dry heat and no air conditioning in the spaces where he worked. It was out of the question. So it was hot, but no one mentioned it.

CHRISTOPHER RAUSCHENBERG: There were two series of work that were being made in Ahmedabad [*Bones* and *Unions*, both 1975]. One was being made at the Gandhi Ashram, where they made paper. And they were multiples being made for Gemini, so there was a basic structure: make a piece of paper a certain shape. The Indian papermakers would make a sheet of paper that shape. Then, depending on which piece it was, we would have a bamboo structure and a pile of random fabrics that were cut into the shapes to fit into this thing. So even though it was a multiple, each one was very different because this is a red sari fabric and this is blue and et cetera, all through them. So this was part of his curiosity. You don't just make a bunch of things that are exactly the same if you can think of [a] way to make them each be pretty different. This is another thing that drove his gallerists crazy I think—your multiples are too similar to unique pieces.

ASHA SARABHAI: The paper part was what [Rauschenberg's work] began with. Going to the Gandhi Ashram, seeing the paper process and beginning to use that. And then there were lots of textiles as well, so it was going to the textile markets.

Ahmedabad was a big textile center at one point, and that was where [Mohandas K.] Gandhi's movement emerged. [There] was very much a cooperative kind of basis to it with the trade unions.* Ahmedabad used to be called the Manchester of India because it was actually mill textiles that they began making. But there was a whole other side, which was the handspun fabrics, which was right through India.† Gandhi really began his main thrust [for independence] from Ahmedabad, which is where he also started the Salt March from, the Dandi March. It was a very resonant place with all these things, so one thought there are all kinds of things that one can try and do.

The Khadi shops, which is where we went with Bob, where he bought the fabrics, many of which appeared in *Jammers* [1975–1976], were shops that came about postindependence, after Gandhi had died. But Gandhi was very instrumental in making the whole Khadi movement a kind of nationwide practice, because he really believed that hand spinning and hand weaving were the backbone of India.

Women used to wear saris and men used to wear dhotis, and it was really a tradition of the unstitched garment in India. And Gandhi felt that was something that people used in their lives as a—I'm putting it this way, but it was the first architecture that surrounded you. So he felt that it should really be something you were involved in and that was handspun, handwoven. It was also, actually, a direct snub to the British, because they were importing into India huge amounts of fabric from Manchester and places and killing the local [manufacturing], which they did over the time that they colonized India. This was really to try and say, "No, we need to go the other way, and symbolically just make and use and wear this fabric."

So it was a very powerful symbol, and it was very nice that Bob used some of that fabric in what he did. There was a very—I was going to say primitive in the best sense—engagement with basics.

* *Narrator: The early trade union movements, strikes, and attempts at resolving these issues through cooperation were a key precursor to the freedom movement. Gandhi was an important mediator in these movements.*

† *Narrator: The handspun Khadi movement was a part of Gandhi's movement for Swaraj (self-rule), one that he linked closely to questions of personal freedoms and self-dependence. He advocated the practice of hand spinning both as a symbolic act and as a material one.*

Ahmedabad still has very busy secondhand fabric markets on the street, probably five days of the week if not more, where people, you know, poor people will go. It's an interesting exchange, actually, because people will go around. Women will buy new—it sounds bizarre—they will buy new stainless steel utensils. Then they'll go from home to home, and they'll exchange the utensils for secondhand clothes: saris, clothing, whatever. Then they'll go away. They'll sell those clothes in the secondhand market, and it becomes a kind of real trade. As a result, people put together the most extraordinary combinations of print and plain. The fabrics, when you see them, you just think, "Who needs people like Jean Paul Gaultier?" Because these guys just put it together with a real [flair and panache]. I'm sure that was something that struck Bob as well, because it's a very powerful visual image. In spite of often really dire poverty, people still look extraordinary because they will combine—from very little, they will make a huge amount. There's a real thing about necessity, but not at all delinked from beauty. I think that that was something that Bob was really struck by.

It would come out in strange things that he would say. I used to wear these—because it was hot—these thin cotton saris [that] sometimes had a very simple edging in gold thread. You'd be walking through the mud in the garden because, when they watered the garden to cool it down, there would be real muddy patches. He'd say, "You're walking through the mud [and the gold is trailing in it]." And I'd say, "Yes, but it's okay." We used to talk about concepts of what real luxury is about. I think his response to the range of textiles in India was very powerful. It was a strong impression, both from seeing these piles of secondhand fabrics, going to the Khadi shops, and then thinking of working them into the paper and sandwiching them into the paper in different ways.

To be honest, how the mud thing emerged, I'm not sure, but I do know that there were all kinds of people who were called in who would say, "if you take fenugreek seeds and crush them, they hold together, and they smell." So there were all these kitchen herbs and spices that came into the making of the mud.

CHRISTOPHER RAUSCHENBERG: I was at the Gandhi Ashram mostly. And then at the Sarabhai's house, they set up a thing, they were figuring out about the pieces that are made out of what they called mud, which was paper pulp. Mud with turmeric in it. He knew that they built houses out of paper, paper

pulp, and he wanted to make basically sculptural pieces using that same technique [*Unions*, 1975]. "This is what you do here," [Bob said.] "I want to do it, but I want to do my thing with it." And he said, "But listen, I'm going to need it to be like cotton rag paper." And they said, "Oh yeah, that's what we use." "Really, oh? That's nice." And plus they put turmeric in it because it keeps bugs from eating it. Why? I don't know, oh, it seems like it would make it delicious, but bugs have different taste, apparently. So those were being made at the Sarabhai's house, compound.

So the pieces that were made with that are wonderful because they're very spicy smelling. They're terrific. I was just basically working all the time. Whenever we would need something, okay, we need some more camel whips. Not that we were whipping camels, but he was making pieces that had camel whips as part of their art materials. I'd say "Oh, I'll go get them." So a driver would drive me into town, and I'd buy the camel whips.

ASHA SARABHAI: A lot of buildings and homes were built with a combination of cow dung, straw, and earth, and then tamarind seed as something to strengthen it. And then very thick walls were built up, which are great insulation as well because they keep cool in the summer and warm in the winter. I think Bob had seen [one]. Mani, my mother-in-law, had had one of these houses, a small one, a hut built in the garden. So that was there. Then they were occasionally embellished with mirror work and seeds and all sorts of things from whatever you find around you. So the sense of earth being used as something else was also part of the sort of visual environment that Bob encountered.

[These raw materials] for the *Bones* [1975] and *Unions* [1975] [projects were] very much a combination of Anand suggesting ideas and Bob saying, "Yes" or "No" or "Maybe." Or Bob asking, saying, "I'd like to do this," and "How do we do it?" At that point, someone would be brought in. But there were no experts on it. It was just slightly ad hoc. You know, "Somebody might know something about that, so let's ask them." It was really—I think the word *organic* is bandied around rather horribly at the moment. But I think, actually, it was really very much part of a process that just emerged as you went along, and it was really trial and error and seeing what worked and what didn't. I think Sidney Felsen, if I remember right, was completely sort of, "What is going on?" You know, all this sort of smelly stuff. But he was great. Everyone was just amazing, because

it was such a disparate group, in a way, and yet, on the whole, it just worked. It worked quite fluently on the whole, probably helped with some Jack Daniels.

HE THOUGHT THE POTENTIAL IN EVERY HUMAN BEING WAS THERE TO BE MORE OF THEMSELVES

ASHA SARABHAI: I loved [having Bob there]. I loved it partly because it just felt right. It didn't feel as though it was an interruption. It felt as though this is what life should be. Samir was young, but he was happy to be a part of it. Sanjay was already at school, so he was away for part of the day. I hate the words *energizing* and *inspirational*, but it was really all that and more, just being there. Because [all] the way through, knowing Bob, I never ceased to wonder at the kind of tremendous energy he brought to everything.

What was it that really struck me about Bob? The main thing was that it was as though he thought the potential in every human being was there to either be more of themselves, or to be both more of themselves and more of something else. So it was this strange thing of drawing out and bringing in—that you could just keep expanding in the best sense.

That's something that I felt very powerfully during that time. So it didn't feel like a disruption at all. It felt—it was like swimming in the sea. You were there, and you just did it. It was great.

Everyone was just doing it. It really is what happened. Sidney was probably having to think of the technical side. It was an experiment, and it was an experiment in seeing how you could stretch boundaries. Bob was just pushing the boundaries of material and seeing how to do it. Because there was a prevalence of bamboo there and there were textiles and there was the paper and there was mud and there was earth and there was a lot of—because of the heat, there was a lot of wet earth and mud. So you really felt—your feet would sometimes squish into it. So I think that all these things were probably impressions that found a way into the work. But that's just a personal thought on it, because actually, we never really talked about the work. When one was helping, one just did it.

The other thing about Bob was that there was always a sense of quiet assurance that he knew what he was doing. Yet he was willing to turn it all upside down if need be.

The first time I went to Captiva, I didn't feel it was that different, actually—the working situation there. It felt very much of a piece. It was allowing things in, which I think [is] the only way in India, because unless you have a very fixed idea and you just go in and do that, which narrows the field enormously, I think you really do need to lay yourself open to possibility and error and basically to what happens to happen. Which doesn't mean that you don't have a sense of it or you're not actually in touch with it. But it means that it can surprise you as well. I'm sure that was part of the enlivening part of what happened. It probably was tough for the people who were trying to keep it organized and keep it under control. But Anand, to his credit, was also a very experimental kind of person, and became more so as time went on. Things seemed to work.

Rauschenberg taking photographs in Kuala Lumpur during a research trip for ROCI Malaysia,
September 1989. Photograph: Terry Van Brunt.
Photograph Collection: Robert Rauschenberg Foundation Archives, New York.

CHAPTER 6

Rauschenberg Overseas Culture Interchange [ROCI]

IF THE working projects described in the previous chapter were indicative of how Rauschenberg's ravenous appetite for more material drove him to travel, "ROCI institutionalized the artist's needs for such dislocation and the collaborative process."[1] In 1982, Rauschenberg made his first trip to China to work on a project at the Xuan paper mill in Jingxian, Anhui province. The Los Angeles print shop Gemini G.E.L. had initiated the trip to what was said to be the oldest paper mill in the world. Rauschenberg spent three weeks traveling through China, followed by two weeks at the mill.

Even six years earlier the Cultural Revolution would have made the trip impossible, and despite the initiation of Deng Xiaoping's open door policy, it was still very difficult. The central government had granted Rauschenberg permission to make the trip, but Chinese officials were suspicious that he might steal their papermaking secrets, so they insisted that Rauschenberg and his team stay forty miles away from the mill itself.[2]

Beyond the limitations placed upon him during his stay, Rauschenberg was taken aback by the restrictions placed on Chinese citizens' travel within their own country and how disconnected they appeared to be compared to him from the outside world. Don Saff was with Rauschenberg in China and remembers how a conversation between the artist and a local cook informed what would become Rauschenberg's work for the next decade.

He said that he couldn't see his family because he needed permission to go twenty miles away, and he didn't know what was happening there and he hadn't been there for years or decades. Bob started thinking at that time

that if these people didn't know what was going on twenty miles away, they certainly didn't know what was going on two thousand miles away and ten thousand miles away. This conversation—almost a singular conversation with this cook—somehow gave him the idea that what he needs to do is introduce the world to itself through his art.[3]

"There were moments when we felt like Marco Polo," Rauschenberg recalled of his experience in China. He was struck by the sense of isolation; "from one city to another," he said, "the Chinese didn't know what another person was doing." Special passes were required to travel anywhere, so people lacked information about what was happening in villages as close as ten miles away. What especially bothered Rauschenberg was his sense that people lacked curiosity. He said, "Without curiosity, you can't have individuality. It just doesn't exist. And without curiosity or individuality, you're not going to be able to adjust to the modern world."[4]

Rauschenberg had long viewed art as an important transmitter of information. The trip to China awakened a desire in him to use his work to share art and information across borders, enliven curiosity, and maybe even promote worldwide peace. Together with a team of dedicated collaborators, Rauschenberg established the Rauschenberg Overseas Culture Interchange [ROCI], which he hoped would act as a network for artistic communication on an international level. Pronounced "Rocky," after his pet turtle (previously best known for an appearance in 1965s performance piece, *Spring Training*), ROCI was announced at the United Nations in New York on December 14, 1984. The venue was emblematic of the project's scope.[5]

The plan was that Rauschenberg would go to countries in what he called " 'sensitive areas of the world'; developing countries crippled by poverty, countries with totalitarian governments, which have been isolated not only from American art but from their own artistic traditions, and Communist countries with which the U.S. [had] been in political deadlock."[6] He would spend time with artists and artisans there, study their artistic traditions, create in their environments, and engage with students. His aim was "to foster a dialogue with other nations through the language of art."[7] Rauschenberg spoke of his belief that "one to one contact through art contains peaceful powers and is the most non-elitist way to share exotic and common information."[8]

Rauschenberg hoped that the artworks he made for ROCI might change the way people see each other.

After many failed attempts to secure financing for the project, the enterprise was ultimately funded by the artist himself. "Absolutely nobody was interested in sponsoring," Rauschenberg said, "Which was terrific, because if you have a really thorough rejection then you have to act realistically."[9] Rauschenberg sold many pieces from his own art collection, including work by Cy Twombly, Jasper Johns, and Andy Warhol,[10] to fund what would become ROCI's overall budget of $11 million.[11]

For the nine years that ROCI was operational, Rauschenberg's life was a pattern of travel, artistic production, and exhibition. Mexico (1985), Chile (1985), Venezuela (1985), China (1985), Tibet (1985), Japan (1986), Cuba (1988), USSR (1989), Berlin (1990), Malaysia (1990), and the United States (1991) were included in the enterprise. In each case, Rauschenberg spent time in the country on research trips, traveling around for inspiration, meeting and sometimes working with artists and writers there, while his partner Terry Van Brunt documented the experience through photography and video. Each trip was followed by a return to Captiva to make the work inspired by his travels, and within a year or two, a major exhibit of the work was displayed in the host country. At the close of each exhibition, Rauschenberg left a gift for the country's people. As the show moved from nation to nation, it brought works from each of the preceding destinations too.[12]

To meet this demanding program, Rauschenberg had to dream up and then quickly execute new work. As then National Gallery of Art curator Jack Cowart wrote in the ROCI catalog, Rauschenberg was "testing himself during his late middle age to make deadline art in fresh circumstances . . . new art was needed to vary the ROCI message and fuel the dialogue. Under such pressures, his artistic instinct and rich associative memory had to play as crucial a role as his actual travels."[13] As was the case in the work he made throughout his earlier career, the 125-plus pieces Rauschenberg made for ROCI demonstrate both a building upon and a reinvention of the ways he used familiar materials and methods.

Picking up from the new acceptance of color he experienced in India, almost every painting made for ROCI featured "highly charged" colors.[14] In Tibet, the people's interest in objects mirrored his own, and Rauschenberg

was led to assemble "witty and engaging" sculpture comprised of "dissimilar, Dada-like parts." Although Rauschenberg had previously shown an interest in reflective materials, his paintings on "polished screen-like metals," inspired by the copper in Chile, are considered one of ROCI's "most important technical and visual developments."[15]

Equally important was Rauschenberg's return to direct silk screening, a technique he had developed in 1962.[16] In earlier incarnations, Rauschenberg had used images taken from newspapers and magazines, but in the work for ROCI, he used his own photos, and those of his assistants, infusing the work with "an immediate record of the information and facts about what he observed in each country. . . . We are given quick autobiographical and documentary glimpses of things, people and places visited by the artist."[17]

This emphasis on capturing and sharing information, infused the work with a distinct function. As Don Saff and Rauschenberg remembered it:

There was something about the way the art functioned in the exhibitions in those countries that rarely seems to happen here. It was less a commodity and more of a vehicle for human communication. In a sense, the audiences here see it as art; the audiences there used it as art.

What was it for them? Information. A new way of looking at things and an opportunity to see things that they might never have seen in their lives.[18]

From today's vantage point, ROCI can be seen to "mark a significant moment pointing not only toward the globalization of art but also to an idea of socially engaged or community based art." But Rauschenberg's hope to engage with the "world" as one large community was criticized by some Americans for being too ambitious and populist. In her review of the ROCI exhibition at the National Gallery in Washington, the *New York Times* critic Roberta Smith described it as "at once altruistic and self-aggrandizing." Another reviewer branded Rauschenberg an "art imperialist . . . [a] big-time visiting American aided by ambassadors and surrounded by his entourage."[19]

Whatever one's belief about Rauschenberg's work, intentions, or travel experiences, ROCI was exceptional in its scale. By 1991, more than two million people had seen a ROCI show, and to foreign audiences, "especially those in countries where freedom of information is unknown, the exhibition [made]

a powerful statement about America itself." With the Cold War coming to an end, and with it the dissolution of the cultural blockade between East and West, "ROCI positioned Rauschenberg, long seen as a quintessentially American artist, as a model of what an artist could do in a free society." As one critic wrote of the ROCI USSR, "To us, the show symbolized freedom."[20]

ROCI did coincide with the beginning of the globalization and diversification of the contemporary art system: art fairs and biennials were popping up outside of established trade centers, and artists of the former Eastern Bloc and of the world's developing nations were emerging in the international scene. "Rauschenberg's work on ROCI, somewhat contradictory in nature, torn between altruistic service and ego-centric self-aggrandizement, was nonetheless a crucial catalyst for the diversification of the global art scene in the years to come."[21]

The narrators in this chapter describe how the idea for ROCI as a traveling show emerged, how it was put together, and the political and cultural contexts in which ROCI operated. While bombs were going off down the road, ROCI tried to create a conversation. That conversation changed the nature of the art world, although it would be decades before this was realized.

EVENTUALLY WE GOT TO JINGXIAN

DONALD SAFF: Around 1977, Gemini [G.E.L.] wanted to organize a paper project in China. So they went to, I think, Fred Lazarus [IV], the president of [the] Maryland Institute College of Art. And through [the] Maryland art institute, they made a connection with a woman by the name [of] Chun-Wei Su Chien. Her husband was a physicist at [Johns] Hopkins [University] who was associated with the University of Nanjing [China], so they had really solid connections. And the object was to work at the Xuan paper mill, the world's oldest paper mill, in Jingxian, China. So Bob wanted me to go on the trip because I had coauthored a book on printmaking and I knew about paper making, and he didn't know what he was going to do. So he would bring me along as the technical person. We went there and traveled. I collected posters, which I had been collecting from my earlier China visit. I thought that that would be helpful to him, so we bought tons of posters on this trip. Then, on the way to

Jingxian, which is rather isolated, we went through the Yellow Mountains, and there we waited because they had decided that they didn't want us to go to the world's oldest paper mill because we might steal their secrets. So they kept us in the Yellow Mountains.

And I remember one day, while we were waiting—it was in the morning—we walked out on a balcony, we looked out at the mountains, and it was just like a Song Dynasty painting. You had these mountains that were going straight up with fog in between. It was right out of a scroll painting. And I'm looking at this scene, and Bob's looking at it, and he says, "Disappointed again. All they were doing was painting what they were seeing."

Eventually, we got to Jingxian, [but] they never did let us go to the paper mill. They claimed that the workers were in the paper vats nude and mixing pulp—they would stand in the paper vats nude. And, of course, Bob, given his proclivity, was very anxious to see this and claimed that he would not be offended by any of that. But that didn't work for them. So we worked in a so-called VIP compound. And at this VIP compound he was such a sweetie pie on so many levels that people who would not normally work a minute past the time they had to started staying there. Because they didn't understand. They didn't understand the work ethic, actually, of this guy who would get up in the morning and work—just never stop and keep going. So they started staying there—the chef started staying there and eventually started to teach Bob how to make dumplings. Somehow they all loved him.

CHRISTOPHER RAUSCHENBERG: [Bob] was in China, at a place where they do handmade paper [Jingxian, Anhui province, summer 1982]. There aren't that many places around the world where they make handmade paper, so he went to most of them. He was in China, and through the interpreter he was talking, as he would always do, to the workers. He wants to understand people around him, he's curious about them. So he was talking to the workers, and he was asking them, had they been here or there. And they said, "No, no, we're not allowed to travel. You have to have an internal passport to go to the next village, and you have to have permission. We're not allowed to travel." And he was horrified. It [was], like, that's the most terrible thing I've ever heard. There wasn't a way that he could change that; that wasn't something that he could change. But I think he felt [that] I have to do something.

DONALD SAFF: Before we left, Doug Chrismas was trying to convince Bob to do a world tour. Bob wanted to do something, but it didn't have a purpose other than just being an exhibition. It didn't make any sense to him. This conversation—almost a singular conversation with this cook—somehow gave him the idea that what he needed to do is introduce the world to itself through his art. And the way you would do it is go to a country, take their imagery, make art, show it to them, and then show it to other countries. He would go to countries that had sensitive issues. He certainly wasn't interested in going to England or France or any of those places. He wanted to go to places that had political or social problems and needed him being there so perhaps the art would make a difference.

So when we got back to Beijing, the idea was crystallized. He had made up his mind that there was going to be this world tour, indeed. But that the world tour would be fashioned in a way that it would do some good and that maybe it would contribute, in some way, to world peace. Now he wasn't naive about the notion of world peace. He didn't think it would happen because he did some sort of project. But he actually thought he could contribute in a significant way and [a] positive way. The plan was that Bob would go there and work with the artists in each country. That's the way it was promoted.

It didn't happen that way. The way it worked was that Bob would go and travel and get material, and he'd find everything—from feed bags, to tin cans, to whatever—and bring all this material back with him or have it shipped back. He would then go to his studio and make these works and return to the country with their imagery. That was the game plan. "We'll use your images, things that you're familiar with, and show you how it can be used in ways that you never conceived of using it." And that was the way he worked. The show was an additive process.

I'M GOING TO HAVE A TRAVELING SHOW

DONALD SAFF: And so by the time we left Beijing, he had conceived of the idea that he would give a work of art from each country to some museum in the United States, and a work of art to the people of each of the countries he visited. The people, not the government, because the countries that he wanted

to go to—Cuba, [the] Soviet Union, and others—he certainly didn't want to give it to the government. He didn't want to be seen as anything other than a citizen of the world. He didn't want it to be perceived as a vehicle for American imperialism and that he was a pawn in that activity. So he wanted to stay away from association with American embassies.

CHRISTOPHER RAUSCHENBERG: So that became the inspiration for his Rauschenberg Overseas Culture Interchange, where he said, "Well, I'm going to go to these places that don't get art, and they're not on the circuit, and the people aren't allowed to travel. And I'm going to have a traveling show that goes from one place like this to the next. It starts off in the first venue with work that I've made all over the world. And then it gets to the next venue, and it's work that I've made all over the world plus the city that I was just in. And I'm going to make work about your city where you are."

It was this traveling, moveable feast. Before the show, Bob would walk around and photograph to get images to make art of, but also picking up tin cans, picking up materials to make art with, so that he could make art about that place. And he would have Terry Van Brunt walk around and shoot videos, just, what does it look like to walk around in Caracas, Venezuela. So that when the show got to Beijing, where people were not allowed to travel, or to Havana or to Tibet, where people couldn't afford to travel, they could see, in addition to seeing all this work that was about these other places, and what's the soul of them, there was also, what does it look like to walk on the sidewalk in these places.

JANET BEGNEAUD: The whole deal about ROCI, [was] Bob felt that [if] people of different cultures and different nations understood and knew the people in other cultures, then there wouldn't be any reason to be afraid of them or to not like them. He wanted the Asian people to see what the European people were doing, and they were doing the same thing! They were going to work, and the wives are washing the clothes and cooking the dinners, and the little kids are playing on the playgrounds and going to school. We have to teach our kids to hate somebody. They don't start out that way. Bob was really, really just intent on these different nations and these different cultures being able to like each other and to understand each other.

1 *Mother of God*, ca. 1950
Oil, enamel, printed maps, newspaper, and metallic paint on Masonite
48 × 32 1/8 inches (121.9 × 81.6 cm)
San Francisco Museum of Modern Art
Fractional purchase through a gift of Phyllis Wattis and promised gift
of an anonymous donor

2 *Dirt Painting (for John Cage)*, ca. 1953
Dirt and mold in wood box
15 1/2 × 16 × 2 1/2 inches (39.4 × 40.6 × 6.4 cm)
Robert Rauschenberg Foundation

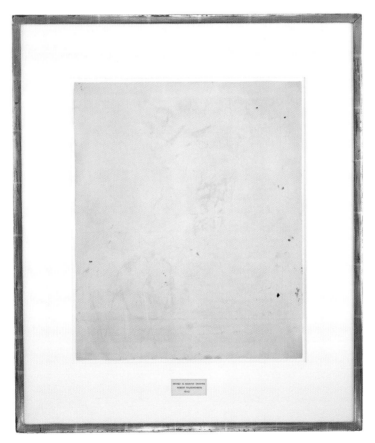

3 *Erased de Kooning Drawing*, 1953
Traces of ink and crayon on paper, with mat, and hand-lettered label in ink,
in gold-leafed frame
25 1/4 × 21 3/4 × 1/2 inches (64.1 × 55.2 × 1.3 cm)
San Francisco Museum of Modern Art
Purchase through a gift of Phyllis C. Wattis

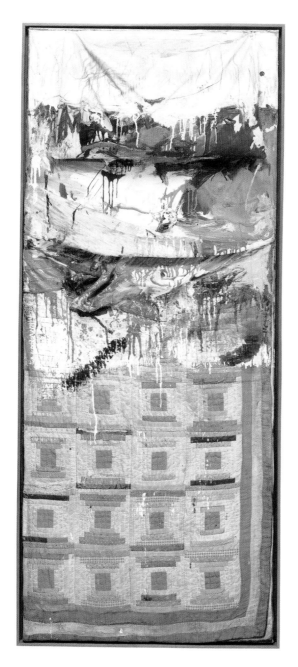

4 *Bed*, 1955
Combine: oil and pencil on pillow, quilt, and sheet, mounted
on wood support
75 1/4 × 31 1/2 × 8 inches (191.1 × 80 × 20.3 cm)
The Museum of Modern Art, New York
Gift of Leo Castelli in honor of Alfred H. Barr, Jr.

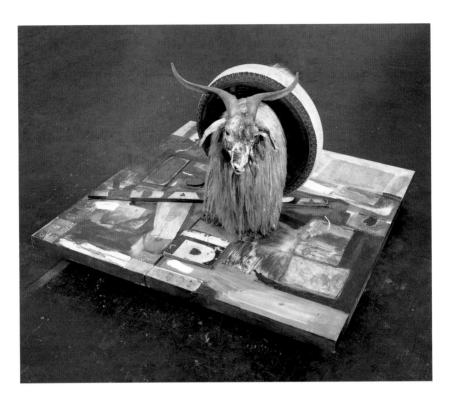

5 *Monogram*, 1955–59
Combine: oil, paper, fabric, printed paper, printed reproductions, metal, wood, rubber shoe heel, and tennis ball on canvas with oil and rubber tire on Angora goat on wood platform mounted on four casters
42 × 63 1/4 × 64 1/2 inches (106.7 × 160.7 × 163.8 cm)
Moderna Museet, Stockholm
Purchase 1965 with contribution from Moderna Museets Vänner/The Friends of Moderna Museet

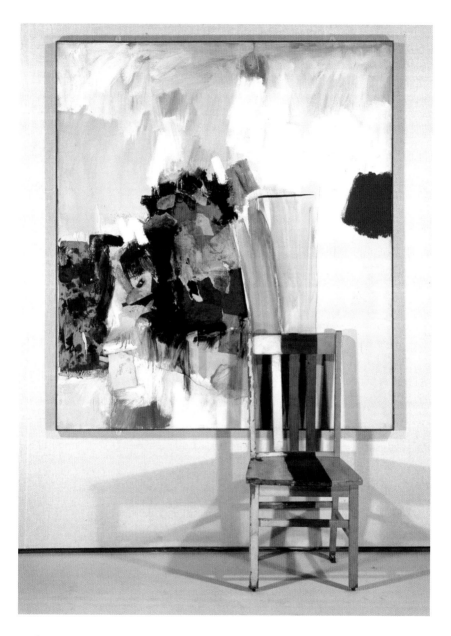

6 *Pilgrim, 1960*
Combine: oil, graphite, paper, printed paper, and fabric on canvas
with painted wood chair
79 1/4 × 53 7/8 × 18 5/8 inches (201.3 × 136.8 × 47.3 cm)
Private collection

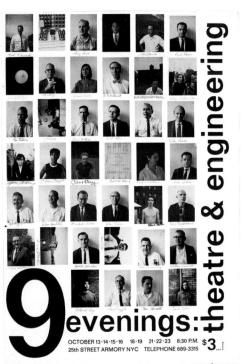

7 *Poster for 9 Evenings: Theatre & Engineering*, 1966
Offset lithograph
36 1/2 × 24 1/4 inches (92.7 × 61.6 cm)
From an edition of 90

8 *Acre (Carnal Clock)*, 1969
Mirrored Plexiglas and silkscreen ink on Plexiglas in metal frame,
with concealed electric lights and clock movement
67 × 60 × 18 inches (170.2 × 152.4 × 45.7 cm)
Minneapolis Institute of Arts
Gift of Robert Rauschenberg
Photo: Minneapolis Institute of Arts

9 *Baton Blanche (Cardboard)*, 1971
Cardboard
67 1/2 × 130 3/4 × 16 1/2 inches (171.5 × 332.1 × 41.9 cm)
Private collection

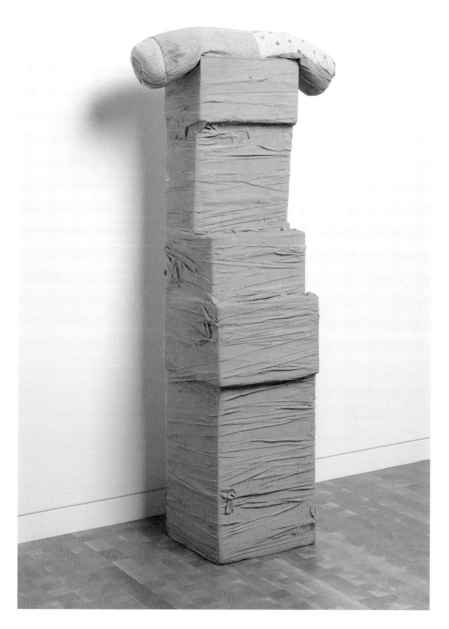

10 Untitled *(Early Egyptian),* 1973
Cardboard, fabric, sand, pillow, and Day-Glo paint
78 × 28 × 18 1/2 inches (198.1 × 71.1 × 47 cm)
Glenstone

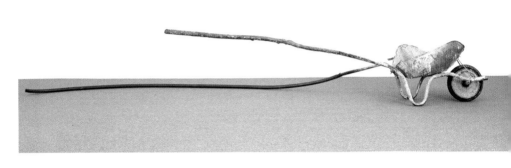

11 Untitled, 1974
Wheelbarrow, rubber hose, and wood stick
28 × 190 × 54 inches (71.1 × 482.6 × 137.2 cm)
Robert Rauschenberg Foundation

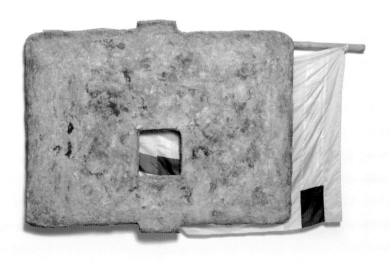

12 *Capitol (Unions)*, 1975
Rag-mud, bamboo, silk, string, glass and teakwood
34 × 53 1/2 × 4 inches; dimensions variable (86.4 × 135.9 × 10.2 cm)
From an edition of 10, published by Gemini G.E.L., Los Angeles
© Robert Rauschenberg Foundation and Gemini G.E.L.

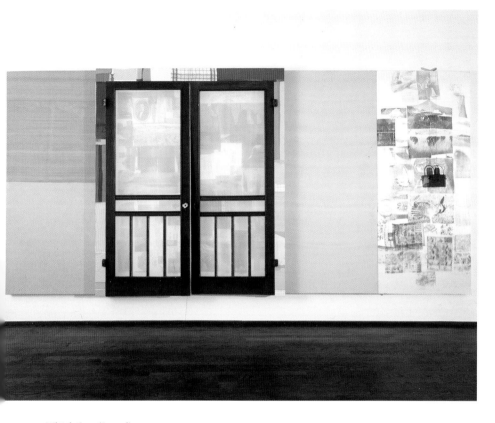

13 *Whistle Stop (Spread)*, 1977
Solvent transfer, fabric and paper on wood panels with objects and train signal light
84 × 180 × 9 inches (213.4 × 457.2 × 22.9 cm)
Modern Art Museum of Fort Worth, Texas
Museum purchase and commission, The Benjamin J. Tiller Memorial Trust

14 *Half A Grandstand (Spread)*, 1978
Solvent transfer, fabric, acrylic, and graphite, on wood panels with objects
72 × 252 3/8 × 2 inches (183 × 641 × 5.1 cm)
Robert Rauschenberg Foundation

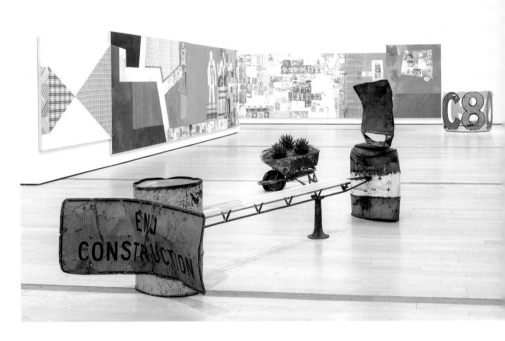

15 *The 1/4 Mile or 2 Furlong Piece* (detail), 1981–98
Robert Rauschenberg Foundation
installation view, *Rauschenberg: The 1/4 Mile*
Los Angeles County Museum of Art, 2018–19
Photo: © Museum Associates/LACMA

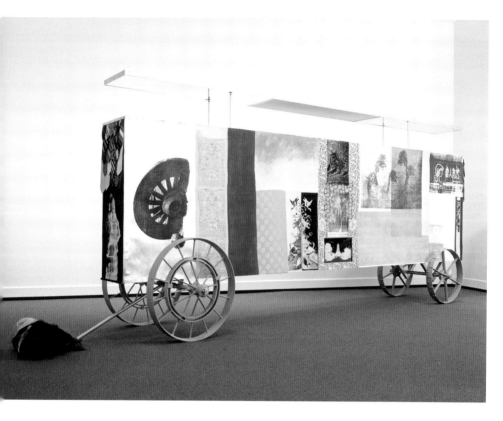

16 *Sino-Trolley / ROCI CHINA*, 1986
Acrylic and fabric on fabric-laminated paper, mounted on aluminum support, with objects
105 × 264 × 60 inches (266.7 × 670.6 × 152.4 cm)
National Gallery of Art, Washington, D.C.
Gift of the Robert Rauschenberg Foundation

DONALD SAFF: He was ready to go back and figure out how to finance it and all. Of course, at the time, he didn't necessarily think of financing it himself. This was a huge undertaking. He was going to get money. So we went back and he went to Fred [Frederick R.] Weisman. Fred Weisman was a difficult guy. A big collector, a lot of money. I guess he was a big distributor for Toyota. And Bob cut a deal with Fred Weisman, saying, "You can pick any work you want, before anybody else, from each of the countries I go to, if you help finance the exhibition." Fred agreed. And he came down on a few occasions to Captiva. I would meet him and he would pick works, and he would pick just extraordinary works. Well, Bob didn't like him. Bob didn't like Fred Weisman. And I remember Fred flying in—he flew in and I had to go meet him—and Bob would say, "I want to talk to you some more, Don. Why don't you stay here a little longer." He wanted me to be late. And so he delayed me like a good hour, hour and a half—just, "Screw you, Fred Weisman. You're going to wait." When I arrived there, Fred Weisman was so angry. He was just furious. Came in, picked out some glorious work. Once, he was flying back, and he said, "Oh, I'll drop you off on the way back." So I got on his jet, and during the flight Fred said, "Listen, this is what I want you to do. As you set up these exhibitions, I would like you to set up an exhibition of my collection to follow the Rauschenberg exhibition." I said, "Okay." I got off the plane, I called Bob, told him what he had said. And Bob had his guy call Fred and say, "I'm not doing the deal with you." So he never took the money, and he stopped the arrangement. Bob was not going to be exploited.

Then it was a matter of, "okay, well, we'll get money from United Technologies or the cigarette company, Philip Morris." So we spoke to people from these companies, and then it was like, no, we don't want cigarette money. And United Technologies makes bad things in terms of weapons. So maybe it's a bad idea to be associated with them. In the end, they didn't give us money anyhow—everybody turned us down. Since everybody turned us down, it was in Bob's interest to say, "I don't want anybody's money because that would corrupt the whole project." And so he wouldn't allow the project to be corrupted by outside money, although, God knows, we tried to get it.

Eventually, what was a way of turning the facts around actually became the way he really wanted it to happen. Because eventually Bob realized that it was the only way to do this with some integrity, and that ROCI had a lot of integrity.

He didn't sell work from that project. He devoted years—time. And he wasn't selling work, and he wasn't trying to sell any of the ROCI work.

Eventually, he had me work with Jack Cowart at the National Gallery [of Art, Washington, D.C.]. And, of course, at the time, the National Gallery had a rule that they could not have an exhibition of a living artist. And so how do we arrange a show at the National? We talked about having a show at the Met [Metropolitan Museum of Art] or at the [Museum of] Modern [Art]. But nothing made sense other than the National Gallery because that's the way he was doing it all around. And because his idea was that you would have the ambassadors or attachés, or whomever a given government was using in Washington, come to an opening, which Bob would sponsor, and he presented a work from that country to the National Gallery. And by having that event take place, he would get people together in a social setting that they would not normally be in, and therefore, he'd make some inroads into easing relationships.

He did have this in mind. Again, not like, "I'm going to create peace in our time." But he did intend to have these people together and, as he went to each country, to bring all these people back each time, so that these ambassadors and politicians and government agents would be together in a social setting. And he gave a major work, and he selected the best to give to the National Gallery.

JACK COWART: We started this artist room project at the National Gallery, which was endless loans from artists: Jasper Johns, Sam Francis, and we went on and on. If there was a significant gift component to an exhibition, and if the institution felt the artist was important enough, they would consider doing an exhibition provided [that] the National Gallery could help curate and make [the] decision about what work would come to the National Gallery.

So, in my fractured fairy-tale recollections of ROCI, which went on for so many years, it became an endless delight and a certain big distraction. I thought that we could make a deal that I would be able to curate the pick of litter from the best of the best from whatever country Bob was going in.*

* Narrator: The National Gallery of Art acquired one unique work from each international ROCI country as gifts of the Robert Rauschenberg Foundation, with the exception of the Union of Soviet Socialist Republics, for which Rauschenberg made two editioned series but no unique works, and Tibet.

We were very struck by the fact that Bob's idea was going to be to travel and to work in situ with the artists who were there, and it would be international. We were a national gallery, but we had international artists—European and American and Asian and everybody else.

Along the way, this began to intrigue [John] Carter Brown [III], my supra director, because he liked reliving part of his youth as well. He remembered Rauschenberg and contemporary art, and pop art was very much an EOB [eye of the beholder] at Harvard [University], and a very classical operation. But this represented some of *les affaires*, the joie de vivre of his youth before he got structured into blockbuster land, running big exhibitions and museums. It also appealed to John [Currie] Wilmerding, who was my deputy director. Basically, it looked like they would indulge a program like ROCI because nobody knew what ROCI was, from day one. It wasn't until later that we became aware that it was everything. It started out naively simple. Rauschenberg is going around the world, and the best of these works will come to the National Gallery. It will someday make a show, which is a summarization of either the acquisitions themselves, in the short version, or if it's the long version, then we'll figure out how much space we have for it.

I think that this course was appropriately subversive. I must say that we, in the twentieth-century department, certainly felt that we were helping to bring the National Gallery onto the beam of contemporary art, with living artists, practicing artists involved in many ways outside the general taste categories that had been established by the so-called West Building, which was the historic center of the institution, and to the new building, which had gotten up as far as [Jackson] Pollock and Abstract Expressionism. There was a Warhol in the collection that I inherited, *A Boy for Meg I* [1962], and some other early pop [art] pieces, but not many. Pop was considered to be a little common at that moment. Zero minimal, no conceptual—anything post-1965 was not yet there. This was only 1980-something. No muss, no fuss. You have [in Washington, D.C.] the Hirschhorn [Museum and Sculpture Garden], you've got the Corcoran, [and] the National Museum of American Art, at that time, for the Smithsonian. Other things were happening. It didn't have to be everything to everybody.

The National Gallery was elite and reflective and contemplative, totally not Rauschenberg by then. I think that amused Bob too. But I do think he had the

goodwill of Carter Brown and the support of John Wilmerding, and certainly our engagement, and Bob's infectious and sometimes overindulging personality, which always worried the very proper folks at the National Gallery. The show opened in Mexico [*Rauschenberg Overseas Culture Interchange: ROCI MEXICO*, Museo Rufino Tamayo Arte Contemporáneo Internacional, Mexico City, 1985]. For the first stage, I had decided that I would try to make the curatorial selection, which didn't go down terribly well with the Rauschenberg gang. It became very clear that Bob would make the decisions, or somebody on the Bob side of the line would make the decisions. It was not going to be curated by me. I would then vouch for it, and then this would be the assigned work to come to the National Gallery as part of the ROCI collection. We could go along with that. I would just be the buffer in between. I lost some curatorial control, but I didn't realize how much total curatorial control I had lost on the whole exhibition project anyway. It was international relations, and the National Gallery was very interested in international cultural exchanges. We were working with every embassy in Washington. We were an international arm of cultural diplomacy, and here's Bob out doing things like going to Cuba or Tibet or China. The notion was that he was another kind of ambassador. It may have been raggedy and rough, going to Moscow and all those places, but this was not outside the larger worldview of the National Gallery.

I went to Mexico. I didn't have enough time to go jaunting around the world because we were still running exhibitions, which were up and coming and going to be next, but I would follow them from afar and be involved in the published handouts and look at the work, and commune with either Don or Bob, or anybody else about what kinds of work were there. We would see that there was a nominated National Gallery piece. I had to follow the work because as I recall, it was still a fight to keep the show on the books.

In my department, we had to make sure that this was kept as a going concern, and that institutionally we weren't going to just put it into limbo. We also had to plan far enough out. We tried to figure out whether we would show the work independently, one at a time, or how it was going to conclude, whether or when there would be a grand finale exhibition. We kept moving goalposts to keep it within a planning sequence: when it was, if there was ever an end, and then who would expire first—us or me or somebody [else]. I do remember within the mechanics of the institution, not everybody in the

National Gallery world was happy about giving this much liberty to an artist, regardless—just on principle.

NOBODY KNEW WHAT IT WAS

JACK COWART: It wasn't about Bob; it was just that he was part of the blunt edge of where we were moving. The exhibition planning office could plan this thing out of existence in a pen stroke by saying, "I'm sorry, we're moving *Angkor Wat* [*Sculpture of Angkor and Ancient Cambodia*, June 29–September 28, 1997] to the National Gallery, and therefore there is no room for their show, ever." *The Treasure Houses of Britain* [*: 500 Years of Private Patronage and Art Collecting*, 1985–1986], all these massive exhibitions, [*Circa*] *1492* [*: Art in the Age of Exploration*, 1991–1992]—we would take everything and it would just clear the deck. There is no East Building anymore; it's turned into the "show palace." So there were times when we had to have meetings where Carter Brown, John Wilmerding, my department, and the exhibition planners were all in a room, and Carter would have to say, "We keep this on the books." He would leave the room to go to another meeting, [and] two minutes later people are trying to cancel it. Five minutes later, I'm calling Carter to get back in the room to remind them what he just said, because he was the supreme authority. He would say, "What don't you understand, boys and girls? This is going to be a National Gallery project, this is going to happen. Got it?" "Yes, boss."

Nobody knew what it was. It was a pig in the poke. When the National Gallery did an exhibition, before the commitment to the exhibition there was a full slideshow by the curator of everything in the exhibition. You sat there in front of the exhibition planning committee, which included a lot of other people, the development officer, PR people, the treasurer, all these third parties. It wasn't just done by curators having fun; they were not going to give you hundreds of thousands or millions of dollars just because you like an idea. You had to prove it up against every other potential show. So with the exhibition planning committee, you had no control of your destiny. That was one of the most exhausting parts of the National Gallery, in my opinion. I had to fight daily to maintain the status quo. The status quo was that we were going to have a ROCI show, and you had to fight to keep that every waking moment so you didn't get cut off at

the pass. We would never make the decisions about what was actually going to be an exhibition; it was a committee, of which I was not a representing voting member at that time. Now, under [Earl Alexander] "Rusty" Powell [III], it's an entirely different system. But if Carter didn't like it, it wasn't going to happen.

DONALD SAFF: Brenda Woodward was my long-term assistant at [the] University of South Florida. An absolute whiz as a—you're not supposed to say "secretary," but she was that to begin with. And then she was my assistant [and] sometimes traveled with me. Thomas Buehler was in charge of shipping the work around. That, fundamentally, was the working team.

Basically the methodology was for me to travel to these sensitive areas and come back to Bob and make suggestions. So that, for example, you go to Peru—and I was in Lima and the Shining Path was really active. And it became clear to me that Bob would be in jeopardy, as would the show, especially at that time—that that would be a good opportunity for them to create problems. So I would go back and say to Bob, "This is a problem. It's a great place for you to have a show, but bad idea." The records were kept by Brenda, and Thomas facilitated the shipping.

ANNE LIVET: I think he had to do the tour for the same reason he had to collaborate with dancers. He was the most inclusive of artists, and he wanted to include the world. I don't know much about the art he made during this time and whether it was great or not, but it was the proliferation of everything he believed about making art.

DOROTHY LICHTENSTEIN: He really put everything he had into it. He sold a lot of work that he owned to raise the money to do this. He traveled to New Guinea, he had a show in Venezuela. He was so happy, he got the Venezuelan Air Force to actually fly his work to wherever the next place was. He thought this is really something. I've got the air force, and they're using their planes to transport art.

Bob just refus[ed] to give up. [He] really want[ed] to make that happen. People don't even realize [or] know about that very much, I mean, that aspect of Bob. But he said to me, "Well, I never wanted to be some kind of boutique artist." I mean, he really wanted to interact globally. And he was early at that.

Now everyone's talking about global this, global that, but you know, at that time there was no internet, there were no cell phones.

THOMAS BUEHLER: It started here [at 381 Lafayette Street]. We got loan lists together. Mind you, this was before computers. Just on the edge of computer time. So we had the loan lists typed, and then when there were corrections, we whited-out the page or we cut out something with paper and glued the replacement line over it and made photocopies. [Later] RadioShack [came] out with a little miniature thing that had four lines of eighty characters apiece on the display, but at least it had a memory. I typed our entire inventory into that little computer, and it had a battery-powered printer. So suddenly you had a little office, and you could make lists and we could sort things.

Rauschenberg's friend and CPA [certified public accountant] was Rubin [L.] Gorewitz, and he kind of ran the office for ROCI. There was a company formed called Cloud Management [International], and Cloud Management did all of the negotiations with the shipping companies. Rubin Gorewitz was friends with the president of [DB] Schenker USA. This is not insignificant in a weird way. Schenker is a big German company. They're affiliated with the German railway system, and they had an office on the fifty-second floor of the World Trade Center [New York] as Schenker U.S. Art Division. Schenker made all those promises to Rauschenberg, "Oh, yeah, we'll take you around the world, and you'll get free tickets, and we'll get free charter flights." They're huge, they're a gigantic company. They relied on that so we said okay, we don't have to deal with that much. They do all this because they're a big company. Charlie Yoder and I had to go every now and then to their headquarters in the World Trade Center and give them all the lists and all the changes and things like that, so they could stay on top and prepare the steps along the way as they evolved. That was a lot of administrative work. That pretty much backfired.

THERE WAS NO DRY RUN

THOMAS BUEHLER: On the first trip to Mexico, we had all the crates built by Crozier [Fine Arts, New York]. It's now a big art shipping company that still exists. We had three, four, five tractor-trailers going out to, I think, Stewart

Air Force Base [Newburgh, New York], north of Manhattan somewhere, on the other side of the Hudson [River]. It was also a civilian airport, but not of significance. It was an airbase. They said, okay we have a C-130 charter that's a Hercules cargo plane, and the crates need to be there at so-and-so time. We had sent them loan lists and crate lists and dimensions lists ahead of time. We were lining up all the crates on the tarmac, no roof, it was a beautiful day. The plane landed and the guy in big cowboy boots came walking toward us with a British accent. They said, "Oh this is the loadmaster," and he looked at all the crates and said, "What the hell is this?" We said, "Well that's the load for Mexico for you." He said, "It won't fit." "What do you mean it won't fit?" It turned out that Schenker, when they studied the art lists, obviously they didn't have much experience in art. We had the dimensions for all the crates, but in the art business you always have the height first and then the length and then the width. That's the rule. We sent them this list, and they just cubed it out and said so-and-so many cubic feet, it will fit. But the plane is round and crates are square, so they miscalculated by literally one hundred percent. We were already in the red by one hundred fifty thousand dollars when we landed in Mexico. They turned around and made a second trip. As simple as that.

My wife and I were on the first trip. She had the little dog that we got in India, the Lhasa Apso. We were sleeping in the plane on top of the crates on the way to Mexico with a doggy between us.

[Mexico] was the first venue. There was no dry run. This was it, and it worked really well. I think we were well prepared. I'm known to be a true fanatic. The first thing we built was a mobile office and a mobile tool shop. It was a crate about the size of this table here in volume, and it opened in the front. It also had a little trap door on the side. It arrived with the crates with something called a J-bar—a Johnson bar. It's a lever that you put under heavy, big crates to get them up and rolling and onto dollies. I had designed this crate so the first thing you do is to get that thing out so you can move crates. Then you open it up in the front, and there were dollies in there and there was a little stove and we brought astronaut food, freeze-dried things so we were independent, and there was a toolbox in there, of course. There was a little compartment for dogs so there was a little bowl. We were really well prepared. Wherever we went throughout the tour, they always said they'd never seen anything like that. I had all the tools.

Bob was always very generous with all things that we did. I'm more frugal. I've never had much money anyway, so I didn't have huge amounts to spend. To suddenly have a Rauschenberg credit card in my pocket was a different ballgame. I called him or his accountant every now and then and said, "Are we over budget? Are we too expensive?" He'd say, "Just do your thing. Don't worry about it. You'll know." It never happened. He was always very generous. "Just do your thing. I worry about the art. You worry about storing it and moving it."

DELI SACILOTTO: I was definitely not on [the] payroll. I would just be there; if they needed a hand with anything, then I would help them. But basically I had no particular work to do, specifically. I mean, the fact that some of the works that I had done with Rauschenberg were being shown, that was my entrée into the whole world of Rauschenberg. So I was just another person whose plane flight and hotel were paid for, and so it was just another expense that they had, along with their whole entourage. In the entourage, of course, you had people who were hanging shows, who specifically had tasks they would do. And, of course, since I was there and other people were there who didn't have these specific tasks, we were there to help if need be. I would sometimes go over and help with hanging a picture, or doing this, or some other thing. But there was no specific task that I had to do.

THOMAS BUEHLER: You always depend on the crew in the museum, and they had a great crew. If I remember, there were also people from Bob's studio in Florida who came to help install. It was a beautiful museum, Museo Rufino Tamayo. It was built for the famous painter. There were some issues, of course, like everything else. The museum wanted to sponsor their namesake artist, so when you got into the museum, as per their plan, you see Rufino Tamayo works first. The artistic director of ROCI, a friend of Bob Rauschenberg's, [Donald] Don Saff, he was there most of the time, ahead of time, and also when we were there installing. He did all the dirty work, the discussion and negotiations with the director. They managed to get the Rufino Tamayo put in another room, so when people came into the museum, they saw Rauschenberg with the big show that was advertised.

DONALD SAFF: [He gave] a work of art to the people of the country that he had visited. Of course, how he gave it to them also was a thorn in their side. For example, in Mexico, he wanted to give it to Tamayo's paramour. Not the widow. Her name was Lola. It was an in-your-face kind of thing, so that the museum director at the Rufino Tamayo came to me and said, "The government is outraged. You're giving it to basically a prostitute for the people." She was, however, much beloved by the people. The director said it should be going to the government. Well, Bob wouldn't give it to the government—just wouldn't do it. So there was this big standoff. He wants to give the work, they want the work given to the minister of culture. Bob didn't give in. He did not give in. It was very awkward. And, of course, I was caught in between all these things.

He sure made it entertaining. And so the work went to the people through that conduit, and basically that's what happened in each of the countries. He tried not to work with the government of that country, and he didn't work with our government. And he wanted this to be a people-to-people activity.

It went to the Tamayo Museum. [*Forecaster*/ROCI MEXICO, 1985, was given to Centro Cultural/Arte Contemporáneo, Mexico City.] But he didn't want it to come to the museum through the government. If he could turn the knife, he would. To make a point he would do it.

THOMAS BUEHLER: The next venue after Mexico was Chile. Rauschenberg went there first to look at it and travel, a year before or something like that, and take pictures and gather materials. In Chile he went to copper mines and took copper, went to foundries and smelting companies, and was impressed with that. So the Chile series are all on copper and gorgeous.

RICK BEGNEAUD: Chile was very hot politically; he went to a talk with a lot of [people]—I don't know if they were students, exactly, but the younger crowd—the place was packed. It got a little hostile there. You could hear bombs going off down the road, with the [Augusto] Pinochet thing happening. I didn't totally understand what was going on at the time. But it was pretty wild what was happening, and people were freaked out living there. Of course, Bob was a peacemaker. He was there, like, "Look, I'm here to help generate conversation and peace, I'm not taking sides. I'm just here to open some communication up."

They were really trying to put Bob on the spot. You didn't always see Bob get upset, but you could tell he was a little tense that day, and really trying to defend himself: "If I'm taking a side, I would be taking your side. I'm not." He had to really be careful what he was saying because we were in a foreign land, a hostile foreign land, so to speak. And you don't want to get on anybody's bad side. Bob can talk between the lines a little bit. He could talk between the lines sometimes and say things clearly but abstractly, and [he] kind of left it up to you to figure out what he was really trying to say without having to say it outright. He was very good at that.

WE WORKED NONSTOP UNTIL THEY SHIPPED ROCI CHINA

THOMAS BUEHLER: I would arrive first most of the time, and then the trucks would arrive, or I would travel with the art in cargo planes. The venue after Chile was Venezuela [ROCI VENEZUELA, Museo de Arte Contemporáneo de Caracas, 1985], and they came up with an idea. They said, well, air cargo is really expensive but we have an air force, and we can have air force planes bring the art from Chile to Venezuela. I was supposed to have a meeting with a Major so-and-so on the way back from Chile to New York. In Caracas I had the meeting, and we discussed the logistics, how we can do this and when and who and where the trucks go. They also had C-130s, cargo planes that load from the back. The back flops down. I said, "So how do we do this? I bring a whole stack of money?" They said they would provide the crew and the plane, but we had to pay for our own jet fuel, which was about forty thousand dollars if I remember correctly. I said, "Well, what do I do? Do we have a wad of money and then pay at the pump or something like that?" He said, "No, no. No cash. You bring cash, we'll lose the plane and the crew and you and the money." He was a major or something like that. They didn't trust their own pilots. They said, "No, no. We'll make an arrangement." It was a good thing Schenker was well involved in Germany. They contacted Lufthansa, and Lufthansa has a station in Lima, Peru, I think—or Quito [Ecuador]—and they said okay, that's the halfway stop. We'll fuel up there, and we'll pay the Lufthansa agent in Lima. They had a station there. They pay for the gas and you pay us, so no money changes hands. That's how we did it.

LAURENCE GETFORD: The way I formally got involved with Bob, working, was because I had been a sculptor, and Lawrence Voytek was also a sculptor. When they were working on ROCI CHINA, he called me up and said, "Have you got a couple of days you can come help us? We've got to ship on Wednesday." This was maybe the Sunday before, or something. Because he knew I knew my way around fabrication, he said, "Can you just come out and help us for three days," work the weekend. So we worked pretty much nonstop until they shipped ROCI CHINA. I think the first thing I actually worked on was *Sino-Trolley* [/ROCI CHINA, 1986], which is a large piece with wheels and a yak's tail on the front.

We arrived, I think, in the afternoon, and we worked until four in the morning. Then we all went over to the Beach House, and we went to sleep. They had a gym downstairs, a gym and a ping-pong table. There was always a ping-pong table. I remember we worked until we were absolutely fatigued, found places to sleep, I think I slept on some sort of shiatsu massage device until maybe ten in the morning, and then we just went at it again. We did that for several days until we were done, until we were ready to ship. People would bring whatever we needed so that we wouldn't stop working, and, of course, there was always as much food and alcohol as you needed to fuel the fire.

THOMAS BUEHLER: China was quite something. There were no cars in the streets, and there were five thousand bicycles at any given time of the day. It was winter, and they had open trucks at the airport. When they picked up the cargo from Beijing airports, Lufthansa had open trucks, and they threw blankets over the artwork. Unimaginable, even at the time, for U.S. art shipping standards. We got them to the museum, the national gallery of art [National Art Museum of China, Beijing]. Huge, gigantic, and filthy as hell. We got crews together through the museum and through the Ministry of Culture. Mind you, I speak Spanish, but I don't speak Chinese. So they assigned us an interpreter through the Ministry of Culture who was supposed to be with us at all times, but so many things went wrong.

We had [a] limited power supply. It was winter, it got dark early, and we only had so many kilowatt-hours per day. They would look at the meter and just turn off the power when we had reached our quota. Then they would lock the box. It was four in the afternoon. I said, "Where's the electrician?" He just

left. He's on the bicycle. You see five thousand bicycles and one of them was the electrician. I did that for one day, and on the second day I took a little crowbar and broke the thing open and switched on the power and said, "Come on, we can do this." I think the lock is still broken to this day because they were really inactive, passive. Of course, every time something happened and we wanted to complain, they withdrew the interpreter so we were without a voice. The interpreter just went for lunch, or was not there.

Rauschenberg was there, his nephew was there, Bill Goldston from ULAE [Universal Limited Art Editions, West Islip, New York] was there with his younger son, and everybody helped. It was a huge show. Gigantic. The museum was gigantic, and Rauschenberg was afraid that it would look empty, so he had added umpteen tons of work that we shipped separately from what we had before, just to make sure the show wouldn't look empty. We had some electric works and some electronic works, twelve TV monitors traveling with us that were running at all times, two stacked together with either comics or Rauschenberg's travelogues, or one part would be his biography. They were hugely popular in China. We had to lock them up during installation because the crew would just sit and watch TV when we made test runs. We had to put those in a separate room. We had to test them somewhere else.

ART WAS SACRED FOR THEM

ANNE LIVET: For the China opening, I had arranged our tour through the curator of Chinese painting from the Metropolitan Museum of Art, who accompanied us. We brought a chef out of hiding in Beijing; they were in hiding because it was still the Cultural Revolution. And he cooked a Peking duck dinner for Bob at a restaurant that they opened for us. It was great. It was a fantastic trip.

At that dinner, he was adorable, just adorable. He was so excited that we were there and he was so excited about being in China and even more excited about the people he was working with. I just remember him telling stories. He loved to tell stories about how complicated it was to get the installation up. You ask for an extension cord, and they bring you a rope—things like that, challenges along those lines.

THOMAS BUEHLER: [It was] a huge success. Everyday there were lines of people, four abreast, around the museum to see the show. Gigantic. [People responded] with disbelief. They had never seen anything like that. Especially artists. I read [about it] every now and then still. There's a young woman, a Chinese woman I think, who just wrote something about ROCI in China, and there's another one who wrote about ROCI in Berlin. Especially in China, we made a deep impression on the artists. To this day they still talk about how much Rauschenberg's appearance and his art, and seeing his art, has changed the Chinese art scene.

While the Beijing show was up, we were preparing the Tibet show in Lhasa, in Tibet. So again, the air force flew the art. The woman who had helped organize ROCI CHINA was [Dr.] Chun-Wei [Su Chien]. Her husband was a medical doctor in Baltimore. [He was] Chinese, well connected to the Chinese government, and he made the bridge into China. They made this happen. Chun-Wei was there as Bob's interpreter and also as a liaison to the Chinese officials. We were having the show installed, and we knew we had an airplane. I said, "Well, what kind of airplane is it? What size?" Bob had selected works and television sets and all sorts of things for Tibet and had everything in crates, but we didn't know how big the plane was. Again, volume.

[The] crates are big and bulky—a lot of it was sculptural work for Tibet. So how about we unpack all those other crates and just ship them wrapped in blankets, like what we do locally here. Like, a sculpture gets wrapped in moving pads and blankets and gets put on the truck. It's safe if you're with it and know how to deal with it.

As it happened, China had what they called a bumper harvest in those long cabbages, Chinese cabbages. They had so much cabbage that when you went to the city, they had cabbage on the balconies and they had big piles of cabbage with down blankets over them to protect them from the frost. There would be a guard next to it or someone with the party armband who said he was watching cabbage. I said, "I see all of those blankets on the cabbage there. Those are good, and they have down fabrication, and they make down jackets and down blankets and comforters. Why don't you find us like a truckload of down blankets, and then we'll wrap the art in that and we'll be fine, I guess," which we did.

The truck was not the prettiest, but nice and thick down blankets arrived. And we wrapped everything in those, and put the crates in the museum.

They had lots of space there. So the truck arrived, an army truck. We put everything on two or three trucks, I don't remember. We were going out to the airbase and it was an almost identical plane to the C-130 except it was Russian—Antonov [An-12]—but the same loading principle; drop the back, load the art in, boom. It had a cabin with six seats for people to travel with it. So they loaded it up.

To fly to Lhasa, you had to fly to Chengdu in Sichuan in western China, and then you could only fly to Lhasa, at the time, at a certain time of the day in the morning because you literally fly through the mountains. You don't fly over the mountains, you fly through the valleys, the Himalayas, and there's a certain time window where you can land in Lhasa because of wind and fog. You lose that and you go back. So we went to Chengdu.

They picked me up at the hotel, and there was this long line. We were getting closer to the plane way out on the tarmac. They had armed guards around it. I mean, art was sacred for them, valuable. That was the word, "valuable" American. So there were long lines of rickshaws and people with vegetables and fruit and things like that, and there was a scale and the crew of the plane took each crate of fruit and vegetables and weighed it and put it in the plane. I said, "What the hell is going on here?" Well, there was no fruit or vegetables in Lhasa, and there was a Chinese garrison there. These guys, the pilot and the copilot and the other officers, were buying this fruit in Chengdu and selling them at maximum profit in Lhasa. Of course, we had tons of space. It was a huge plane. Half the plane was loaded with fruit and vegetables and the other half with Rauschenberg art and materials. Usually the C-130 gets flown with two or three people at the most. They had, I think, thirteen people on board. I think they all wanted to take a little vacation and go to Lhasa, and there was extra room behind the cockpit for all the people sitting on benches, strapped in.

It was a long haul to Lhasa from the airport. It was a couple of hours in an open truck and bad roads, and I was like, ugh, my God. "Go slow guys. Please. We have fragile art." Not extremely fragile, not ceramic, but still fragile enough for bad roads like this and bad trucks like that. We made it. It was not a museum. It was called the Tibet Revolution Exhibition Hall [Lhasa], and it was built at the foot of the Potala, the Dalai Lama's palace on the mountain. There were all these temples around the foot of the Potala, and all the Tibetan

pilgrims and Buddhists had come to Lhasa to honor the Dalai Lama and Buddha. They go from one temple to the other and turn their prayer wheels and put a little yak butter on their idols and things like that. The Chinese built that exhibition hall right in that path where all the pilgrims went from one temple to the other, with the mandate basically for them to go into that exhibition hall where the Chinese explained why Tibet is really Chinese, because some Chinese prince married the Tibetan princess in 1400-something. That was their way of explaining history to whoever wanted to know or not to know. Apparently at Bob Rauschenberg's request, they changed the name of that hall from Revolution Exhibition Hall to Lhasa Art Exhibition Hall and changed the writing on the wall.

We arrived there, and it looked pretty bad. We brought our own light system that I had bought previously, and they said "okay, we have paint and all this, and what do we do?" I said, "We'll make a solo gallery out of it." We had them clean the floors and repaint the walls, and we had the lights adjusted. It looked great, looked really nice. And we installed the show.

The exhibition hall was on street level, so two people had special jobs as guards. One was at the door, and he was to make sure that the cows didn't wander into the exhibition. He had a big stick, and every time a cow came near, he raised the stick so the cow would shy away and go on its merry way. The other person was in the exhibition hall, and she was supposed to prevent the pilgrims from doing what they do in the other temples: smear yak butter on the artwork as a sign of appreciation. They said "Uh-uh, not on this." It was great. People came in. It didn't happen like that. Bob always said, literally, they had their goats over their shoulders as they came in to look at the art. It was very folksy. Very nice. The show was gorgeous.

Just before they had had a show for agricultural education, and there was a stuffed pig behind the museum, lying on its side in the dirt. Bob saw it and said, "Can I have that?" I said, "Sure, I'll ask, and see how we do." They said sure, "We're throwing it away." It was okay. It was in good condition. A little torn on some parts. We had to make a crate for it, and, of course, there were no materials there. I scrounged from what we had and what they had in the museum and I built a crate, and I put that pig in there and we shipped it back to Beijing with us.

OH, MAN, CUBA

THOMAS BUEHLER: Oh, man. Cuba. Don Saff had, I think, a relative who had contacts through the special interest section of Cuba in Washington. The United States had something, and Cuba was in the Swiss Embassy, I think. They took care of Cuban interests, and Don Saff knew somebody in Washington. So they got this together.

Then, of course, the next question was, how do we get everything there? It turned out that at Havana Airport no runway was big enough for 747s or other big cargo planes, and, of course, the U.S. Air Force was out of the question to Cuba. Then the Cubans said, "We have a shipping line that runs from the Soviet Union, at the time, Kamchatka, the peninsula in the Soviet Union, very close to Japan. We have a ship that flies regularly between there and Tokyo. If you agree, we'll put the containers on the ship. It's going to be a four to six week journey. We communicated that to our insurance company, and they said absolutely not. Those ships are known to be unreliable and to make stops somewhere and maybe take up other cargo. They always have space—the Cuban economy is down—and they hardly have any cargo to take back, but they always take up things on the way if they can get it. If they unload the containers somewhere with the art, then we're screwed. So somebody has to go with it. Me.

Now it gets very curious. They had a ship in China—for six months in drydock to clean the hull and take the mussels off and repaint—that was just on the way back from China through the Soviet Union where they take diesel, because the fuel was cheaper in the Soviet Union than in Japan. They said that the ship would be here soon. Well, we were ready. We had everything in order. Everything was de-installed at the museum and loaded at the shipping company. The ship arrived, and I said, "I can't believe this." The ship was named *la Bahía de Cochinos*—the Bay of Pigs. Just like the big battle with the Cubans against the Americans.

On the way, it took forever. It literally took forever. I went up to the bridge at night usually. Again, I speak Spanish so I was able to become friends with the first officer and usually when he was on duty I was there. In the daytime, we

went on the Pacific [Ocean] and the Pacific did what its name said; it was very peaceful, very nice for that six weeks or four weeks.

Two things. Before I went on the ship, the agent said, "Well, I can advise you to take some fruit with you. Take a crate of apples or pears or whatever is available, and take a case of Coca-Cola with you." I said, "Okay, sounds like good advice." As it turned out, fruit and vegetables ran out pretty much after we passed Hawaii, or even before that. We didn't have much fruit and vegetables. They always had pork. They had freezers full of frozen pork, and beans of course, and then they'd fish every couple of days. They'd slow down the engine to four knots, and the cook would be on the deck and fish. Sometimes things that were illegal, like big tortoises. But they didn't care. They had a big tank of Cuban rum on this ship, and they said you could trade Coca-Cola, because they can make *Cuba Libres* in mass quantities but they don't have Coca-Cola. I had two cases, small bottles of Coke. So that came in handy. We became friends. There were forty-five in the crew, three shifts.

They were all Cuban. They were all in a bad mood in the beginning because they had been in China for six months. Whereas the captains had been flown in and out, the crew was on the ship for six months in Shanghai or somewhere, and they wanted to go home. They just wanted to go.

Then we passed Hawaii, and of course they couldn't stop in Hawaii because it was American. They wanted to watch American TV, over the airwaves. Not digital TV and all that. So they had all these homemade, handmade antennas that they stuck out of their cabin windows, and they were always watching grainy pictures of American TV.

The ship was really slow. We had a handwritten note from Fidel Castro—a photocopied note on the bridge to ask the comrades to preserve fuel and not go faster than seventeen knots, which is really slow for a cargo ship that goes twenty. So that's why it took forever. The first fruit and vegetables they had was when we got to the Panama Canal and an agent came alongside with a launch, and they hoisted crates of fruit and vegetables. We finally got to Cuba, and it was heartbreaking because all the families were on a long pier, saying, "Pablo, Pedro!" It was heartbreaking. Then we got there and the next adventure started.

There were two venues that were scheduled officially. One was the National Museum of Fine Arts [Museo Nacional de Bellas Artes, Havana] and then something for a show of Rauschenberg black-and-white photographs and

prints in something called Casa de las Américas, America House, [at the Galería Haydée Santamaría, Havana] that was dedicated not only to U.S. America, but to America as Latin Americans see it, as all of America, including north and south; *las Américas*. They were dedicated to poetry and journalism from the Americas, and a show of the black-and-white photographs was supposed to be there.

For some reason, Bob had seen a little octagonal building around Castillo, if I remember, at the mouth of the harbor, Castillo de la Real Fuerza [Havana], and fell in love with it. "Can I see that from the inside? Do they have shows on the inside?" It was used for storage for old office furniture and refrigerators and stuff like that, and it was in pretty bad shape. Bob said, "I want part of the show there." The ceramic works and things like that. It had raw rock walls. No glass on the windows. Shooting slots. So they said okay, we'll clean it out and we'll make it ready for you. We'll have Plexiglas windows made so the salt spray wouldn't come in, and put little frames in those little slots. We had meetings and, of course, Bob wanted certain works installed there, and you have to drill holes in the wall. And suddenly, after it was in bad shape all those years and they had all their furniture stored there, they say, well, it's a landmark, and you can't drill any holes in the walls. There were thousands of holes from other things that they had hung there, but now suddenly it was something precious. Of course, we were all very positive in meetings and all that, and so, well, not a problem. We'll construct something out of two-by-fours and lumber, we'll use the existing holes to anchor them, and then we'll mount our artwork on that. It sounded great, and it was pretty convincing in the meetings. It didn't work. It didn't work at all.

They had given us a chaperone—like a guard—and he was there also to make sure we didn't do any damage to the landmark. We thought we had to do something about this. We got to be friends with this guy. He was always sitting there half asleep. "Would you go and get us some water? A couple of bottles of water?" Then we would drill our holes, or we'd cough and drill the holes then. It looked great. It looked really, really, really nice. I had saved all the dust that came out from the walls, like what we do here all the time when we install art—we collect the dust that falls down in envelopes under where you're drilling, so it doesn't fall on the floor or the carpet. We had all the rock dust collected and when we de-installed the show at the end of the exhibition, we mixed that with

epoxy and it had exactly the same color, and we fixed all the holes. It looked better than before. It was good. We fixed the walls.

It was a big success. Cuba was great.

DONALD SAFF: I flew directly. Eastern Air Lines, at midnight, would become ABC Airlines. And at midnight, you could get on an Eastern Air Lines flight, and they would put you in Havana. The engines were never turned off. You got off the plane, and they took off again. It was Eastern Air Lines staff, an Eastern Air Lines pilot—he's sitting on the plane—and they had some sort of arrangement where they could go in under ABC Airlines at that time. So I just flew in directly. You were supposed to have a treasury license in order to go there, and I didn't have that.

That's when I started getting calls from Marian Javits who was just beside herself, especially since I was flying from Cuba to the Soviet Union. She wanted to know why we weren't going through the State Department, and I said that we weren't working with the government. She said, over the phone, "You and Bob are a bunch of fucking communists!" and slammed the phone down.

We tried to avoid that. It was a problem. It was a big problem for me because at a certain point I could not return to this country without being interviewed both by the CIA and the FBI. And it was absurd because the information they could get from me they could more readily get from *Time* magazine. But they did have a lot of questions about who I met with and what I thought each person did—especially in the Soviet Union at the Artists Union [Union of Artists of the USSR], by name. They knew the people by name, and they wanted to know what each person did. I was obliged to meet with these people as I got back, and it became [a] standard routine. I don't think they ever bothered Bob, but they did hound me a lot.

They would ask questions. They'd give me a name and say, "What does that person do." I'd say, "That person's in charge—as far as I know—of the publicity." Or "That person? I don't know what that person did. He just sat in on the meetings." It was very, very strange. There was a difference. The FBI guy became sort of a friend, supposedly. He would take me to lunch and all of that. She, from the CIA, was not so pleasant and very businesslike. I remember having to cancel a meeting with her, and she was out of Orlando, and

I called Orlando and they said, "There's no office here." So I called [CIA Head-quarters in] Langley [Virginia]—they never admitted that there was such a person. I said, "Well, I have to cancel a meeting with her and she doesn't exist, whatever. I'm canceling a meeting." And then a half hour later I get a call from her saying, "I understand you have to cancel a meeting." So I never contacted them. They watched what I was doing and contacted me after our return from any number of these countries, especially [the] Soviet Union, Cuba, and China.

RICHARD LANDRY: Cuba was like going back in time to my 1956 high school prom. All the cars were 1956 or pre-1956. We flew in a private plane from Miami [International] Airport direct to Havana, which was unheard of in 1988. Armand Hammer, the Russian philanthropist, liked Bob's work. He contacted Castro and had him invite Bob to this festival where Castro was giving prizes to artist, poets, and writers from Central and South America. Mr. Hammer then went to the State Department and got clearance for us to fly to Cuba.

We waited hours in the Miami Airport; we were scheduled to leave at seven. Time passes, eight, nine, ten, no word or pilot. We keep seeing this guy sticking his head out the door, looking both ways. Finally, he hollered, "Hey! Are you the people that are going to Havana?" I said, "Yes." He said, "We have a half hour to get off the ground." So we hustled everything on the plane.

JANET BEGNEAUD: We had to fly into Cuba on a private plane, and we sat in the Miami airport having margaritas or something until almost midnight; we couldn't go sooner. We had to wait until the pilot came to get us or called us. Then we had to walk, it seemed like ten miles, luggage and all, to get on the private plane, and it was off in some hanger. It was, of course, part of the airport, but it was not where we were supposed to be. So we were walking across the tarmac and all just dragging luggage.

When we landed, the thing that they were really concerned about, Bob had three or four, five-gallon barrels of Sears & Roebuck white paint. We didn't go through customs or anything because we landed late at night—that's probably part of why we had to go so late. It was really exciting. It was kind of scary, but it was exciting. They couldn't understand what those big jugs were and why we

had them. At first they weren't going to let him take them, but he had to paint the inside of that castle with white walls because of his art. He was fanatic about the walls being light and clean. So we ended up taking the paint with us after we stayed there for an hour negotiating the paint deal.

AND CASTRO SAYS, "YOU WANT ME TO COME TO CAPTIVA?"

JANET BEGNEAUD: They were having some kind of art week there, and it didn't have anything to do with Bob. They were entertaining their writers and their artists. We were invited to this function. Castro was there. He was huge. And that big, big beard and really tall. He was like six-foot-two or -three, and he was the only one in the room that was dressed in military attire. He had on that kind of wool that has little things sticking out of it. That old wool? Looks scratchy?

Of course, this is in Cuba, where it's not cold. So he's got this huge suit—big wide shoulders, a tremendous presence. The whole front of it was full of medals and ribbons and all sorts of awards. His whole chest. The whole thing.

Anyway, I knew that there had to be some people there with him, guards. But there was no one that looked like they were supposed to be there until we got to this one part of the conversation where Bob reaches over and pokes him in the chest. We were talking about cooking. It was so funny because [Castro], of course, did his schooling in the United States so he reads and writes and speaks English perfectly—or at least beautifully. But in Cuba, he only speaks Spanish. So we had a little lady translator, and she was really, really cute. Her name was Carmen.

And he's very demonstrative. He'd be telling stories, and he kept reaching over and hugging me. Of course, I was a pretty cute little blonde at that time, see. Well, Bob [said], "Why don't you come over and let me cook dinner for you?" And so Fidel told him that our government wouldn't let him come. Bob said, "Well, you don't need to go with them." He said, "I just live right across that water. On the water. You just come in your boat, let me know when you're going to be there, and we'll come out and get you and we'll cook dinner. Then I'll put you back on the boat, and you won't even have to see the people in our government."

DONALD SAFF: And Castro says, "You want me to come to Captiva? You're the first person in twenty some-odd years that's ever invited me to the United States." But Bob said, "You should absolutely come. You should come." And Fidel says, "What will I do there? Look at the garbage in the Gulf of Mexico that you throw out there?" So things started turning. So Fidel says, "I'll cook a meal for you if I go there." And Bob says, "Good, you can cook breakfast." Fidel says, "Fine." And Bob says, "Good, because I don't eat breakfast."

This was Rauschenberg being Rauschenberg. Nobody upstages him. I don't give a shit who you are. He's going to have the last word. And he snookered Castro. He absolutely snookered him into a position where Bob had the last word.

JANET BEGNEAUD: Anyway, Bob reaches over and punches Fidel in the chest, like this, like you do with "I'll betcha." You know how we do that kind of thing all the time? And when he did that about eight people came forward, and Fidel just kind of shook them off. Of course, they didn't know what Bob was saying—they didn't know what our conversation was. So then I knew that he had some protection in the room. Then he would punch Bob—we had a really neat conversation with him.

DONALD SAFF: The conversation developed. Of course, Castro could speak English but wouldn't speak English. He had an interpreter who would stand by us and could interpret simultaneously with what Castro was saying. So either she was unbelievably great, or this was canned stuff that she was used to. The conversation just ranged. He talked about—what did he talk about? He talked about cooking shark. And that the Chinese had nobility, and they had people that could do that for them, and it took a long time to cook shark, and they needed a caste system to do that. And he said it without any judgment. He just talked about the caste system. He talked about Gregor Mendel—talked about being bald and inherited traits. He turned to me [and said], "Why do you have a beard?" I said, "Well, I've got a fat face. It looks better." I said, "Why do you have a beard?" He said, "I don't want a beard." He said, "I have to keep it because of the revolution. It's a symbol."

He talked about being bored by the East Germans. How boring it was to go over there—fly all night—and to sit in, listen to their politics, and then he would fall asleep. It's like—this guy's wonderful. What's the problem?

JANET BEGNEAUD: Carmen is doing this and this [gesturing]—she's doing things just like he does, except very, very minimal. And I'm watching her, and at one point I said, "Carmen," and of course when I said Carmen she stopped translating. And everybody stopped, and he looked at me. I said, "I've been watching you. I think you tell the stories better than he does!" And he just died laughing. So he reached over and grabbed me and hugged me and laughed and laughed and laughed.

DONALD SAFF: On occasion, I didn't particularly like being around him. It's too anxiety-ridden for me. I never knew what he was going to do next. In Cuba, for example, they wanted to honor him, and they put on a dance performance for him—a local dance company, small stage. They were dancing. Bob got up on the stage, shit-faced drunk, and started dancing and interrupting their dancing. And eventually fell off the stage—fell off the stage. I thought he was going to kill himself. I walked out at that point. Let his other people take care of him. He would never allow that to happen to his work. For him to interfere with somebody else's art is just something that he would never accept for himself. On the other hand, he had no hesitation to get up there and to interrupt what they were doing. There was no feeling for that at all. I sat there cringing because it was such an embarrassment. Of course, everybody had a smile on their face—nobody got insulted. Nobody was insulted by him. They didn't dare be insulted by him.

DOROTHY LICHTENSTEIN: [Bob] was full of energy. I think he was just so excited. He knew that this really meant something different for Cuba, for a country that had been so isolated. Because he wanted to make a difference. And so, I think he really felt that there. At one point, at the party, he was dancing on the stage with Chris, and he actually kept going back, and back, and he disappeared, we heard this terrible crash. And then he got up, and I remember thinking, I wonder how sore he's going to feel tomorrow. But he was okay.

JANET BEGNEAUD: Then [Castro] invited us to go to his summer house. We were supposed to leave on that Friday, but he wanted us to go to his summer house on the beach for the weekend. And Bob didn't really want to go, and

I almost begged him. I just said, "Look. How many times are we going to be invited to go to Fidel Castro's summer house?" I said, "Bob, I really want to!" Finally Bob said okay. So he had to change his plans. It scared my mom to death. I think she thought we were not going to be able to come back or something. But it all worked out.

The morning that [Castro] was coming to get us—well, not he, but his car. As it turned out, he was not going to go. That's how Bob did relinquish to go ahead and go, was that he found out that Fidel could not go himself. Carmen was going to come with us, but he wanted us to be his guest. Bob said he didn't think he could spend the whole weekend with [Fidel].

That morning we started packing. We were checking out of our hotel. So here's a little black car that drives up out there with the flags on the front fender and all that kind of stuff. A little black Mercedes. I look out the window and all those guys with the uniforms and all are leaning against the fender of the car and I'm thinking, "This is just crazy." It was so much fun going out there because we just drove really fast through these villages, and the little chickens were having to jump out of the way of our car and everything. Everybody would watch us because I'm sure that was not common to see the black Mercedes racing down the street with the little flags on the fenders and all. It was really fun.

We drove up to his place, and there's this huge, big brick wall. I know that brick wall had to be close to ten feet tall, and in brass letters about three feet tall is the word "DuPont." I think the DuPonts had probably left in the middle of the night with their clothes on their back, and this was what they left and now it was Fidel's. We had fun out there that day, and Carmen ended up being a real kick, and I had to leave her my heat rollers because she was so taken with those.

IT WAS THE LAST THROES OF THE SOVIET UNION

RICHARD LANDRY: Moscow, we arrived there in the middle of February. The Russians were apologizing because the snow was melting and it was not cold enough. I was not complaining. This was before Glasnost, before Mikhail Gorbachev. We had this robust blonde woman as our tour manager. We want to do this, "No, you cannot do that." We want to do that. "You cannot do that." We want to do this. "You cannot do that!"

Very mean, bulldog-looking: "No, you cannot do that." The restaurants looked empty, and when we would ask for a table, waiters answered, "We are full." A twenty-dollar bill would get us in. We basically ate tomatoes, potatoes, and an occasional piece of beef for the entire period we were there. Most of the time we lived off of caviar and champagne! Not bad, but after a while, I just wanted to get out of there.

THOMAS BUEHLER: It was the last throes of the Soviet Union. We stayed in a huge hotel, us, the crew. Bob stayed in another hotel, I think. We stayed in the Rossiya Hotel [Moscow]. I think it was the biggest hotel in the world at the time. It doesn't exist anymore. They razed it down. It was four street blocks. They had four corners, I think, twelve floors on each, and each floor in each direction—east, west, north, south—had a cafeteria, a little shop where you could buy hard boiled eggs and kefir, things like that. Good stuff. The ground floor was what, in the Eastern Bloc, they called Friendship Stores [in the People's Republic of China] or Intershops [in the German Democratic Republic], where you can buy foreign goods for hard currency. If you had dollars, you could buy Jack Daniel's and things like that. If you didn't, then you didn't.

It was always unpredictable. There was a car that was available for us; it was a little van. And once a week we were allowed to go to what was called a free market where farmers could sell things that they didn't have to sell to the government. Of course, prices were high and quality was also good. You could buy flowers from there, things like that. We had the van once a week, and we went there to buy things.

Learning from China, we said we were going to have to take our own interpreter with us. We were not going to have that again, because none of us spoke Russian. We were going to have our own guy with us. New York is full of Russians. We said, "We'll see if we can find somebody." I put ads in the paper, advertised [for] preferably young artists, Russian speaking, wanted for a project. Quite a few kids sent in their resumes and their pictures, and we sent them down to Bob, and Bob said, "This one here." The guy was named Alex Rudinksi. He works at MoMA now as an art preparator, and his family is from Odessa [Ukraine].

So we had Alex as our interpreter. The first day we get to the hotel—there is a restaurant on top of the Rossiya Hotel, and we're maybe ten or fifteen of us,

flexing in and out. There were always people come and visiting and helping or things like that. We were going up to the hotel, and the waiters were already there, saying, "Americans, dollars, yes, we've got it made." Of course, Alex had good connections in Moscow, and some of his uncles lived there and some came traveling in from Odessa. So he was well connected to the black market, so we had rubles in mass quantities, more than we could ever spend in our lives. We took the waiters to the side, Alex and I, and said, "Okay, we're going to be here for four or five weeks probably. We'll come up every day for dinner. We'll pay you in rubles, but we'll tip you in dollars. You get the drift, no?" So every evening we came back to the hotel and sat at the long dinner table, all of us, all set with bottles of vodka, bottles of cognac, bottles of champagne, and the best caviar and sturgeon and salmon and all that, for peanuts really. It cost maybe twenty dollars. The way we exchanged on the black market, it bought dollars like nuts. So we had it made.

DELI SACILOTTO: [Yevgeny Aleksandrovich] Yevtushenko was going to write an introduction to Rauschenberg's show. Well, we got to know Yevtushenko quite well. At [that] point, I was at Graphicstudio, and Don, I think, was the dean of the College of Fine Arts at that point, and [Francis T.] Borkowski was the president of the university. And they wanted to give Armand Hammer an honorary doctorate. Now, at the time, I was part of that group that went. We flew into Moscow [but] couldn't find a hotel room. There was nothing to be had. We even went to the American Embassy to try to find something, and they said there was nothing. It turned out there was an Italian trade delegation in Moscow at that time, and they booked up everything.

So we went to see [Yevgeny] Yevtushenko, and we had dinner with him. His publisher from Denmark, I think, was there at the time. His wife was eight months pregnant, and she was home, but he was quite interested in the publisher; she was an attractive woman, see. But anyway, we kept saying, "But we don't have a place to stay." Meanwhile, it was getting late. "We don't have a place to stay." He said, "Don't worry, don't worry." So ultimately, he said, "Come with me," and so he took Don and I both to his place. He got in, and the driver, he said, "Just a minute, just a minute." He went into his house, outside of Moscow. He came back with some glasses and a bottle of vodka and he told something to the driver, and he drove to Boris Pasternak's gravesite. And there we were in

the cold Moscow winter: it was cold, the trees were bare, we were all bundled up, and we were having shots of vodka over Pasternak's grave. Then he drove us back to his house, and he had a cottage aside from the house; he had the house and he had the cottage. In the cottage it was heated. He had thick English towels. He had hot and cold running water and a shower. It was really quite a luxurious place. So we ended up staying there. And, of course, he wrote the foreword to Rauschenberg's exhibition in Moscow.

DONALD SAFF: Bob's crew disliked him in the Soviet Union. I guess he was being difficult with the people who were installing the work—Thomas and Darryl [Pottorf] and Terry Van Brunt, whoever was there. And he was being difficult. So one night he calls me. He said, "You're the only friend I have." It's like three in the morning. "You're the only friend I have. Can you come up and talk with me?" I went up there, and I spoke with him for a few hours. The guy could be terribly lonely. If he got enough people angry, nobody wanted to go near him.

Well, he would get pretty drunk on some of these occasions. I'll just say it this way. On one occasion, he inadvertently went out the outside door of his hotel room—because sometimes he didn't know whether he was going to a closet, a bathroom, or exiting the room because he traveled so much and changed rooms and often was drinking. That's what the state of affairs was, if it was late enough. This was not the way he was when making art, but sometimes it could get to that degree. And if he was waking up from a deep sleep, he wasn't sure. He traveled so much, the geography of a given room was not necessarily in his mind. So he walked out the door to his room—buck naked—and the door closed. He was locked out. Of course, on each floor, they had a babushka lady who guarded the elevators. And he was obliged to walk up to one in all his glory and ask her if she could let him back into the room. That was not an unusual occurrence.

THOMAS BUEHLER: The venue in Moscow was huge, like China basically, and Bob pumped art in like crazy. New things came from New York, and he made extra work. It was a huge success also. Like in China, the people were so interested, especially young people. It was amazing how much they knew about him considering that they lived in an environment not very

generous with information from outside the country. Let's put it that way. They knew exactly where he went to school and paintings that he had and early work. Fantastic.

DELI SACILOTTO: They weren't quite used to Americans putting on a show, you see? Some of the pieces that Rauschenberg had would come out onto the floor, and they'd have to be very careful to avoid people coming over and stepping on [them], or not walking around it. They had to put little barriers around some of the pieces because people would be looking around. This was very new to them, a lot of the artwork.

RICHARD LANDRY: Outside there was a line about a mile long waiting to get in [to the show]. I was standing in the middle of the museum, and I started playing when they opened the doors. I usually close my eyes when I play, but I could hear people coming in. All of a sudden, I realized my sound was getting smaller and smaller. When I opened my eyes, there was a circle of women and men around me. Some were touching my clothes, and many of them were crying. They were also rushing to the art and feeling the fabric and touching all the works. Bob's crew and the museum staff were freaking out. It was intense. It was the first time they had seen such provocative art.

JAPAN. WE WERE DYING. IT WAS JUST TOO BEAUTIFUL.

THOMAS BUEHLER: Bob was invited to participate in a kite project in Japan. The director of the Goethe-Institut—or Goethe Haus in Osaka I think at the time—Paul Eubel, passed away just recently. He said he was standing at this window and looking out. It was a beautiful day, and there were kites in the sky—we have the catalog right here. He had the idea of having artists produce kites and fly them for philanthropy. So we got all these artists together, including Bob Rauschenberg and Tom Wesselmann and a lot of Japanese artists, to produce kites to be flown at a kite festival in Osaka, near a castle. It's called Himeji Castle. It has a beautiful garden around it, and of course the kite festival was in cherry blossom time, so all the cherry trees were in blossom. We were just dying. It was too beautiful.

Bob made two kites. The idea was that he would keep one—and they were big. They were three by five feet or even bigger than that. We still have one. Bob made two kites with very classic Rauschenberg silk screens, one in a chair. They were called *Sky House I* [1988] and *Sky House II* [1988]. They were flown. Bob's kites were a little bit heavy because they had too much silk screen, too much fabric collage on them, but we got some good footage. Terry Van Brunt was Bob's assistant at the time and videographer, and he took some good footage. The kite didn't get very high. Terry was lying on his back with a wide angle lens, and it looked like it was way up in the sky, but it wasn't.

The kite festival started. It was a beautiful day, probably April first, around this time. *Sakura* is Japanese for "cherry blossom." It was *Sakura* day. The park was gorgeous. There was a medieval Japanese castle on the hill behind it and all the cherry blossom trees, and the Japanese visitors all came and had blue tarps. And they were sitting under those trees with bottles of sake and little boilers, where they were making sake hot, and little grills, where they were grilling skewers, and the smells—I still have the smell in my nose. The only thing that was missing was wind.

It was still early morning, maybe nine o'clock, ten o'clock, and they had a group of kite flyers from a fishing village in Japan, Hamamatsu. They were famous for kite flying. They were also famous for being a little bit raunchy. The director of the kite festival said, "We'll have to make sure they don't get too much to drink in the morning because they get really wild." There was still no wind. They had big rolls of cable that they had anchored in the ground for the kites to fly on. It was all prepared, but no wind. There was a big square, or maybe a rectangle, and the castle was here. We were all sitting around, the trees were around, and there was a big open space in the middle. They started walking around the perimeter of the square, slowly at first, always chanting something. We couldn't understand what it was. Then they were going faster and faster and faster and faster, and louder and louder, and the chanting got faster, until they got to the center of the square and they were almost frantic and had this circle thing, and the wind started. They got the wind down. It was a beautiful day. A lot of wind. A lot of kites in the sky, and that was it.

Bob, of course, had the Samarkand fabrics and the kite in the National Gallery [of Art] in Washington [, D.C.; for the exhibition *Rauschenberg Overseas Culture Interchange*, 1991] even though the kite was not really part of Washington, it was

part of his international doings. It was very nice. It was installed with the full harness of strings under the ceiling of the National Gallery in the big hall, and Jack Cowart was the curator at the time, who is now the director of the Lichtenstein Foundation. He has things to say, I'm sure, about Bob and his collaborations.

80 PERCENT SYMBOLISM AND 20 PERCENT ART

DAVID WHITE: I remember the catalog for the concluding venue of the ROCI exhibition, at the National Gallery [of Art, Washington, D.C.]—this was in 1990 or 1991—we were working on the catalog for the exhibition. We were having discussions with the people in the publications department. And the young woman said—Bob said something about the photographs bleeding off the page or whatever it was—then she said, well, ordinarily we don't. And he just cut her short in midsentence and said, "We're not talking about ordinary." So he had very strong ideas about how he wanted things done.

I saw him install a gallery full of photographs. On the ROCI tours, he took photographs in all the different countries. There'd be a stack of photographs just against the wall. And he would just start to [hang them, saying], hand me this one, hand me this one, and work his way around and get to the last wall and there'd be one last photograph on the floor and one last space. You don't know if he had that in mind the whole way around, but it just worked out. So he knew what he was doing for sure.

We disagreed, in one sense, in that he was almost like a mother hen that wanted every chick up on the wall for everyone to see and love. Some of us thought that more space around the works would've made each work look more special. Sometimes I would walk in and think, oh, I wish there were two fewer paintings on this wall or that wall.

JACK COWART: I think it's pretty well documented that, in the design department, which was responsible for installing all the exhibitions, the head designers had a fairly jaundiced view of the importance or necessity of contemporary art for the National Gallery, even though they had the East Building. They were reluctant and grudging in many ways, and really never got enthusiastic about anything that was post-1960, even when I was there. There were some very

strong personalities there, and they [were] able to inflict their opinions onto the senior management of the museum. Many of them were exhibitions by design. So you ran into these issues; they couldn't see anything to design yet, there was nothing to build yet. There was no castle to re-create yet. There was no Tibetan mountain to build, or anything else. So this, to them, was just stuff, and it wasn't deemed necessary stuff.

We saw it as a bigger picture, because it laid out a whole collaborative agenda for the National Gallery with contemporary art artists. It was a collision of wills, but a lot of it had to do with the command and control system of exhibition by design, and what constitutes National Gallery quality. We were dealing with an artist who said—I think it's been published that Bob said [this]—"I make it, you figure out if it's any good, and how to keep it together." Because it's all mixed materials, you had no idea what it is. That amount of honesty—I'm doing this, you figure it out—rather than being a curated exercise, and knowing that we were not in a kind of curatorial control system, but we took it on faith. That was not the way the National Gallery tended to operate.

That's how things can get sent off to the gulag, simply enough. So you had to build a support group that continually spoke about the importance of the big picture, of ROCI, and didn't obsess over those little bits. As I recall, we ended up taking over the entire East Building, or substantially as much as we could get, and the show basically became an all-museum installation. It was a fiesta.

Symbolically, I think largely, ROCI at the National Gallery was 80 percent symbolism and 20 percent art—and a hundred percent progress and two hundred percent developmental leverage to develop inherent flexibilities with the way one can approach a living artist. Bob had so much scope that it paid off. At the same time, I think it was a celebration of Bob's rangy creativity that could find this amount of canvas, of gallery space, and a desire to do it well. They still did it very well, however grudgingly the design team was. The lighting team was great, and the installation team was great. Everybody performed professionally.

Aside from all the interior intrigues, it ended up as an astonishing array that all of us had to walk through every day on the way to work, because you had to get through the atrium and the galleries to get to the East Building administrative wing where everybody was, from CASVA [Center for Advanced Study

in the Visual Arts], to the event planners, to the researchers. None of us said, "Well, I told you so," and none of us said, "This was good for you, shut up, and take your medicine." We didn't take hostages, and we didn't preen and say how it was. It was just part of a life-changing event. We felt empowered. For me, personally, it was that we had brought it off.

Curators get very territorial about building their collections and the legacies of collections. I do think that everything's related; you can't say that the dots don't connect in a linear fashion. It's a swarm of events [that] create an atmosphere of inclusion. The ROCI thing certainly made the Meyerhoff thing much more credible, in developing my previous and long-term relationship with Bob and Jane Meyerhoff, which began around Bob, too, and also with Jasper and Roy Lichtenstein and the artists they were collecting. That gave the National Gallery credibility in their eyes as a place where they could do stuff with contemporary art.

I'm biased, of course. I thought it was great. Not all parts of it were as good as other parts, I don't think. But that wasn't the point. The sum was better than its parts, in this case. The totality was fascinating. I was exhausted by it, so I don't think I ever really enjoyed the exhibition as it was. But I enjoyed that it had come to a conclusion. I enjoyed that it had sent so many good signals, and that the National Gallery maintained its good grace throughout. I don't know if other people heard other things. We didn't live and die by critical reviews, but I think people were still making up their mind about the range of Bob's current work, and whether it was just an indulged sense of "I want to see the world and I'll make some art and raise money from others to go around," even when he self-funded it at the end. I know he had asked people for money, and they were like, "So, why should I give you a free ticket to go because you want to do something? Go ahead and do it, if you're going to do it, if you believe that strongly in it." There was divided opinion about the mechanics of ROCI, as I recall, about the quality of the production, and also its parts. But the *Gesamtkunstwerk* of the whole thing together, I think it was fascinating. I have no recollection of what the audience view was. I don't remember the reviews anymore. I remember the fact that we did it.

DONALD SAFF: Well, my perception was that it was very enthusiastically received by the various countries, with the exception of those who thought

that it was an extension of American imperialism and wanted to bring that out and sort that out with him. So sometimes it was contentious in terms of these discussions with students afterward. But, for the most part, it was a great gift to the people that they received with great enthusiasm. In China, they really began talking about "art before Rauschenberg" and "art after Rauschenberg." To go to such places as Tibet—to bring the art there was so unusual and had such a strong impact, and the people were so appreciative—I think it made a big difference. Historically that's been confirmed by people who subsequently went there. I know that somebody I worked with when I was curating at the Guggenheim, one of the deputy directors, ended up going to Hong Kong and working with the mainland in terms of the impact of Bob in China. And she would convey to me the strength of that impact in terms of the students of that country.

But even here, who gave license to everybody? Bob. It's students here, it's students there. The governments, for the most part, even though they were not involved, I think, were quite thrilled. It didn't cost them any money. It was a big event. They didn't see the subtleties of what that would do in terms of undermining positions. Art works sort of like Lamont Cranston [*The Shadow*]. You don't know what the Shadow's doing. He's there, and it does have its effect, although you don't necessarily see it directly.

But I don't think that the U.S. imperialism was something that was thought of by the government. It was more the students. There was never a situation where the government wasn't happy to receive the exhibition, or the state wasn't happy to receive the work or whatever. They didn't have a problem. It was the students who were shrewd and who thought they could see this tour as a gambit for the USIA [U.S. Information Agency] to be advancing some agenda, which it wasn't.

This thing, ROCI—this was pure. This is just pure Bob.

Jack Cowart's original introduction to the NGA [National Gallery of Art] catalog was problematic. He wrote an introduction in which he brought up this whole thing about the motive being questionable—American imperialism, cultural imperialism—I couldn't believe that he wrote that. I read the thing and I went back to him and I said, "I don't understand why you're writing this. After all we've done, and what this has all been about, why do you have to write that?

Why do you have to exacerbate this issue?" I asked him to modify it, and he did. He modified his introduction.

JACK COWART: I didn't realize I was that blunt about cultural imperialism. I was always very awkward about writing about Bob anyway—about notions of Bob. By this time, I am sure that it was probably a first draft. But I did expect that eventually it would get beaten into compliance. Yes, and Don fancies himself as a writer as well. So we had a collision of views, no doubt. But I don't think I would have left that on the table. It may have been that I proposed that as an opening argument, and then would say, "On the contrary, it ended up being something entirely different."

So it gave the appearance of what one was always hearing about, "Here's the American artist coming into a third world or second world country, let me show you how we do it together, boys and girls." It ended up being far more sentimental and far more engaging. But I do know that the argument that I had pitched the show on was a collaboration between the locals and the drop-in, and that that was a cultural exchange.

In the end, it had gotten a little bit more one-sided. It got more Bob-sided for a ton of practical reasons. Bob is collaborative in many ways, and he infuses a lot of collaboration from others. Eventually he ends up being the mouthpiece. So I think some of the other contributors may. . . . It ended up all being Bob Rauschenberg work. With that many other hands involved, I may have been frustrated by that and thought that it was a little too top-down. That's now speaking twenty years later. I was probably setting up an argument that would then say, "But he absorbed"—I don't remember.

But no doubt, Don and I were always arm wrestling over something. He was the protagonist on behalf of ROCI and Bob, and I had to be the protagonist on the point of view of curatorial objectivity for the National Gallery. So we were inherently going to be in conflict with each other in a certain way.

[Bob] had become institutionalized in his own way in the United States, so he's a known commodity. So wherever he goes, it's the same deal. These were more off-the-grid places. He didn't go to Paris, and the complexities of getting to Africa were another matter. But the idea that there were these places on the edge of things—he wanted to go with the belief that these

communications between struggling artists could debate the natures of art as well. All this became political, too, mind you. I was at the Havana thing, and I know that it was complicated. He still did look like the reigning sultan who was coming in—the big guy from the West who was coming in; they wanted to meet him.

It was kind of what happened to Georg Baselitz, who would be in Berlin and huge people, like Julian Schnabel, would sidle up to Baselitz and say, "Oh, I love your work." What can we do? That's where the United States art was three steps ahead. Where something was going to be in China or Tibet or Havana or Chile or even Mexico, where Bob wouldn't be taken so much as a grand personage but as a communication hope. I think that kind of communication was Bob getting new material. He wanted to level the playing field again, which had gotten so hierarchical. It was a dumb luck thing, but he may have sensed it inherently from the very beginning, that: "I want to get back to basics. I want to make it difficult to make art and to make concepts, and so I have to deprive myself of certain advantages that I have here in the States, and if I'm going for the reset, that these areas, however they're chosen, put enough impediments in the way that making art wasn't going to be easy." It was like a Christo project negotiation, with cultural agencies and visas and fixers and hustlers and workers and supports, and bring your own paint.

At the same time, meeting people who lived that life as their daily life, where they just don't go to SoHo and go out to swank restaurants and stuff, in the power system—it could have been a revolt against that status quo. It wasn't a joyride. That is certainly where I would think that it was this return to basics thing, and you had to leave the country to do it. You had to go into exile to actually find both more material [and] more bedrock. So, yes, both in retrospect, and I think even at the time, I thought he was newly sourcing, resourcing work. Maybe I had never thought about the personal need or desire to get back to a simpler time, but if you're traveling with some entourage, it's not a simpler time anyway; you're just not going to sit back and have a beer with somebody. You have to have a translator, a venue, and all of this. But I do think he liked to be as low to the ground as possible with young or upcoming or undiscovered or frustrated or other artists.

The notion was to give their culture back to them for their eyes as seen through his eyes. That's a little patronizing, but not saying, "I've got the right

view on the things that I have collaged out of your culture to make it a Rauschenberg," and Rauschenberging it, Rauschenbergizing it. But I think Bob thought this was really double hearsay, no-say—I'm just imaging this—that he thought it was probably better than nothing, and that it was the start of a dialogue [that] couldn't have been had through other cultural emissaries. He had to be it. He was the vibrating mechanism that needed to go into these settings, however passingly, and then make something of it. That was a big challenge. I mean, it was crazy. Other artists would be very comfortable within their own system. Except Bob's system wasn't about necessarily comfort. So I think it was entirely Bob's system he was very comfortable in, but you got to strip away the stuff, and we're going to go on the road.

[In the introduction that was, then, published, I wrote that "ROCI institutionalized Rauschenberg's need for dislocation and the collaborative process."] Bob was always taking risks. I think his enjoyment of working against obstacles was a part of his art. His visual juxtapositions of that are so chance involved. Though you look at it in the long run of things, and for the catalog *raisonné*, you may find that there's some grand synthesis that's going on with Bob's aesthetic. As I said, he was inclusive. He was inclusive enough to include the National Gallery and to deal with all the crap that we were putting in the way. That was already a dislocation for him.

This sense of the dislocations are physical and cultural; they're communicative, the communications dislocations, the having to work through other fixers, rolling the dice—all of this seemed, in my view, to take ten to fifteen years off of his life, but add ten to fifteen years back to his creative life. It was exhausting, but it was creative exhaustion, which added to a repertoire of imagery [that] he then used in various ways. Things cropped up through this collage mentality—the world is a sampler of things—that he could reincorporate in future art. I really did feel that he was gathering materials for art not yet made. And wouldn't that be great?

It was up to him to then use this, almost a force feeding of exotica, or stuff that you just can't find photographing in either New York City or in dumps in Captiva, or in trash piles or in the Outback. It obliged this getting out of a comfort zone where it's "Bob World," and everybody else is their world, and having to interface with it. That works aesthetically, and I think it works personally, and it was invigorating, if not scary. For the people who had to make it

all happen, whether it's the Thomas Buehlers, or the Don Saffs, it was a logistics nightmare. How are you going to get the car batteries that were not going to be stolen in Russia, or the Soviet Union, to be able to do this thing? But he had people who also had drunk the Kool-Aid.

DONALD SAFF: I guess one would always feel—and probably to this day—that Bob was either advancing a cause for himself or for somebody else or [for] some other purpose. But I really think he thought that he would help facilitate communication, and indirectly made an effort toward some sort of world peace through his art. He really felt that. His ego was sufficient to think that he could make a difference. And he did make a difference on one level or another. He absolutely made a difference.

JANET BEGNEAUD: One time, I was standing there in front of one of these television sets—we were in Mexico—and I don't [remember] what country it was, but it was Asian. There were these precious little girls, looked about four or five years old, and they had their little pink tutus on, and Asian music—doo-doo-doo—and these little girls are dancing. And standing in front of the television set in front of us were two little Mexican girls. They didn't have tutus or headpieces and they were doing the same thing. I thought, "This is what this is about. Those little girls are playing with these little girls."

CHRISTOPHER RAUSCHENBERG: When he had this idea, and this'll bring world peace, and people will understand each other, and all that stuff—everybody's going, "Yes, Bob, yes, yes, yes," you know? But there was this directness and childlike-ness about that. It was just like, "I'm going to do this."

So the idea that seemed so childlike and simple, it actually worked. It was really important. It was probably the most important thing that happened in China in terms of the art world in China now. And there was this richness, to go to Havana for the Cuban people? That was this really important thing. And he was the first non-Tibetan to have a show in Tibet. It was all this stuff that actually did what he said it was going to do.

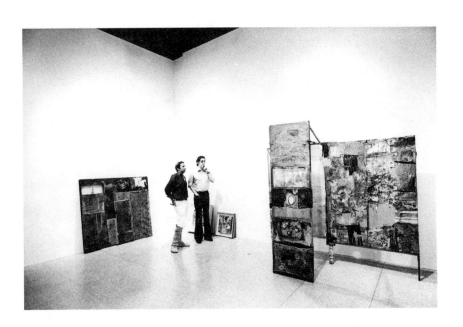

Rauschenberg and Walter Hopps discussing *Minutiae* (1954) during the installation of the retrospective exhibition *Robert Rauschenberg*, National Collection of Fine Arts, Smithsonian Institution, Washington, DC, 1976. Works in background are *Red Interior* (1954) and *Untitled* (1954), 1976. Photograph: Gianfranco Gorgoni.
Photograph Collection: Robert Rauschenberg Foundation Archives, New York.

CHAPTER 7

Curating and Installations

A T the very same time that the culmination of ROCI was on dis-
play at the National Gallery, Washington's Corcoran Gallery of Art
was presenting *Robert Rauschenberg: The Early 1950s*. The show
included 101 lesser-known works by the artist, made when he was between
twenty-four and twenty-nine years old. Seen by many critics as the perfect
counterpoint to ROCI, which demonstrated the artist's "wanderlust, wealth
and prolificacy at age 65," the Corcoran show "is about his originality, poverty
and prolificacy at 25."[1]

The simultaneous presentation of these shows created an opportunity for
an easy contrast to be drawn between old and new that resulted in a "loved
then, hated now" reaction among most critics. Although not everyone agreed,
Hilton Kramer titled his review, "Justly Ignored Early 50's Rauschenberg upon
Us."[2] The popular opinion was that the recent work didn't measure up to his
early achievements.[3]

The Early 1950s show was especially celebrated for the insight it granted into
how Rauschenberg's youthful innovations altered the course of art history.
Jasper Johns, Rauschenberg's partner for much of the 1950s, called him the
"most influential living artist, a man who has 'invented more than any artist
since Picasso.' " And most critics agreed that the many art movements that the
exhibit's work anticipated, including minimalism, pop art, and conceptual art,
substantiated this view.[4]

The exhibition was organized by legendary curator Walter Hopps, cel-
ebrated for his "groundbreaking exhibitions, inspired installations and an
empathy with living artists." His career developed alongside the emergence of

postwar American art, and his work promoted the rise of the museum as a site of contemporary art.[5]

Susan Davidson, who worked with Hopps on *The Early 1950s* exhibit, recalls the research conducted for it:

> The first time I remember going to Captiva with Walter, we sat for three days with all this material just laid out on the ping-pong table, which was what Bob used for a work table. We weren't in the studio, we were in the house, because Bob didn't want to mix that earlier life with his current work, and we just sat there for three days. We'd sit, we'd talk, we'd watch television, all these things you would do with Bob . . . and I had a legal pad on my lap, and I just wrote down everything they said. Through the course of that, we started finally getting Bob to look at things, and getting more material released. Walter and I went back to Houston, and with Don Quaintance, the catalog designer, we produced the essay and designed the catalog and put the show together.[6]

Caroline Huber, Hopps's widow, remembers that the show was "a way of setting the record straight and saying, "Okay, this is really important, and you need to know about it, and I'm going to show you why.""[7]

Hopps also organized Rauschenberg's first midcareer survey (1976) at the National Collection of Fine Arts in Washington, now the Smithsonian American Art Museum, and with Susan Davidson, a subsequent Rauschenberg retrospective at the Guggenheim Museum, New York, and the Menil Collection, Houston in 1997–1998.[8]

The 1997 retrospective was enormous in its scale, representing over sixty years of work with 432 pieces installed in three New York City locations. As had been the case with ROCI USA, many critics' foremost preoccupation was the scale of the artist's production and the show's volume. Writing for *Vanity Fair*, John Richardson observed:

> The word that best defines Robert Rauschenberg's achievements as a painter, printmaker, photographer, sculptor, theater designer, performance artist, and technologist is "epic." According to my dictionary, it means "heroic and impressive in quality" and "surpassing the usual or ordinary in scope or size."

What better way to describe the only artist of our time who continues to address major themes of worldwide concern without bombast or cant or an aesthetic or political agenda, and who does so by utilizing technology in ever more imaginative and inventive ways? Rauschenberg is a painter of history—the history of now rather than then—and it is in this light that we should approach the mammoth retrospective which is going to fill the uptown and downtown sections of the Guggenheim Museum in New York this month.[9]

Or, in the words of Calvin Tomkins:

One of the achievements of Robert Rauschenberg's art is that it makes criticism irrelevant. When you're confronted with the vast range and multiplicity of works on display in his current retrospective, which fills not only the Guggenheim Museum's uptown and SoHo buildings but also the Ace Gallery, a large downtown space commandeered for the occasion, the only way to sustain an "objective" critical approach, it seems to me, is to close your mind.[10]

Despite having opened his *New Yorker* review with these words, Tomkins then concedes:

My own feeling, reluctantly arrived at, is that something essential went out of Rauschenberg's work when he started using skilled carpenters, metalworkers, and craftspeople to construct his big pieces. "Painting is always strongest when in spite of composition, color, etc. it appears as a fact, as an inevitability," Rauschenberg once wrote. Too many of the late works, it seems to me, do not have that sense of inevitability about them, and I wish Hopps had not put so many in the show.[11]

Retrospective co-curator Susan Davidson addressed this criticism in her reminiscences:

One of the things that always sticks in my mind is something that Walter [Hopps] drilled into me, which was something he believed in, that every

show needed as many dogs as it needed masterpieces. He meant that both literally and figuratively, particularly with Bob's work, because Bob does include a lot of animals in his vocabulary. But what Walter meant by that, really, was that by choosing works that weren't necessarily always iconic or the most beautiful, that it actually began to show that an artist doesn't everyday have great days, and that they struggle like any of us, in terms of their aesthetic.[12]

In this chapter, we hear from some of the curators and gallerists with whom Rauschenberg worked throughout his career. Their recollections provide insight into how Rauschenberg's shows were researched, planned, and executed; the effect that their work has on how audiences engage with the materials; and how artists are ultimately viewed by history. These curatorial memories are supplemented by Rauschenberg's longtime senior registrar Thomas Buehler's adventures installing his art around the world, and Janet Begneaud's happy memories of watching audiences engage with it.

IT WAS VERY REVELATORY MATERIAL

JANET BEGNEAUD: We built a new church here, and [these churches] usually have a scene behind the baptistry, and so Mother said, "My son's an artist. I'll get him to paint a scene." You see the baptisms of a long time ago, it's like in a river or something with the trees, and it's just real scenic and calm and that kind of look, and that's what she thought he was going to do. And so when it came in on some plywood, and it was greens and browns and [was] just in [a] very different direction, Mother was just mortified. She called him and she said, "Milton, what is that? What did you paint? What is that?" He said, "Well, this is the piece to put behind the baptistry." And she said, "Well, I know, but I wanted to have some trees and a nice little scene and everything." And he said, "Mother, it is a tree. The bird sees the tree when he's flying over, that's what the tree is." And then when you looked at it—not that he did it that way particularly—but you could stretch your imagination and think of it as being that. But they hung it up. They hung it up.

SUSAN DAVIDSON: I was born in Houston, Texas, and grew up there. I had an early exposure to art through my mother, who went to work for John de Menil as his private assistant in 1968. Through that professional relationship, I was introduced to the de Menils. At that time, I would have been about ten or eleven years of age, and occasionally, as mothers encounter family situations, they have to bring their children to work, and that's how I first met the de Menils and started being around fine art, really as a young person.

I had had this funny experience with Walter Hopps while I was in graduate school. I had not yet met him, but there was this very complicated project that the de Menils were doing, and I knew nothing about it. I had a phone call from my mother one day, saying, "Walter would like to speak to you." I said, "Okay, fine." She gave me a time and a place that he would telephone me. So I waited for the call, and this is long before cell phones or anything like that, so it really had to be orchestrated. I was told to be at Dumbarton Oaks [Washington, D.C.], which is a Byzantine museum, a private collection, in Georgetown, and they have a remarkable photographic library. I remember being in the basement area to receive this call, and the phone rang. I picked it up, and it was Walter. He said, "Okay, this is Walter Hopps." I said, "Hello." He said, "I'd like you to go into the photo library and to look for a particular church in a particular region, and I'll call you in three days at this number." That was it. No reason why he needed this information or anything. And so I went, and I spent two or three days looking everywhere and getting quite frustrated because I couldn't find anything, and of course I didn't want to look bad. When the appointed time came for the second phone call, he rang and I answered it, and he said, "And?" I said, "Well, I'm terribly sorry, I haven't found anything." "That's excellent news!"[he said,] and he hung up the phone. I still didn't know what it was about, and I didn't know if I had helped him or not, and I didn't really have any further contact with him for maybe another two or three years.

I never met him until I finished graduate school and went back to Houston. Of course, my mother, who was not going to allow me not to work, to sit around and not do anything, she said, "Walter's working on this show, and he's agreed to let you come and be a curatorial assistant for a couple of months until you figure out what you're doing."

It's interesting that Walter ended up at Menil, because the de Menils had this kind of connective relationship with Bob early on as well. Walter [had] done the 1976 retrospective at what was then the National Collection of Fine Arts, now the Smithsonian American Art Museum [Washington, D.C.; *Robert Rauschenberg*, 1976–1977]. So he had been deeply engaged with Bob.

Walter always had about five or six shows that he wanted to do; things that never had a date attached to them, they were just things he was going to do in his life. [*The Early 1950s* show] was one of them. It was very revelatory material. No one had really ever seen it, and at the time we did a lot of very primary research, and it was very informative for everyone. Walter, I guess, had a glimpse of the material when he did the 1976 retrospective. There were a few bits and bobs in that, but at that time, from what Walter recounted and also what I soon encountered myself with Bob, he didn't ever really want to talk about that material. So it took real coaxing on Walter's part to get all of this out of him.

BOB ALWAYS SORT OF HAD HIS FINGER ON THE PULSE WITHOUT EVEN REALLY KNOWING IT

SUSAN DAVIDSON: Walter's intent was to bring the material forward. He was interested in the material; he knew that it was critical in terms of setting Bob's vocabulary. Walter had an amazing thirst for the unknown, and that was the scientist in him.

CAROLINE HUBER: He was just relentless in terms of finding the material, and also really interested in the material. He looked under every stone and followed every lead he could, like a detective would almost. And the people he was working with, they all had to look behind every wall to see what they could find. That was important for him too. And to reestablish the significance of this early work prior to the Combines, [Walter wanted to show] how important that was, and how innovative it was, and how much it informed what Bob was doing later.

Especially as a precursor to the retrospective, he wanted to set the stage for what would come later, and to show the significance of this early work.

I know a lot of people went "whoa," they didn't realize it existed or didn't realize how significant it was. It was a groundbreaking show. I think a lot of the work probably had been collected and wasn't seen much, so people didn't know about it.

But that's a hallmark of Walter's approach. Basically he doesn't care what anybody else thinks. If he thinks something is interesting or important, then he'll pursue it. If he thinks an artist is out there in the hinterlands but is really interesting, even if it's stuff that doesn't fit in with anything, he will go find it or explore it or celebrate it. He's not afraid if people disagree with him about the significance of something or the interest of something. That's something he's always done. He's always written his own canon, in a way. He's also just fascinated by what people are doing, whether or not it's even really great or not; he's just interested in people's creative endeavors. But, with something like this, it's a way of setting the record straight and saying, "Okay, this is really important, and you need to know about it, and I'm going to show you why."

SUSAN DAVIDSON: We actually had two tasks: locating what was physically still available, and we also went deep into identifying other works that had been lost. We relied quite specifically, and fortunately, on these photographs that Bob had taken in the early 1950s when he was recording his own work. It was a combination of him recording his own work and his studio's, but it was also his own explorations as a photographer in fine art photography. Those photographs were really essential to what we were doing because there was a lot of material in them. So I guess we saw these vintage photo sheets, and that's how we knew that this material was going to be available to us. We called them vintage because they're these early photographs, but they were printed in the 1980s when Bob had his first photography show at the [Centre George] Pompidou [*Rauschenberg Photographe*, Musée National d'Art Moderne, Paris, 1981]. So all those negatives were printed into these proof sheets, and we had eight by ten prints made, and we just would start combing through them.

Because I had been to the Corcoran [Gallery of Art, Washington, D.C.] and I had looked at a lot of the black paintings, and I started to see the layering of them and the way the newspaper was working, and the dates of the

newspaper, that helped us to begin to date things. Then it was really like a big jigsaw puzzle that just kind of went on. One clue would lead to the next. I think at the time a lot of the work was still with Bob, the physical work, so that made that easy. We started reaching out to and interviewing other people he knew in the 1950s. We interviewed lots of people at that time. Walter would have phone interviews, and I would be on the other line and I would just handwrite out the conversation and then type it up.

We tried desperately to get Charles Egan and never could. We spoke with Nicolas Carone, we spoke with Knox Martin, Cy Twombly, Sue Weil, Leo Steinberg, we talked a lot with him. We often would talk to Bob. So ten, eleven, twelve o'clock at night, Walter would call Bob and try to get him to focus on things and help [us] sort through some things. Now, as I look back on the work we did, and knowing Walter as well as I do, I can see there were occasionally some times where maybe Walter was leading Bob into certain decisions.

I wrote an essay for the San Francisco [Museum of Art] Rauschenberg Research Project a year or two ago, and I wrote on *Mother of God* [ca. 1950], which was a Betty Parsons era painting. And through the research I was conducting for that text, I began to realize that maybe some of the things that Walter and Bob were talking about weren't potentially accurate. But I only know that because new research has come along in those twenty years. At the time, and this is always the case with research, you have to accept the state of your research, and that's what we were doing then. I just have been fortunate to have a continuous dialogue with the material, and having had that experience, I'm able to continue to connect other dots as new information comes forward.

You have to believe that the work you're doing then is the highest state of your knowledge, and it's important to publish it. There are lots of art historians who will wait and wait until they have that definitive answer, and I don't think that that does a service to art history, because it doesn't get the information out so that other people can build on it. Walter had a real urgency about the 1950s material to do that.

[The show] revealed a kind of process and intellectual thinking of an artist before the bodies of work for which he was well known. So in that sense it was revelatory. Nobody had really seen it, and they didn't quite know what to do with it. And I think that most people thought by this time that Bob was purely

an imagistic artist, and in fact you saw the very deep strain of abstraction that was in the work. Actually, something that I've come to realize more and more is so fundamental to Bob is the whole sense of the element and the object. That was very present. You also saw his abiding interest in photography, something that really nobody had seen.

As the exhibition traveled, it hit a lot of important art cities, that's how it continued to grow in interest and in engagement. So much so, that, in fact, [Thomas] "Tom" Krens saw the show in San Francisco and insisted that it come to New York. It was never planned to come to New York. It was a groundswell. And it was radical-looking art from what people knew of Bob.

Bob always sort of had his finger on the pulse without even really knowing it. I think, in many ways, it was because of the materials that he was using, and the fact that he had this humble approach to a moment of great prosperity and wealth that was starting to happen in the United States. And yet he didn't embody it in that way. He chose to be more down to earth about it, if you will, in the sense of the materials that he was using. I think that is what gave him this sense of the everyman that he became in spite of the fact he was a rising star.

It had a huge impact on artists. I still encounter people, art historians and artists, who saw that show and say it was the most important thing they'd ever seen. For me, it's become the foundation for the way that I look at Bob's work, absolutely. I see how those kernels continue to be planted throughout the entire oeuvre.

MARY LYNN KOTZ: [Bob] referred later in life back to himself. People ask him what he meant by this or that [image]. "Where did this come from?" He said, "Oh, I just liked it." Wrong. Every single image that he chose was his own—his autobiography is his entire body of work. He knows where it came from, he knows what it means to him in his own history. Rauschenberg coined the phrase "random order" in a photo-and-text collage for *Location* magazine in the spring 1963 issue. But it wasn't random. He chose every single artifact, every single thing that had some meaning in his own personal history or that he wanted to share. People have argued with me about this. They said, "Oh, no, there's no way he could have done that." Wrong.

HE WAS SHOWING US—THIS IS THE WORLD YOU LIVE IN

EALAN WINGATE: I like it that I can see that he—that there's so much interesting subtext. The 1962 silk-screen paintings—1962 to 1964 silk-screen paintings—are full of potential. There are space launches. There are helicopters. There are swimmers swimming, a man swimmer who is swimming hopefully to win something. There are birds flying. There's [John Fitzgerald] Kennedy. Even though the screen came days after Kennedy's death, I mean, there's all this potential of the early 1960s, and it was the first time that Bob used silk screen. Then, 1989, he returns to wanting to use silk screen. [Rauschenberg brought silk screening back into his work in 1983 with the *Salvage* series (1983–1985)]. Now the images are his own sources. They're not publicly found newspaper clippings. They're photographs that he's taken. What's very curious is that they showed things that are downtrodden. They showed things that are wrecks. There was this image in the early 1960s silk screens of a kind of linear box, with an arrow usually going up. Now everything is pointing down. Arrows are constantly down.

It's a very curious thing that he's able to [do]. It was after the oil glut. The Gluts, of course, were happening around the same time. What had been beautiful, the [Peter Paul] Rubens Venus looking into the mirror, all of a sudden becomes a Venus who's a garden ornament statue. You know, she's kitsch. It's very, very pointed. I became so caught up with the images and his own understanding of images that he had used before, which we always ascribe to him not focusing. We had thought of them as, "Oh, give me any image." But it's not. It's what I was talking about being an editor. There is a beautiful one in which—it was a Borealis and it was a photograph of the top of the sardine can with the key that always has that kind of triangular shape, and you're supposed to turn the key to get the lid off, right? Then, in the 1963 paintings, there [are] dangling keys, and those keys open a door, and these open your chance to eat dead sardines. Maybe I'm reading too much in it, but they're infused with so much emotion and yet they're on metal, which is so ungiving and so unresponsive. He also rubs them, and he gets them to tarnish instead of to color. He doesn't add color onto them. He has them change their color, their own color. Very interesting. He uses them in

a human way, and I find that very extraordinary. I find that very collaborative with the material.

MARY LYNN KOTZ: He told me that he got his uncanny ability to put things together from his mother. "She could put down a pattern on a piece of cloth and never waste an inch!" That was what he grew up with. You waste not, want not. I was younger than he, but he was of my brother's generation, so we grew up with those same rural values. You don't throw things away; you find a way to use them. When I was growing up, you could go down a Mississippi country road and see somebody's shack. That shack could have maybe an old crank washing machine on the front porch, or it could have an automobile tire on the ground. And somebody would have planted petunias inside the automobile tire. It was that kind of saving things that people had used up [that] was in his psyche.

He was showing us—he was doing, shall we say, a giant selfie of the world. He was telling us, "This is the world you live in."

We were [in Nice] the summer that there was an exhibition of Bob and Roy Lichtenstein, a joint exhibition in the Van Gogh museum at Arles [*Roy Lichtenstein, Robert Rauschenberg: 38 Oeuvres gravées de 1965 à 1989*, Fondation Vincent Van Gogh, Palais de Luppé, Arles, France, 1990]. So he and Darryl rode with us, to spend the night at our house in Cap d'Antibes.

Our bedrooms were on the second floor, and he and Darryl were up above [on] the third floor. He said, "I was up all night long because it's the first time in I don't know when that I've slept in somebody's house." The third floor was their now-adult son Michele's room. It was where he had lived. Bob said, "I just looked and looked and looked and picked up and studied every object and little piece in this room." This is an example of Rauschenberg's interest in other people's old possessions. People's chairs. He once told me that he liked chairs because when he would find an old chair that looked particularly interesting to him, he would sit there and imagine who had sat in this chair—and when. It was his interest in human beings—the life history of objects—just as he, in his art, gives you his own life history as a jigsaw puzzle.

I once asked him about what was it about the tires that they rolled along in so many of his paintings. He said, "Well, that was the only way you could get out of Texas. You had to have wheels."

OF COURSE, HE CHANGED THE CONFIGURATION

THOMAS BUEHLER: Nearing 1979 [there] was a show that five European venues wanted to put together, a Rauschenberg retrospective of sorts. I got a loan list ticket through the telex, and most of the loans were by Ileana Sonnabend. She had the main collection of Rauschenbergs, and all the famous Combines that now are in museums were in her collection. I made an appointment, got my list, and the show [*Rauschenberg: Werke 1950–1980*] was supposed to take place in Berlin. Staatliche Kunsthalle in Berlin, [Städtische Galerie im] Lenbachhaus in Munich, Städel Museum in Frankfurt, Louisiana Museum [of Modern Art] in Humblebaek, Demark, and Tate Gallery in London. That was the final venue. There were five. They all chipped in [on] the costs, the crating costs.

I had my appointment with Ileana Sonnabend at 420 West Broadway [New York], and the receptionist was a very nice blonde young woman. Her name was Mimi Thompson.*

She's now Mrs. Mimi Rosenquist. She was my first contact in the art world in the Rauschenberg realm. Mimi said, "Well, it'll be a moment. Sit down, and someone will be with you in a moment." So it happened, and Ileana looked at me from top to bottom and said, "I don't know you. I don't know your company, and what do you want?" I said, "Well, I have this list." I showed her my list. She went through it and said, "You know, I said it before. I don't know you. I don't know your company. My answer would be no." That was not very successful.

My next thing on the list that same day was a visit to Rauschenberg's [studio], 381 Lafayette Street [New York], where we are right now. I rang the bell, and a tall young man opened the door, really tall, six foot nine. His name [was] [Charles] Charlie Yoder.

He opened the door. The first floor—where the gallery and the receptionist are now—was full of crates. They had storage across the street there, on Great Jones Street, a garage, and then they had storage all over town with shipping companies. Rauschenberg's artwork was all over the world. Charlie Yoder and I got along together, and I explained to him that I just got kicked out at

* Editor: Mimi Thompson worked at Castelli, one floor below Ileana's at 420 W. Broadway. Ileana was often in Leo's gallery and that is where this meeting took place.

Ileana Sonnabend's. He said, "Oh yeah, Ileana. I know her well, and she knows me well." I said, "You know, you installed these works. You've been at the Smithsonian" [American Art Museum, formerly the National Collection of Fine Arts, Washington, D.C.]. He installed works for Rauschenberg. He said, "Yes, yes, sure man." I said, "Well, how about you and I travel with the show and we assure Ileana that her works will be taken care of, she'll get new crates, and everything will be state of the art and the way she wants it?" He said, "Sure." I asked for a second appointment at Ileana's and got the second appointment, and she looked at me and says, "You've got some nerve, young man. I just said no, don't you remember?" I said, "Well, there's a new development. I was at Rauschenberg's studio and met Charlie Yoder, and he knows the work," and she said, "Oh, yes, Charlie. I know Charlie." I said, "Well, Charlie has agreed that he and I will travel with the show, and we'll supervise the crating and handling of your works personally." She said okay. Boom.

So, [we] had the job. I telex to Berlin that we have additional travel expenses for Charlie, and they did the round with the museum and said okay fine, done. We got the show together, got the bid out for crates, and awarded the contract to one company that we knew was good, and so that got the show on the road. We traveled to Berlin in 1980. Bob came to supervise the installation. It was a complicated venue. It was two stories with a flight of beautiful stairs, but no freight elevator to match, so everything had to be carried up and down the stairs. Of course, [Bob] changed the configuration. Classic Bob Rauschenberg. If you say, "Oh, let's make it red," then he'll say "No, let's make it green." He wanted the chronology reversed. He wanted the older paintings on the second floor and the newer paintings on the first floor, and we had just preinstalled everything the other way around. He gave us a hard time, but it worked really well and the show was gorgeous. At the opening night, he pulled me over and said, "I think you did that real well. I heard that from other people also. I'm thinking of running this world tour. It's a plan that's not really fixed yet, but can you help running that?" I said, "Sure." It was not immediate. I thought it was the Jack Daniel's talking, actually. I said, "Sure, I'd be happy to."

The show went until 1981 and the Tate Gallery took it back to New York, and I went back to Europe to be with my first wife, Ilona. We had a house in [Ibiza] in Spain and had some time off, and a year later somebody contacted me by fax or by letter—I don't recall exactly—saying the world tour is happening.

Rauschenberg is looking for you, and there's money for you in Frankfurt and a ticket, and come back to New York. The company that did all the deliveries was the leading art shipping company in New York, Ollendorff Fine Arts. Mr. Ollendorff came in the morning to supervise his guys. They were really moving men. Today art handlers are students from Brooklyn and kids. Those guys were union teamsters in uniforms. They did a great job. They delivered the crates and helped install and things like that. Mr. Ollendorff at some point said, "You know, I could use a little help in my shop in art. Do you want the job, young man?" I said, "Sure." He said, "Come to the warehouse tomorrow morning. Six o'clock we start." It paid good money. It paid I think twelve dollars an hour and time and a half. I did that for a while, part-time. I learned a lot about the trade. I learned how to make crates and how to be in the truck and deliver art. We went to [Willem] de Kooning's studio and got sculptures to take back to galleries on Fifty-Seventh Street. I had my lunch in the storeroom and looked at famous paintings, like you never get close enough. Suddenly I had a job.

THE NATURE OF HIS WORK WAS NOT FOR THE MASTERPIECE

SUSAN DAVIDSON: As I said, Tom Krens had seen *The Early 1950s* show in San Francisco, which was to be the last stop, and he really insisted that it come to New York and be at the Guggenheim SoHo [New York]. This was maybe in the winter of 1993. [The exhibition traveled to the Guggenheim Museum SoHo, 1992–1993]. The show must have been traveling then for a year and a half. So you have this ongoing engagement because you're dealing with each venue and lenders and press material and didactics and all that kind of stuff. So Walter and I came to New York to install the show. Tom, at that time, was already talking about doing a retrospective.

[Conversations] really started when we showed the early fifties material in the SoHo space, and that looked spectacular there. I remember quite clearly there wasn't enough material to fill the space, and so Walter had this idea to bring up, from the Guggenheim's collection, other artists who were working in that time period, just a kind of little coda. People like Conrad Marca-Relli

and Ad Reinhardt and such, just to show people what was going on in the New York art world at that time and how Bob was really very different from that because he wasn't an Abstract Expressionist artist. He may have been coming out of that sensibility, but he was just so image driven. And yet a lot of the work in the 1950s is not so much about that; it's about covering up and veiling and reflection and elements, materiality, different materials.

What Walter wanted to do was the next step. He really saw Bob's work in series, which is how Bob made it, and we had already started working on a Combine [1954–1964] show. That was what we were going to do next. We were going to apply the same methodology that we had applied to *The Early 1950s* show to the Combines. I was pretty deep into that research, and I remember Walter talking to Tom, saying that's what we were doing next, and Tom said no, it's going to be a retrospective.

Tom's a big thinker, and he was always a fan of Bob's, and I think he saw that he was the artist that could hold the rotunda, in a way, and, ultimately, three other spaces in New York. He was very committed to that. For several years, Tom and Walter teased each other back and forth about "Oh, I'm doing the Combine show"; "No, you're doing a retrospective."

Once I heard that [the retrospective was on], I reached out to David [White] right away and asked for a copy of the database so that I could start to look through things. I started to make photo books, because that's always how you start a project, you start accumulating images in a chronological fashion. I started coming to New York pretty regularly, coming here to 381 [Lafayette Street] and working with David, going through the registry books and just assembling a lot of [visual] material. Then Walter and I laid all of that out in the curatorial hallway at Menil because it would be fairly massive [and we needed the space]. You'd kind of start choosing your show that way.

We always shoot for the moon. One of the things that we did at the time was bring Carol Mancusi-Ungaro, the conservator at Menil [now at the Whitney], into the process because we knew that getting the Combines was going to be complicated. I also started traveling quite a bit to look at Combines and to meet with people and lay the groundwork. I remember Walter always saying it's really a lot easier to travel a Combine than it is a Barnett Newman painting, because if something happens to a Combine, it's easy to repair because of all the layering of materials. But it's very hard to fix a

monochromatic painting. So that sort of became a little bit of a mantra in trying to convince people to lend.

Walter and I were doing this for an institution we didn't work for, and that was strange and complicated; dealing with their internal politics, which we weren't always privy to. We were coming from a land where there were no limits. Menil [in those days] never had limits on it. You didn't really do budgets, and if you needed a loan at the last minute, if something fell out, you just got it. That's how it always was. That was the difficulty, I guess, that it was a big institutional machine, and we just didn't have that. But we didn't worry about it either. We just kept going forward. That's always how Bob thought and functioned anyway. I guess we would've thought that that was our mission. We had that stamp of approval from Bob, and Tom was really engaged in the show too.

[The show] had so many different components to it, between developing the checklist, looking at the art, traveling, meeting with people, catalog authors, catalog design, and then installation.

Part of the curatorial work is to examine [the] works, to begin to understand how they fit into the artist's oeuvre, and then to begin to hone your selections that tell a particular narrative. You also begin to better contextualize [the] masterpieces by seeing things that weren't always—I don't want to say the worst examples, but that helped to define works that were quirky or unusual, especially when you're looking holistically and retrospectively. At first, as usual with Walter, I always thought it was sort of wacky. But I began, over my career, to really understand the need for that, that it gives you a benchmark, if you will, and that becomes important to telling the story.

I think every curator has a different approach to how they prepare shows. Some are much more academic in their thinking; others are more visual, and they only want the more beautiful examples, the things that shore up what the artist's achievements are. But, in fact, an artist's achievement is about the good and the bad, the beautiful and the ugly. So you really, I think, need to embrace those works that you may not instantly feel comfortable with because, over time, they tell you something. They start to reveal other bits about an artist and what their thought process is, and in Bob's case, how he assembles images or not. There are still pictures that we put in the retrospective—not many, but enough—that still make my stomach a bit queasy because I didn't get to that point with them in terms of their aesthetic quality

and appreciating them from that level. But I certainly understood how they fit into what Bob was doing.

ARNE GLIMCHER: The nature of his work was not for the masterpiece. The nature of his work was really like channel surfing. All of this information that's on the page is for you to create the narrative within it. Aesthetically, they're dazzling, the way he balances the work and uses the space. But they're incredibly challenging because so many of the images have nothing to do with each other, and you have to stretch your perception in a way—learn how to look at something in a different way. You have to look at parts of the picture as well as the whole, because parts of these pictures are whole pictures.

BOB MONK: Back then I didn't know what to think. Years later, as I started to try to put it all together, I think it really was this idea that the moment really counted and this, I think, was because of his dyslexia. He wasn't going to go back home and pick up a book. It was the very moment that counted, which is why he was afraid to be alone. He almost never slept. The idea of interaction, either working on a canvas, on a sculpture, whatever, or just speaking with people, it was very immediate and very necessary for him. So the whole idea of down, quiet time, other than sleeping, just didn't seem like that was ever in the mix. When a really bright person who was a close friend of his put thoughts into his mind, he would act on them because he couldn't run to that book or to that sheaf of poems.

Jasper [Johns] from the moment he [was] with Tatyana Grossman or Ileana—but even going back earlier, when he's with Agnes Martin, when he's with John Cage, when he's with Merce Cunningham—the things that different people would talk about in these groups he could then go and explore. He could buy the book, he could go to the library. But with Bob, it's something that would energize him. He might stay up all night making something from that conversation, and then the only way he could bring it even further along was to continue the conversation, either with the person that he began it with or—which is kind of fun in life—to go to another person and say, "You know, I was just talking to so-and-so."

[Bob] would have to keep it in his brain, and then it came out intuitively in this incredible work, the way he would just pick things up. He was a beautiful,

natural designer. That's why some of those works just sing. He'd put all this stuff together, and then it was this narrative like no other, just the most beautiful.

MARY LYNN KOTZ: He was like a sponge, absorbing and recycling what he saw around him. Not only photographically—which you know, he was a photographic genius, for heaven's sake. It was his photographic eye, I think, that perhaps gave him a sense of a detail that he wanted to put somewhere. One time, when I was in his studio, I was watching him make a painting from the series in which he was recycling a lot of the silk screens that he had made from the ROCI [Rauschenberg Overseas Culture Interchange] trip into some more contemporary screens. He was putting this image here, that image there. Then he would stand back, and finally he would say to his studio assistant, "Bring me that yellow flower from China. You know the one, Darryl, the one that da-da-da-da-da-da-da." So Darryl went into the back of the studio and found this screen with the yellow flower. They'd put it down, and there was suddenly a yellow flower on this steel background. You could see [that] it just made the painting, not a patchwork quilt but a work of art. I said, "Bob! How in the world did you know to do that?" He was cross. He said, "I've been doing this for forty-three years, and if I don't know by now, I'd get out of the business."

SUSAN DAVIDSON: Our remit, if you will, was that it be a retrospective, which meant it needed to be chronological in the way that it was presented, and we didn't really deviate from that. But following that course, and at that point it was nearly sixty years of work to look at, there were particular narratives or stories that we wanted to tell that explicated how Bob not only fit into art history but how he also was ahead of art history in a lot of ways, particularly in the 1950s and 1960s. Then as he came back through the 1970s and 1980s and picked up a lot of those visual tropes to begin to focus in on them more directly, or more singularly, say with the *Cardboards* [1971–1972] or with the *Hoarfrosts* [1974–1976] or *Jammers* [1975–1976], where he was just working with material. Cardboards and fabric are all there in the 1950s, especially in the Combines, but he pulls them out and gives a singular focus to them in the decades of the 1970s, 1980s, and 1990s, and that was part of what we wanted to let people know to see, to understand not only his explorations of materials but to see how inventive he was.

For instance, with the *Cardboards* that start in the 1970s, you know, a lot of people may not realize that through his friendship with [Donald] "Don" Saff, which was beginning around this time with Graphicstudio in Tampa [University of South Florida] when Don was there, Bob made editioned ceramics that look as if they are fabricated from cardboard. And you look at one of those today, and unless you go and physically ping it, touch it, you don't know that it's ceramic [*Tampa Clay Piece*, 1972–1973]. The idea that he would work across material like that is really indicative of how Bob thought. So it was areas like that we were able to explore. Also, bringing in all media was absolutely essential, not just showing paintings and sculpture, but photography, editions, drawings—all media and materials became part of what we were doing. With Bob, that's big—that's big. So we were fortunate that we had as much space as we needed.

So as we began to kind of assemble the checklist, and also you have to know, too, at that time the Guggenheim had a space in SoHo, so they were very keen to use it. It was not so far into their programming there that it was starting to become a hassle for the institution. We knew going in we had both spaces. There were crazy things that we wanted to do, or Tom wanted to do, and lots and lots of money was spent on investigating how to do these things. For instance, the *1/4 Mile* painting [*1/4 Mile or 2 Furlong Piece*, 1981–1998] everyone felt needed to be part of the exhibition, and there were, I don't know, months spent, maybe nearly a year, looking at how to install the *1/4 Mile* painting in the center of the rotunda: building a scaffold, like a Tower of Babel, if you will, and then hanging it off of that and having ramps from the ramp itself, from the Frank Lloyd Wright ramp, onto this scaffold so that you could walk around it. It was completely ludicrous. But there was just a commitment to showing as much as possible and really exploring it in as much depth as one could and at any cost.

Tom always had an interest in utilizing the rotunda of the Frank Lloyd Wright building, and ultimately the institution finally got there with the Maurizio Cattelan show [*Maurizio Cattelan: All*, 2011–2012], when the artist, who's a sculptor, hung everything from the center of it. But those were three-dimensional works, and they hung better in a central space like that. Doing a painting spiral probably wasn't a smart thing. Certainly that was the most outrageous thought. As I said, it took probably six to nine months before anybody moved

off of it. I don't think Bob was ever really that committed to doing it, but he was amused enough by it to let it continue to be part of the dialogue.

The Guggenheim works with models, a scale model. They had maquettes made up of everything that we were ever thinking about on the checklist, and when Walter and I would be in New York, we would spend several hours playing in the model. It's like a little dollhouse. A number of museums work this way; it's really the only way you can begin to understand how much material you need. It doesn't really give you a sense of how you'll hang particular works when they physically come in front of you, because there are issues of framing or coloration or things of that nature that don't speak to you when you're just dealing with a color reproduction, in a dollhouse format. So it helps you define how much space you need to tell certain parts of the story. We'd spend a lot of time with the models, and you're always moving things in and out and things like that, until you get to the point where you really need to request your loans, so that you can begin to understand how the show will begin to take shape.

Most museums require nine months in advance to process loans anyway, so you need a year and a half out to know where you're going with it. You may not request every loan at that moment, but within a year, certainly, you need to have things in people's hands so that they know to reserve them because there are always competing exhibitions as well. You always want to go where you think a loan will be easy, but one of the things I've learned over the years is that for every show you do, every loan you think will be easy becomes difficult, and everything that you thought would be difficult was easy. So it's funny in that regard.

The most challenging loans really were the technology loans, and those works were intended to be displayed in SoHo, and they were challenging for two reasons. One, they weren't in great condition, and they needed to be upgraded or migrated technologically. So that required working with a number of the scientists Bob had originally worked with to create them. A number of these larger works are in institutions too, and they don't necessarily travel so well, so there was negotiating all of that. I think we got into a really crazy situation with the work *Mud Muse* [1968–1971], because while the Moderna Museet [Stockholm], which owns it, had restored it recently, it was a very expensive loan at that time to take. I think it was close to forty thousand dollars just to

ship it. Plus it required a certain level of daily maintenance, and this became a breaking point on a budget level. But I was really convinced that it had to be in the show, and I pushed really hard, and ultimately gave up other things in order to get that. I knew it would be something that was just so completely unusual and fascinating for people. As I think back now, I'm not sure at the time I was fully cognizant of the whole sense of materialness with Bob, but not to have *Mud Muse*, with this vat of mud that percolates and bubbles to a soundtrack, it would've—it ended up being one of the most remarkable works in the exhibition. It really appealed to a lot of people. So it was worth the effort.

The retrospective got started in 1995. Once it was signed on and agreed to, [it] was going to have five venues: New York, Houston, Cologne [Germany], Bilbao [Spain], and finally Los Angeles. To do a show that big through five venues, it's very difficult to hold the loans together, and it was mostly a loan show, it wasn't all coming from the artist by any stretch. MoCA Los Angeles [Museum of Contemporary Art, Los Angeles] sits on the holdings of the Panza Collection, and they have eleven Combines. Paul Schimmel was very focused on the Combines, and he very much wanted to have a lot of Combines in the retrospective that he was going to host, and we just couldn't deliver that [after four previous venues].

From a strategic or structural loans point of view, it just wasn't holding up. And also, to be perfectly frank with you, Bob didn't want to do a Combine show with Paul Schimmel. I don't think he was that crazy about him. He knew that Walter and I had been working on it, he was fine with that, but the combination of things—Bob was offended that Paul Schimmel wanted to turn the retrospective into a Combine show, and I think also he was tired of the retrospective. So before we went to Bilbao, Bob pulled the plug on L.A. as a venue.

I remember that very clearly, because I was in Houston and I was deep into a catalog deadline and I had a phone call that said I had to be in New York the next day for a meeting with Bob. And completely exhausted, I got on a plane, came up, and Bob said, "We're not going to L.A., that's it. Bilbao will be the last venue."

Walter and I had some struggles in terms of thinking about the placement, and how the show divided between two venues. I actually have no memory about how the *1/4 Mile* painting ended up being shown at Ace Gallery [New York], who came up with that and who brokered it. So that then became

a fully stand-alone part of the exhibition that was downtown on the West Side, on Hudson Street. It looked fantastic there because the spaces were slightly carved up, and it created a kind of labyrinth, which was just terrific. And if you didn't see anything else of the exhibition, you got a full measure of it, in a way, through the 1/4 *Mile* painting.

I think that as Walter and I were thinking about how to separate uptown from downtown, the 1071 [Fifth Avenue] building from the SoHo building, it was how to tell the story if a visitor only saw one and not the other. That kind of became our largest challenge. What happens with artists' work is that, as they age and become more successful, their work generally becomes bigger, and the Frank Lloyd Wright building has limitations in terms of heights on the ramp. So it quickly became evident that the later work would be shown in SoHo, but the question was where do you make that break?

I think I learned to always be open and to look and to be tolerant. I learned this great word, which I subsequently use quite a bit, which is a "hiccup." There's a wonderful work that Bob made called *Hiccups* [1978], which is, I don't know, a hundred small five by seven little drawings that are zipped together, and you can install it in different ways. [*Hiccups* contains ninety-seven parts, each 9 × 7 3/4 inches.] One of the things that happens when you're doing a show, there's always crazy things that go on or things you don't expect or people come out of the woodwork or a loan doesn't ship the right way or there's damage, or anyway, there's myriad of things that can go wrong. If you just keep your calm and you just look at it as, "oh, that's just the hiccup of the day" and you look for a quick and viable solution; that has become, really, how I like to work. Not to get ruffled, not to freak out, there's always a solution, you just have to find it. So that's the hiccup. Today we have a hiccup.

THE SHERIFF IS HERE AND THE MARSHAL, AND THEY WANT TO CONFISCATE ART

SUSAN DAVIDSON: Of course, in Houston we had this huge hiccup with the seizure of the artwork. Bob had a dealer, a German dealer, who I think was based in Austin, named Alfred Kren. They had been doing a couple of deals together and something happened. I actually never really learned the

full story as to what happened—I think it had to do with payment of the com-
mission or something like that. I wasn't privy to what was going on in Bob's
daily business life.

I remember being in New York in April; we were downstairs with Don
Quaintance and Walter here at 381 [Lafayette Street], in the kitchen, as usual,
and we were showing Bob the cover of the catalog, showing the layouts of how
the catalog would be. A letter arrived for Bob, a registered letter or something,
and he just sort of looked at the envelope and tossed it aside. Well, it turned
out that he'd been doing this, tossing these envelopes aside, for some time,
and it came to a head when the show opened in Houston. Alfred Kren was
trying to sue Bob about this commission, and Bob wasn't answering the com-
plaints. In Texas there happen to be laws that you can seize people's property
if you have a judgment against them. Because Alfred Kren was then based in
Austin, after this frustrated year he was having, not getting Bob to respond,
he went to a judge and got a judgment against Bob and therefore was able to
seize a particular value of property belonging to Bob. This is another lesson
that you learn in life, that you shouldn't always state things, "Collection of
the artist," but you may want to consider them as "Private collection." That
allowed Alfred Kren to go through the catalog and target what he thought was
the value of his judgment.

THOMAS BUEHLER: We were done installing. I was in the hotel. It was a
Friday—it's of significance why this was a Friday. I was in the hotel. Bob was on
the way to Lafayette [Louisiana] to see his family [Rauschenberg at this point
had not yet left Houston]. Don Saff was somewhere also in a car. I was in the
hotel. Friday morning. We're done installing. Oh, great, weekend coming up.

The registrar called me—Julie Bakke—and said, "Thomas, you have to come
here right away. The police are here and the sheriff is here and the marshal, and
they want to confiscate art." My hotel wasn't very far, so I jumped in a taxi, got
to the Menil. The road was blocked on both sides with police cars with their
lights flashing. There was a horse trailer in front of the Menil hooked up to a
pickup truck. I had an ID card from Menil so they let me in.

Alfred Kren claimed that Bob owed him five million dollars or something
like that. He had a company in Texas—Austin Art Consortium—and so he
had Texas jurisdiction, and he was waiting for Bob's show to come to Texas to

make his move. He found a judge that gave an order to confiscate artwork in the value he owed. They had a list, *Erased de Kooning Drawing* [1953], *White Painting* [1951], all the things that they wanted.

This is why it's significant it's a Friday. The judge signed that thing on Friday morning and went to play golf. He was not available for comment, and the sheriff said, "I have a court order. I have the judge's order. There's nothing I can do." They were there with working gloves. The registrar and I said, "You cannot touch artwork with those gloves. No way. We will not allow that. You have to really manhandle us if you do that."

SUSAN DAVIDSON: It was the Friday of the opening, and he got a judge, it turned out to be the sheriff, and they arrived at the museum with papers saying that they could seize the artwork to this [stated] value, and there was no stopping the situation. It was pretty hair-raising. They literally arrived with a cattle truck to carry—you know, it was during the rodeo in Houston, because we opened in February when the rodeo is in town—I mean, it was just, it was absolutely insane. I cannot tell you. Everybody was freaking out and going in different directions. Tom Krens was trying to deal with lawyers in New York because they were the organizing institution. But the state law existed, and you had to deal with that. The director of the Menil collection, Paul Winkler, was trying to deal with Menil lawyers to try to see that it wouldn't happen. I was upstairs in my office, which overlooked the director's office in one of the bungalows below, and trying to figure out value [of the artworks against the judgment Kren had]. It was a complete free-for-all.

Bob was nowhere to be found, and couldn't say yes or no, and at the end of the day we were obligated legally to let the sheriff take the work off the wall. I think that Paul Winkler did get them to agree to wait until after the show opened that evening, so that we'd have the opening, nobody would know. Everybody was kind of in an embargo, on tenterhooks, and then they took it away. The next morning Walter and I had to rehang the show so that no one would know this had happened, which was a whole scene too. Paul, with Menil lawyers, was able to go in front of a judge and to prove that these were high-value artworks that shouldn't be held improperly in storage, and this, that, and the next thing, and put up a bond or whatever on Bob's behalf to get the works back in the exhibition.

Texas didn't, at that time, have an antiseizure law like New York did, where it's against the law to remove artworks on public display if there's a dispute. It's a very valuable law. It comes in from that [Egon] Schiele case with the Leopold Museum [Vienna] because that, I think, was also taken from an exhibition at [the Museum of Modern Art] at the time. It's a way to protect property and also not to air disputes between people in a forum that's really for the public. After all the dust settled, the registrar at Menil, Julie Bakke, did propose a law to the Texas Legislature, and it was passed, so they now have an antiseizure law. But at the time they didn't, and Alfred Kren knew this. And he also knew that there was a law that allowed him to legally do what he was doing. It was crazy.

It was maybe twelve or thirteen [pieces]. You know, *Erased de Kooning Drawing* [1953] was one of them. I do remember when the sheriffs came in to take the things, that was what I was trying to do before they came in, direct them to things that weren't so fragile, that were glazed, and that would still meet the value that they needed. I was also trying not to upset the exhibition too much because we had to paper over the whole thing rather quickly. It was absolutely insane.

We got up the next morning, after having this big blowout party at the Bayou Club in Houston, everybody dancing and rodeoing, it was a great party. Bob seemed totally unaffected by it, although it ended up costing him a lot of money because he had to then hire lawyers in Houston and come for depositions, and this, that, and the next thing. But it ultimately got solved.

I remember going to pick up the work. It wasn't stored in a bank vault or anything like what you would expect for that kind of value and the rarity of the works. They were in an office trailer in a car impoundment lot out on the East Texas Freeway in Houston, with a single air conditioner running for climate control. I mean, it was horrible. It was just terrible.

BOB HAD VERY STRONG OPINIONS

SUSAN DAVIDSON: In Bilbao, Bob had very strong opinions about what needed to be shown. He had been in Bilbao the year before, for when the building had opened. He was completely in love with the building. We were,

in fact, the second show that they did. So the crew was not as experienced in everything, but of course Bob always had not only David but Thomas [Buehler] and Lawrence ["Larry" Voytek] and other people traveling with him, so they knew the work. In Bilbao, we brought the *1/4 Mile* back, and we installed that in what's called the Fish Gallery on the first floor, which is now a permanent installation to Richard Serra, but at the time it wasn't, and it just fit to a tee. Bob made, I think, three or four [five] new panels for it, to bring it up to date.

THOMAS BUEHLER: *1/4 Mile* was supposed to go to Bilbao [Guggenheim Museum Bilbao, 1998–19] and of course it's 350 parts and none of them are crated. [There are 190 numbered parts or segments in the *1/4 Mile or 2 Furlong Piece*, several of which contain multiple components, resulting in the estimated three hundred parts.] So, of course, head scratching and budgeting. How do we get three hundred parts to Bilbao? It had been shown here [Guggenheim Museum at Ace Gallery], it had been shown at Houston [Museum of Fine Arts, 1998], but Bilbao was a different animal.

I was always interested, and still am, in sea freight, which is not very common because art insurers don't like sea freight; the exposure time is too long for risk exposure and things like that. Nobody likes sea freight really. But I know from looking at them a lot and looking at container ships, that there are really first class containers. If they're brand new, they're like a house. They have forty-foot or forty-five-foot containers, and they have climate control, they have a graph that shows exactly what the temperature differences are and humidity. There's a generator attached to them—they're called "refers," refrigerated containers.

I started playing with that idea. We were close with the Guggenheim at the time, and one of the preparators said, "You know, what if we build a container as if it were an art storage room." The containers have nothing in them. They're like stainless steel boxes with no D-rings, nothing. That's it. There are no racks, nothing you put things on, the floors have slots so that refrigerated air can circulate. If you have a stack of frozen chicken there, you want to make sure they don't sit on the ground, they sit on something cool. So they have these T things—one T next to the other—so the air can circulate under the floors and cool or heat it. Whatever you want.

We said "Well, that should be possible." We started devising a system. The registrar at the Guggenheim at the time was [L.] Lynne Addison, and she was very much in favor of that also. Curators didn't seem to have any problems with it, so we pursued that idea. I went to Maersk Line, that's a Danish or Scandinavian shipping line. You see their containers all the time, everywhere around the world. And they said "Yes." I had gone to the insurance first, and they said, "Ask for the best class containers, ask for the history of the container, see there hasn't been any dried fish in it before or dangerous chemicals." I went out to the yard in Elizabeth, New Jersey, and he said, "I have one here, I can show. It's A class, it's brand new, it's never been anywhere. It just came. And I have another one coming in that's also brand new." I said, "Well, can we book these?" He said, "Yes, sure, we can book these." They have numbers and they're like FedEx, you can look up the history. You can look up where they've been before. So we had that.

The rep from Maersk Line said we also have forty-five-foot containers. Wow, that's good, because we never knew exactly how much we [would] need. When you load a truck, you know exactly really only at the end when you close the door. A container is the same thing. Forty-five-foot containers sounded like a good thing. I had a friend in Germany who has an art shipping company, and I called and said, "Günter, I can get forty-five-foot containers. Isn't that great? To truck down from Rotterdam [Netherlands] to Bilbao?" He said, "Stay away from that. The only company that has the trailers for those forty-five containers is Maersk Line themselves, and they can kill us with the price because they can dictate the price. Take a forty-foot. I can find trailers for this in mass quantities, and if you need another ten feet, I'll pay for it." So, I said, "OK, sounds like a deal."

We booked the two forty-foot containers, and we made a plan. The idea was, you had to return the containers right away. You couldn't keep them for the duration of the show. Whatever we built in there—a rack system or wall system—had to be collapsible, had to be numbered so part A to part B and dot to dot and circle to circle so you can take this apart later on, put it in storage, and when the containers come back for the return you put this thing together again. So the fabricators, the preparators at Guggenheim, were great. The carpenters they had were great. We had the containers delivered to our warehouse at Thirty-Eighth Street one at a time. We built—when you build

sheetrock walls, you build a frame and then the sheetrock goes in front. So they did the same thing; they built the frame, and they put it up. I invented something—one of my million-dollar inventions—a hook system, a toggle bolt that you can put in the T on the floor so we could strap webbing over things and secure them because everything had to be securely secured. A truck is one thing, but a ship for four weeks, you want to make sure nothing shakes loose and it's all really tight, tight, tight. So we had fun. We had a shop there, and the carpenters came and truckloads of two-by-fours were delivered. And we loaded the 1/4 *Mile* into two forty-foot containers, and when we closed the last door of the second container, it was loaded to the end. It was great. A lot of fun.

JANET BEGNEAUD: I was at the show in Bilbao [*Robert Rauschenberg: A Retrospective*, Guggenheim Museum Bilbao, 1998–1999]. That show was unbelievably well attended, and people [were] oohing and aahing. You could tell they're not just walking around and looking at art; they're discussing it and Bob and "Look at this!" And that's what Bob liked. He really wanted you to not just to look but to see. And a lot of his work[s] were participation pieces for the seer.

One of his really fun pieces that I loved—the big piece that's mirrored and it has sound [*Soundings*, 1968; the work is activated by sound sensors]—it must be, I'm guessing, at least twelve, fourteen, maybe sixteen feet wide [it is thirty-six feet wide]. Great big piece. To look at it, it's just dark images, kind of mirrored, and no color. But then it responds to sound, and so when it hears the sound, different things light up depending on the frequency. It's so much fun because you'd walk by it and it'd go do-do and something goes up, and then you'd da-da and something else lights up. It's really a fun piece. The story was that it was at the Museum of Modern Art [*Rauschenberg: Soundings*, 1968–1969], and there was a little group of Catholic school girls in their uniforms and all were coming through the thing, so the nun sat them all down in front of there. And they started singing to it, and the thing almost blew up. It was just going crazy with those little girls sitting there singing. But a lot of Bob's art was about—you had to work it, and that's really what he wanted. He wanted you to be a part of it, not just look at it.

MARY LYNN KOTZ: He wants you to bring yourself into it. He wants to involve the viewer. Maybe, just maybe, he says the viewer might learn something about the world around them. His vision is so egalitarian that a piece of cardboard is equal to a stained glass window in a cathedral, for example. It was his concept of society that he manages with his imperative—to create a visual sermon, if I could call it that, which [preaching] is what he wanted to do when he was a boy.

HIS ACHILLES HEEL WAS THAT HE LOVED ALL HIS WORKS

SUSAN DAVIDSON: I'm motivated by the artwork that is exciting to me and invigorating to me, [but] you can't let your enthusiasm govern your choices. You do need to be critical about what you're doing, and mindful of what you're doing, and rigorous about what you're doing. But that comes from your position as an art historian, not your concern [about] how people will respond to it.

When you're a curator, you have this great responsibility to educate; that is what you're doing in organizing a show and producing, doing the research and the catalog and such. But you have to follow the code of the artist, and every artist is different. I think that's what the curator must have, that sensibility, and it has to be a sensibility, a reverence, and a curiosity without putting yourself in front. Now there are some curators who do that and they have great names, but I think your role is to be the interpreter, without overexposing the artist. At the same time, you are exposing the artist. It's a very fine line. It's about sensibilities I guess, and I guess this was one of the things that always drew me to Bob. The work is very intuitive. I feel as a curator I've been very intuitive; you have to follow your gut.

I think we knew, or I certainly knew, that doing a retrospective with 432 works in three locations in New York City was probably not smart because it was just too much for people. You should be able to do a show in sixty works and tell the same story. But with Bob, that's actually not really possible.

CAROLINE HUBER: [Walter Hopps] was radical without trying to be radical. He just was. He had a really curious mind that could go into any subject and

be interested in it and really explore it and understand it, and he had a gift with putting things together in a visually compelling way. There are a lot of curators who are really smart, but they're not good at installation. It's a gift. It's just something you're born with or you're not.

He just loved the objects so much; he just loved them, and he loved the people who made them. He was so interested and fascinated by it all, and that came through too. He had a real gift with putting things on the wall or in the room and making it anew. That's not something that you can learn—you can learn how to do it better, but I think it's innate.

[There was a] kind of inventiveness or poetic ability that Walter had to make things really come alive in a very beautiful way, the way a good writer can make words sound so different and beautiful. I don't know that anybody can replicate that. Special people like that, they only come along once in a blue moon. So it's not like you're going to have fifty Walter Hopps, just like you're not going to have fifty of [Pablo] Picasso in a century or [Marcel] Duchamp or Rauschenberg.

I think [Walter and Bob] could feed off each other because they both were funny and very witty and bright. They were both very, very smart, and they enjoyed each other's company, and they both admired each other's work. It was fun. That feeds on itself and makes it even more exciting. Bob would say, "Oh, I've just made a new painting, I want to put it in," and Walter would go, "Okay." He was open to anything that Bob wanted to do, and I think Bob appreciated that. I mean, it certainly was his show, and he had a vision for it, but he was very open. It was a real collaboration, and [Walter] was willing to have it change and evolve and ebb and flow because he was really interested in what Bob wanted. It was very much about Bob's input, and some curators aren't like that. With Walter, it was a real collaborative process. He was really open to whatever Bob wanted to do. If Bob wanted to do it, it was okay with him.

ANNE LIVET: On one trip to a museum show in Vancouver, the director began talking about the installation as if he was the artist. [Vancouver Art Gallery; *Robert Rauschenberg: Works from Captiva*, 1978]. He went on and on saying, "The way I do installations," and "My vision for the exhibition," and so on. Bob shot his eyes around at me and said, "Somehow I thought I was the artist. Where'd I get that idea, Anne?" Everyone laughed, but he wasn't kidding, and if you knew him well, you could almost predict what his reaction would be.

So in the end [Bob] completely changed the installation. The director had laid it out for months in a certain way that he [had] convinced himself was smarter than Bob. But Bob remained firmly in control and got his way. It was not Bob's style to plan this thing out four months in advance. Instead, he wanted to let the works come to life in the space.

I think that's one of the reasons that he got along so well with the legendary curator Walter Hopps, who worked beautifully with Bob. Walter was known for being a genius at installing shows, and he and Bob would sit in the gallery with the work and talk about it, and think about how the show should flow, and it would be a back and forth.

Bob respected Walter a lot because he thought that Walter really was a kind of artist. He knew how to put up work where you would get the most out of the work in the space. Once again, when Bob was with someone he could go nose to nose with, he would have a real collaboration.

CAROLINE HUBER: That's another reason I think the show was so interesting. To me, why I learned so much from it, it was because, with every installation, every building had different architectural elements that created new possibilities for Bob to make something different. I remember in [Guggenheim] Bilbao there were these ropes hanging off the balcony [*Earth Pull*, 1998, a site-specific installation].

He made it for there, so it was a new piece, and a new way of seeing his work. That was thrilling. The early Combines and other early works are seminal, groundbreaking, but I think it misses the boat when they are considered the main event because it was interesting from the beginning to the end to me. That was a real revelation, and that was something that Bob and Walter could show you from the way the shows were done.

DONALD SAFF: His exhibitions as a work of art. It's an interesting issue, with his exhibitions, because in a sense, just like his art, nobody could lay out a show better than Bob. Nobody could hold a corner better than Bob. He knew the problems of corners and rooms. And you know, you're never as much aware of it until you see him hang something that deals with a corner. Brilliant. His Achilles heel was that he loved all his works. So the tendency to overcrowd the show was inevitably there. If I, or someone, would suggest spare, he knew that

meant that one of his babies [was] not going to be in the show, and that was tough for him to take. So it was always this sort of compromise of what you should put in a show and what he wanted in a show.

SUSAN DAVIDSON: I think, really, the critics got it. While they may not have embraced what we're going to call the later work, you know, the work from the 1970s on, I remember one comment that Bob would often say: "It takes twenty-five years for the critics to catch up with me." So he was used to not being instantly appreciated. The work is so advanced and yet it's so simple, and that's where it puzzles people, and that's why they sometimes don't think it's so good—because they don't understand the inventiveness of it. But he was fine with it. He'd gone through some tough times critically, and I know that most of the criticism about the retrospective was about the scale of it, being too much. But the opportunity to see all of that work together was amazing.

THAT'S ALL HE REALLY WANTED TO DO

RICK BEGNEAUD: Bob always seemed to be enjoying himself while he was making his work. It didn't seem like it was a struggle to him. Not that he didn't work hard at it. I meant just that I don't think he gave himself ulcers worrying about making this piece, which I do sometimes. I kind of always flash back to what Bob always said: "Have fun when you're making your work." But the other thing is I think Bob was always just incredibly curious about what the possibilities were, where you could take something. For me that's true. When I start a piece, I have no idea where it's going. It's just blank. And then I just start. I think the cool thing for me is the surprise of where it ends up going because it was not planned. It's unexpected, and there are twists and turns along the way. When you get in that flow, it's really a beautiful thing. It's hard to get in the flow for me. But I feel like Bob just trooped ahead. Even when it was difficult, he just kept moving. That's something I think about, that he just made stuff and he wasn't worried whether someone liked it or not. He was just making it for himself, really. I mean everybody too. But I don't think he was making it specifically to be judged by somebody else in that moment.

BOB MONK: I think that many artists, whether they become successful or not, fall into that thing that once you have the great idea—suppose the great idea is when you're twenty or the great idea is when you're forty? But if it happens when you're twenty and you make this work that everyone says, "This is absolutely remarkable," and then you become sixty-five or seventy years old, and people are not saying it's so remarkable—it's very natural and normal that that would happen.

For me and for a lot of other people, there's a point where, to use my horrible expression, it falls off a cliff.

ARNE GLIMCHER: One of the great artists of all time, [Pablo] Picasso, never edited himself—and he is probably one of the greatest artists of all time—who made the most terrible work of any famous artist. Because he was, like Rauschenberg, making art every day. Jean Dubuffet got up every day and made art. It wasn't this nitsy attitude of making masterpieces, or making a picture. Bob was never making a picture. If fifteen of the works in a group of twenty were not really great pictures, they were Rauschenberg's, and those fifteen got him to those two.

That's what it's about. That's what you want to see. The idea of seeing a painting hanging on your wall—you know, it's a weird way for me to talk. It's ridiculous, this idea of masterpieces. When I was a kid, if you had a tiny little scrap of drawing that Picasso had laid a hand on or something, you were so lucky to have a work by Picasso. I knew that the *Demoiselles d'Avignon* [1907] was in the [Museum of] Modern [Art, New York]. It didn't mean that I wouldn't be happy with a little drawing. It's not the attitude anymore. There is no connoisseurship. It's easy to pick the paintings that are in all of the coloring books and all of the art books. But how about the paintings that really show you how pictures are being made? That's what is so exciting, the paintings that show the struggle. The Rothkos that look like picture postcards, three bands of red—and they're gorgeous, and they're terrific—those are not the Rothkos that interest me. The Rothkos that are burgundy and black and clay color, and you can see the struggle to get that painting made. The thing is, that painting is a gift because the artist allows all levels of its creation to be visible. So it's a painting, and it's a notebook for the painting. Some of the paintings that are three bands of red, that knock you out, they're not the same thing. They don't have the

same life for me. So I'm so interested in seeing something that struggles, that near misses, that then comes out with something great. That's so interesting. I don't think people, for the most part, know how to look at it. They're too valuable now. It's an investment, and they want the picture-book paintings. I hope there are young people out there who just wish they could have something by Rauschenberg.

EALAN WINGATE: When you're chewing up absolutely the entire world, and you want to know what to say, to spit out: he knew what to say and spit out. Every image shows a caress and a care, and so you can feel that and you can feel when it's done by rote, when it's done because "that looks like a Rauschenberg image. I might as well use it."

I own a painting from 1962, a black and white painting [*Buffalo I*, 1962]. I know it well. I made a show just this past autumn in Los Angeles of paintings on metal from 1989 to 1991, 1992, as well as some *Gluts* [1986–1989/1991–1994; *Robert Rauschenberg: Works on Metal*, Gagosian Gallery, Beverly Hills, 2014].

But the paintings from the *Borealis* series [1988–1992], which are on copper or brass—the way that he applies the paint and tarnish and various other things is so much like that amazing way he applies the paint on my 1962 painting. It's like somebody having a signature, or a style of handwriting, but he's able to make it work anew and make it do things that it couldn't do in 1962 and it couldn't do with oil and canvas. And regardless of what one thinks about that trajectory through the years, that, in itself, is extraordinary. That is demanding—to do the same dance step but all of a sudden [to] have it mean new things. It's really kind of wonderful. Really, really, really wonderful.

He wasn't stingy, in any aspect. It's true. There's a lot. Seeing what the estate has, it's vast. It's vast.

When I found out that, unbeknownst to me, [Gagosian] had been negotiating and were successful in being able to represent the Rauschenberg estate, I walked into Larry's office and I said, "I just heard. I want to do that show. I want to be the person to make that show." I was very keen on bringing together works that people had not known. I had observed that [Bob] had been taken for granted, and he had been not followed, and his shows—maybe they had financial success because in the 2000s the prices were low and the work had a

decorative aspect to it. It should not alter the fact that this was an arc from very late 1949, 1950, until 2007.

So I started to pull together those things that would be surprising and tried to juxtapose them altogether. The first thing you saw was something from 2005, and then you went back to 1952. But then things settled down in the middle. You knew where you were. Also, it was to cover up the fact that the estate didn't have examples. I could only work from the estate. I couldn't borrow from museums to amplify. It wasn't the kind of show like at the [Solomon R.] Guggenheim [Museum, New York; *Robert Rauschenberg: A Retrospective*, 1997–1998].

Bob would always talk about floating images and also the whole notion of hoarfrost, that for a few split half-seconds you think you see an image, and then it's gone. You think you see clarity, and it's gone. That's like the description of what hoarfrost is in the morning: when you look through the window and you think you see something—that kind of ephemeral understanding of imagery was what I wanted to do in the installation. Sure, a lot of things had to be concretely placed on the floor, but by and large, I hoped that we went through all those years not knowing where we were grounded.

I was surprised at how wonderfully generous and strong the works that had the most reduced surfaces were—like the *Jammers* and some of the *Venetian* works and certainly the *Borealis* works, which was the first time that I ever had the chance to work with [them]. When I was working on it, with models and with my selections, I was very clear and I was very happy until I got to the *Jammers*, and then I just didn't know what to do. I just didn't know what to do. I was stuck because I kept on seeing them as poles. Instead, I stopped seeing the wall. In other words, I saw them as objects and not as space makers. It's very extraordinary when you all of a sudden realize that this object that you're dealing with is not at all an object. It's something that's charging the space.

And I don't want this to sound, "Whoo, whoo," but I just had to channel. I asked Bob, kind of like, "Okay. What do I do now?" And I just started to put them up, and they were just wonderful.

I liked [the show] a lot. I liked it a lot. At the end, it became a little bit of a cook's nightmare because certain people said, "Oh, you've really got to include this and you've really got to include this but we don't want to take this." So what I had wanted, which was a much more sparse show, became a little bit

overcrowded. One of the things that I really didn't like about the Guggenheim show was how crowded it was. I had wanted so much to make this into something much more urgent, so that people felt they had to walk up to this thing that they'd never seen rather than being barraged by an entire wall of too much information, that they would keep a middle distance and say, like, "Okay, I can take it all in from here." I wanted them to go up, like, "What's going on here?" For that, I needed fewer things. But . . . they needed to be sold. There was the potential of selling.

BOB MONK: What I find is interesting, too, about galleries and dealers, the whole thing, is that even now there's been another switcheroo. I think people are determined, who represent somehow either the good of the [Robert Rauschenberg] Foundation or the good of his memory—who want to stand up, like, in a movie theater and say, "Stop! This guy is still as brilliant as he ever was, and I want you all to pay attention. And I want you all to love him by buying this work." What I find interesting is it doesn't have the same visceral, amazing punch in the gut that it did when it was first done. Even now, if you go to a museum that has a great Rauschenberg—say MoMA right now, Ileana's estate having *Canyon* [1959] there, it's just—it's phenomenal. From my generation, going to art school when I did, it wasn't the Pollocks. It wasn't those people who meant anything to us as students. It was these guys who took the baton from these Ab Ex [Abstract Expressionist] people and then made something new of it, you know? Twombly, Johns, Rauschenberg.

Nauman, Ruscha, Artschwager, [John] Baldessari—the precursors of the Pictures Generation. It was like that new media image age. Being younger than Rauschenberg and Johns, I really got into that whole aesthetic. Well, where [Rauschenberg] would, say, go through the newspaper and find an image of a [Dwight D.] Eisenhower or a [John F.] Kennedy and maybe, using lighter fluid, rub that onto something and use it once and have it be very topical because of the image; that next generation, the whole idea was—well, there would be a thousand Eisenhowers, a thousand Kennedys. It would be on a billboard, on the televisions, everywhere, and these images were everywhere, and you could begin to use them in a way where, like, with John Baldessari, you could actually really play with them. It all starts with Rauschenberg, in a sense. There'll always be his influence on everyone, really, for good reason.

To this day, when I go to MoMA and I see *Rebus* [1955], I get goose bumps! All the years I would go over to Leo's apartment and see *Bed* [1955], it's just amazing. *Canyon,* amazing. Even the early 1970s, the *Cardboards* [1971–1972], they were just amazing things. You know, Bob Rauschenberg, Arte Povera— who would have thought? But when you look at those *Cardboards,* you can put Bob next to any of those Italians, and he will absolutely hold his own. So he was also part of that great international movement. The beauty of it; the beauty of it is [that] his whole life was about being an artist. That's what he wanted to do; that's what he did. That was his beautiful life, that was his meaning in life, that was the thing he did in life, and that's why, I think, he was such a great artist. That's all he really wanted to do.

Rauschenberg walking his dogs Kid and Star on the beach, Captiva, Florida, ca. 1984. Photograph: Terry Van Brunt.
Photograph Collection: Robert Rauschenberg Foundation Archives, New York.

CHAPTER 8

An Expanding American Art Market

THE previous chapter provided insight into the curatorial thinking behind exhibiting Rauschenberg's art. In this chapter, many of the same narrators share their perspectives on the life of his art in the marketplace.

Commercial success did not come quickly to Rauschenberg. He sold nothing at his first solo show, *Paintings by Bob Rauschenberg*, at New York's Betty Parsons Gallery (1951), although he gained two important allies there, meeting both Leo Castelli and John Cage for the first time.

In 1953, John Cage brought composer Morton Feldman to Rauschenberg's Fulton Street studio, where Feldman bought one of the artist's black paintings for the sixteen dollars and change he carried in his pocket. In a similar transaction later that fall, at a Stable Gallery show alongside the work of Cy Twombly, Rauschenberg's only sale was to his friends, Carolyn and Earle Brown, who bought a black painting for money they gained by cashing a refund check issued to them by the telephone company.

However, the art market changed quickly after Rauschenberg's first sales in the early 1950s. In 1958, Morton Feldman brought Castelli and his then wife Ileana (later Sonnabend) to Rauschenberg's studio on Pearl Street. In a now famous occurrence, Rauschenberg had to go downstairs to Jasper Johns's loft to get ice for their drinks (as Ileana remembers it, they shared a refrigerator), and Castelli excitedly followed him downstairs to see Johns's work. Johns was offered a show on the spot, and the Castellis departed without extending an offer to Rauschenberg. Several days later, however, that was remedied and Rauschenberg was offered a solo show too. Still, success was not immediate.

The exhibition, *Robert Rauschenberg*, in the newly opened Leo Castelli Gallery was comprised of around twenty works, and nothing sold but *Bed*, which was bought by the dealer himself.

The lack of monetary value ascribed to contemporary art at the time was not only true for Rauschenberg's work. In 1959, he purchased one of Marcel Duchamp's ready-mades from an exhibition both men were participating in for a mere three dollars.

Things started to turn around for Rauschenberg in the early 1960s. The Museum of Modern Art was gifted with the drawings for Dante's *Inferno* (1958–1960) from an anonymous donor who bought them from Castelli for thirty thousand dollars, and the value of Rauschenberg's work continued to rise quickly. In 1973, at a Sotheby's auction of pieces from Robert C. Scull's collection, Rauschenberg's Combines *Thaw* (1958) and *Double Feature* (1959), for which Scull had paid nine hundred and twenty-five hundred dollars, were sold for eighty-five thousand and ninety thousand dollars, respectively.

Rauschenberg was furious about the resale, from which the collector but not the artist benefited. "I worked my ass off just for you to make a profit," he famously said, and he continued to speak out about this issue over the years, even campaigning, unsuccessfully, for new legislation that would provide a share of earnings made from these kinds of resales to artists and their heirs.

From the perspective of even fifteen years later, Scull's profits were tiny; the value of Rauschenberg's work had soared. In 1988, *Rebus* (1955) sold at Sotheby's for five million seven hundred-fifty thousand dollars, and by 2005 MoMA spent a reported thirty million dollars on the piece.[1]

For the first half of the twentieth century, art history was still being shaped by European dealers who created markets "for everything from Renaissance art to Cubism." These works were often sold to Americans who coveted some semblance of Old World culture. Widely considered one of the most influential figures in the twentieth century art world, Italian émigré Castelli changed that by mixing American and European classics, "[as] a ploy to attract collectors," and in this way presented American art on the same level as the European work.[2]

His *Ninth Street Show* (1951) celebrated America's new artistic triumphs with the world and set Castelli on a course to do whatever possible to promote American art worldwide. These efforts also contributed to Rauschenberg's

victory at the 1964 Venice Biennale, at which he won the International Grand Prize for Painting—a moment many art historians see as the turning point at which American art secured its new international status.[3]

Ironically, the man responsible for ushering American art onto the international stage was a "consummate European," who considered a Frenchman the largest influence on his own artistic vision. "The key figure in my gallery is somebody that I never showed, and that was Marcel Duchamp. . . . Painters who are not influenced by Duchamp just don't belong here."[4]

Castelli represented Rauschenberg for close to thirty years and operated his gallery until his death in 1999. For more than four decades, he represented the biggest names in the business, including Andy Warhol, Johns, Roy Lichtenstein, Donald Judd, Cy Twombly, Richard Serra, Joseph Kosuth, Claes Oldenburg, James Rosenquist, Dan Flavin, Bruce Nauman, Ed Ruscha, and many more.

Castelli was celebrated for having both a good eye, and a good ear, but he was also renowned for his silver tongue. Willem de Kooning, a friend, once said "You could give that son of a bitch two beer cans and he could sell them." The challenge was taken up by Jasper Johns, who gave Castelli a sculpture of two Ballantine ale cans, which Castelli promptly sold.[5]

Castelli and Ileana divorced in 1959, and she later married Michael Sonnabend, with whom she established the Sonnabend Gallery in Paris in 1962.[6] The Sonnabends represented Rauschenberg in Paris from the opening of their gallery until 1980. Throughout the 1980s, Castelli and Sonnabend collaborated on shows with the artist in New York. Rauschenberg and Sonnabend were very close over the years, and he believed that she possessed the deepest possible understanding of his art. As he told Calvin Tomkins, "It always seemed to me that Leo went for the intellectual side, and she headed to the sensual. Let's just say I've never finished a painting without wondering what Ileana would think of it."[7]

One-time employees of both Castelli's and Sonnabend's galleries lend their voices to this chapter. Both present day Gagosian Gallery directors Bob Monk and Ealan Wingate speak to their roles working for Castelli and Sonnabend, respectively. Ealan Wingate recalls, "Once, when being interviewed about Ileana [Sonnabend] and those early years, the interviewer was going on about the art market. I went, Wait a second. Please. Please. There was no thing as

'the art market.' There were galleries. They made shows. Two hundred people would come. Things would not sell."[8]

Curator Susan Davidson added, "I think the whole structure for those artists becomes better defined. There are more galleries. There are more museums that are looking at contemporary art. So the whole infrastructure around what it was to be an artist happened. It took that twenty years, through the 1950s and through the middle of the 1960s, I guess, to really grow that."[9]

Arne Glimcher speaks to how the infrastructure around art has changed the scene in New York City. "I think [the market] might change the energy in New York City, and, more dangerously, it changes the energy in the artist. That's the danger."[10] Ealan Wingate concurs, "You know, when I first heard somebody say, "I'd like to talk with you but I've got to make art," I thought to myself, how do they say those words? Art comes from some kind of Netherworld of magical creation, and you don't do it like boiled pasta."[11]

Modern and contemporary art writer Dore Ashton, Texas Gallery owner Fredericka Hunter, and artist Lawrence Weiner add their voices to round out the conversation.

BRING ME A PORTRAIT AND A PHOTOGRAPH OF WHAT YOU PAINT, AND I'LL GIVE YOU FIFTY DOLLARS

JANET BEGNEAUD: When [Bob] lived on Broad Street, Bob had made Mother kind of a little bedroom. By using some sheets and string, he had sort of partitioned a little part off so she could kind of have some privacy. I didn't get to sleep in there; I slept out in the open area. But it was fun. That's where Mother found the portrait of me that Bob had leaned against a wall somewhere.

The portrait was [from] Bob's first art show, and it was a multiartist show and it was out of doors. The piece that he had in it was his dirt piece [*Dirt Painting (for John Cage)*, 1953], which was really like an ant house. It was two pieces of glass with dirt in it. He was a little distressed because he accidentally had captured a few little bugs in there. And it really made the piece a little bit more interesting, but he felt badly about it because he had messed up the bugs.

Anyway, the critic, when he came through—it was somebody from the *New York Times*—and actually Bob got some write-up about it. He really got some ink about it. But [the critic] was just adamant [about] Bob saying that he was an artist and calling himself an artist. [The critic said], "This is just ridiculous." And he really, really was hard on him. He said, "Not only are you not an artist, it belittles artists for you to consider that you're an artist and you're making garbage."

Anyway, during this confrontation, [the critic] said, "You can't paint." Bob said, "Well, I can." And [the critic] said, "You can't do a portrait," and Bob said, "Sure I can." So [the critic] bet [Bob] fifty dollars. This was probably in the early, early fifties—fifty dollars was really a lot of money to Bob, especially since he didn't have any. And [the critic] said, "I'll bet you fifty dollars you can't paint a portrait." And [Bob] said, "Well of course I can." So [the critic] said, "Well, bring me a portrait and a photograph of what you paint, and I'll give you fifty dollars."

So Bob came home not too long after that and he put me out in the yard in front of one of the oak trees there at Mom's house, and I'm holding the green parasol that he brought me from Paris. And he painted a portrait of me, and took my picture, and he went back to New York, and got his fifty bucks. But [he] sort of discarded the painting. Then when Mother found it and wanted it, he said, "Oh, yes, you can have that."

Leo Castelli, years later, Mother was telling him about it—because see, to Mother, that was really painting. She was a little bit like that critic. She didn't really understand all the things that Bob was doing too much. So she was talking to Leo about it, and Leo was very interested. In fact, he told Mother, he said, "Ms. Rauschenberg, I don't have any idea what you own or what other possessions you have, but if your house ever catches on fire, that's the first thing you get out."

I'M KIND OF TIRED OF THAT UP ON THE WALL. DO YOU WANT IT?

JANET BEGNEAUD: [Years later, Bob] was making a series of cardboards, and he was at home here and visiting. He said, "I'm going to make you a piece

of art." This was during duck season when Byron was hunting. It was a Sunday, and this was back before we had Lowe's and Home Depot and places like that that were open on Sunday. I had to call a friend of ours who owns a lumber company here, for him to go open his place of business for us that morning so Bob could get some plywood. Because, even though he used a lot of garbage, he always used good garbage and good materials because it has to last.

So Doug Ashey, who owns Ashey Lumber Company, opened his place that Sunday morning, and we got some lumber. In fact, he didn't even charge us for it. I think he thought the whole idea was so crazy. Anyway, we had ridden around, and one of our big hospitals here was doing a big, big renovation, so Bob picked up some cardboard pieces from that. It had been raining, and it had sand dried in the edge of the box that had been rained on and then dried. So it was a little cement there. Anyway, he picked up several pieces of cardboard.

So he was here in our garage and had that plywood laid out, and he was putting cardboards on it. A friend of mine that lives down the street, she had gone by in a little convertible and waved at us. She had met Bob several times at little gatherings. She waved at us, and then she went off somewhere. She came back later that afternoon, and we were still out there doing it. So she said, "I can't stand it," and she pulled up in my driveway and jumped out and she said, "Now I need to know, what are you all doing? What are you all doing?" Bob said, "Well, I'm making Janet some art." And she said, "Well, where is it?" And he said, "You're standing on it." And she was like a gazelle, just whoop, and she was off it.

Anyway, he finished the piece [*Baton Blanche (Cardboard)*, 1971]. He came in here, and I'm holding it up while he's nailing, and he had these big—these nails are like this, like my finger. So he's nailing all this stuff in the wall, and I hear Byron pulling up in the driveway, and I think, "This is not going to go over real big." I didn't have any of Bob's art hanging, except in my bathroom— well both bathrooms and in the bedroom. Anyway, I went out to the car, and I said, "Let me tell you what. You're probably not going to like what Bob's hanging on the wall, but" I said, "just zip it. We can always redo the wall later. It's just sheetrock." So Byron came in, and he was really good about it. He was kind of like Mom. He was, "Oh, yes, uh-huh." It was not negative. But then it turned out to be a really, really good conversation piece when we had dinners

and things after that. Everybody loved seeing it and talking about it. In fact, the electrical company owner whose name was on that box, he got a big kick out of that because it was very, very prominent. But then we kept it up, I don't know, [for] three or four or five years.

So finally Byron told Rick [Begneaud, Janet's son], he said, "I'm kind of tired of that up on the wall. Do you want it?" And of course Rick wanted it. So Rick took it down and took it back home with him, and then Bob found out that Rick had it. So Bob bought it back from Rick, which was really cool for Rick. This was back a long time ago, and that was a lot of money for him. Time goes by, and at the big Guggenheim retrospective show that Bob had [*Robert Rauschenberg: A Retrospective*, 1997], I walked into one of the rooms there at the Guggenheim—the uptown Guggenheim—and there's this piece on the wall. And it's just the piece in the room. I was standing next to David White. So I said, "David, what about that piece up there?" I said, "What would Bob get for that?" He said, "Oh, he doesn't want to—he won't sell that. That's his." I said, "Well, if he did, what would he get for it?" And I've forgotten the exact number. It was something like 350 or 375 [thousand], at least. There was a person there with a cell phone, so I called Byron from there and I said, "You remember the *Cardboard*?" And so I told him that, and he said, "Damn."

THEY BOUGHT IT ALL

ARNE GLIMCHER: I had grown up on the *Erased de Kooning* [1953]. That was one of the milestones in the history of art. I think [Marcel] Duchamp's urinal [*Fountain*, 1917], and then the *Erased de Kooning*, were the two most iconic images in the first fifty years of the century. It had a huge influence on me, the *Erased de Kooning*, and on people like [Robert] Ryman too. I was worried about what was going to happen to [it] because Bob was always not well, the period of our lives together. So I went to [John] Kirk [Train] Varnedoe, and I said, "I think that I could get the *Erased de Kooning* for sale for MoMA." He said, "Oh, it has to be in MoMA. That's just where it belongs. It's such a great thing," blah blah blah. "I'll work on it." So two months went by, three months went by. I said, "You know, I can't wait for you forever on this work of art." "Oh, we should have it. We'll get it." A year went by, and I kept reminding him, and nothing happened.

David [A.] Ross, who became the director of the San Francisco [Museum of Modern Art]—he left the Whitney—we were pretty good friends. They had a huge budget. I called him and I said, "If I put together in essence a history of Rauschenberg, would you have money to buy it? And it would include *Erased de Kooning.*" He said, "Absolutely. I'd do anything for that." At that time, we put three million dollars on the *Erased de Kooning,* which was a huge price. Now I think it would be ten million dollars.

They bought it all.

THE COMMERCIAL SIDE OF THE ART WORLD GREW ENORMOUSLY

SUSAN DAVIDSON: Through a historic lens, I would say that, actually, Bob didn't sell very well at all. [At] his first show at [Leo] Castelli [New York, *Robert Rauschenberg,* 1958], only one piece sold, and it was bought by the dealer. That work now belongs to MoMA as a gift of the dealer: *Bed* [1955], the Combine. Unlike Jasper Johns, whose show had been the month before and was a complete sellout, I think it wasn't until about 1959 when Bob actually sold a painting to a museum. He [previously] had sold a photograph to the Museum of Modern Art, very early on in the 1950s [Untitled (Interior of an Old Carriage), 1949]. And Alan [R.] Solomon, who was the director [at the Andrew Dickson White Museum of Art, currently the Herbert F. Johnson Museum of Art, Cornell University] and somebody very much on the scene with contemporary art, he bought a Combine of Bob's called *Migration* [1959]. That was probably 1959, so that's the first serious sale that he had.

He'd already been producing work for ten years. That's kind of a poor time. He remembered it very much as a poor time and talked a lot about the cold-water flats and not having enough money for gasoline. He was one of the few artists who had a car, a station wagon, and so he often could move work for other people and sometimes earned a little bit of money doing that, taking things from downtown uptown to galleries and things like that. I would say he really didn't start earning money until probably late 1959, 1960, and then it went pretty quickly. Of course, it was cemented by winning the Venice Biennale in 1964.

I've never actually gone and started to look at it through a financial window to say, oh, well, this is the amount of money that he earned in this time. But— just a couple of things I've seen—he seemed to have [had] enough money to buy the silk screens that made the silk-screen paintings. These were not necessarily cheap. When I was doing research on *Barge* [1962–1963], I could see what the prices were. At the same time, I remember also seeing checks to the school that his son was going to, and so he was obviously earning enough of a living at that time to live fairly well.

Then, of course, as time went forward, he sold more and more. And I would say even today, as we look back on it, almost half or just over half of Bob's output is already in the world—in museums or with private collectors. To have sold that much in your lifetime is pretty good.

EALAN WINGATE: I go back and think about the way galleries were, especially galleries of the new art or of current art, contemporary art. One of the gallery artists, I remember, the only sale he made was when something was accidentally lifted and so he got the insurance money on a stolen work. It was the time of performance art in which the public would say, "But there's nothing for sale."

So we didn't really gear ourselves for sale, and [Ileana Sonnabend] knew that. If she needed to sell something in order to finance the gallery, she had— over the years since opening Galerie Sonnabend in Paris in 1962—purchased works that she had imported for her shows, either from [Leo] Castelli or directly from the artists. In many cases, she had prebought the works and also not sold them very rapidly, much to her happiness, so that she would hold onto them. So she would pull out a wonderful picture, and it would be to Dr. [Peter or Irene] Ludwig from Cologne or something like that. That would finance us for eight months, ten months.

But there was interest. There was excitement. First of all, Leo Castelli was in the building [420 West Broadway], and he was a serious gallerist. Ileana would become known as a serious gallerist but had not yet proven herself with her uptown gallery, which she opened around 1969 [1970]. Virginia Dwan was supposed to be in the building, but she decided that she would not open the gallery for tax purposes, so her director, John Weber, opened the gallery instead. So [the galleries] were diversified, and it was a very good moment.

We opened up with Gilbert [Prousch] and George [Passmore]. They did *The Singing Sculpture* [1970] six hours a day. I met Bob Rauschenberg, Andy Warhol, [and] Roy Lichtenstein. I ate with them, [and] we would have studio visits, always with Ileana. She didn't do anything alone. It was very, very magical.

I remember some people made sales, and they would be kind of, like, dumbfounded. Like, "I can't believe that." So the entire notion about art and it selling that we are so entrenched in today—the role of auction houses, what we read about, and the five hundred million dollar gift that Stefan Edlis and his wife Gael [Neeson] give—you know, this was, I could be talking Neanderthal in comparison, and it's only 1971, 1972, and 1973.

SUSAN DAVIDSON: I think there are several things that happen[ed]. I think there are just more artists who realize—who are people who want to make art and who are able to sell art. Up until then, everybody else sort of hopped along and either showed in cooperative galleries or maybe they had an uptown gallery, like Castelli. But there were only about four dealers at the time, and as Dorothy [Lichtenstein] said, you could hold the art world in your hand.

DORE ASHTON: I think that the commercial side of the art world, so to speak, grew enormously in the early 1970s, probably late 1960s. That did change the atmosphere and the way you got along with each other. I myself didn't follow the commercial side very closely. I wouldn't have been privy to all of the backroom deals and so on. The wonderful thing was when J. B. Neumann would lock the door and talk to me about El Greco. And now, when I go to the Met [Metropolitan Museum of Art] and see that El Greco, I think, "God, that's the El Greco that he showed us." Those are the little adventures of the trade that were great for me, very, very right for me. I discovered that I could make a living and support my artist husband and my kids as a teacher, and it turned out very well, until recently. And now it's a big mess and very nasty, very nasty.

Things have changed so much. People do the unthinkable now, art world types, things that they would never have done in my early days. Make deals that are dubious and connect up wealthy billionaires with whatever. The business side is very often monkey business.

I talked to people like Jack Tworkov, who eventually ran the Yale [University, New Haven] art department. Or whoever I ran into in the neighborhood,

I'd talk with them and keep up with what they were pissed off about, which was a lot of the commercialization. They were not for that. The interest in money was very different; they weren't so greedy in those days.

FREDERICKA HUNTER: Younger people will always say, "Oh, I wish it were like that now. I wish I could have been there" or "It sounds like more fun." But it also really didn't feel like a scene or anything, because the only thing one could aspire to be was a rock and roller if you wanted to be famous or get rich. No one really had any aspirations because what you were doing didn't have that possibility, or at least it didn't seem to. As much as I found [Patti Smith's] *Just Kids* [2010] a fantasy, having known more about it than that—I mean, she is a poet, okay? But she does mention that. Maybe you wanted to be famous. Maybe you wanted to be ambitious. Maybe you wanted to leave Pittsburgh or Long Island. But the promise of any kind of financial success connected with what you were doing, you weren't self-consciously making a plan. It wasn't possible. Someone like Robert Mapplethorpe was always ambitious, but it was hard for him to figure that out. And there wasn't a place for him for a long, long time.

Well, he always did want to make money but it just wasn't—and even the kind of unprecedented success that people like Jasper seemed to have, and Bob had amazing success, and Andy did too. But one didn't necessarily think one was going to be able to replicate that, or expect to replicate that. Also, one couldn't imitate that. You just couldn't. You couldn't do the same thing, and people had different concerns. Those were the heroes.

It was more the graciousness of the wealthy. It was part of life. The enrichment of life. At the time, again, to my mind, those things meshed rather than [being] separated out. Society and art—they wanted to hang out together—wealth and art liked hanging out together. It was the 1960s.

Now that changed in the 1980s. I suppose some people would say there'd been a lot more art schools and career advice for artists themselves, but the nation changed to the conservative. It was Ronald [Wilson] Reagan, thank you very much. Andy adapted beautifully. Artists' business, artists' commerce—it was okay again to be politically incorrect. There was a hardening that I feel is oppression right now, and I would place [its beginnings] right then and there.

[In the early 1970s] things didn't seem to have many barriers, and certainly I was able to sell art. And people weren't going to fuss at me whether their auction

prices were any good or whether they would be able to cash [out on it]—will they make a good investment? I mean, the most you could say back in those days was, "Buy a lot of art, and if one of them pays for everything you bought, that's great."

[BOB] BEGAN TO ALMOST RESENT CASTELLI

BOB MONK: I met Rauschenberg about a year after starting [at Leo Castelli Gallery], around 1975. He was such a friendly person. The cliché I made up about him is that if he could hug everyone in the world, he would do that. He just had that kind of personality. He was really kind and interested in everybody. Whether that interest would wane after a certain amount of time because of whatever the person he was interested in could give back, I don't know. But for a young guy my age, he was incredibly welcoming.

What would happen was that one would be invited over to the house. So you'd go from seeing him in the gallery or somewhere else, he or one of his staff would say, "Oh, on Friday night, Elyse and Stanley Grinstein are coming to town." Elyse and Bob would make these giant pots of chili. If Leo was asked to come over, he would come over very early before the party started, and then he would leave. But he didn't come over that often. I think that things [between them] were beginning to cool around 1975.

In any case, when I started going over to the house, I started getting to know a wider circle. I got to know, as an acquaintance, Brice Marden and Richard Serra. Richard Serra was so dynamic. It was unbelievable just to be around him.

At the house, Ileana would come, usually a little bit after Leo, and you could just tell, the way Bob's eyes sparkled [that] he just adored her and she adored him. She was the one, I believe, for all those years, who actually kept Bob in the Castelli stable, even though Bob and Ellsworth Kelly began to complain that Leo's favorites obviously were Johns and [Roy] Lichtenstein. I think they, and several artists there, began to feel a bit underappreciated. Because, don't forget, it was then twenty years then into their career with Castelli. That's a long time. You could begin to tell by watching Bob around Ileana. Ileana and Leo were no longer married, but from Bob first knowing them as a couple, and then the

history, moving forward she became more and more and more endearing to him. He loved being around her.

When Ileana would leave, the party would really start. All sorts of people would show up. I remember [John A.] Chamberlain beating people up on that great couch in the living room, the Chamberlain couch. I remember fistfights between Richard Serra and other people. I don't remember if it was Richard Serra versus John Chamberlain or [Salvatore] "Sal" Scarpitta—but all kinds of crazy stuff went on there. Between the alcohol and the drugs that the younger people were doing, they were wild, wild parties. I remember going to work the next day so hung over. Luckily, Leo—he was just such a great guy—he didn't notice. I remember staying up all night long and then having to go home, shower, get dressed, and go to work and suffer through the day.

I think that the beginning of Bob's disenchantment with [the] Leo Castelli Gallery [was] after the MoMA [Museum of Modern Art, New York] show. I think this is a discussion that will go on for several years: Do you blame the art dealer or—when I see the whole succession, even the problems with Pace [Gallery, New York] and all these other galleries—really, was it the work? Was it that people had expectations?

When I was a student at Pratt, Bob Rauschenberg's work was the cat's pajamas. The idea that somebody would take minutiae that was all around, ethereal stuff, and put it into those Combines [1954–1964], collages that were just amazing, they were so powerful. I think it's influenced all art since then, whether it's minimal, conceptual—everything.

But there was a point where the work became something else. I think all artists are victims of that. I think what started to happen was—I think [Bob's] inclination was to blame Leo Castelli. Leo also had a very healthy ego, and at the same time, Bob was feeling not loved. Not only was Leo on a second rise with all of his conceptual and minimal artists, and that was a great thing for Leo, but there was still this incredible success around Johns, around Lichtenstein, around Warhol. I believe now that slowly [Bob] began to almost resent Castelli.

I think there's still a lot more to be said about Leo Castelli. One of the things about [him], even about the way he dressed and his impeccable persona, whether the persona was made up a bit or whether it was natural, it's hard to say. He was very formal. He was a delight to be around. I don't know

anyone who ever worked there who didn't say, "Oh, my God, it was one of the great thrills of my life." Because he was a very generous boss. But he was very closed down.

Ileana, who loved boys much more than girls, she was so intelligent but she had this coquettish quality about her. I can't explain it any other way. There was just this way about Ileana. I think [Bob] felt so loved by her and so comfortable around her and so charmed by her that, except for getting down to the facts—like the old Jack Webb, "Just the facts, ma'am"—the Leo Castelli thing was much more the facts, "Just the facts, ma'am." Bob wasn't that kind of person. As I said, if he could hug everyone in the world, he would hug everyone in the world. He just had that kind of thing. Leo was much more guarded. He was a very elegant man. He was super charming. He loved everything from American movies to murder mysteries, but he also could quote [Rainer Maria] Rilke poems. Of course, so could Ileana. But with Ileana, there was a way that when she was with Bob Rauschenberg it was like he was submerged in a warm bath. The scenario with Ileana was lovely and sparkly and charming, and the thing with Leo, I think, after a while became either forced or businesslike.

Also, Leo didn't like negative things. So, if Bob would express negative things or his accountant or his lawyer [would do so], I think it would make Leo, without even seeming to do it, withdraw a bit, where[as] Ileana was there for him. Like I said, every time he came to town, she came over before our crazy parties started, she was always there. They would spend time together, and then when it would start getting a little wild, of course, she and Antonio [Homem] would leave. But Bob always got his Ileana fix, and she always got her Bob Rauschenberg fix. There was a difference between what it was like for Bob to be around her and what it was like for Bob to be around Leo. Slowly but surely, I think, with Leo, it became problematic, and they became very distant.

EVERYBODY WAS TAKING A LITTLE PART OF HIM

EALAN WINGATE: In many ways, everybody was taking a little part of him. He had relations with so many people. It used to be a very, very small group. It was Hisachika [Takahashi] and the man he would be living with and maybe two or three other people. Sure, there was Brice [Marden] and there was

Al Taylor and there was Debbie [Taylor]. That was all very nice, but they were more friends. I can't remember—was it [Mayo Thompson]? He's still alive. I just saw him in Los Angeles. He had a very, very strange, beautiful girlfriend [Christine Kozlov] who subsequently died from like an early onset Parkinson [disease]. Very frail. Blond, white eyebrows, and long, white hair. They worked together with Bob on *Made in Israel* [1974]. That was a very big suck on Bob. That was the first time I noticed the suck on Bob, how it was. It only increased. It only increased. It became more and more people who were like that.

Everybody had had studio assistants, but the studio assistants—it was a profession. Then it became a lifestyle, and then it became a family, or who you were stuck with or lived with. The workday didn't end at six or at "Okay, I'm going up to the apartment or out of here." It's like you're at dinner and you're there and we're traveling together and we're—it's a very different kind of thing, so you become part of this entourage.

I think it was—this is going to sound weird—I think that the making of art put artists by default in a vulnerable position. I've always said that it's the blank page syndrome. You can imagine it with an old Olivetti. You put in a blank page and you stare at it and you wonder, "What words do I start putting on this that communicate what I want, communicate to somebody else, are invented? Looking at a blank canvas, how do I fill it? So they're very, very vulnerable. The art of our more current time, from the time of the East Village, corresponds with the new return to representational imagery with David Salle, Eric Fischl, Georg Baselitz, so many people. There was a sense of painterly representation that emerged in the early 1980s or became codified in the early 1980s. There's a certain kind of sardonic quality, of—I'm not going to say insincerity, but—a removal from connection of the image to the artist. We feel the artist in earlier times [was] loving that which they've created. In more recent times, they are creating it to make a point.

I don't know how to put it in any other words, but there's a separation. There's irony in paintings that, although there had been with Dada, it had been with a certain kind of love of the irony. Now it's irony for irony's sake. It's not [Jonathan] Jon Stewart kind of sardonic humor. It's like, "You know that I know that I know that you know that you know that I know that I could paint better than this, but I don't have to because I'm making a point." And that has created a new kind of artist. Do I dare say not the vulnerable artist anymore?

Not the one who's willing to shake. Much more calculating. Maybe calculated. A more calculated approach to "Okay, I've got to go make art."

So I think that from the mid-1980s or so we have a very different kind of professional artist. I think that if you look at the artists before, you have a very different kind of vulnerability, more needy. Much more needy. I know this because I work very much with older artists today. I work closely with Howard [Eliot] Hodgkin. He's in his eighties and he's phenomenally needy, and I don't feel that as a very split personality divide to somebody else. They are, of course, needy because they're making something. They want you to like it. I'm not saying that they're calculating in that. There's a different trampoline. There's a net. There's a different kind of net. Also, they've gotten now to where they are without as many years of the history in which they failed in public and had to get up and keep on going and believe more in their vision. It's a curious sort of thing.

THERE'S NO QUINTESSENTIAL RAUSCHENBERG

ARNE GLIMCHER: I would see Bob every so often at exhibitions. I'd go to his openings, and he'd come to our openings, and we became friends, but not good friends. Then things changed drastically for him in the marketplace. While the demand for work by his friends—specifically Jasper and Twombly—was escalating, the demand for Bob's work was diminishing.

I'm talking about the late 1980s and early 1990s. It was a kind of fallow period. Some of it was because Bob is such a different artist. Jasper is intent on painting a masterpiece every time he makes a picture. Rauschenberg is intent on becoming the wind that blows through the art world, and he doesn't care what that picture looks like. And he makes the greatest pictures. They're the most challenging. He's the biggest influence of the second half of the twentieth century on contemporary art. This force is a force to be reckoned with and respected. But I think people didn't know how to sell it or collect it. Everyone has this idea that they have to have the quintessential work. There's no quintessential Rauschenberg. There were the Combines [1954–1964]. There are other periods of the work, *Cardboards* [1971–1972] and things like that. There is no quintessential Rauschenberg. Just because the market has focused now on the Combines, because there are so few of

them left in private hands, it doesn't mean the Combines were the beginning and the end of Rauschenberg. There's major work before the Combines and extraordinary work throughout his life afterward.

He is such a fast moving target that nobody seems to be able to hit him. However, we seemed to change that in the last twenty years. Before Bob's first show here [at Pace], he hadn't shown in New York for a while, and the relationship with [M.] Knoedler [& Co., New York] was over. I just made a beeline for Bob. We had known each other, and we just connected for the first time in a very different way. I went down to Captiva, [Florida], and the relationship seemed deeper immediately than it had been. Then we became really intimate, close, close friends.

I told Bob that he knew how much I loved the work, and that I thought the new work was as good as any work he had ever made, and [that I] would love to present it, and to trust me to present the work in a new way. I think the reality is that the other artists in the [Leo] Castelli stable were running away pricewise, and Leo was very lazy.

Leo has this image of a deity, but he was far from it. I knew Leo quite well. He was lazy. He loved to go to lunch. He was a gentleman farmer, and he sold things over lunch. Those are the easy things to sell. Rauschenberg wasn't given the attention. Even though Ileana [Sonnabend] loved Rauschenberg more than Leo did, and he loved Ileana more, Leo didn't give Rauschenberg the same respect that he gave Johns. Johns was his artist, although he didn't discover him. Johns was in another gallery before,* as was Rauschenberg—in the Stable Gallery [New York]. So that's not where it started, and Leo gets the credit for finding all these people, which is not true. But he was so poised and elegant, and had a sense of refinement about him that the Midwesterners and the West Coast were knocked out by. Everyone was.

I liked Leo a lot. He was terrific, but I don't think he was a great dealer. Isn't that a weird thing to say? I don't think he was a great dealer at all because what he sold, he sold easily, and he gave a lot of his work to other galleries to sell. Other galleries supported him. [Lawrence G. "Larry"] Gagosian got his start by being there and picking up all the droppings that Leo would give him.

* Editor: Johns previously participated in the Third Annual invitational exhibition at Tanager Gallery, New York, 1955, and a drawing exhibition at Poindexter Gallery, New York, 1955–1956.

Then it turned into the point where he was selling Leo's work for him. Leo liked that. Leo liked that. But he anointed Larry into this salesmanship position, which is very different from what Leo was.

[Bob] agreed. When Bob was leaving them to go to Knoedler, because he needed the financial support for ROCI [Rauschenberg Overseas Culture Interchange, 1984–1991], there were rumors that this was happening. I met with Leo and Ileana, and I said, "He's going to leave your gallery." Leo said, "Rauschenberg will never, ever leave us." I said, "Look, he's going to leave the gallery. I'm going to make a pitch for him. Why don't we do it together? I think you need me, and you would continue your role with Rauschenberg." I thought it would be a very good combination. They wouldn't do it. They kept telling me, "That's impossible." Ileana said, "Impossible that Bob would leave." [Or else] Pace would have had Bob ten, fifteen years earlier, and it would have been a very different market profile.

But Julian Schnabel left the Castelli Gallery to come with me, and that really hurt Leo because he had never lost an artist before, and at that point, Julian was the biggest deal in the art world. So that hurt our relationship. But there's a reality—if an artist doesn't want to be with me, I can't hold onto the artist. You have a life of gratification and some disappointments. That's how it goes.

FREDERICKA HUNTER: At some point, [Bob] then affiliated with Pace [Gallery, New York], and he put a couple of galleries in as the galleries he would work with independently. He just wanted to make sure he had alternatives, even though we [Texas Gallery, Houston] are not anywhere near as powerful or as rich as the Pace Gallery or what they could do for Bob. He also, I believe, had the idea that he would like to encourage a younger gallery. At the time, we were still younger. I think he had a fondness for galleries that weren't as rich; again, a feeling of support. You know, we're the kind of gallery that likes to work with our colleagues. I don't mind if there's a New York gallery involved in things. I did work with Leo on a number of things.

[All works for *Summer Gluts* at the Texas Gallery, 1987, were consigned from the artist's studio.] They consign it to you. It depends on the artist, his stature, her stature. Sometimes you buy outright, guarantee, whatever you want to call it. But, in many cases, it's just consignment, and you negotiate—if you're giving a whole show, you get a little bit more of a break on the price.

For us it was the opportunity and the honor to work with someone this important. I also felt, and this has been one of my main concerns, that it was impressive—not avant-garde but innovative work. It was the great honor of being able to show his work, and I believe, in most of my shows, it should be worth it for our clients. It's not necessarily so much establishing a market as it is, for the clients you're close to, who trust you, who become your friends—you want them to get the best advantage they can get. Yes, you'd like to make a living off this, you're trying to make a living, but you really would like to make sure that they acquire museum-quality art or at least very interesting art that might become museum quality. And contrary to the idea of showing off and paying too much money, the idea [is] that you don't pay too much money, that you actually get a lot of value for what you pay. You were getting all the quality you could get for the money you were spending. I'm attracted to that it is not overpriced, or not irrational, in relationship to career, quality, whatever. I know that it probably sounds so stupid and naive compared to what happens now.

IT'S THE CLASS EXCLUSION THAT DESTROYED THE SCENE

FREDERICKA HUNTER: My two wealthy partners, they had taken out an ad in the *Wall Street Journal*, in 1971 or 1970, that said, "Protect against downside risk." I thought that was horrifying because with art you really can't. But it was using the language of the marketplace, and maybe I overreacted even then, not understanding the marketplace. I have always tried to stay away from making that kind of promise.

ARNE GLIMCHER: I think [a dealer's responsibility to their artists has] changed in the subsequent generations of dealers, most of which I don't have a lot of respect for. I think you live your life with the artist. I don't think it's about making a show this season, and selling the show, or getting works for an art fair. I think it's about being there when the works are being made, having conversations in the studio, having dinners; those are your friends. Now so many of those people are gone from my generation. The artists were all older than I am. But I saw Chuck Close yesterday, and I'm having dinner with him tomorrow night. I live with these people. We're a partnership. I don't think it's

like that anymore. First of all, they have so many artists, and they're buzzing around the world so much, how can you keep up with anyone? We do, too, but I have a group of artists in China that mean a great deal to me. I go visit them four times a year, and China's pretty far away, so eight weeks a year in China is a lot. But there wasn't such a separation between the artist and the dealer as there is today. We just were all together. We interacted in a different way.

Leo loved Johns, and he loved some of his artists very much and really gave them huge attention. But I like the idea of being accessible to people. Now, probably because of my age and history, a lot of people don't ask for me in the gallery. They ask for other people, younger people. I think they don't think I'm here, maybe. I certainly have my own clients whom I work with. But if somebody came in downstairs who was twenty-five years old and said they were interested, and had questions, and they'd like to see me, I'd be down there in a minute. I don't think it's that way in most galleries today. I think it's kind of imperious. I'm sorry for the fact that, when the gallery gets to this scale, it becomes intimidating to people.

LAWRENCE WEINER: I would say [the New York scene] probably does [still] exist. It's not as open as it was before because there's more money involved. It's the class exclusion that destroyed the scene. Before, people came from all different classes. Ten percent of the ruling class would run away to the circus, 10 percent of the middle, 10 percent of the emerging. We were the circus. Now it's not that way at all, but that'll change. For all you know, it's going on now someplace. Maybe in Detroit, for all you know.

It might be someplace else that we don't know about. It could be Phoenix or Austin. You have no idea what's going to happen until the people who do it put it out in the world, and you find yourself dancing to their tune. It's hard to imagine it happening in New York right now. But it's harder to imagine it happening anyplace else. It's harder to imagine it anyplace else because those places are locked. This place, at least, is so broken up and so fucked up that it's not locked.

They'll take one part of Bensonhurst or Williamsburg and turn it into a gated community. Three blocks away there might be a whole other world in the same area. In New York, one block is one thing, and then you turn the corner and you're in another world. So I wouldn't prejudge. I really don't like

this taking people you don't know, and just because they're younger than you, you put them into a category, saying, well, they're younger, they're this, they don't know this. What the fuck, what do you mean they don't know it? They know it; they're not doing it. They're doing something else. I really am so tired of people putting people, any emerging artist, any emerging musician, in a slot. What do you get from that? They can't hurt you. They can only enrich you. If they're schmucks, it's not going to hurt or affect anybody. It's just going to peter out. It's going to be a fart in the wind. But if they really are good, they will only enrich your existence.

Because you want to stay, you want to be in the European model, you want to stay who you are exactly. Okay, when I say American, that's what I [mean]: you don't have to stay who you are. Robert Rauschenberg did not have to stay who he was.

I'd say it was one of the privileges of being in an immigrant society. You are what you do. You wake up in the morning and you don't know who you are, you know what you are. Well, that's fair.

NOBODY I KNEW LEARNED SHIT FROM BEING UNCOMFORTABLE

LAWRENCE WEINER: It took art students to enter the music world to open up the music world. John [Winston Ono] Lennon, [Sir Michael Philip] "Mick" Jagger. They were all art students. It took art students to break that whole thing open. That's interesting. So it's going to take something here to break it open. Maybe it'll be curators. Who the hell knows. I know a lot of aspiring curators who haven't gotten their act together yet, but I have great faith in them because their honesty is legitimate. It's emotional, but it's legitimate. If they see something they don't understand, they look at it until they understand it. Well, that's something great. I don't know where it's going to come from. But I don't like that people keep coming to do interviews with me, saying, "Oh, it was better then." No, it wasn't. It was different. The work was better, but there was a reason for it. This is just work that's made for a market. Some of them might turn out to be okay. A majority is made for a market. Off the rack clothes are sometimes good; blue jeans really and truly have made the world a wonderful place.

It doesn't matter any longer if the blue jeans are made by Levi Strauss, Wrangler, or Uniqlo, they're just blue jeans.

I think Rauschenberg would agree with this. You're looking at something, and in that group of people you're having distain for, there [are] four or five people who are really going to make a contribution to the world. Why should they be uncomfortable? I didn't learn shit from being uncomfortable, nothing. I'm very serious by the way.

Nobody I knew in that world learned shit from being uncomfortable. Even the people who could write about it like Baldwin made it clear that it would've been a hell of a lot of easier if he wasn't so uncomfortable all the time. He could've written better. Or been happier. Being happy is worth something.

I learned nothing from having made the choices to not enter into the academy. Nothing. It just made it a little bit harder, and it made it so that you had to do three more things and you were hungry. I don't mean ambitious, I mean hungry.

I'm looking at it on a personal level of physical discomfort. I'm seventy-three now and having physical problems that I shouldn't be having. I don't think anybody learns anything from it. I'm upset sometimes when somebody does something that I don't find useful. But I don't really want them to be uncomfortable, I really don't. Like I said, I don't think you get shit out of it. You get something out of being able to do your stuff and get up on a platform and sing.

SUSAN DAVIDSON: I would imagine from a commercial point of view, yes [the expansion of the market is a good thing]. It certainly resulted in a lot of wealth for a lot of people. I do think that it brought on new kinds of art and new ways to look at art and such, but it does require a lot more energy. I mean, I would say even in the time that I've been involved in the art world, it's changed so radically, and so it'll just keep going, I guess. You long for those quieter, more controlled days when it seemed to really matter to be involved in the art world.

It seems [to be] so much about social activity. Somebody once said, or I read recently, that the sign of a good curator is the number of frequent flier miles they have. That just means you're on a plane a lot, and maybe you see a lot of art, but I think there's more to weed through and to sort through and

to think about, and there's very little that actually rises to the top. It gets heavy under its own weight.

ARNE GLIMCHER: When dealers are saying, "I need a painting for Frieze [Art Fair]; I need a painting for [Art] Basel; I need a painting for [Art Basel] Miami [Beach]," what does that tell us? It's that the artists are painting for dollars. That's not making a painting out of inspiration. I think that's the terrible thing that's happening. That's the commercialization of art that is so destructive. If a young artist in his twenties has an exhibition, and everybody agrees that this is a real talent, a real budding talent, the paintings go to the most important collectors on that dealer's list. Then thirty or forty of the second level collectors are all on the waiting list for paintings. Our policy has always been that the paintings go up about 10 percent every time we sell out a show. But now they double and triple during the show. I know some dealers who change their prices, which is unconscionable. So you're twenty-three years old, and you have this huge hit, and you've been working on these paintings for years before anybody found you. Now there are forty people waiting, and they're paying three times as much, and you're a millionaire. Are you going to make a left turn and say, "I'd like to experiment with something else"—I don't think so.

Promise and fulfillment are two different things. There are a lot of people with promise. That doesn't mean they can carry it to fulfillment. One needs time and space. All of these young artists, who I feel terrible for now, are living under a microscope. There's nothing that isn't shared immediately in the media. It's not a way that art develops.

I think it can change. It could change with a great catastrophe, like the art market—which isn't going to happen—totally collapsing, a huge depression, which would be a terrible thing for the world, but it would be a wonderful thing for art.

[Art] needs time, and space, and investigation. Look at the greatest artists that we can think about, how long they worked before anyone knew the work, before anyone would buy the work. I remember, in sixty-five, I sold a [Alberto] Giacometti to the Art Institute of Chicago, *L'homme qui marche* [*II*, 1960], six-foot-tall walking man. It sold last year, at Sotheby's, another cast of it, for one hundred ten or one hundred fifteen million dollars. I knew Giacometti. I was very lucky. I was having lunch with him one day, and I told him that I had sold

his *L'homme qui marche* to the Chicago Art Institute for sixty-five thousand dollars, which was huge; it was the highest price ever achieved for a Giacometti. He looked across the table, and he said to me, "You will be arrested." He couldn't believe it.

Mark Rothko couldn't believe that his paintings were a hundred million dollars either. It's ridiculous, really ridiculous. But there's so much money out there, and people just want things, and it doesn't matter. If you have ten billion dollars, and you wanted that Rothko for one hundred fifty million dollars, it's not going to change your lifestyle.

FREDERICKA HUNTER: I do connect it more with the 1980s; there was a different kind of celebrity associated with artists, even different from Johns and Bob. Something happened. It could be easily because everyone got a little more sophisticated about PR. Mr. [Charles] Saatchi certainly had something to do with it, as he became a player in the art market. Something really clicked, shifted, switched. And internationally. Consequently, then, there was a more orchestrated approach, and there was the potential to make more money. Of course, auction houses before 1972 or 1973 did not deal in contemporary or living artists. They slowly, in the late 1970s, Christie's, Martha Baer, started putting in the contemporary. No one thought it would work, and the auctions sold, really, only to the trade. It was an entirely different situation. I would buy at auction, even then, 30 percent below, 40 percent retail, and that's the way it went. Now the numbers were miniscule, but you could go in and buy Ed Ruschas, or there was a downturn in Andy Warhol, you could buy one for a couple of thousand dollars, and the next year it was suddenly worth thirty-five thousand dollars. But you didn't really anticipate that. It was to the trade. We were pickers. We knew who was in the room. Now it's on a very steroided up-market manipulation, whatever you want to say. But, also, of course, with the art, it will change in a flash, and you can't predict it.

DORE ASHTON: I went to see the de Kooning show [at MoMA] with Peter Selz, who ran the painting department for at least twelve years, and the bookstore was full of books by him. When I said to the woman, who wasn't young, she was at least fifty, "This is Peter Selz," she said, "Who?" He was standing right next to me. I felt mortified. To think [that] he spent so much of his life

[there] and [that] they were all making money off of what he did, and they don't remember his name? That's America. That is really America. That day I really didn't like America, and I didn't like MoMA at all.

BOB MONK: Because he was so famous and he was Rauschenberg—you can say Rauschenberg the way you can say Warhol and the way you can say Johns. It's Rauschenberg. People know Rauschenberg. Many artists, whether they become successful or not, fall into that thing that, once you have the great idea—suppose the great idea is when you're twenty or the great idea is when you're forty? But if it happens when you're twenty and you make this work that everyone says, "This is absolutely remarkable," and then you become sixty-five or seventy years old, and people are not saying it's so remarkable—it's very natural and normal that that would happen.

But this whole thing with the market and the art world becomes this tumble, this tussle. Because even in leaving his estate after he dies, as a foundation, to do good things for people, which is what he always thought about, you have to have the success of that market in order to carry that forward. It seems to me that now what is left in the estate is the really very last or, late, late, late work. That, to me, is problematic, and they'll have to figure something out. I don't know what they're going to figure out, but they'll figure something out.

I think [Bob] thought about money only as a way of knowing that, himself, his closest friends, his family, and the people who worked for him and his expenses were paid for. I don't think he thought about money. He never struck me as that kind of person.

HE MADE ME PROMISE AND CROSS MY HEART
AND HOPE TO DIE

JANET BEGNEAUD: I have two pieces of Bob's art that's like hidden, and Bob made me promise that neither one of them see [the] light of day. He made me promise and cross my heart and hope to die that I would never, ever let them be seen or be in a show.

One is a nude [*Delores*] that came from Black Mountain, North Carolina. It's a four-by-eight piece of plywood, not even very good plywood, and this

great big, black, voluptuous—very voluptuous—nude [is] on it. It covers the whole four-by-eight, just about.

He brought that back—and I don't really remember it coming back—but I know that it never got on a wall. There'd been no way in the world my mother would have hung anything naked on the wall. Mother's little house is two bedrooms upstairs, and there was a long closet—an impractical closet. The door was right here, and it was a narrow closet, but long. You could kind of just pack junk in there that you never thought you were going to see again. Well, that's where the thing of *Delores* would go, and not only in the closet but against the wall in the closet.

Years later we were sitting in the living room downstairs, we were talking about paintings and she said, "You know what? There's something I've been wanting you to see." She said, "It's upstairs." So here we parade upstairs and open the closet door, and we had to get all the clothes and stuff out of the closet so we could get back to the part you couldn't get to. So we finally wiggled that thing out and under the rod and everything and got it out, and she turned it around and I think she said, "Now, isn't this better?" Mother had painted a pink bra and pink panties on that big, voluptuous, big tummy kind of thing, and these little pink panties underneath it, and this little pink bra across here. And Bob started laughing. He [said], "Mother. She was nude, and now she's naked."

Then one time, it was so funny, I don't know, maybe in the 1980s—this hurricane was coming through. At the time, Rick and his kids were in Colorado, and so I was out there visiting them when this happened—and of course Bob was in Florida. And this hurricane was coming in, and it was really big—Andrew is what it was—and so Bob and I were talking on the phone. Bob was real concerned because Mother's house, in fact this little house that he designed, had what we called a picture window. It was like a window that was about ten feet by about nine feet. Real big. In fact, it was half the size of the room, and it was all glass. And so he was concerned about—because with her trees and all—that a branch or something might break the glass. So I called her and I said, "Mother, we need to figure this out. Why don't you let Byron come get you and you can just come to our house?" And she said, "Don't worry. I've got it all worked out." I said, "What do you mean you worked it out? What did you work out?" She said, "Well, I had one of the neighbors put—you know,

those paintings that Bob has here?" She said, "You know, the ones that I don't like?" She said, "He nailed them to the window." So, she said, "It can't break the window now." But she said, "Don't worry, I didn't turn them out." See, that nude lady was not going to be facing the street. When I told Bob that, Bob loved it. He said, "Do you know a photographer?" I said, "Well sure." So he said, "Get somebody to go take a picture of her over there." So I called Philip Gould, and everybody got a big kick out of it. I called Mother and I said, "Mother, Philip Gould is going to come over. He's a friend of ours, and he wants to take a picture of you." She said, "Well, why does he want to take a picture?" I said, "Well, he just wants to take a picture of you in front of Bob's art." So she said, "Well, I don't want him to see that naked lady." I said, "Well don't worry about that. I'll tell Philip not to get that part in the picture." She said okay.

Rauschenberg (profile view), 1998.
Photograph © 1998 Sidney B. Felsen

CHAPTER 9

No One Wanted It to End

THE seventeen years that Rauschenberg lived following ROCI [1984–1991] were productive, but Bob was increasingly slowed by challenges to his health. Here are the voices of Rauschenberg's companions at the end of his life, sharing their memories of his final days. They are then joined by characters from his earlier days, all offering reflections on his great legacy.

DONALD SAFF: [Bob's] a person who had issues of time—you could ask him about a date, and he'd get very offended. If you asked him, "Well, what [year] was that, in 2000? in 1950?" [He'd say,] "I don't know." He'd get very petulant about it. He didn't like to think in terms of timelines that way. There's a kind of avoidance of specificity of the past, or of the future, that was there. The future I understood. He just could not deal with planning for his absence.

You know, I think he had a big problem with himself. I think he saw himself as damaged goods in a way. Between the so-called dyslexia, then the broken relationships, personally, I think he had a big problem. I think that was a cause for him to lash out. I think these things built up in him. I think, basically, he didn't suffer from angst in terms of the work, but I think he personally suffered from a great deal of angst. I do think he had a deep problem with his father. I do think he had a significant problem with his education and his upbringing in Texas, and his homosexuality, and his relationship to clients, and to people who were getting rich off of him, which he deeply resented. The Robert [C.] Sculls of this world really, really got to him. I don't think he was a particularly happy person in spite of the fact that the work is always upbeat and it was positive. That became the alter ego. That's where

he could be happy. That's where he could celebrate. And I think it made him happy to give. It made him feel better. It made him feel better. He felt better about himself by giving.

GIVE ME ANOTHER GLASS OF WINE

MATT HALL: The last trip Bob took to Europe—it happened to be Darryl Pottorf's show, and it was in Valencia, Spain. Bob also had a show at the Edison [Community College]—it's now Florida SouthWestern [State] College here in Fort Myers—coming up to this Valencia show. I was at the house, and Bob said, "Sweets," he goes, "can you go with me to that opening?" And I'm, like, "Well, sure." He said, "Well, talk to Janine [Boardman]," who was the head nurse at the time, "Talk to Janine about the menu going over and coming back." I'm [think-ing], like, we're going to Fort Myers. Okay. So, I called Janine, and she goes, "Well, on the flight over." I go, "Whoa, whoa, whoa, whoa. Hold on a second. Flight to where?" She goes, "We're going to Valencia, Spain, for Darryl's open-ing." I'm, like, what? I thought we were going to Fort Myers. So I called my wife and said, "Hey, Bob wants me to go to Valencia, Spain." [My wife said,] "Well, you're going." So that was amazing. It was just—when I told him the story, he's just laughing. He goes, "You dummy." I go, "Well, you said the opening. You didn't say which opening." So we went to the Fort Myers opening and then traveled with him to Valencia, Spain, in a Gulfstream V.

We flew out of Fort Myers, and it was so fantastic because [Dr.] John [B.] Fenning, John and [Frances C.] Fran Fenning—John was a surgeon [who] served in 'Nam. He was instrumental in doing hip replacements, knees, that kind of thing. He actually, for lack of a better term, in my opinion, proba-bly saved Bob's life one time. When Bob first had his fall in New York City on his hip, he crushed his hip. It [was] just pulverized. He was at Beth Israel Hospital, and when he came to and was cognizant, said, "Get me out of here" because I think Andy Warhol died there, and I believe some other people died there, and he was really superstitious about that. So we med flighted him down. He was at the hospital here in Fort Myers, and John Fenning came out and was doing the surgery to repair his hip and said, "Guys, if we don't operate, he's definitely going to die. If we operate, he could." He had bloated up, and

it was just all these other issues. And, of course, Bob pulls through the surgery and bounced back and started making art. The guy had more lives than a cat.

But John and Fran Fenning were able to go with us, which was fantastic. So now we've got a doctor on board. We had two nurses and myself [who] flew in this plane. Oh, my gosh. Sushi on the way over, and cocktails, flying over there like that, in style, was just fantastic. The best story about the opening was there was a Julio González award that Bob was going to present to an artist. Obviously, it was Darryl's show, but Bob's coming. There were big events for him. I pulled nurse shift one night to give the nurses a break, so we had gone to dinner in a hotel, and it was just Bob and I in the hotel room. He said, "Sweets," he goes, "let's have a glass of wine." I'm like, "Okay." So we have a glass of wine, and he goes, "Let's look through this book of this artist."

So we're looking through this book, and I'm being quiet because I want him to concentrate. Finally, about twenty minutes into it, he looks at me and he goes, "Well, what do you think?" I go, "Really?" He goes, "Yes." I mean, that always blew me away. Even when I was working with him here in the studio, he'd ask you what you thought about the piece. I came to recognize his style, his things that he did like and not like, and I was very honest. If I weren't honest, he wouldn't have me here. That was the whole thing. He wanted you to say. So, anyway, I said about this artist, I said, "Oh, it kind of all looks the same." He goes, "Exactly!" Slams the book. "Give me another glass of wine!"

HE NEEDS WHAT YOU DON'T ANTICIPATE HIM NEEDING

ANNE LIVET: I think Bob had a lot of trouble in the night. I think demons came out then, which is why he didn't like to go to sleep. He slept very late. Mornings were, I think, hard on him, and I don't know what the demons were, but they were there; and I think that was probably a large reason for his drinking. But I definitely don't think he had to drink to make art. I really don't think that. He made art all the time. I think he drank to chase demons.

It was better early on than it was later, you know, but he could be a lot of fun, or he could just be so sentimental he'd burst into tears, cry his eyes out because of something. He was so not judgmental, so if you had been drinking with him, as I did on many occasions, and you woke up with a splitting headache and

horrible hangover and thought, "What did I do? What did I say?" He was like, "Come on back over!" You know, he never passed judgment on you if you were tipsy—only for things you might have done sober that he didn't approve of.

When I first knew him, he handled alcohol a lot better than he did as he got older, but he did pretty much wake up, have a drink, and drink all day until he went to sleep at night. Then when he was with Terry [Van Brunt], Terry tried to get him to just drink wine. There's a wonderful interview with Charlie Rose who asked him about his drinking. "Was it a big struggle for you?" he asked. And Bob said, "Still is." And Charlie Rose asked more questions about it, and Bob answered them until suddenly Bob looked at him and he said, "Can we talk about something else?" So cool. He didn't like to dwell on his struggles. I never asked him why he drank. I never would do that.

DONALD SAFF: I remember I was in Tampa visiting, and I received a call from Darryl saying "Bob's having a stroke. He can't get his toothbrush to his mouth and couldn't feed himself. There's something wrong." I was in pretty tight with people at [Johns] Hopkins [Hospital, Baltimore], and so Bob and Darryl wanted me to arrange for him to get to Hopkins. They had a plane pick up my wife and me in the airport in Tampa, and we flew on to Hopkins. The next day I'd arranged for doctors to see him, and through the people I knew he had a battery of doctors who looked him over, performed many tests, and said that he did have one of those TIAs [transient ischemic attacks] and that he would have to go on Coumadin—blood thinner—and that he would be fine. Either take the blood thinner or drink, but you can't drink and take blood thinner. The reason is, if you fall, something bad is going to happen. You're going to bleed.

We got out of the hospital that evening, went to the hotel. I decided instead of coming back out here [Maryland], I would stay at the hotel with him. When we arrived at the hotel, he went directly to the bar with Darryl and they ordered a drink. The next morning, I was going to drive him back to his private jet. And I said sheepishly, "Bob, would you mind if I reviewed what the doctor said yesterday?" "No," he said, "you can do that." If I just said, "The doctor said so and so," he would then react negatively. But I asked him, and he said, "Fine." So I said, "If you take Coumadin, you can't drink. If you drink, you can't take Coumadin." "Got it." Well, you fast forward on that—of course, he did take

Coumadin, and he did drink. He did fall. He did bang his head. He refused to go to the emergency room. Two days later he keeled over off one of his bar stools and, because he had that brain swelling because of the blood thinner, hemorrhage damaged one side of his body, and then it was a downhill spiral for him.

LAURENCE GETFORD: Bob sort of walked around with one of those, with Jack Daniel's and water, or Jack Daniel's and ice, because, as he said, "Ice is water." You didn't really need water in your drink if you have ice. That's the way you would see him until he got to the point where he had the strokes, and [his staff] tried to cut him off. Then he went to white wine, and we still tried to— because, well, he wanted to drink. Nobody else wanted him to drink, because we knew that the more he drank, the quicker he would be debilitated. Because it really was not good for him—it was just a physical thing. We knew that the end would be sooner rather than later the more he drank.

Everything changed after he had that stroke. Mostly having to do with his independence. He became much more dependent on us, I mean physically. It got to the point where we literally had to move him around. Every time he went from one place to another, it took a couple of people because the paralysis on one side was pretty severe. Well, there were several strokes, and it got consecutively worse.

LAWRENCE VOYTEK: Also, now Bob couldn't take his own photographs. After Bob had fallen and had—it's not really a stroke—but he had damage in his brain from the Coumadin, and he lost [the] use of his right hand and his right arm, [so] he could no longer take his own photographs. He had his assistants there working. I actually was the first person to have a photograph that Bob used. My sister Cindy was ill, and I had to drive cross-country to pick up a sculpture in Santa Fe. My wife had a neon piece that had to be picked up. I knew that my sister was not doing well, and I was talking to Bob, and I was pretty depressed that my sister wasn't doing well. I was going to be driving, and I don't know if he suggested it or I suggested it. I just said, "I could take pictures while I'm driving cross-country." He said, "Please do that, and I want you to FedEx me the film as you're going." In some ways, at a really sad time of my life, having the job of looking at the world and seeing what Bob would

want to see while I was traveling was very comforting. To drive down Route 66 and see weird hotels and strange things—all of a sudden the whole world was a stage set for Bob. I was stopping, having my film developed, and having them FedEx it back to Bob. When I came back, he was working on a painting that had images that I had taken on it.

DONALD SAFF: That happened a few times even early after the stroke, and even slightly before that. Occasionally he needed images, but they were never acceptable to him for the most part you see—because they were obviously Rauschenbergs. I did some of that. I've taken a picture. He sent me to the Seaquarium somewhere in Miami, whatever. He needed pictures. Well, the pictures that I took would be the kinds of things you would think would be a Rauschenberg. I knew what Bob wanted just like I knew what he was going to select, and I was never right. I took photographs that you'd think would be a natural Rauschenberg, and the problem was that they were a Rauschenberg—so they weren't acceptable to him. So these things were basically useless. You would give him what you think he needs, but what he needs is not what you think he needs. He needs what you don't anticipate him needing. The people that surrounded him were not in the league of creativity that he was. And so you couldn't very easily supply him with what his needs were.

MATT HALL: Losing the use of his right arm, that was another whole issue. "Am I ever going to be able to even [do this]?" Because he was doing the transfer process then, which was a very physical act of transferring the image onto the panel. Literally, his trust in us to start assisting him in doing that, which I'm sure was very, very difficult for him, [was great]. But I think the confidence of all the years we'd been here, [and] knowing he was right there on you too, [helped]. He was standing right there, and how you trimmed out the image, and how it was laid down, and how it was transferred—you'd get a quick little whack with his good hand if you did it wrong. He was very serious that it was assisting, but you're really his hands. He was like—it's his work. He's doing it. You just happen to be the mechanism that he was using. That was very different. It was very pressured on yourself, not from him, but just trying to do things right because—oh, my God, you're making a Rauschenberg with the man.

ED CHAPPELL: He was going through a certain amount of depression. He wasn't the man he once was in the physical sense, and we went through a period of, I would say, a year, a couple years, where the productivity [fell off]—he was depressed. He didn't want to go to the studio as much [just] to sit around there, and you could only sit. Sure, we'd read him correspondence, we'd help him with whatever he needed help with, and he'd ask for opinions and so forth on some of the decisions that were happening at the time. But the biggest change I saw at that time was [that] he did lose some of the spark.

But over time, I can't pinpoint exactly when it happened, I saw him coming back. He did not like having nurses around 24/7. He tolerated it; he didn't like it. But after we got a routine going and really figured out what he could do physically, and work[ed] with some rehab, and saw how much of his strength he could get back, we saw Bob coming back. I'd show up there sometimes in the evening and say, "Bob, ready to go to [the] studio?" "No, I don't know," [he'd say], and we had times we didn't go to the studio. That had never happened before. Then I saw the Bob [we knew]—once he could figure out a system, how many more assistants, how much more assistance did he need to get that painting done? He couldn't physically lift up the painting anymore, but he could have us lay it down, and set it there, and turn it around, and work with him on that, and he could sit. So there were things that he could do and couldn't do, and once he worked that out, then he was back into producing. Producing by way of going through the imagery and really starting to come back to life again.

When you [saw] the man with as many issues as he was getting, with his body and so forth, but [he was] still wanting to be in the studio like that and working in there. He may not put out ten paintings in a couple [of] days, but he put two or three or four out. And when he got on a roll, he'd put more out. It was very easy for him to get in the studio. [There's] this huge lift in there, the elevator. We used to drive all the way up into the studio, get him out, put him in the elevator, and there he went. There was not a lot of effort in there. It was easy to get him around; it's a big studio.

Even though he had nurses, we tried to keep them at bay as much as possible, in the other room or something. So whether it was the feeding, helping him through this way, going to the bathroom, so yes, you became

part caregiver. If you were a friend of his, you helped out with that. A close friend. Everyone tried to help each other. The nurses obviously were on the front line with all this. I just enjoyed seeing him, and his face always lit up. He always had that spark, that little spark in his eye.

KAT EPPLE: Toward the last few years, I would call every Sunday morning, not too early because I had to wait until he would be up, but I would call and say, "Hey, Bob, do you want company?" On Sunday, all of his staff would go home to their families. So a lot of times he'd be there—not by himself, there was always somebody there helping, or especially toward the later years, there would be a nurse on the property—but there wouldn't be any of his friends there. For years I would call and he'd say, "No, I'm really busy, can't come over, we can't get together today." But toward the later years I started spending every Sunday out there on Captiva, because he really appreciated having the company, and having somebody to have dinner with, and to sit and talk with. So I would just hang out with him, which was great, and sometimes stay over, sometimes not, depending on how late we stayed up.

It changed a lot. There were different stages of his being able to move around, and his condition got worse. He still continued to work on his art. On some of those Sundays when I would be there all day and stay overnight, he would talk about thank goodness for his art, because that was the only thing in his day that hadn't changed that much. He could still create.

ARNE GLIMCHER: We would go down to visit while things were being made, and then one of the visits would be a selection because there was a show coming up. It got more and more difficult for him toward the end of his life. He was a very emotional man. I remember one day sitting in the studio toward the end of his life, and he looked at his hands, and he began to cry, and he said, "Arne, I have lost so much." It was so sad. I said, "Bob, you've given so much."

DONALD SAFF: I thought [he reacted] rather remarkably well, given how bad it was. Then again, you have to understand that—it's a cliché but—he played the hand he was dealt. I mean, it was his fault that he fell. He was warned.

He just played it. And I wasn't around to see or hear him complain about "poorme" or "it's difficult." When I was with him, to get him into a wheelchair—people helping him and all of that—he went out. He didn't complain. He had his withered arm. He might be a little frustrated and try and get the doctors to try and do something. But he just went with it. He just went with it. He was terribly afraid of dying and certainly would never talk about death early on. He was very fearful about death. He wanted to go on forever. He intended to go on forever.

CHARLES LAHTI: I [was] in Porto with Anthony Gammardella and David White and Robert [Jakob], and we're all there seeing the show in Porto. So we're at Porto, he's in his wheelchair. He's sitting there, and this may have been, well, it wasn't the last time I saw him, but it was not so far away from that. And I went up to him, and he's sitting in this little antechamber outside of this house where the dinner is after the opening, and everybody's there and the TV cameras are rolling. You would have to wait with Bob, and there would be a moment to approach him because people weren't in the way. I went over to give him [a kiss]; he's sitting there in this chair, and the cameras are rolling, getting ready to do this interview, and it's my moment to walk up. And I go over and give him a kiss, which I thought was going to be a little thing, but it turns out that it was rather a passionate kiss, if you know what I'm saying. And nobody saw it, and we were being filmed on the camera. So, at the last minute, the rascal, even in his wheelchair, could slip you a little tongue.

DONALD SAFF: It was always strange to me that with all of the drinking he never compromised the art. I've never seen it any other way than that. He was such a pro. I mean, when he had to perform or do anything, he worked a crowd. When he went to an opening, you'd never see him eat a thing—nothing. He may have a drink in his hand, but he would never eat anything. He worked, and he wouldn't be seen eating. He was a pro, you know? And he was full of focus on that. I mean, he was a great manipulator of his own career and his own persona and how he appeared. And he was always on stage and never compromised that position, ever. Never. But it was always about Bob. It was always about Bob.

PLAYING LIKE HE WAS GOING TO GET WELL

MARY LYNN KOTZ: The last time [I] saw Bob[was] after we had gone through the exhibition preview [*Let the World In: Prints by Robert Rauschenberg from the National Gallery of Art and Related Collections*, National Gallery of Art, Washington, D.C., 2007–2008], [and] he had dinner in the hotel with Sid [Felsen] and Joni [Moisant Weyl]. After dinner they had left, and his nurse got him into the bed, and she had given him his go-to-bed pills. He choked on one of the pills, but she did not hear him. She was not the regular nurse. And he just was choking and choking and choking. By the time they called Bradley, Bradley called 9-1-1 and got him into an emergency room at George Washington University Hospital.

The next morning, I drove over to the hospital to see him, and he was alone in this little teeny, tiny room. It wasn't like what he had been accustomed to in his evermore frequent hospital stays. I went in to see him, and I told him about a good review of his new show in New York, and I read it to him, a review that had just arrived in *ARTnews*. He grinned, "Huh, that's nice." He liked that. Then Darryl came to the door, and he was just blathering. He was absolutely blathering. He said, "Bob, you've got to get up now. I've called a medevac. You're going back home to your own doctor." So Bob said, "Well, I guess I'm leaving now." I said, "Bye, Bob." I said, "See you later, Bob. I'll be down," and he said, "I love you."

ED CHAPPELL: As far as the passing, it's such a whirlwind. I was supposed to go meet with him in Washington, D.C. That's where he had his heart attack. I was up at the hospital that next day and spent most of the time up there with him. Bob was in a lot of pain at that time. Getting him back to Captiva [was the goal]. I talked with the doctors and with the staff and everyone else to help try to get that [done], because they wanted to bring him back. He was in pain, but he was doing much better, but from there it just snowballed and got worse.

JANET BEGNEAUD: After he had the stroke and he was so sick, I stayed down there [in Captiva]. I think it was like seven or eight weeks that I stayed down there, and he didn't want me to leave, and I didn't want to leave. He and

I kept playing like he was going to get well, and I think in my heart of hearts I kind of thought he would. Because he had been sick—really bad sick—at least three other times. In intensive care. And he'd pull out of it. In fact, while he was in the hospital there in Fort Myers, every morning the doctors would have a little gathering of the loved ones of the people that were in there, and they would kind of do a little bitty thing about what was going on. I was always there, and so I would go to those little meeting things. And one morning the doctor said, "Now, Mr. Rauschenberg is"—he didn't say "not going to make it." I've forgotten the exact words he used, but it was like saying that he's terminal. And he looked over at me and he said, "The only people that think that he's going to make it are he and his little sister." He pointed at me, and I said, "Well, he will. He just will." I held it better, thinking that he was going to get well.

I'm a big half cup full rather than half cup empty [person], because I've always felt like anticipation is way longer than realization. So, if you're anticipating and you're negative about it, then you're unhappy this whole time. And if it turns out bad like you thought it was going to, then you're still unhappy. But if you think about it being good and it turns out bad, then you can get over that, but at least you've had this happy time in there. At least—positive time. And so Bob and I, the whole time, it was like this was temporary. We talked about "When you get through with this."

Anyway, there were some really cool things that were like omens. He and I are both superstitious-like. In my purse right now is my whole little purse full of charms. He and I used to trade charms. I had a little stone—a little rock, like a street rock—it was the shape of a heart. And I showed it to him one time, and he took it in his hand and he said, "I want this." He said, "I'll trade you." So, we would trade things. He would give me something. It wasn't the end of the world.

KAT EPPLE: The last time I saw Bob, it was in the hospital, and the doctors were making the decision to release him. So I was there, waiting with him. It was just me and him, and maybe his sister. I think his sister was there too; she was in and out, talking to nurses. I said, "Okay, Bob, looks like you're going to go back home. I'll come out and play flute for you on Captiva." He said, "No, no, no." I thought, oh, well, he doesn't want to hear it. He was on a respirator, and he couldn't talk well, so he grabbed me with the strength like he used to,

and I was thinking it's okay. He said, "No, now." I went down to my car, to get my flute, and I had a flute with me. He was in ICU, so I knew it was like, I can't play something raucous here, so I played, really softly, a piece of music that was just very emotional and spiritual. Bob listened to every single note and then the last note just tapered out to a whisper. Bob was crying, and he grabbed my hand, and I hear [claps hands] all over the ICU, patients and doctors and nurses had all been listening too. Bob smiled at hearing that.

I had planned to go out and see him again, but after I played for him and I hugged him, held him real close, and we connected spiritually, I knew that I'd already said goodbye to him, and he knew that too. I had planned to go back out to see him, but I also felt like I didn't really need to, because he was fully conscious and present at that moment, and it was a beautiful thing that he asked me to go get my flute and play for him. It was one of the hardest concerts I ever played.

LAWRENCE VOYTEK: Bob was in the hospital, and Dr. John Fenning was there. Bob was having multiple organ failures, and they had to put him on a ventilator. Bob wanted to be back on Captiva. I believe Bob wanted to go to his house. Bob had to be on this machine. Bob's studio had a giant elevator that could bring all the machines upstairs. Basically, I think Dr. Fenning lined up a ventilator IC [intensive care] unit [that] could transport Bob out to Captiva and set him up in his studio. They brought Bob out to the studio and set an ICU unit in his studio.

He was in a bed in the room, in his studio, on this ventilating machine. The first thing I did when Bob got there [was]—since his bed was really up high and all the tables were really low, I welded up a quick table that would make the TV set high enough so that he could see it. The last series that he was working on, the *Runts*, had a standard size panel. And so I decided to make the table—and I did a little drawing to talk to Bob. I said, "Bob, I'm going to make a table that is the exact size of the *Runts*. It'll be hinged, so that we can tilt it up, and you can see it, and we can hold up images, and then when you decide where you like it, we can put it down and transfer it, and then we can show it to you again."

He agreed that I could make the table. He had had a trach and things like that, so communicating with him at that time was very hard. It [was] usually,

like, you just sort of tell him something and he could nod yes or no and say things. And with only his left hand working, he couldn't write really well. It was a lot of trying to understand what he was trying to tell you. All my tools and shop stuff [were] below Bob in the shop. I asked Bob—I said, "Bob, if I'm going to make this table, I'm going to be making a lot of noise below you. Is that okay?" The last thing he said to me was, "Music."

ED CHAPPELL: I was there the last day before he died. I spent the whole weekend with him at Captiva, when he had everything set up. I spent the whole weekend with him. Then, that Monday, he passed away. It was just a really tough time because he got brought back to where he wanted to be, and everyone realized that Bob's not going to come back from this. The best we could do was just come to grips with it; even though all his art was around him, it was more like a hospital environment. He would struggle to talk, and he had a hard time speaking at the time because of the apparatus that he had on him. And so he got to pull it out, and he could talk to you a little bit, and go back in. We'd talk about a few things, and a lot of nice things were said to each other. It was very touching. Even though he had lived a full life, I don't feel he was ready. He did go quickly. Then it was more about caregiving, just being there with him, holding his hand, putting compresses on his head. It was a pretty sad time. And he didn't want to live that way any longer. There were a lot of complications there.

No one wanted it to end. I think Bob thought he would live for another twenty, thirty years, seriously. He was so resilient after so many of these other incidents happened that put him in hospitals; he would just come back. This is one that he couldn't come back from. And so it was tough.

DONALD SAFF: They brought him back into the studio at the very end. Put him in the studio. And in the end, he asked his friend who's a physician down there who was helping him understand the prognosis and whether he was ever going to get better. And by that time, whatever it is, the COPD [chronic obstructive pulmonary disease] was horrific, and the road back was, at that point, barred by the angel with a flaming sword. He was not going to get back. And it was at that point that he agreed to basically pull the plug, and he made the decision.

MARY LYNN KOTZ: He had said to the doctor, "Okay, am I going to get any better?" He had a feeding tube, a breathing tube, and other tubes. The doctor said, "I'm afraid not. I'm afraid you'll have to think up the ideas and have your people work them out for you." He said to the doctor, "Then I don't want a life like that, thank you." He said, "It's bad enough being paralyzed, and it's bad enough having to have somebody take care of your every function. But I do not want to have that life."

So he called his nearest and dearest, including Christopher.

NEVER WAIT FOR ANYTHING

KAT EPPLE: [Bob had] some really fun stories, about back in Port Arthur [Texas], where he lived, about his mother, and about getting on the train and just going. He liked to talk about when he worked at a mental institution. He talked about the people, about how he really connected with the people there.[*]

I think it was an important perspective for him, to see people with such alternative ways of thinking, whether it was healthy or good or not. But it wasn't all just cut and dry like what he'd seen back in his early days in Texas, where he really was a square peg in a round hole. I mean, I can't imagine him as a little boy surviving that. Art wasn't even considered anything of value. You've probably heard him tell the story where he went to an art museum and saw paintings and asked somebody, "What are these?" They explained that people paint these, and he was so amazed that somebody could do that and get paid for it, and that's when he said, "That's what I want to do." It had never occurred to him before. I mean, he hadn't been exposed to art before.

But I think he always felt like a square peg in a round hole, and [he] became not only comfortable but wore it as a badge of honor. I learned so much from him in that way. I've always been very committed to music and my music career, and he really helped me feel more valid in my own stance with that. You really get more people telling you that you should be doing it differently,

[*] *Editor: While in the U.S. Navy, Rauschenberg worked as a neuropsychiatric technician in the Navy Hospital Corps, while stationed at Camp Pendleton, San Diego, 1944–1945.*

and Bob never did that, and to see how genuine he was. He really wasn't putting on airs, he was being who he was. He just was very thoughtful about what he did artistically and also in life. I think he really thought about it a lot. Trying not to do harm to people. Although sometimes he'd be painfully honest with you. If you asked his opinion about something, you better be prepared to get it.

[When I look at his work now,] I see his energy and segments of his life in each one. It's kind of his energy and his perspective, his philosophy, maybe is the way to see it. If you knew him and knew how much fun he was, you see that fun in every piece. There are some that are just intense, but most of his art has an element of play. By learning to see that through looking at it with Bob, and learning about visual art through Bob, it gives me much more appreciation of other artists. I can see much more about where they're coming from. Are they fun, or are they a pain in the butt?

I think I learned a lot about being fearless from watching Bob be fearless—fearless in art, especially, but in life also. The chances he would take, not necessarily physically doing daredevil stuff, but he did a lot of daredevil stuff with his career and art. And the choices he made were based on who he felt he was and what was real. I learned a lot from that.

DOROTHY LICHTENSTEIN: I think his generosity in spirit was great. Roy was very much like that too. With Bob, really, just this idea of chance, that he was kind of willing to go where things took him. So that was a kind of courage on his part, not to be afraid of the unknown and to follow it. And this positive attitude that, "well, we'll make it better"—that was really inspiring. And his concern for people who were less fortunate. It's sort of recognition of the fact that not every artist does well, that emergencies come up. At the time he started Change Inc., there was really no way, if an artist got sick or had a fire or something. He thought about that. He was conscious of it.

CHRISTOPHER RAUSCHENBERG: Well, when people say to me how generous Bob was, sometimes I just sort of say, "Oh, yes." And sometimes I say, "well, actually, that's not quite what it is." If you're a point guard on a basketball team and you pass the ball to your teammate and they make a shot, you weren't being generous to give them the ball, you were being a team player. It's not that

you're trying to achieve a personal goal and generously sacrificing something that you could use on your personal goal for somebody else. To me, that's what generous means. But if you say, I have a team goal and whatever resources I bring to the team, I'm going to contribute. If I'm a good rebounder, I'm going to rebound. If I'm a good shooter, I'm going to shoot. If I'm a good passer, I'm going to pass. And you know, he started out with no money. He started out in a cold-water place where he would have to go to parties so he could go somewhere where there was hot water and duck into the bathroom and take a shower and dry off real quick and look innocent. I mean, he understood where the needs were among the team because he'd had them.

At his memorials—we had memorials for him, a few of them in different places—and at each one, after it was over people would come up to me one at a time and say, you probably don't know this, but when I had such and such a need, your father took care of it. Your father paid my hospital bill, your father paid my rent when we were going to lose our house. Your father did this and did that. And no, I didn't know any of that. But none of that surprised me. Actually, we've set up something; the [Rauschenberg] Foundation is working with a community foundation in Florida. We have a certain amount of giving we want to do in Bob's community in Florida. From here, we just don't know enough. We've supported places. We continue to support places that he had been supporting. But that's a dead thing. It's like, there has to be somebody on the ground who is paying attention to what is going on there, to say, he supported this, but now he would support that. So we're working with a community foundation, and the first round of grants they gave us were like, okay, here's somebody with an innovative program for this. And the symphony is doing concerts at the library, and this is innovative and interesting. And we got back to the foundation, said, okay, look, here's a steering thing. The things that my dad did were much more about safety net kind of stuff. What about the food bank? He supported the battered women's shelter, you know, this kind of stuff. This is what really spoke to him. It's like, where are the holes? Not where are the opportunities to leap above, necessarily. But like, where are the needs in my team? He organized this thing where artists who were lucky enough to become famous and their work was worth a lot of money donated artworks to hospitals in New York, and said, you give an equal amount of health care

to artists to what we gave you. You know, if we're giving you a million dollars for the painting, you do a million dollars' worth of free health care for artists. It's always been about that for him. Where is there need?

Anyway, so that's kind of that sense of how do you operate in the world, and how do you see yourself in the world? It's something that I got really strongly, and that's why I live in Portland because it's a community where people come together and do stuff like that. And to me, it's just more powerful. A team of five basketball players will always beat one superstar player who is not sharing the ball.

JANET BEGNEAUD: He was just a sweet guy, but he was particularly attentive to Mother. Our father died in 1963, and Mother died in—she was 97, so she died the middle of 1999. So, for all of those years she was by herself, but she did well being by herself. She did a lot of art. She had a couple of little buddies that were also widows or divorced or something, about three or four of them, and they'd get their art supplies and drive around, and they'd make a picnic lunch, and they'd drive out around New Iberia or some of these places where these antebellum homes are, and they would get permission from the owner [to] sit out in the yard. Of course, usually the yards were several acres. And they would set up their blanket and their art stuff and have their lunch and paint.

One of Mother's paintings was funny. It was a scene, and there's sort of a vacant area in the middle of the scene, and she was showing this to Bob. Every time Bob would come in she would get all of her art out and discuss it with him. One time he told her, he said, "Mom, what I'm going to do, just to save paint, I'm going to buy you a camera and then you can accomplish the same thing and you won't have to paint." And Mother said, "No, I don't want to do that. Why would I do that?" I mean, she didn't understand what he was trying to tell her. But this one painting, it was so funny, because it's the willow trees and all this and then there's this sort of vacant place right there and so Bob said, "Well, are you finished?" And she said, "Well, yes. I have it figured out." She said there was a car right here and she said, "I didn't want to paint the car in there." This was a Chevrolet ad, so she painted the Chevrolet ad, but left the Chevrolet out. Bob said, "This is a classic."

RICK BEGNEAUD: Bob wasn't much on giving advice. Bob was more observation. I remember once walking, I guess it was after dinner, somewhere in New York. I don't remember how old I was, twenty or something. We were just walking around, and we were having a conversation about observing things. What are you paying attention to? Are you looking at the fence or are you looking at the shadows from the fence? Are you looking at the trees or the shadow of the branches? I felt like I was getting lessons in observation and how to look at things and how to think about things very differently than where I was in Lafayette, hanging out, doing my normal life. I got that from him. It really changed my whole way of looking at life, hanging out with Bob.

ARNE GLIMCHER: Look how many different areas, artistic areas, he's performed in. There's performance, there's sculpture, there's assemblage. There's painting. He's done everything. He takes cardboards and makes works out of them, signs and turns them into sculptures. What he does is create areas in which other artists can work. I remember going through the Rauschenberg exhibition at the Guggenheim Museum [*Robert Rauschenberg: A Retrospective*, 1997–1998], the retrospective, with Kiki Smith. She seemed very sad, and I said, "What's the matter, Kiki?" She said, "Everything I'll ever do in my life, he did before I was born." So he did make it possible for other artists to work. He really did. Things like his *White Paintings* [1951], the *Black Paintings* [1951–1953]. They were conceptual art; so much of it comes out of Rauschenberg. I think minimal art comes so much out of just a piece of fabric hung with a pole on the side, and everything's perfect. We don't even know Rauschenberg yet. It's such an enigma, and there's so much to mine in that work. I think generations will make works from Rauschenberg, influenced by Rauschenberg.

SIMONE FORTI: A way that Rauschenberg has influenced me [is through this technique]. I was working with a group at one time, it was called Simone Forti & Troupe. We were moving and speaking. We were making portraits of different places, and we would go to that place and—anyway, I was doing a lot of speaking. One of us was a geologist, and so he would explain to us how the land there had come to the shape it's in, and how it was still moving, and we would reenact that. I would read about any battles that had happened there, and shoot myself out of a cannon, and talk about the battle. David Zambrano

didn't want to speak, and he just wanted to dance. I remembered Rauschenberg's collages, or where he got the imprint from a newspaper to bleed onto the surface that he was creating an image on, and that he had maybe the obelisk upside down, and an airplane taking off, and all these different images. Then he'd have some paint, and I realized that David could just be paint. We would be making all these images, and he could just go dancing through however he likes. That's a technique I learned from Rauschenberg.

DEBORAH HAY: I'm sure I learned a lot more, maybe from Bob than anybody, about how to work. One quote of Bob's that changed my life was when Bob said [this] to me. At one point, I was going to work on a piece. I said, "Well, I don't even have any dates yet." I can't quite remember the context, and Bob said to me, "Never wait for anything." And that, whoa, that changed my life right there. "Never wait for anything," four words, and what a message. Yes, I mean, so I learned how to work. I think I learned how to work being around Bob. I think I learned what work is.

CALVIN TOMKINS: On the point of influence and continuing to convey the spirit of this country, I don't think there's anybody who has touched Bob before or since. And the idea of the freedom and the nerve, or sort of the unbeatable originality of what comes out of him.

In some ways, I think I learned a lot about how to write from watching Bob work. That you trust the process. That you don't have to think it out beforehand. You don't have to know where you're going. You just have to trust the process. And that's an extraordinary lesson. I didn't know that beforehand. I thought you had to have it pretty well planned out and proceed from one step to the next. He didn't work that way. He could plunge in anywhere and go backward and forward at the same time.

LARRY WRIGHT: Bob was such an incredible whirlwind of energy, but it was all so positive, it was all so happy. And he didn't separate his art from his life. Everything was all-inclusive, and in his case he made it look easy because it was truly his passion. I think for my students, you want to get joy out of this. You want this to be your core coming through. "There [are] no mistakes in art." All of that kind of stuff that he would bring to the table, his wisdom,

but I think overall he just didn't exclude anything. Everything was possible. Whether you were putting up a piece of grass growing in a frame or an angora goat with a tire around it. It was all grist for the mill, and there were absolutely no rules, and he really broke whatever ones he could find. He was truly a huge impact personally on my teaching style and my style of making prints. I took a huge cue from him as a young man in the way that he approached things, and so my way of working is very inclusive. And I try to be very happy, and I try to make that kind of fuel that's energy for the whole process. He was like that. He created energy. He got people excited.

LAWRENCE VOYTEK: There's a funny thing that he said. He was watching some TV show, and it was about some plant that lives, like, a hundred years and then a flower comes out of it and it dies. Bob said that he would like his art to be like the most precious thing you've ever seen and [then] die rather than [being] something ugly that'll last forever.

RICK BEGNEAUD: I remember one time my friend Chuck and I went to Captiva. We were probably in our early twenties or something like that, and we showed up in Captiva at two or three in the afternoon. We started having cocktails, and it was just the three of us. Bob had a bar, which was the kitchen table. There were no stools, and we stood around that for a while, a long while. And it was just one thing after another. I mean, I really—my stomach was sore the next day. Chuck and I had the best time just standing there talking to Bob for hours having cocktails. We laughed so hard, it was just—it was endless.

That same afternoon, we were sitting there and there was a fly flying around the kitchen table. Everything was white, the whole house was white, the whole kitchen was white. Every once in a while you'd kind of snap at the fly to try to get rid of it. It would land on your drink, or it was just bugging us. And it was there for hours. I must have grabbed for that fly a dozen times. Chuck probably did the same thing. And at one point we're just sitting there, and Bob looks over, and he takes a sip of his drink, and sets it down, and he just reaches over, and he goes—he picks up the fly real slowly—and he walks over to the screen door, opens it up, and lets it out to the beach, and closes the door, and comes over just like nothing ever happened.

And Chuck and I were looking at each other going, "How did he do that?" There was something supernatural about that.

Network Diagrams

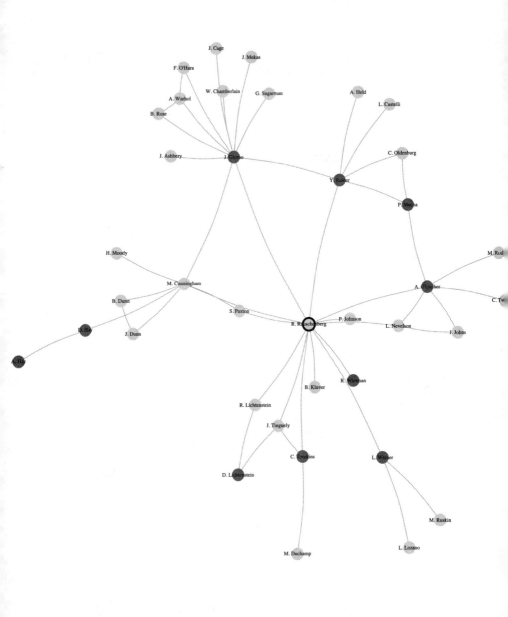

1 It's a small world. Narrators are represented by dark circles; others by light circles. Circle size reflects the centrality of the individual in the network, as cited by our project narrators at that time. Rauschenberg is the center of a diverse world of choreographers, musicians, engineers, and artists. This network and others provide a way to envision the art world as seen from the perspective of our narrators, the relationships they had with Rauschenberg and with others who were active in the scene at the same time. Over time, the structure of the art world changes, and these changes are captured by and reflected in the network graphs that end each chapter.

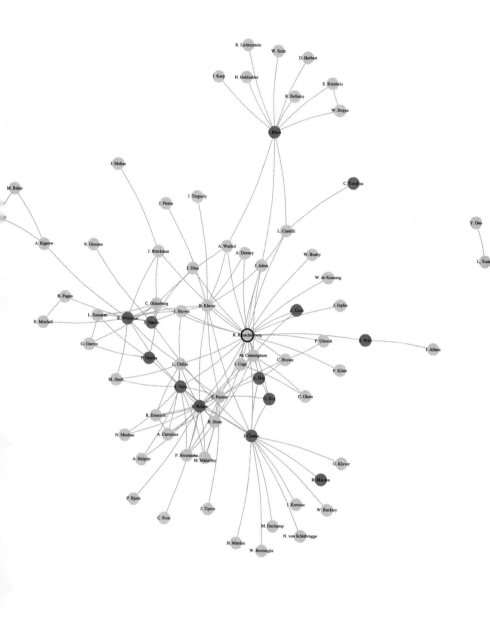

2 The art world explodes in New York City. The centrality of Klüver, Cunningham, Cage, Forti, Paxton, Hay, and Rainer arise from blurring the boundaries between art and performance and technology.

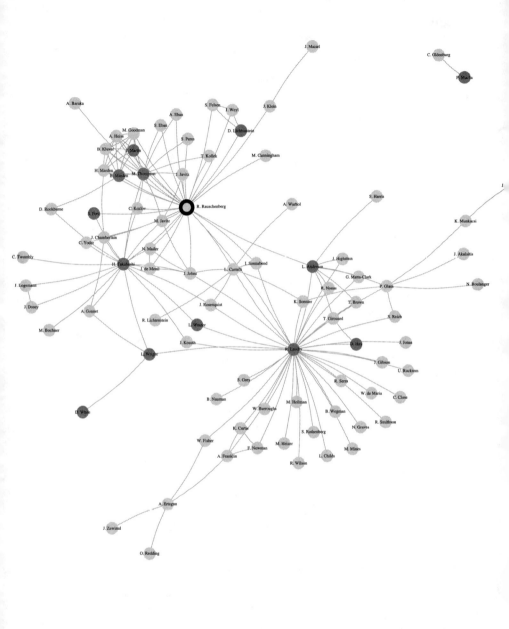

3 The circuit around 381 Lafayette Street is still close, but the art world outside of New York emerges as the art world expands nationally and globally. Old friends and collaborators move off toward the periphery.

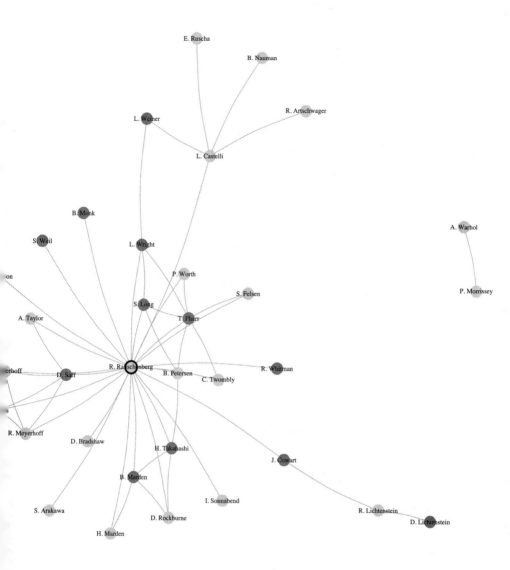

4 Rauschenberg moves to Captiva, Florida, and the world shrinks dramatically.

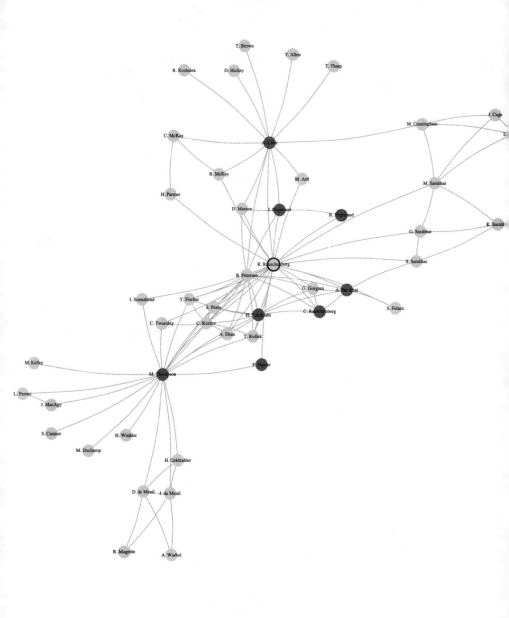

5 The small dense world of Captiva expands globally, but the connections between the larger global art world, induced through international travels and shows, and home remain anemic.

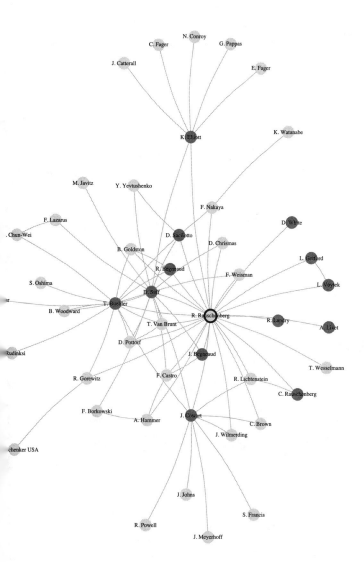

N. Conroy
C. Fager
G. Pappas
J. Catterall
E. Fager
K. Elliott
K. Watanabe
M. Javitz
Y. Yevtushenko
F. Nakaya
D. White
G. Baselitz
F. Lazarus
.Chun-Wei
D. Saclotto
D. Chrismas
L. Gettord
J. Schnabel
B. Goldston
R. Begnaud
F. Weisman
S. Oshima
L. Voytek
D. Saff
T. Buehler
R. Rauschenberg
B. Woodward
R. Landry
T. Van Brunt
A. Livet
D. Pottorf
J. Begnaud
T. Wesselmann
Rudinksi
R. Gorewitz
F. Castro
R. Lichtenstein
C. Rauschenberg
F. Borkowski
A. Hammer
J. Cowart
C. Brown
.chenker USA
J. Wilmerding
J. Johns
S. Francis
R. Powell
J. Meyerhoff

6 Saff and others bridge Rauschenberg to the global art world.

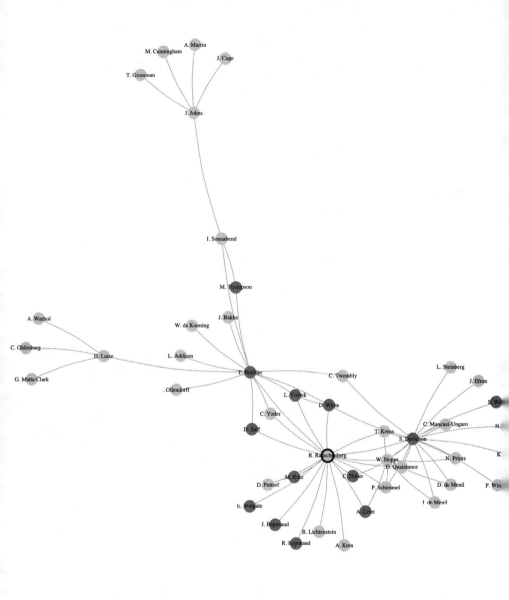

7 A few old friends remain at the periphery of the network, which is partitioned into geographically distinct subcomponents.

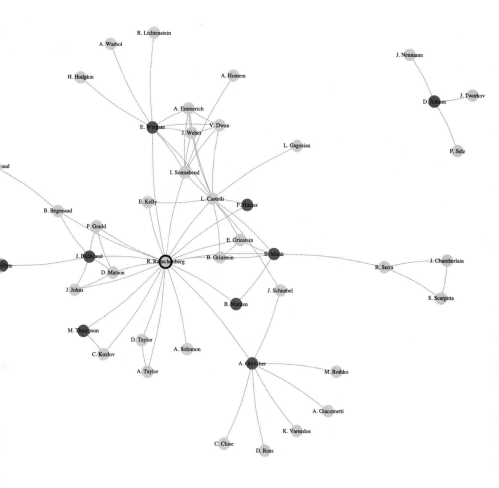

8 Castelli and other gallerists, but mainly Castelli, knit together the art world.

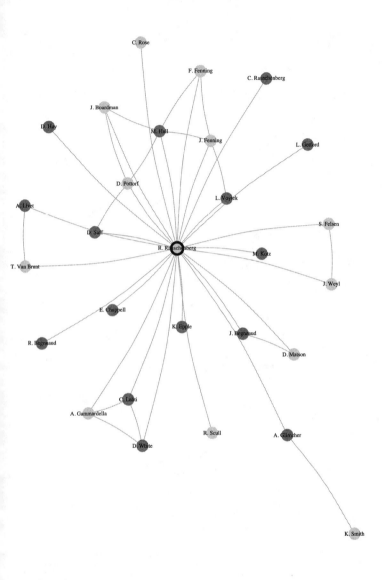

9 Everyone comes together. The world in which Rauschenberg worked and played was rich with friends and collaborators.

Narrators

LAURIE ANDERSON was born in Glen Ellyn, Illinois. She is an experimental artist, musician, composer, film director, and instrumentalist and is a pioneer in the field of electronic music. Anderson was interviewed by Alessandra Nicifero on October 23, 2015, in New York City.

DORE ASHTON was born in Newark, New Jersey. She is an art critic, professor, and writer who has authored more than thirty books on art. As an art critic, she was a champion of the New York School. She is a professor of art history at Cooper Union in New York and a senior critic in painting and printmaking at Yale. Ashton was interviewed by Sara Sinclair on April 29, 2015, in New York City.

JANET BEGNEAUD was born in Port Arthur, Texas, and grew up in Lafayette, Louisiana. She is Robert Rauschenberg's sister and was ten years younger than Robert. Begneaud was interviewed by Sara Sinclair on January 14, 15, & 16, 2015, in Lafayette, Louisiana.

RICK BEGNEAUD was born in Lafayette, Louisiana, the son of Janet and Byron Begneaud, Robert Rauschenberg's nephew. He is an artist. Begneaud was interviewed by Sara Sinclair on May 28, 2015, in New York City.

THOMAS BUEHLER was born in Berlin, Germany, and was the senior registrar for the Robert Rauschenberg Foundation. He worked as an art handler and projects curator for Robert Rauschenberg from 1979 until his death. Buehler was interviewed by Sara Sinclair on April 2 & May 5, 2015, in New York City.

ED CHAPPELL is a photographer based in Florida, who worked with Robert Rauschenberg beginning in the early 1990s. Chappell was interviewed by Cameron Vanderscoff on August 21, 2015, in Naples, Florida.

JACK COWART was born in Fort Riley, Kansas, and grew up outside of Philadelphia. An art historian with a particular expertise in Henri Matisse and Roy Lichtenstein, he has held leadership positions at a number of U.S. art institutions and is the current executive director of the Lichtenstein Foundation. Cowart was interviewed by Sara Sinclair on May 6, 2015, in New York City.

SUSAN DAVIDSON was born in Houston, Texas, and was a senior curator at the Solomon R. Guggenheim Museum and curatorial advisor to Robert Rauschenberg and later to the Robert Rauschenberg Foundation. Previously, she was the collections curator at the Menil Collection in Houston for eighteen years. Davidson was interviewed by Sara Sinclair on March 3, 31, & May 5, 2015, in New York City.

KAT EPPLE was born in Ohio. An instrumentalist and composer, she has released thirty music albums internationally and composed scores for film and television, working in musical styles including World Music, New Age, Jazz, Metal, Orchestral Film Scores, Electronic Space, and Ambient Music, for which she has won Emmy and Peabody awards. She performs live in various ensembles including the band Emerald Web. Epple was interviewed by Sara Sinclair on February 19, 2015, in Fort Myers, Florida.

SIMONE FORTI was born in Florence, Italy. She is a postmodern artist, dancer, choreographer, and writer who contributed to the early Fluxus movement and performed in Happenings. Forti was interviewed by Alessandra Nicifero on June 2, 2015, in Los Angeles.

LAURENCE GETFORD was born in Silver Springs, Florida. He worked as a studio assistant to Robert Rauschenberg in Captiva, Florida, beginning in the mid-1980s, joining as full-time staff in the early 1990s, and worked for the Robert Rauschenberg Foundation until March 2014. Getford was interviewed by Sara Sinclair on May 12, 2015, in New York City.

JOHN GIORNO was born in New York and is a poet and performance artist who came to prominence as the subject of Andy Warhol's 1963 film *Sleep*. He is the founder of Giorno Poetry Systems and is an AIDS activist. Giorno was interviewed by Sara Sinclair on October 22, 2014, in New York City.

ARNE GLIMCHER was born in Duluth, Minnesota. An art dealer, film producer, and director, he is the founder of the Pace Gallery in Boston, Massachusetts. Glimcher was interviewed by Sara Sinclair on May 27, 2015, in New York City.

MATT HALL was born in Englewood, Ohio. He has worked on Robert Rauschenberg's property at Captiva, Florida, since the early 1990s and is currently the facilities supervisor for the Robert Rauschenberg Residency. Hall was interviewed by Sara Sinclair on February 17, 2015, in Captiva, Florida.

ALEX HAY was born in Valrico, Florida. He is an artist who, in the 1960s, performed with the Judson Dance Theater, and he worked as an assistant to Robert Rauschenberg with Merce Cunningham and John Cage. In the late 1960s, he left the New York art scene and moved to Arizona. Hay was interviewed by Alessandra Nicifero on December 8 & 9, 2014, in Bisbee, Arizona.

DEBORAH HAY was born in Brooklyn, New York. She is a postmodern dancer and choreographer and a founding member of the Judson Dance Theater. Hay was interviewed by Alessandra Nicifero on July 29, 2014, in East Charleston, Vermont.

CAROLINE HUBER was born outside of Philadelphia and grew up in Glower, Pennsylvania. She married Walter C. Hopps in 1983 and worked as codirector of the nonprofit contemporary arts organization in Houston, Diverse-Works. Huber was interviewed by Alessandra Nicifero on May 29, 2015, in Pasadena, California.

FREDERICKA HUNTER was born in Galveston, Texas, and is the owner of Texas Gallery in Houston, Texas. Hunter was interviewed by Brent Edwards on September 9, 2016, in New York City.

MARY LYNN Kotz was born in Mathiston, Mississippi. She is a journalist and author and wrote the biography *Rauschenberg: Art and Life*. Kotz was interviewed by Mary Marshall Clark on July 16, 2015, & June 15, 2016, in Washington, D.C.

CHARLES LAHTI was born in Brunswick, GA. He is a master printer and artist.

DICKIE LANDRY was born in Cecilia, Louisiana. A saxophonist and composer, his solo career has included more than six hundred concerts in the United States and internationally, and he has collaborated with a number of composers, artists, and choreographers. Landry was interviewed by Sara Sinclair on January 14, 2015, in Lafayette, Louisiana, and on March 6, 2015, in New York City.

DOROTHY LICHTENSTEIN was born Dorothy Herzka in New York City. She married Roy Lichtenstein in 1968. She is the president of the Board of Directors of the Lichtenstein Foundation and a member of the Board of Directors

of the Rauschenberg Foundation. In 2001, French Ministry of Culture and Communication made her an Officier de l'Order des Arts et des Lettres. Lichtenstein was interviewed by Jean-Marie Theobalds on August 20, 2014, in Southampton, New York, and by Sara Sinclair on February 3, 2015, in New York City.

ANNE LIVET was born in Fort Worth, Texas. She is the author of *Contemporary Dance* and *The Words of Edward Ruscha* and is the founder and president of Livet Reichard Company, Inc. Livet was interviewed by Sara Sinclair on October 15 & November 18, 2014, in New York City.

SHERYL LONG was born in Iowa. She worked as an assistant for Robert Rauschenberg in Captiva, Florida. Long was interviewed by Cameron Vanderscoff on July 22, 2015, in St. Petersburg, Florida.

BRICE MARDEN was born in Bronxville, New York, and is an artist. In 1963 he earned his MFA from the Yale School of Art and Architecture. In 1966 he was hired as Robert Rauschenberg's assistant. Marden was interviewed by Mary Marshall Clark on March 19, 2015, in New York City.

JULIE MARTIN was born in Nashville, Tennessee. She is the executive director of Experiments in Art and Technology (E.A.T.), a nonprofit organization founded in 1966 by Robert Rauschenberg, Robert Whitman, Fred Waldhauer, and Martin's late husband, Johan Wilhelm "Billy" Klüver. She is the co–executive producer of a series of films documenting *9 Evenings: Theatre and Engineering*. Martin was interviewed by Brent Edwards on August 5 & 14, 2013, in Berkeley Heights, New Jersey.

BOB MONK was born in Brooklyn, New York. He is a director at Gagosian Gallery and previously was a director at Sotheby's. He began his career at Leo Castelli Gallery and went on to cofound the Lorence-Monk Gallery with Susan Lorence, which operated from 1985 to 1991. Monk was interviewed by Sara Sinclair on May 18, 2015, in New York City.

PATTY MUCHA was born in Milwaukee, Wisconsin. She was married to Claes Oldenburg from 1960 to 1970. She sewed many of Oldenburg's early soft sculptures and performed in Happenings. Mucha was interviewed by Alessandra Nicifero on August 12, 2015, in St. Johnsbury, Vermont.

BOB PETERSEN was born in Le Mars, Iowa, and is an artist and printer. In 1969, he began working as an assistant printer at Gemini G.E.L., and in 1970 began working with Robert Rauschenberg in Captiva, Florida, where

they established Untitled Press, Inc, and worked together until 1980. Bob Petersen was interviewed by Brent Edwards on October 24, 2014, February 9, May 20, & October 23, 2015, in Tivoli, New York, and New York City.

TIM PHARR was born in Georgia. He is a carpenter and worked building frameworks for Robert Rauschenberg in Captiva, Florida. Pharr was interviewed by Sara Sinclair on February 17, 2015.

YVONNE RAINER was born in San Francisco, California. She is an experimental dancer, choreographer, and filmmaker. She cofounded the Judson Dance Theater. Rainer was interviewed by Alessandra Nicifero on August 16, 2014, & May 14, 2015, in New York City.

CHRISTOPHER RAUSCHENBERG was born in New York. He is a photographer and the son of Robert Rauschenberg and Susan Weil. He is cofounder, cocurator, and board chairman of Blue Sky Gallery in Portland, Oregon, and president and president of the board of the Robert Rauschenberg Foundation. Rauschenberg was interviewed by Mary Marshall Clark on January 13, 2015, & January 17, 2016, in New York City.

DELI SACILOTTO was born in British Columbia, Canada. A master printer and a specialist in photogravure, he establised Iris Editions in New York. He worked at Graphicstudio at the University of South Florida where he was the Director of Research.

DONALD SAFF was born in Brooklyn, New York. He is an artist, art historian, and educator. He is emeritus dean and distinguished professor at the University of South Florida, where he founded Graphicstudio in 1968. He was director of Saff Tech Arts in Oxford, Maryland. He collaborated with Robert Rauschenberg, and beginning in 1984 he was the artistic director of the Rauschenberg Overseas Culture Interchange [ROCI]. Saff was interviewed by James L. McElhinney on August 15 & 16, 2013, in Oxford, Maryland.

ASHA SARABHAI was born in India. She is a fashion designer and founder of Raag Studios in Ahmedabad, India, and is married to Suhrid Sarabhai. Sarabhai was interviewed by Cameron Vanderscoff on March 18, 2015, in New York City.

HISACHIKA TAKAHASHI was born in Tokyo, Japan. He is an artist and was a studio assistant to Robert Rauschenberg. Takahashi was interviewed by Sara Sinclair on July 29, 30, & 31, 2014, in New York City.

MAYO THOMPSON was born in Houston, Texas. He is leader of the avant-garde rock band, Red Krayola. He worked as a studio assistant for Robert Rauschenberg in the early 1970s. Thompson was interviewed by Sara Sinclair on March 19 & 20, 2015, in Los Angeles.

CALVIN TOMKINS was born in Orange, New Jersey. He is an author and art critic for the *New Yorker*. Tomkins was interviewed by Mary Marshall Clark on March 21, 2015, in New York City.

LAWRENCE VOYTEK was born in Bridgeport, Connecticut. He is a sculptor and, along with Kat Epple and Laurence Getford, a member of the band Sonic Combine. He is a fabricator and was director of art production at Untitled Press, Inc. for Robert Rauschenberg in Captiva, Florida. Voytek was interviewed by Donald Saff on April 29, 30, & May 1, 2016, in Fort Myers, Florida.

SUSAN WEIL is an artist. She met Robert Rauschenberg while studying at the Académie Julian in Paris, France, and they attended Black Mountain College together in North Carolina, studying under Josef Albers. She and Rauschenberg were married in 1950 and had a son, Christopher Rauschenberg, in 1951. They divorced in 1952. Weil was interviewed by Mary Marshall Clark on January 27, 2014, June 6, 2014, & September 10, 2014, in New York City.

LAWRENCE WEINER was born in the Bronx, New York, and was central to the development of conceptual art in New York City in the 1960s. Weiner was interviewed by Brent Edwards on May 6, 2016, in New York City.

DAVID WHITE was born in St. Petersburg, Florida. He was a curator for Rauschenberg from 1980 until 2008 and is currently senior curator at the Robert Rauschenberg Foundation. He was interviewed by James L. McElhinney on July 13, 31, & August 1, 2013, in New York City.

ROBERT WHITMAN was born in New York, New York. A visual artist, he worked with fellow artists Allan Kaprow, Jim Dine, Red Grooms, and Claes Oldenburg to create Happenings on the Lower East Side of Manhattan in the 1960s. Along with Robert Rauschenberg, he was one of ten artists to make performance art for *9 Evenings: Theatre and Engineering* in 1966. He was interviewed by Alessandra Nicifero on November 20, 2014, & April 22, 2015, in New York City.

EALAN WINGATE was born in Tel Aviv, Israel. He began his career as director of the Sonnabend Gallery New York and is director of Gagosian Gallery in New York. Wingate was interviewed by Sara Sinclair on April 23, 2015, in New York City.

LARRY B. Wright was born in Brooklyn, New York. He is a master printer and was an assistant to Robert Rauschenberg in Captiva, Florida. Wright was interviewed by Sara Sinclair and Christine Frohnert on May 13, 2015, in Mount Vernon, New York.

Notes

PREFACE

1. Frances A. Yates, *The Art of Memory* (Chicago: University of Chicago Press, 1966), xi.
2. Mary Marshall Clark, "Oral History," in *Encyclopedia of Life Writing: Autobiographical and Biographical Forms*, ed. Margaretta Jolly (Chicago: Fitzroy Dearborn, 2001), 677–79.
3. Jan Assmann and John Czaplicka, "Collective Memory and Cultural Identity," *New German Critique*, no. 65: 125–133.
4. Andreas Huyssen, *Present Pasts: Urban Palimpsests and the Politics of Memory* (Stanford, CA: Stanford University Press, 2003).
5. Columbia University Libraries Oral History Research Office, "Voices of South Africa," http://www.columbia.edu/cu/lweb/digital/collections/oral_hist/carnegie/.
6. Luisa Passerini, "Work Ideology and Consensus Under Italian Fascism," *History Workshop Journal* 8, no. 1 (October 1979): 82–108, at 84, https://doi.org/10.1093/hwj/8.1
7. Alessandro Portelli, *The Death of Luigi Trastulli and Other Stories: Form and Meaning in Oral History* (Albany, NY: SUNY Press, 1991).
8. Alessandro Portelli, *The Order Has Been Carried Out: History, Memory and Meaning of a Nazi Massacre in Rome* (New York: Palgrave Macmillan, 2003).
9. Louisa Passerini, *Memory and Utopia: The Primacy of Intersubjectivity* (New York: Routledge, 2014).
10. Clark, "Oral History," eyewitness account.
11. Ann Cvetkovich, *An Archive of Feelings: Trauma, Sexuality and Lesbian Public Cultures* (Durham, NC: Duke, 2003).

2. COLLABORATIONS

1. Rachel Wolff, "A Homage to a Homage, Destruction at Its Core," *New York Times*, April 10, 2011.
2. "The Reminiscences of Calvin Tomkins, May 21, 2015," Robert Rauschenberg Oral History Project, Columbia Center for Oral History Research, Columbia University in the City of New York and Robert Rauschenberg Foundation Archives, 5.

3. Unpublished interview conducted by Calvin Tomkins for a 1962 article for the *New Yorker*, courtesy Calvin Tomkins Papers, II.A.5, The Museum of Modern Art Archives, New York.

4. Mary Emma Harris, *The Arts at Black Mountain College* (Cambridge, Mass.: MIT Press, 2012), 9.

5. Harris, *The Arts at Black Mountain College*, 16–20.

6. Harris, 168–240.

7. Julia Blaut, "Robert Rauschenberg: A Retrospective," Robert Rauschenberg Foundation, https://www.rauschenbergfoundation.org/artist/early-works-1948-54.

8. Leta E. Miller, "Cage's Collaborations," in *Cambridge Companion to John Cage*, ed. David Nicholls (Cambridge, UK: Cambridge University Press, 2002), 152.

9. Editors of Phaidon Press, *The 20th Century Art Book* (London: Phaidon Press, 2001), 506.

10. Blaut, "Robert Rauschenberg: A Retrospective."

11. Blaut.

12. Marcus Boon, "John Giorno," *Bomb Magazine*, Fall 2008. https://bombmagazine.org/articles/john-giorno-1/.

13. Janice Ross, *Anna Halprin: Experience as Dance* (Oakland: University of California Press, 2009), 143.

14. Nancy Kim, "MoMA Collects: Simone Forti's Dance Constructions," *Inside/Out* (blog), MoMA/MoMA PS1, January 27, 2016, https://www.moma.org/explore/inside_out/2016/01/27/moma-collects-simone-fortis-dance-constructions/.

15. Kim, "MoMA Collects: Simone Forti's Dance Constructions."

16. Edward Strickland, *Minimalism: Origins* (Bloomington: Indiana University Press, 1993), A/11.

17. Strickland, *Minimalism: Origins*.

18. Sally Banes, *Democracy's Body: Judson Dance Theater, 1962–1964* (Durham, N.C.: Duke University Press, 1993), xviii.

19. Program for *9 Evenings: Theatre and Engineering*, Experiments in Art and Technology (New York: The Foundation for Contemporary Performance Arts, 1966), 3–15.

20. Program for *9 Evenings*.

21. Abigail Cain, "A Brief History of the 'Happenings' in 1960s New York," *Artsy*, March 12, 2016, https://www.artsy.net/article/artsy-editorial-what-were-1960s-happenings-and-why-do-they-matter.

22. Carol Kino, "What Happened at Those Happenings?", *New York Times*, February 5, 2012.

23. Allan Kaprow, *Essays on the Blurring of Art and Life* (Berkeley: University of California Press, 1993), 1–9.

3. 381 LAFAYETTE STREET

1. Calvin Tomkins, "Moving Out," *New Yorker*, February 29, 1964.

2. Tomkins, "Moving Out."

3. "Chronology," Robert Rauschenberg Foundation, accessed May 1, 2017, https://www.rauschenbergfoundation.org/artist/chronology-new.

4. Tomkins, "Moving Out."

5. "Chronology," Rauschenberg Foundation.

6. Carolyn Brown, *Chance and Circumstance: Twenty Years with Cage and Cunningham*, e-reader version (New York: Knopf, 2009), chap. 23, para. 6.

7. "Chronology," Rauschenberg Foundation.

8. Katherine Wisniewski, "In a Soho Loft, New York City's 1970s Art Scene Lives On," *Curbed New York*, August 3, 2015.

9. Celia McGee. "A Building Famous for Its Parties (Not to Mention Art)." *New York Times*, June 16, 2013.

10. "The Reminiscences of Dorothy Lichtenstein, August 20, 2014 & February 3, 2015," Robert Rauschenberg Oral History Project, Columbia Center for Oral History Research, Columbia University in the City of New York and Robert Rauschenberg Foundation Archives, session 1, 34.

11. "The Reminiscences of Hisachika Takahashi, July 29, 30, & 31, 2014," Robert Rauschenberg Oral History Project, Columbia Center for Oral History Research, Columbia University in the City of New York and Robert Rauschenberg Foundation Archives, session 2, 47.

12. Leo Lerman, "The New Old Masters," *Mademoiselle*, February 1965.

13. "Chronology," Rauschenberg Foundation.

14. "Chronology."

15. "Chronology."

16. Julie Baumgardner, "The Most Iconic Artists of the 1970s," *Artsy*, August 11, 2015.

17. Rachel Corbett, "7 of History's Most Mouth-Watering Artist-Run Restaurants," *Artspace*, May 7, 2013, https://www.artspace.com/magazine/interviews_features/art_market/artist _restaurants-51112.

18. "Remembering Gordon Matta-Clark: Food: and How the Cutting Pieces Began," *M-Kos*, May 7, 2013.

19. "The Reminiscences of Laurie Anderson, October 23, 2015," Robert Rauschenberg Oral History Project, Columbia Center for Oral History Research, Columbia University in the City of New York and Robert Rauschenberg Foundation Archives, 19.

4. CAPTIVA

1. Mark Godfrey, "Source and Reserve of My Energies: Working from Captiva," in *Robert Rauschenberg*, ed. Leah Dickerman and Achim Borchardt-Hume (New York: Museum of Modern Art, 2017), 285.

2. "The Reminiscences of Bob Monk, May 18, 2015," Robert Rauschenberg Oral History Project, Columbia Center for Oral History Research, Columbia University in the City of New York and Robert Rauschenberg Foundation Archives, 23.

3. Alina Cohen, "Captiva Island: Robert Rauschenberg's Escape from New York," *Observer*, November 16, 2016, https://observer.com/2016/11/captiva-island-robert-rauschenbergs-escape-from-new-york/.

4. "The Reminiscences of Christopher Rauschenberg, January 13, 2015, & January 17, 2016," Robert Rauschenberg Oral History Project, Columbia Center for Oral History Research,

Columbia University in the City of New York and Robert Rauschenberg Foundation Archives, session 1, 49.

5. Robert Rauschenberg, "Statement on Captiva," letter to Ron Bishop, n.d., Robert Rauschenberg Foundation Archives.

6. Julia Halperin, "The Florida Island That Revived Rauschenberg," *The Art Newspaper*, December 2, 2016.

7. Robert Rauschenberg, *Cardbirds*, brochure with statement by the artist (Los Angeles: Gemini G.E.L., 1971).

8. Halperin, "The Florida Island That Revived Rauschenberg."

9. Rauschenberg, *Cardbirds*.

10. Adrian Serle, "Robert Rauschenberg Review," *The Guardian*, November 29, 2016.

11. Serle, "Robert Rauschenberg Review."

12. "The Reminiscences of Don Saff, August 15 & 16, 2013," Robert Rauschenberg Oral History Project, Columbia Center for Oral History Research, Columbia University in the City of New York and Robert Rauschenberg Foundation Archives, session 3, 178.

13. "Print House," Robert Rauschenberg Foundation. Accessed May 9, 2017, https://www.rauschenbergfoundation.org/residency/print-house.

14. "The Reminiscences of Jack Cowart, May 6, 2015," Robert Rauschenberg Oral History Project, Columbia Center for Oral History Research, Columbia University in the City of New York and Robert Rauschenberg Foundation Archives, 15.

15. "The Reminiscences of Sheryl Long,. July 22, 2015," Robert Rauschenberg Oral History Project, Columbia Center for Oral History Research, Columbia University in the City of New York and Robert Rauschenberg Foundation Archives, 11.

16. "The Reminiscences of Calvin Tomkins, May 21, 2015," Robert Rauschenberg Oral History Project, Columbia Center for Oral History Research, Columbia University in the City of New York and Robert Rauschenberg Foundation Archives, 32.

17. Calvin Tomkins, *Off the Wall: A Portrait of Robert Rauschenberg* (New York: Picador, 1980), 294.

18. "The Reminiscences of Jack Cowart," 16.

19. "The Reminiscences of Jack Cowart," 16.

5. TRAVELOGUE

1. Frances Morris and Glenn D. Lowry, "Foreword," in *Robert Rauschenberg*, ed. Leah Dickerman and Achim Borchardt-Hume (New York: Museum of Modern Art, 2017), 8.

2. Achim Borchardt-Hume, "Robert Rauschenberg: Five Propositions," in *Robert Rauschenberg*, ed. Leah Dickerman and Achim Borchardt-Hume (New York: Museum of Modern Art, 2017), 25.

3. Mark Godfrey, "Source and Reserve of My Energies: Working from Captiva," in *Robert Rauschenberg*, ed. Leah Dickerman and Achim Borchardt-Hume (New York: Museum of Modern Art, 2017), 292.

4. "The Reminiscences of Fredericka Hunter, September 16, 2015," Robert Rauschenberg Oral History Project, Columbia Center for Oral History Research, Columbia University in the City of New York and Robert Rauschenberg Foundation Archives, 26.

5. "Chronology," Robert Rauschenberg Foundation, accessed May 24, 2017, https://www
 .rauschenbergfoundation.org/artist/chronology-new.
6. Mary Lynn Kotz, *Rauschenberg: Art and Life*, new ed. (New York: Abrams, 2004), 45.
7. Kotz, *Rauschenberg*, 193.
8. "Chronology," Robert Rauschenberg Foundation.
9. Kotz, *Rauschenberg*, 194.
10. Godfrey, "Source and Reserve of My Energies," 293.
11. Kotz, *Rauschenberg*, 195.
12. Godfrey, "Source and Reserve of My Energies," 293.
13. Godfrey, 293.
14. Rosamund Felsen, "Rauschenberg's Trip to India," in *Paper: Art and Technology*, ed. Paulette Long (San Francisco: World Print Council), 84.
15. Kotz, *Rauschenberg*, 203.
16. Kotz, 203.
17. Kotz, 206.
18. "Chronology," Robert Rauschenberg Foundation.
19. Kotz, *Rauschenberg*, 206.
20. "The Reminiscences of Asha Sarabhai, March 18 & November 18, 2015," Robert Rauschenberg Oral History Project, Columbia Center for Oral History Research, Columbia University in the City of New York and Robert Rauschenberg Foundation Archives, 34.

6. RAUSCHENBERG OVERSEAS CULTURE INTERCHANGE [ROCI]

1. Jack Cowart, "Introduction," in *Rauschenberg Overseas Culture Interchange* (Washington D.C.: National Gallery of Art, 1991), 9.
2. Hiroko Ikegami, "Art Has No Borders: Rauschenberg Overseas Culture Interchange," in *Robert Rauschenberg*, ed. Leah Dickerman and Achim Borchardt-Hume (New York: Museum of Modern Art, 2017), 342.
3. "The Reminiscences of Don Saff, August 15 & 16, 2013," Robert Rauschenberg Oral History Project, Columbia Center for Oral History Research, Columbia University in the City of New York and Robert Rauschenberg Foundation Archives, session 2, 102.
4. Mary Lynn Kotz, *Rauschenberg, Art and Life*, new ed. (New York: Abrams, 2004), 19.
5. Kotz, *Rauschenberg*, 20.
6. Kotz, 22.
7. Kotz, 22.
8. "Art in Context: Rauschenberg Overseas Culture Interchange (ROCI)," Robert Rauschenberg Foundation, accessed June 5, 2017, https://www.rauschenbergfoundation.org/art/art-in-context/roci.
9. "A Conversation About Art and ROCI, Robert Rauschenberg and Donald Saff," in *Rauschenberg Overseas Culture Interchange* (Washington, D.C.: National Gallery of Art, 1991), 156.
10. "A Conversation About Art and ROCI," 156–57.
11. Ikegami, "Art Has No Borders," 344.

12. Kotz, *Rauschenberg*, 22.
13. Cowart, "Introduction," 9.
14. Cowart, 9.
15. Cowart, 9–10.
16. "Chronology," Robert Rauschenberg Foundation, accessed June 12, 2017, https://www .rauschenbergfoundation.org/artist/chronology-new.
17. Cowart, "Introduction," 10.
18. "A Conversation About Art and ROCI," 158.
19. Ikegami, "Art Has No Borders," 343.
20. Ikegami, 348.
21. Ikegami, 348.

7. CURATING AND INSTALLATIONS

1. Jo Ann Lewis, "Rauschenberg Bright & Early: Accomplished Works of the Young Artist, at the Corcoran," *Washington Post*, June 15, 1991.
2. Hilton Kramer, "Justly Ignored Early 50's Rauschenberg upon Us," *New York Observer*, November 30, 1992.
3. Roberta Smith, "Robert Rauschenberg, at Home and Abroad," *New York Times*, August 26, 1991.
4. Fred Camper, "The Unordered Universe," *Reader*, March 27, 1992, https://www .chicagoreader.com/chicago/the-unordered-universe/Content?oid=879405.
5. Roberta Smith, "Walter Hopps, 72, Curator with a Flair for the Modern, Is Dead," *New York Times*, March 23, 2005, http://www.nytimes.com/2005/03/23/arts/design/walter -hopps-72-curator-with-a-flair-for-the-modern-is-dead.html?_r=0.
6. "The Reminiscences of Susan Davidson, March 3, 2015, March 31, 2015, & May 5, 2015," Robert Rauschenberg Oral History Project, Columbia Center for Oral History Research, Columbia University in the City of New York and Robert Rauschenberg Foundation Archives, session 1, 21.
7. "The Reminiscences of Caroline Huber, May 29, 2015," Robert Rauschenberg Oral History Project, Columbia Center for Oral History Research, Columbia University in the City of New York and Robert Rauschenberg Foundation Archives, 42.
8. Smith, "Walter Hopps."
9. John Richardson, "Rauschenberg's Epic Vision," *Vanity Fair*, September 1997, 277.
10. Calvin Tomkins, "Master of Invention," *New Yorker*, October 13, 1997, 92.
11. Tomkins, "Master of Invention," 96.
12. "The Reminiscences of Susan Davidson," session 3, 123.

8. AN EXPANDING AMERICAN ART MARKET

1. "Chronology," Robert Rauschenberg Foundation, accessed June 21, 2017, https://www .rauschenbergfoundation.org/artist/chronology-new#2000–08

2. Andrew M. Goldstein, "How Leo Castelli Remade the Art World," *Artspace*, February 11, 2013. https://www.artspace.com/magazine/art_101/art_market/leo_castellis_legacy-5836

3. Goldstein, "How Leo Castelli Remade the Art World."

4. Goldstein.

5. Goldstein.

6. Roberta Smith, "Ileana Sonnabend, Art World Figure, Dies at 92," *New York Times*, October 24, 2007.

7. Calvin Tomkins, "Profile: An Eye for the New," *New Yorker*, January 17, 2000, 56.

8. "The Reminiscences of Ealan Wingate, April 23, 2015," Robert Rauschenberg Oral History Project, Columbia Center for Oral History Research, Columbia University in the City of New York and Robert Rauschenberg Foundation Archives, 12.

9. "The Reminiscences of Susan Davidson, March 3, 2015, March 31, 2015, & May 5, 2015," Robert Rauschenberg Oral History Project, Columbia Center for Oral History Research, Columbia University in the City of New York and Robert Rauschenberg Foundation Archives, session 3, 123.

10. "The Reminiscences of Arne Glimcher, May 27, 2015," Robert Rauschenberg Oral History Project, Columbia Center for Oral History Research, Columbia University in the City of New York and Robert Rauschenberg Foundation Archives, 13.

11. "The Reminiscences of Ealan Wingate," 30.

Index

Page numbers in *italics* indicate figures.